ThinkingwithThings

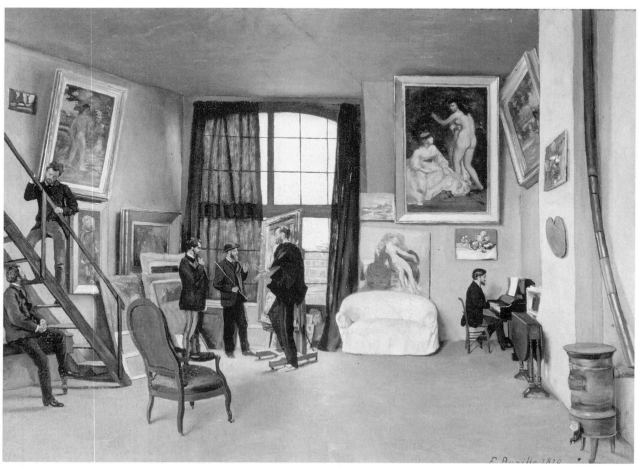

Frédéric Bazille, *The Artist's Studio at 9 Rue de la Condamine in Paris.* Musée d'Orsay, Paris, France.
Copyright Réunion des Musées Nationaux / Art Resource, NY. Photo: Herve Lewandowski.

ESTHER PASZTORY

Thinking with THINGS

Toward a New Vision of Art

UNIVERSITY OF TEXAS PRESS AUSTIN

Copyright © 2005 by the University of Texas Press
All rights reserved
Printed in the United States of America
First edition, 2005

Requests for permission to reproduce material from this work should be sent to
Permissions, University of Texas Press, P.O. Box 7819, Austin, TX 78713-7819.

LIBRARY OF CONGRESS CATALOGING-IN-PUBLICATION DATA

Pasztory, Esther.
 Thinking with things : toward a new vision of art / Esther Pasztory.—1st ed.
 p. cm.
 Includes bibliographical references and index.
 ISBN 0-292-76597-5 (hardcover : alk. paper)— ISBN 0-292-70691-X (pbk. : alk. paper)
 1. Art—Philosophy. 2. Art and society. 3. Art and anthropology. 4. Cognition—Social
aspects. 5. Indian art. I. Title.
 N66.P37 2005
 701—dc22 2004020341

To the memory of the pioneering spirit of **George Kubler**

. . . there literally is art in every artifact, and vice versa, in every work of art there lies the shadow of an artifact or tool.

George Kubler, *The Shape of Time*

CONTENTS

A Note to the Reader .ix

Acknowledgments .xi

PART ONE

 Introduction to Part One .3

 1. Things .6

 2. Thinking with Things .16

 3. Levels of Social Integration28

 4. Insistence .40

 5. Superpositions .44

 6. Impersonation .52

 7. Enhancement .60

 8. Apotheosis .66

 9. Iconoclasm/Aestheticism74

 10. Media/Marginalization86

 11. Transition .102

 Bibliography to Part One107

PART TWO

 Introduction to Part Two: Confessions of a Formalist117

 12. Still Invisible: The Problem of the Aesthetics
 of Abstraction for Pre-Columbian Art and Its
 Implications for Other Cultures119

 13. Identity and Difference: The Uses and Meanings
 of Ethnic Styles .157

 14. The Portrait and the Mask: Invention and Translation179

 15. Aesthetics and Pre-Columbian Art189

 16. Andean Aesthetics197

 17. Three Aztec Masks of the God Xipe209

 18. Shamanism and North American Indian Art225

Index .243

A NOTE TO THE READER

This book is about the nature of things we call art—how we study them and why we should bother with them. Part One is a long study outlining a theory of art based on anthropology, philosophy, and art history. The argument is that things have mostly cognitive rather than visual significance, and that their basic forms and intentions are determined by their position in the sociocultural situation.

Part Two consists of seven previously published articles which analyze the specific issues raised in the above study, such as naturalism versus abstraction, art and identity, and aestheticism. Most of these issues are discussed in the context of pre-Columbian art, brought into the discussion of Western art theory in a major way for the first time, hopefully beginning the process of obliterating the excessive isolation of these fields from one another.

The two parts of this book are meant to intertwine anthropological and art historical theory with a set of global examples in order to create a new way of looking at the things we call art.

ACKNOWLEDGMENTS

Some of this book has been in progress for nearly twenty years, and in that time many assistants helped with one task or another. Unfortunately, I do not remember clearly all who worked specifically on this project, but I am extremely grateful to all of them for their help. In the initial phases the contributions of Joanne Pillsbury and Holland Cotter stand out, and I would like to thank them in particular, and Debra Nagao has been helpful as usual from Mexico. The manuscript was read in its old incarnation, entitled *Towards a Natural History of Art,* by among others Linda Seidel, Keith Moxey, Frederick Zeller, and Zsolt Farkas, and I am indebted to all of them for their comments and reactions.

I would like to thank the staff of the University of Texas Press for their supportiveness and efficiency. Last, but not least, I would like to thank Ben Fried Cassorla, the undergraduate assistant who straightened out the complex mess of illustrations, permits, and notes of the last two years and without whom this book might have had to wait many more years for publication.

Part

ONE

INTRODUCTION TO PART ONE

*Midway in the journey of our life, I found myself
in a dark wood, for the straight way was lost.*
—Dante, *Divine Comedy*

From the first serious task in art history that I undertook in my master's essay on African art, I pursued the idea that the social context—e.g., whether figures are male or female, flanked by others or not—determines the basic nature of art. I had a conviction that such choices are primarily social and only secondarily aesthetic. I do not know where these ideas came from, since they were alien to art history then. Recently, I have come to wonder if they came out of my own background in a traditionally status-conscious society masked by an ideology of classlessness, the contradictions of which were mind-boggling. I was, and am, very aware of minute cues of hidden differentiation. I can further credit my education in communist Hungary with teaching me never to look at overt meanings but instead only to read between the lines. Being good at this could be a matter of life and death. It had a name: the language of flowers.

The process of writing Part One was a curious journey for me. I began by thinking that these ideas had nothing to do with the work of anyone else. I was going to use art history and anthropology to critique, complement, and rewrite each other, and I found no one else engaged in this task—I was alone. I completed a first draft of the manuscript in 1988 as the recipient of a Guggenheim fellowship. It was then entitled *Towards a Natural History of Art*. I showed various versions of the draft to a number of colleagues, friends, and students, most of whom disliked it. They all disapproved of such a "totalizing" theory, and the natural history parallels were particularly anathema to them. (Only one remains.) I was told that my task was to write in detail about a specific culture I know well and not to presume to understand how things work globally. To my disappointment, few actually engaged with the content of my argument.

Part One thus began as a private, personal obsession. I did not teach it, I did not present it in conferences, and only recently did I write about it directly in an article. So, for all these years the manuscript and I lived in isolation. With the final copy this year, I began the colossal task of footnotes and rereading various authors. To my great astonishment my ideas were there, in bits and pieces here and there. The book became less me and mine as I progressed. Evidently I was not alone. Perhaps I was only putting together on one map the various locales already charted by others—amalgamating ideas the way the Inca made a 3,000-mile road system from the roads of their predecessors. I was especially

astonished by the relevance of Marshall McLuhan, whom I had totally forgotten since the 1960s but exhumed for a footnote. I discovered that he already had the concept of the position of technology within society and how position determined form. I was not original there either.

Although the book started out as a structural history of world art, a subtext emerged and took over: my deeply held belief that the purpose of art was primarily cognitive and only secondarily aesthetic. One friend criticized the first draft on the grounds that it did not define art. Though I tried to sidestep that issue by a commonsense definition, since I did not see it as *my* problem—it was too big a problem—in the end I had to face it. When I began to write about it, I found that art as a term was meaningless to me prior to the eighteenth century in Europe, and the determination of "art" versus "non-art" in the non-Western world was in complete chaos. Just yesterday I heard a marvelous lecture contrasting African and Western art that was completely confused because of the assumptions about what "art" is. In any case, my slowly developing theory of the cognitive nature of art was not limited to "art" but included things in general. I have come to the conclusion that the concept of art is more of a hindrance than a help to understanding. I have therefore avoided the use of the term "art" except for the periods in which it is appropriate and have found this to be liberating. Part One begins with the abolition of the concept of art and with a cognitive interpretation of things, because I cannot do without it for the rest of the discussion. Here too, much as I thought myself a pioneer, at the moment of finishing my manuscript I found that this idea is already in the air. Recently there was a conference on the abolition of art in Mexico. Therefore, this section of *Thinking with Things* is deeply embedded in its time, even though it seems to have been born as a highly personal document.

The structural evolution of things in social contexts of increasing complexity is the subject of the rest of the chapters. I differ from most writers of "survey" books in privileging the earlier types of social structures, partly because I derived my theory

from anthropological writings on the subject and the early structures provide the clearest demonstration of my points. A secondary aim is to acquaint the Western art historian with material that is unfamiliar and scattered by presenting it in a comprehensible form. I feel very strongly that later societies fall into types just as the earlier bands, tribes, chiefdoms, and archaic states do, but most anthropological literature is not interested in the later, historic, periods, which have their own separate literature. However, if my approach was to work, it would have to work all the way and so I had to include them. Thus I was forced to invent two more categories, the "textual era" and the "technological era," which have no existence as standard terms outside of this work. To specialists it may seem absurd to oversimplify such complex periods in short chapters. I am only reversing what is usually done to the "primitive." For me, the chapter on writing and things (the textual era) was pivotal in understanding the whole.

Part One, and Chapter 10 in particular, is permeated by an agenda that emerged unexpectedly and that I seem to share with very few (but that, for all I know, will also be in the zeitgeist). All these years that I have been in an exotic "primitive" field, I have always found myself at odds with primitivists. I define "primitivism" as the adulation of non-Western people and their things for their greater spirituality, closeness to nature, closeness to the instinctual life, and so on. As far as I am concerned, these are merely the positive valuations of the stereotype of the stupid and irrational native. It is my tenet that we are all equally rational and irrational but that we express these differently depending on the type of society we live in. I argue that the important differences are not between the eulogized or much maligned West and non-West, as essentializing entities, but between types of societies. Any other culture in the position of the West would be structurally similar to it. It is my aim to level the differences and allow non-Westerners reason and Westerners irrationality. Things stand in as problematic a relationship to other modes of communication as "primitives" to the "civilized": they are much maligned. It was my aim to sketch some aspects of the world of

things and our thinking with them both prior to writing and in our everyday world now. This is a huge subject that I do not claim to exhaust, merely to put on the map.

Given all these agendas, Part One is short. I am not an expert in any of it, but I have been thinking about it for over twenty years. I do not claim to prove my theories with endless examples. I know full well that there are many exceptions to everything. I do not make truth claims. As Claude Lévi-Strauss puts it, I ask for no other utility than that it should be good to think.

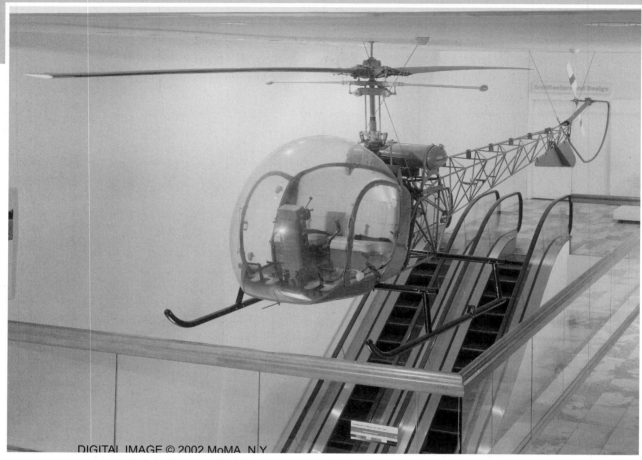

Figure 1.1 Arthur Young, *47D-1 Helicopter,* 1945. Aluminum, steel, and Plexiglas canopy and doors, 9 ft. 2.75 in. x 9 ft. 11 in. x 41 ft. 8.75 in. Museum of Modern Art, New York. Marshall Cogan Purchase fund (126.1984). Digital Image © The Museum of Modern Art / Licensed by SCALA, Art Resource, NY.

ART

Any analysis of "art" comes up against the concept of what *is* art. Paul Oskar Kristeller demonstrates beautifully that the modern concept of art—originality, creativity, genius—is eighteenth century in origin, but he refers to medieval and ancient art as "art," even though he has just shown that they had no such concept or word for it.[1] The term "art" is routinely invoked by current authors for all ornamented or figurative images of all people in all times, and thus has become a universal. Anthropology survey books have chapters on art as they do on kinship. Art is either not defined or very difficult to define. Theoretically, we all know what it is, but in fact we have no idea what we are talking about.

Prior to the eighteenth-century concept of art, there were other concepts about objects. In the sixteenth century, for example, foreign things were put in several categories: treasures such as precious metals and gems desired for their monetary value, strange objects desired for their curiosity value, utilitarian objects largely not desired, and images interpreted as heathen idols usually hated and destroyed. As such, the conquerors of Mexico sent back gold, usually melted down in the form of gold bars; curiosities—i.e., weapons, headdresses, jades, and books—and utilitarian objects like blankets and textiles. Many of the curios came to light in the nineteenth century in trunks in attics and are now in museums as "art." Of the hundreds of utilitarian items such as blankets, none were "treasured" or lasted to the twentieth century. The heathen idols were, of course, not sent back to Europe; they were destroyed in situ. In the nineteenth century, the surviving ones in Mexico became "art" and were sometimes taken to Europe or even faked.[2]

What Albrecht Dürer enthused over in the often quoted passage from his trip to Brussels were Aztec "treasure-curios."

> I saw the things which have been brought to the king from the new land of gold (Mexico), a sun all of gold a whole fathom broad, and a moon all of silver of the same size, also two rooms full of the armour of the people there, and all manner of wondrous weapons of theirs, harness and darts, very strange clothing, beds, and all kinds of wonderful objects of human use, much better worth seeing than prodigies. These things were all so precious that they are valued at 100,000 florins. All the days of my life I have seen nothing that rejoiced my heart so such as these things, for I saw amongst them wonderful works of art, and I marveled at the subtle Ingenia of men in foreign lands. Indeed I cannot express all that I thought there.[3]

It is quite clear from the passage that Dürer's admiration is of riches, curiosities, and craft. When he discusses Western "art" he uses different terms, such as proportion, or alludes to comparisons with antiquity. Contrary to usual

interpretations, he doesn't marvel at the "art" of the New World, he marvels at the "curiosities" and "craft."[4]

Yet by the eighteenth century what were "heathen idols" had become art. Europe was more secular and Mexico was less afraid of native religious revivals. When three Aztec sculptures came to light in the construction in the Zócalo of Mexico City in 1790, two were left visible and eventually moved to a new museum devoted to antiquity. The third, a colossal idol-like female figure, was reburied for some time for fear of its effect on the natives. By the end of the nineteenth century, however, it had found its place in the museum too. Plaster casts were made of the sculptures and exhibited in 1824 in London for a public eager to see exotic monuments.[5]

This change in classification from heathen idol to art is not easily explained. Art and the aesthetic experience were being defined in the eighteenth century as universals—everyone was believed to have an aesthetic sense, although what was thought "beautiful" varied from person to person and culture to culture.[6] Because the beautiful was seen as relative but the sense of beauty as universal, it became possible to admire the monuments of other cultures. Their religious content as truth or untruth became irrelevant. The concept of art in the eighteenth century was very close to the idea of loss. To George Hegel, art was always something "past" in a ruinous condition, through which one contemplated the spirit of history.[7] Because classical art is largely stone, especially monuments, other similar monuments were classified as "art" with them.

The nineteenth-century focus was on big stone monuments, like the monuments of Greece, Rome, and Egypt that were then being excavated and transported to Europe and its new museums. One could say the museums and monuments became shrines to a new religion that celebrated the universal creativity of humanity. They became treasures and relics at the same time. God, no longer specifically dominant in society, was evident in the divine creativity resident in the genius of the artists who had made "art." In contemplating art, the aesthetic experience was the equivalent of the religious experience.[8]

Large stone human figures were among the first foreign objects recognized as art in the eighteenth century. From that point on a domino effect ensued, as art after art was revalued. Captain Cook considered the Northwest Coast masks "monstrous" in 1776 and only collected two,[9] but by 1900 George Emmons and George Hunt were filling the American Museum of Natural History with them.[10] In this whole process of collecting, however, judgments were made as to what is art and what isn't. It is quite clear that in the Western concept of art, the image of the human takes a central place. In fact, it is precisely what was once thought to be the "heathen idol" that is the work of art! The Yoruba people of Nigeria make a pot lid that sometimes has a figure on the top. An example is in the Metropolitan Museum of Art in New York. The covers with figures are collected; the ones without are of little interest to us.[11]

Besides its obsession with figures, the West determines the art of the rest of the world in terms of current taste and styles. Most pre-Columbian "art" has been appreciated, defined, and collected in terms of the prevailing Western styles whose last major stop was the recognition of Peruvian art via conceptual art.[12]

The West has thus created non-Western "art" in its own image out of its own earlier traditions. It has created museums to house its global treasure trove. With scholarly research in libraries and in the field, these selections are not totally alien to the nature of native objects and aesthetics, but they have been fitted into the concept of art of the nineteenth- and twentieth-century West. You cannot find out what art is in the museum.

In a brief but succinct essay, Thomas McEvilley summarized the various current definitions of art:

Formal—*based on beauty of form (which does not appeal to him because it is purely aestheticizing "design").*

Content—*based on the idea that art is expression and not form, (closer to what McEvilley and Arthur Danto see as "art" because it is better at including nonaesthetic art).*

Designation—*art is whatever people designate as art, regardless of form and content—*

and it keeps changing. This is a functional and sociocultural definition.

Honorific—*calling something "art" is a way of designating its importance and value and has no other meaning.*[13]

Nowhere does the contemporary critic McEvilley question the value of the term "art" in either usage or scholarship.

The anthropologist Lewis Binford avoids the term "art" entirely.[14] For him all objects are "material culture," but he distinguishes some as "idiotechnic" and "sociotechnic" in contrast to utilitarian ones. He is implicitly accepting the idea of a definition of art based on content and function but not necessarily of form. Can one refer only to objects that have primarily an ideological or social function as art? Are there not socially and ideologically important things that are not "art"? Moreover, the Western eye often finds beauties among utilitarian objects, if their forms happen to please it.[15] There is simply no avoiding this eye that has sorted through the world's things and found artistic treasures hither and yon.

Suppose one were to give up the concept of art prior to the eighteenth century and consider only later Western "art," created in the contexts of an ideology of "art" art. How does one deal with the past? We have become accustomed to referring to Byzantine icons and Egyptian statues as art—can we unlearn this and see them another way? Art appears to be a convenient universal term. And it all is "artistic," after all, isn't it? It has style, an aesthetic, forms, functions, and meaning. But is it art just because it uses a formal language? Cars use a formal language and we do not consider them art—although as industrial design they are slowly moving into the realm of art as well. There is, after all, a helicopter in the Museum of Modern Art in New York. Most people have an aesthetic but not necessarily a concept of art. How is it possible to talk about things without packaging them in the Western conception of art? Some way that allows for native classification as well as comparative and universalizing statements. Does the concept of art help or hinder discussion about things? Is the definition of art a false problem? It is time to take apart the neat little art-box that has confined our discourse for so long.

NOT ART

What is art not? The Bena Luluwa of the Democratic Republic of the Congo used to make wooden figures of men and women with elaborate scarification designs. Made between the 1890s and the 1920s, many of these figures are now in our museums. For the same purposes the Bena Luluwa now keep magic substances in our cigar boxes and other foreign containers.[16] Now if these cigar boxes were by Marcel Duchamp, we would collect them. As they are Bena Luluwa, we do not consider them art. One of the Western rules in selecting art from a non-Western or tribal context is that it should be well crafted and indicate skill and workmanship, precision of cutting, and polish. The crudeness allowable in modern and contemporary art is not allowed in primitive art.[17] Primitive art has to be refined to be art. In primitive art crudeness is just crudeness. In modern art crudeness has meaning. You figure it out. Michael Fried concludes that non-art is that which avoids theatricality, although theatricality is hard to avoid.[18]

At nineteenth-century potlatches, the Northwest Coast Kwakiutl people gave away beautifully made things, also now in museums. Today, they give away plastic baskets filled with dime-store pots and pans and towels.[19] Obviously, we do not consider this appropriation of Western mass-produced goods to be art, although if a Western artist put them in a gallery installation, we very well might. Certainly a contemporary Kwakiutl artist could show them in a gallery as modern native art, although the Western buyers of native art are more likely to purchase prints with traditional designs.

Our decision of what is art is not necessarily based on its appearance or function, but rather on a complex designation given usually by the West or Asia as to what constitutes aesthetic creativity at a given level of culture or context. Tourist art is not art because it is inauthentic and made for sale to undiscriminating outside buyers. Native groups from the Inuit (Eskimo) to the Australian Aborigines have been

lured to make "art" to produce cash. The Inuit sculptures have a dated 1950s–1960s look and are of little interest at the moment, relegated to the history of oddities. The large, modernistic Aboriginal acrylic paintings have become a big success recently with major exhibitions and collections. Their style, form, and medium are largely Western, but an Aboriginal "story" goes along with each. Whose "art" is it? One was offered to a New York museum as modern art. The curator rejected it as inappropriate and it was then offered to the Africa/Oceania/American (Primitive) Department of the same museum. That curator rejected it for not being traditional. The classification system of the museum could not cope with this hybrid, even though it looked like "art."

I sometimes wonder if aliens went through my apartment what things they would classify as art and what would be non-art. How would they distinguish the garments that hang on the wall from the garments that hang in the closet? When I bought those textiles in the Chichicastenango market from women wearing them, did I transform them into works of art? I bought them as works of art, making sure that they were old and authentic and not tourist art. Maybe the aliens would like my Tupperware,[20] as Kwakiutl potlatchers are happy to get it. Or perhaps the icebox.

Contemporary artists have been playing the art/non-art game since Duchamp exhibited a urinal entitled *Fountain* in 1917. It is art if someone makes a convincing case for it. That includes piles of earth, fat, wrapped islands, and sacrificial blood. That is, if the West does it and it is a happening. If an African sacrifices a chicken on an altar, it is not art. But is not the West's conception of art a form of religion too, consisting of various interlinked cults—from the museums and their ritual and relics, to contemporary artists seeking to be priests and shamans?

If it is not in how the chicken is sacrificed, and not in the context—where exactly is the art? McEvilley would be Kantian and argue that art is only possible when there is no longer religion present.[21] What then of the Sistine Chapel?

Is Bouguereau art? Or are his canvases art but "bad" art, in which case how can "art" be honorific? In their time they were considered excellent. Do we take a people's definition of what is good in their art, or do we make our own selection? And does our selection change as our taste changes? How come we think everything native cultures did at or before Western contact was beautiful and everything they now make is shoddy, tasteless, and worthless?

THINGS

It is not possible to separate art from non-art; there are only things of various sorts, functions, forms, and meanings.[22] Starting with the projectile points of early humans, all human-made things have formal properties and style.[23] It is possible to appreciate them, to prefer a Folsom or a Clovis point. It is possible that there is wide agreement as to which point is more beautiful or interesting. It is possible to prefer the less obvious choice. It is further possible to classify them by material, size, finish, and style. It is possible to interpret their maker's identity from them. That is true of chairs and CDs and garbage cans. Objects heretofore not considered works of art are in no way different—they can all be appreciated and classified by aesthetic criteria. Aesthetic criteria determine dress, the arrangements of homes, cities, highways, transport, and spacecraft. All these things are mixtures of function and forms.

As soon as there is form, there is message. It is impossible to dress in such a way as to convey no meaning. Every fabric, color, and cut has socially and perhaps even biologically determined meaning. The changing form of cars illustrates the power of meaning in nonfigurative form. One can analyze cars and their relationship to their times as one can analyze paintings, or pictures of food in women's magazines, as Roland Barthes did.[24]

Art for art's sake is the only kind of object that would qualify as an "art thing," something made purely as an aesthetic object. These exist in the West from the Renaissance onward and in some periods of Asian art. Nevertheless, "art for art's sake" is a misnomer in every case—all of these objects have "idiotechnic" and "sociotechnic" functions, as Binford would say.[25] Ownership of them conveys status and prestige, the demonstration of monetary and/or intellectual power, continuous or occasional

display, and theatricality. Contemporary art has wittily deconstructed this idea too in its various attempts to create noncollectable or self-destructing arts, with nothing but the check of the patron as material proof of the artistic transaction. But the artistic transaction even here is social and economic and not for "art's sake." When I make a sketch, alone in my living room, and throw it in the garbage, perhaps I have made art (or an art gesture) for art's sake. But not quite. There is no art for art's sake—all things communicate in a social, religious, or economic context. Even in my drawing I communicated with myself.

There is a continuum, however, between things that communicate little and things that communicate a lot. Even potsherds communicate a great deal to the archaeologist—where and when they were made, whether they are coarse and thick or delicate and thin, how the designs vary. Whole cultures, people and periods, have been built up on the basis of broken crockery. But the find of a single carved stone monument gives more information than all the ceramic study. Should it be some fantastic or grotesque figure, it is considered a god or supernatural and it is supposed to give us access to the minds of the people. "Their gods were all important to them." Should it be clearly human dressed in fancy costume, "it must be one of their leaders or kings." In that case, the image is dissected as if it were the photograph of a person. "They wore sandals with feathered ruffs." The informational capacity of some objects is much greater than—and different in kind from—others, because from the time of early humans some things were made primarily for purposes of communication. The means of communication were aesthetic but the aims were not. There are no art things. The aim of something has always been communication.[26] There are only communicative things.

TECHNOLOGIES

Arnold Rubin considered tribal and archaic art to be a form of technology.[27] Masks and figures that are believed to have spirit power are interpreted as agents as active in their societies as microwaves or Walkmans are in ours. Even bodypainting works as a medium of communication about age, status, ritual,

and personality. These ideas are old truisms about archaic art that H. W. Jansen, in his popular survey, once glibly dismissed as purely "spirit traps" and therefore not real art.[28] The fact is, however, that all these "spirit traps" operate with aesthetic means rather than electricity, gears, or computer chips. Western thinking has been unable to relate functionality and aesthetics in a satisfying manner: it has to be either one or the other. But as ethnography after ethnography makes clear, aesthetics are the means of technology in archaic type societies. I would go so far as to suggest that aesthetics are the first technology of communication and control of humanity.

A second major communication technology is writing. There is a significant difference between cultures that have some writing and cultures that are writing-based. In cultures deeply involved with writing, there is strong rivalry with the imaging media, usually manifesting itself as iconoclasm. Images are seen to be evil and false, and the truth is supposed to reside in the immaterial and transcendent text. There is no question that there is a deep and profound philosophical difference between the world of the text and the image, and the image loses out. In most areas it remains as a secondary technology, often "illustrating" the text.[29] It is in this context of conflict that the aesthetic aspects of the image are more self-consciously recognized, and since they are seen as less significant than the "truth value" of texts, they are allowed and encouraged. Aestheticism, i.e., a conscious striving to be visually appealing, emerges.

The third major technology is that of replication and the mass media, from the photograph, film, and computer. A great deal has been written on this subject. The media threaten both writing and image systems. Since they themselves use image systems, their relationship to traditional technologies is complex. On a certain level they have usurped the language of traditional technologies, creating a dense and insistent world of visuality, but at the same time they have nullified old functions by integrating them into a seamless web of power that seems to emanate from an anonymous culture. This supposed "totalitarian" effect of the mass media has been decried by many contemporary critics, from McLuhan to Jean Baudrillard and Sven Birkerts.[30] While writing and

texts are still necessary in this era, traditional aesthetic things are not. The entire modern communications system can exist quite well without Andy Warhol or Willem de Kooning. Insofar as they exist, their works are a critique of both the mass media and aestheticism. Perhaps because the media captured aestheticism so successfully, artists turned against it, hoping to find new avenues to truths. The fact is, however, that contemporary art with its critiques affects very few people. Art (as defined by the eighteenth century) now exists very much on the margins of society, since other technologies—mainly electronic media and to a lesser extent writings—are more in the center.

While contemporary art is no longer a major player in today's culture "art" in general fulfills an important cultic role. There is an inverse relationship between contemporary art practice and museums. We seem to believe with Hegel that art is always something "past," and what is collected in our museums is largely the past. The great museums are vast repositories of the nostalgia that such things will never be made again. Their sad and funereal nature has often been noted. The archaeological collections are poignant as the precious relics of ancient civilizations that came to an end, no matter how great. The ethnographic collections are even sadder: they represent a brief moment in collecting—mostly the late nineteenth century—and make us realize the fantastic forms and styles that once must have existed for millennia all over the world. I find contemporary art in the museum the saddest—having no place to go but this tomb of the past, to be contemplated like a broken Assyrian statue, they are embalmed while still living.

The modern artist retains a raison d'être unrelated to older things. She or he must demonstrate the spiritual aspects of human creativity, likened these days to an archaic shamanistic healer. The perfect embodiment of this spirit of creativity in the modern era was Jackson Pollock dripping paint on canvas in a sort of trance. We need people to embody this creativity in the machine age, for which the metaphor of the archaic shaman has been revived and whose work is duly installed next to the works of the past, suggesting an unbroken and linear development of

"art." The Museum of Modern Art is as linear in its organization as the historical museums. "Art" must appear to go on. In the modern era there is an inverse relationship between the highly elaborated self-consciousness of the artist and the minor role of art in society—in the places and eras where the communications technology is exclusively aesthetic, the artist is not necessarily constructed as a special persona. The artistic persona acquires increasing development as the making of things moves from the center to the margins. At the edge, the concepts of "genius" or "magician" are necessary to give meaning to the works. An archaeologically unearthed Picasso without the legend of Pablo Picasso would mean little. In fact, it would be likely to be dumped into a collective period. "Masterpieces" are hard to find archaeologically.[31]

It would appear, then, that all three technologies of communication exist at present in various hierarchical relationships. It is impossible to know whether they are "universal" and will go on within human culture forever, or whether some will disappear, taken over by others. I will argue that traditional aesthetic technologies, because they are so close experientially to the body and its space and unconscious needs, will find some forms of continuation. But they are unlikely to be close to the centers of cultural power again, and hence any relation to them will be nostalgic.

TERMS

"Music" is a wonderful term because it describes precisely everything from the melody hummed in the bathtub to Beethoven's Choral Fantasy. It suggests organized sound without indicating quality. Birds make music too, and the differences between speech and barking are relatively easy to make, although we can quarrel over what is and what is not organized sound. Terms for the verbal "arts," however, are more of a problem—literature is a qualitative term separating some verbal expressions from others via form, expression, and critical judgment. But the term "visual arts" is the most difficult of all, from the point of view of terminology. It is not even a single word like "literature"—one must specify "art" by the adjective "visual." The last of the arts to be

considered "art" in Paul Kristeller's view, it is the one he has the greatest dilemma in naming and defining. It is much easier to characterize music and even literature in certain clearly bounded categories than the "visual arts." The world is full of significant things. Images and the human-made environment are usually categorized in parts: architecture, costume, paintings, china, and so on. Each of these categories has a "high end" that critical judgment has decided is "art" and is in museums or the homes of the wealthy and a "low end" that is all around everywhere. Things are more ubiquitous than music or literature and there is no term for them. The archaeologist I studied with, Ed Lanning, used the phrase "the fancy stuff" for the "high end" of things to avoid using the word "art." The world of human-made things seems as infinite and varied as the world of nature. It is, in fact, a second nature that humans have created. The anthropological term "material culture" is as awkward a combination of words as "visual art." We seem to have a problem with human-made things.

How is one to talk about "art"? Should one go on using the term "art" in its accepted usage by way of common sense? I am finding it harder and harder to use the term "art." Should we not use the term "art" until the eighteenth century and modern times? Even there, what is considered art has been reclassified many times, but one can speak of an intentionality to make art. If the term "art" isn't used, do we go back to the past practice of discussing objects by media or function (sculpture, clocks) and have no generic noun for the phenomenon? Is "art" so much a part of our ideology that getting rid of the term is unthinkable? Suppose the heroine in a movie says admiringly to a man, "You are a great goldsmith" instead of "You are a great artist." "Artist" implies a creativity that "goldsmith" does not carry. The world is full of objects containing more or less creativity arranged in a hierarchic order. There are grand hierarchies of great art such as the Parthenon or Michelangelo and there are lesser ones such as Southwestern Indian pottery or eighteenth-century toile, but it is all calculated on the basis of culture, imagery, preservation, medium, detail, and relative precision—based on current taste and concepts of "art." I have done my part in defining Aztec and Teotihuacán "art" within the hierarchy of the "pre-Columbian art" field.

We believe that "art" is a concept of as much general validity as "history" or "religion," when in fact it has been a matter of designation that follows no rules or limits. Sculptures, paintings, masks, shields exist, but "art" does not. My argument is that the mystical concepts of art are associated with the decline of things as communicative media and are in themselves signs of loss and nostalgia. I suggest that at this point the concept of "art" hinders rather than helps our analysis of the world of things.

The term "thing" is not very satisfactory, especially since "things" do not specify whether they are human-made or natural. "Human-made things" is as awkward as "built environment," "material culture," or "visual arts." Nevertheless, like many other authors, I am opting for the term "thing" to replace "art." In various cultural contexts, natural things such as rocks can function and have aesthetic properties for their users like human-made objects. I like the term "thing" because it does not conjure up transcendent values inherent in the word "art."

It is customary in art history lectures to mask out the frames of paintings in slides, so that the focus can be on the painting as dematerialized. I would like to put the frame back on and turn the painting back into a thing existing in the physical world.[32]

NOTES

1. Paul Oskar Kristeller, "The Modern System of the Arts," in *Renaissance Thought and the Arts* (Princeton: Princeton University Press, 1990), 163–227.

2. Esther Pasztory, "Three Aztec Masks of the God Xipe," in *Falsifications and Misreconstructions in Pre-Columbian Art,* ed. E. H. Boone (Washington, DC: Dumbarton Oaks, 1982), 77–106.

3. William M. Conway, *The Literary Remains of Albrecht Dürer* (London: Cambridge University Press, 1889), 101–102.

4. Esther Pasztory, "Still Invisible: The Problem of the Aesthetics of Abstraction for Pre-Columbian Art and Its Implications for Other Cultures," in *Res* 19/20 (1990/1991): 105–136.

5. Barbara Braun, *Pre-Columbian Art and the Post-Columbian World* (New York: H. N. Abrams, 1993), 30.

6. Immanuel Kant, *Critique of Judgment* (1790; Indianapolis: Hackett, 1987).

7. ". . . art is and remains for us, on the side of its highest vocation, something past." George Wilhelm Hegel, *Philosophies of Art and Beauty,* ed. Albert Hofstader and Richard Kuhns (Chicago: University of Chicago Press, 1964), 392.

8. There is an extensive bibliography on museums in their social context. Tony Bennett, *The Birth of the Museum* (London: Routledge, 1995); Pierre Bourdieu, *The Love of Art: European Museums and Their Public* (1966; Cambridge: Polity Press, 1990); Carol Duncan, *Civilizing Rituals* (London: Routledge, 1995).

9. Adrienne Kaeppler, *Cook Voyage Artifacts in Leningrad, Berne, and Florence Museums* (Honolulu: Bishop Museum, 1978), 168–169.

10. Just from the Tlingit group Emmons collected four thousand pieces for the American Museum of Natural History between 1888 and 1893. Aldona Jonaitis, *From the Land of the Totem Poles: The Northwest Coast Indian Art Collection at the American Museum of Natural History* (Seattle: University of Washington Press, 1988), 87.

11. Alisa La Gamma, personal communication, 1999.

12. Esther Pasztory, "Andean Aesthetics," *The Spirit of Ancient Peru,* ed. Kathleen Berrin (London: Thames and Hudson, 1997), 60–69.

13. Thomas McEvilley, "Art/Artifact: What Makes Something Art?" in *Art/Artifact: African Art in Anthropology Collections,* introduction by Susan Vogel (New York: Center for African Art, 1988), 200–203.

14. Lewis Binford, "Archaeology as Anthropology," in *American Antiquity* 28, no. 2 (1962): 217–222.

15. It is worth looking at a Japanese catalog of non-Western things, such as Andean textiles, in which both layout and selection indicate that the Japanese see Andean textiles through a Japanese aesthetic and bring out very different aspects of the "Andean" than a similar Western publication.

16. Constantijn Petridis, "In Pursuit of Beauty: Cults, Charms and Figure Sculpture among the Luluwa" (lecture, University Seminars, Columbia University, April 15, 1998). Constantijn Petridis, "Of Mothers and Sorcerers: A Luluwa Maternity Figure," *Museum Studies* 23, no. 2 (1997): 182–195.

17. For example, the objects of the Yoruba in Nigeria or of Teotihuacán in Mexico are considered less "artistic" than more naturalistic and polished traditions.

18. Michael Fried, "Art and Objecthood," in *Art and Objecthood* (Chicago: University of Chicago Press, 1998), 148–172.

19. Aldona Jonaitis, *Chiefly Feasts: The Enduring Kwakiutl Potlatch* (Seattle: University of Washington Press, 1990). These are not illustrated in the catalog as works of art but can be found in an ethnographic photo (fig. 5.19).

20. I attended Tupperware parties in Hungary after the collapse of Communism, when there was a sudden enthusiasm for all things Western, and heard subtle discussions of the form, function, beauty of Tupperware that rivaled discussions of art I heard back home.

21. McEvilley, "Art/Artifact," 202.

22. The notion that art and other objects are all related things has cropped up in many writings over the last fifty years, but always in such a way as to leave the concept of art relatively intact. It almost seems unthinkable to change or tamper with the concept of art. George Kubler in his *The Shape of Time* (subtitled *Remarks on the History of Things*) (New Haven: Yale University Press, 1962), presents the revolutionary idea that the history of all things is related and follows similar trajectories. He uses the term "things" extensively, but is concerned mainly with the temporal evolution of high art. Everything else he sees existing in a limbo of "slow happening." Despite the success of this book and admiration for it, the concept of things has had no major impact on art history.

In anthropology, the concept of things is widely used, as in *History from Things: Essays on Material Culture,* ed. Steven Lubar and W. David Kingery (Washington, DC: Smithsonian Institution Press, 1993), in which the authors generally defend the usefulness of objects in historical research against the privileged status of written documents. This issue is still being discussed in Daniel Miller, ed., *Material Cultures: Why Some Things Matter* (Chicago: University of Chicago Press, 1998). In *The Social Life of Things: Commodities in Cultural Perspective* ed. Arjun Appadurai (London: Cambridge University Press, 1986), the discussion of the "life history" of things is very valuable, but the authors are primarily concerned with exchange. They often make cogent ancient/modern, Western/non-Western parallels, breaking down the usual boundaries.

Mihaly Csikszentmihalyi has written extensively on things and commodities from a sociological and psychological point of view. In *The Meaning of Things: Domestic Symbols and the Self* written with Eugene Rochberg-

Halton (London: Cambridge University Press, 1981), he analyzes the relationship of Chicago area families to things in their living rooms. Although he is deeply involved in analyzing the meaning of things, basically he looks down on things. He suggests that a non-materialistic life dedicated to "science" or "art" is "higher." He makes the valuable observation that things allow the mind to focus, which the mind is otherwise often unable to do, especially in "unsophisticated" individuals. But, as Lubar and Kingery observe, a "Brahmin can afford to live in an empty house because he does not need objects to keep his mind on course." *History from Things*, 28.

Although the term "thing" is now being used by various authors, it is often seen as the opposite of "art" even when the categories are meant to be blended into one. For most writers, the mystique of art remains in place.

23. Polly Wiessner, "Style and Social Information in Kalahari San Projectile Points," *American Antiquity* 48, no. 2 (1983), 253–276. "The definition of style that I will use here is *formal variation in material culture that transmits information about personal and social identity*" (italics in text), 256.

24. Roland Barthes, *Mythologies* (New York: Hill and Wang, 1957), 78–80.

25. I am often confronted by people afraid of losing the spiritual quality of art when I say that there is no "art for art's sake." My reply is that we might do better without a spiritual quality that is meaningless. I suggest the example of the heart-surgeon whose medium is the human body, who has the "altruistic" goal of saving a person's life with all the skill, industry, imagination, and creativity he has. This imaginary surgeon also works for fame and fortune and is no different in kind from the painter, the dancer, the historian, or other dedicated, talented, successful person. A beautiful dental crown and an installation piece differ in the meanings we give them in our social and cultural life. In the twentieth century we have specialists in things who show us to ourselves in their creations in paint, video, installation, performance. Elsewhere that has been done by scarification, tattooing, and even dental inlay.

26. "Art most emphatically is a form of communication," an idea probably generally held in the art field. Irving Lavin, "The Art of Art History: A Professional Allegory," *Art News* (1983), 101.

27. Arnold Rubin, *Art as Technology*, ed. Zena Pearlstone (Santa Ana, CA: Hillcrest Press, 1989).

28. H. W. Janson, *History of Art* (Englewood Cliffs, NJ: Prentice-Hall, New York: Abrams, 1969).

29. This is a widely but vaguely held tenet, well expressed by Belting in the context of Byzantine art. He tends to conflate "word" and "writing." "In the era of Gutenberg, the word was present everywhere. The new humanist culture profited from this, for it claimed the reign of the spirit through the mirror of the word. As the tools of rational argument, the word was the refuge of the thinking subject, who no longer trusted the surface appearance of the visual world but wanted to grasp truth in abstract concepts. These intellectuals emphasized that a painter can represent only their body, but 'the better image (of such persons) is expressed in the books' they have written. (Erasmus)." Hans Belting, *Likeness and Presence: A History of the Image before the Era of Art* (Chicago: University of Chicago Press, 1994), 465.

30. Jean Baudrillard, *Simulacra and Simulation* (Ann Arbor: 1981; University of Michigan Press, 1994). Sven Birkerts, *Readings* (St. Paul MN: Graywolf Press, 1999).

31. Esther Pasztory, "Masterpieces of Pre-Columbian Art," in *Actes du XLII^e Congrès International des Américanistes* (1980), vol. 7, 377–390. This obscure article is the only one I wrote that George Kubler liked and cited.

32. We have even treated frames as works of art. Timothy J. Newberry, George Bisacca, and Laurence B. Kanter, *Italian Renaissance Frames* (New York: Metropolitan Museum, 1990).

2 THINKING WITH THINGS

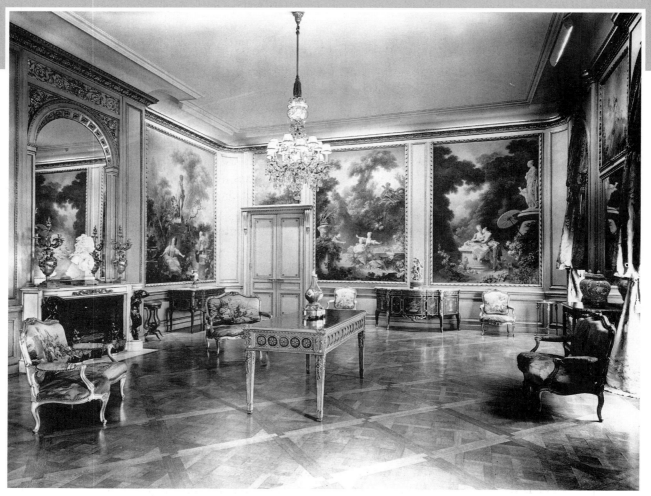

Figure 2.1 The Fragonard Room in the Frick Collection. Courtesy Frick Collection, New York.

Claude Lévi-Strauss put an end to almost a century of European obsession with totemism. Totemism is the custom of many people of having animals as emblems for their clans and their belief that they are descended from those animals. The animals are not to be killed and eaten, but rather they relate to their people in a spiritual way. (In a limited way, this is similar to the use of animal names for sport teams in the United States or names like "Hellcat" for fighter planes used in World War II.) In the nineteenth century, totemism fascinated Europeans as an example of the barbaric lack of reasoning power of primitive people. Scholars tried to figure out how these animals had been selected: Were the animals selected because they were good to eat or because, like people, they were hunters? All major early anthropologists devoted volumes to the topic. Sir James Fraser concluded in *Totemism and Exogamy* (1910) that primitive man could imagine animal-human descent because he didn't understand the biology of paternity and was therefore retarded in intellectual development.[1] Emile Durkheim saw totemism as primitive man's instinctive desire to make images for ideas, which was also a sign of underdevelopment. At least half of Durkheim's *Elementary Forms of Religious Life* (1913) deals with totemism.[2] Freud published an essay in 1913, entitled *Totem and Taboo,* in which he was fascinated by the incest prohibition between members of the same totem.[3] The concept of totem was common and became a part of widespread intellectual discourse, ordinary conversation, and jokes. In general, totemism was seen as the equivalent of the irrational.

Lévi-Strauss argued that primitive man selected totem animals for his systems, not because they were good to eat, good to hunt, or because he couldn't tell the difference between man and animal, but because they were good to think.[4] The animals were devices for an entirely rational classification system, not irrational mythic mumbo-jumbo, and he quotes Henri Bergson who, he said, by way of a compliment, was an armchair philosopher who thought like a savage. The entire gist of *The Savage Mind* is that primitive man is a rational thinker,[5] contrary to the earlier view that made him irrational, as exemplified in Lucien Lévy-Bruhl's *Mentalité primitive* in which the primitive is characterized as prelogical.[6] The issue is relevant from many points of view, including the question of what is (or should be) our basic nature. Various authors from the first half of the twentieth century theorized that early humans could paint realistic images on cave walls because they had no self-conscious reasoning faculties and were at one with the world (eidetic vision).[7]

Totemism and the associated denigration of the primitive reasoning faculty lapsed in the Western imagination in the second half of the twentieth century, even before Lévi-Strauss gave it the final blow. It has been replaced by an equally exaggerated appreciation of the irrational, especially in the form of shamanism. The concept of the primitive mind has not changed; the emphasis is still on the irrational, the magic, and the ecstatic, but now they are seen in positive

terms. These days primitives are accorded extrasensory perception and sensitivity that is beyond plodding "rational" Westerners. Thus although primitives have become overvalued, yet again they are denied rationality.

If early, tribal, and archaic people had not possessed rational minds, the ability to reason, to analyze cause and effect, to be able to distinguish material from mythic, we would not be here. There would have been no tools, no crafts, no plant and animal domestication, and no agricultural revolution. No amount of magic weaves a basket. Despite their myths and trances, most people are remarkably practical. Proof of this is that wherever Europeans encountered native groups, their technology (i.e., knives and guns) was eagerly acquired as superior to that of the natives. Much as we may bemoan the passing of native ways of life and blame ourselves for colonizing and acculturating, in many ways natives have been eager to acquire some Western ways for entirely practical and rational reasons. They most certainly do not want to be shut up in a memory box or to be a theme park for Westerners. It is generally Westerners who try to halt the process of change by teaching native arts and crafts to the natives so they can remain natives for us. We are still alternating the myths of the Stupid Savage and the Noble Savage—yet both are irrational, stupider or wiser than we are but not like us. We always emerge from these comparisons as "different."

The Western "rationality" under discussion is usually something of a caricature. It is based on a simple logic of cause and effect, observation, experimentation, and a separation of religious from material factors. It is often suggested by popular writers like Mircea Eliade that this is how we "Westerners" think.[8] Having graded many a college student exam over the years, I think that, alas, very few think like this very little of the time. We are much more prone to accept authority (or peer group counterauthority, wishful thinking, and cliché) than we imagine. Much as I try to discourage nostalgia for the primitive, the primitivist nostalgia current in the culture at large is reflected back in examination answers. I doubt that in rationality and adherence to myth or

group cultural values, there is much difference between a nineteenth-century Apache and today's Columbia undergraduate.

My observation echoes Franz Boas' words in 1927: ". . . there is no such thing as a "primitive mind," a "magical," or "prelogical" way of thinking . . . Dr. Tozzer's collection of the superstitions of College students (1925) . . . will be read with profit by all those who are convinced of our moral superiority . . ." Boas, however, was struggling against an undervalued negative image of the primitive, while I am struggling against an overvalued, excessively positive image. We agree that primitives are neither better nor worse than ourselves in their mentality.[9]

LANGUAGE

The reigning metaphor for the mind in much of twentieth-century thought was language. Ferdinand de Saussure, Charles Peirce, Jacques Derrida, and the French poststructuralists are driven by a linguistic model of thinking. Jacques Lacan's famous and much repeated suggestion is that the unconscious is also structured like a language.[10] In this view absolutely nothing avoids the structuring of signs and concepts. Curiously enough, Lacan bases his idea of the unconscious structured as a language on Lévi-Strauss's study of totemism in *The Savage Mind,* in which the rationality of man is established through his classificatory ability![11] This is surely a weak link. Lacan is here equating the mind of the "primitive" with the basic nature of humans. While primitive man may be beside the point for much of twentieth-century discussion, his image lurks in the background whether one is aware of it or not. The myths about primitive man are therefore crucial to our understanding of humanity.

I have always been struck that except in the work of Roland Barthes, things and images play a limited role in French poststructuralist thought. The favorite subjects are texts, writing, language. How many seminal texts really required illustrations? Michel Foucault's "*Las Meninas*" manages to deal with the painting while making it beside the point, and even at that it is the exception rather than the rule.

The poststructuralist art par excellence is literature, where language games are possible. This is not to say that rationality and language as we understand them are not important, but twentieth-century thought seems to narrow down experience and leave a vast amount to mysterious and unknown forces. Those mysterious forces include art, things, and expression of ideas somehow outside of the straitjacket of a narrow definition of rationality based excessively on linguistics.

ROLAND BARTHES

My peregrination in this relatively uncharted territory was led at first by Roland Barthes. Barthes, of course, concurs with this emphasis on the linguistic, but he also has a genius for describing things. He often prefers to discuss things with texts or captions, such as newspaper photographs, or advertisements, but occasionally he discusses things without texts with great feeling and perception. Perhaps the article that made the greatest impact on me in 1972 was "The New Citroen." I was increasingly frustrated by the transcendental tone of formal analysis in art history, sensing that this language was not exclusive to "high art." In those days I once stole from the subway an ad for galoshes (the galosh advertised was represented as smooth and sleek, while the rival brand was all crunched up and had a snarling face) to show my students that the principles of form and expression went beyond "art." And here was Barthes analyzing a car:

> It is well known that smoothness is always an attribute of perfection because its opposite reveals a technical and typically human operation of assembling: Christ's robe was seamless, just as the airships of science-fiction are made of unbroken material. The D.S. 19 has no pretensions about being as smooth as cake-icing, although its general shape is very rounded,—yet it's the dove-tailing of its sections which interests the public most . . .[12]

This passage was revelatory in that "formal analysis" was applied brilliantly to a car, and thereby to any other object, thus blurring the boundary between art and non-art. As in art history, every Barthes analysis is an explicit or implicit comparison. The Citroen is a critique of petit bourgeois taste for "smoothness." In the later *Empire of Signs,* the entire book is devoted to a lovingly detailed analysis, in a now unfashionable East-West mode, again focusing on things or visible behavior.

> At the Floating Market in Bangkok, each vendor sits in a tiny, motionless canoe, selling minuscule quantities of food . . . From himself to his merchandise, including his vessel, everything is *small.* Occidental food, heaped up, dignified, swollen to the majestic, linked to a certain operation of prestige, always tends towards the heavy, the grand, the abundant, the copious; the Oriental follows the converse movement, and tends towards the infinitesimal . . . The harmony between Oriental food and chopsticks cannot be merely functional, instrumental. The foodstuffs are cut up so they can be grasped by the sticks, but also the chopsticks exist because the foodstuffs are cut into small pieces; one and the same movement, one and the same form transcends the substance and its utensil: division . . . [the chopsticks] . . . in order to divide, must separate, part, peck, instead of cutting, and piercing, in the manner of our implements; they never violate the foodstuff: either they gradually unravel it . . . or else prod it into separate pieces . . . thereby rediscovering the natural fissures of the substance . . . by chopsticks food becomes no longer prey to which one does violence . . . but a substance harmoniously transferred.[13]

What is also striking to an art historian in these passages is that Barthes gives himself the freedom of a literary writer to use metaphor and vivid language beyond the pseudoscientific confines of art historical analysis. All this is his gift, and he does not really take it seriously because of his linguistic focus. He dismisses images without words, "In order to find images given without words, it is doubtless necessary to go back to partially illiterate societies, to a sort of

pictographic state of the image."[14] All that is just one sentence, and then he goes back to discussing texts, and the text-image relationship with which he is fascinated. When I read Barthes, however, it was the visual descriptions that I found gripping and not so much his semiotic system. The visual descriptions transcended, contradicted, and subverted the very passages in which they were located. He is most minimalist in the description of wood in children's toys, which he contrasts to ugly modern plastic ones:

> Wood removes, from all the forms which it supports, the wounding quality of angles which are too sharp, the chemical coldness of metal. When the child handles it and knocks it, it neither vibrates nor grates, it has a sound at once muffled and sharp. It is a familiar and poetic substance, which does not sever the child from close contact with the tree, the table, the floor. Wood does not wound or break down; it does not shatter. If it dies, it is in dwindling, not in swelling out . . .[15]

Art history taught me to see art, but Barthes taught me to see everything. You could hate it or love it, but everything had meaning encoded into its very form. Only on rereading Barthes, now do I see how much my interpretation of Aztec art was unknowingly and unintentionally based on him. I argued that in Aztec art, objects had "intended meanings," "underlying meanings" and "connotations."[16] The intended meanings were the overt ones presumably available to many in society, while in the underlying meanings I saw the formal language that could be revealed in Barthian analysis but that generally was experienced nonverbally by nearly everyone. Connotations were various assorted ideas related tangentially to the object. All these categories come from readings and misreading of Barthes. I wanted Barthes to say what I wanted to say. It is curious how Barthes never dissected his own formal analysis. He took it for granted, as if it were common sense.

Barthes did not just teach me to see things, he also demolished my preoccupation with visuality. He wrote of his experience of things in terms of their appearance, their touch and texture, their use and behavior in one "seamless" text that made them present to the imagination more than I had ever seen done. He authorized my departure from the visual in approaching things. Nevertheless, he valued things with texts more than I did.

EXPERIENCE

It has been very difficult to find sources or an author to address this vague issue of nonverbal cognition that seemed important to me and grew out of my interest in the "primitive." I feel that tribal and ancient things have been all too easily lumped into the religious and magical category, either to be dismissed as uninteresting or to be praised as spiritual. More recently political and sociological approaches have demystified the spiritual, but in doing so they have left behind a suggestion of cynical manipulativeness that does not really do justice either to the cultures or the people who made the things. In museums and art history classes, things have been subjected to visual analysis that may have brought out certain aspects of proportion or patterning but didn't have anywhere to go in conclusion beyond Western taste. It was clear to me that things are important indeed for religious, political, and aesthetic reasons, but that none of these are their most basic functions. My own experience gave me some of the answers until I found some appropriate literature that helped to explain this process.

About five years ago I spent a sabbatical in Hungary, one of the longest times I had been away from the United States. When I returned my apartment looked all wrong to me. I hated it. The morning after arrival I got up all exhausted and jet-lagged and, before doing anything else, I started taking the pictures and textiles off the walls and moving them. A couple of hours later I found that I had rearranged everything, including the sculptures. Only then did I begin to dress and unpack. Once I had finished I looked to see what I had done—I analyzed it and it made perfect sense. Evidently my things had been arranged in separate categories and I now wanted them more juxtaposed and integrated. Both arrangements were internally coherent. It was at that time

that I began to think of things and art as primarily cognitive. As Lévi-Strauss says about totemism, things are good to think with, rather than merely good to look at. What interested me then was that my process seemed entirely unconscious—I was climbing ladders and carrying around heavy frames without a conscious idea of what I was doing. Was this the Freudian unconscious? Moreover, I was not in a mythic daze; my activity was perfectly rational and made sense. After a long absence the apartment did not reflect me in some way, and I was not comfortable in it until I brought us into accord.

Probably I had done that sort of thing before and now I know that I do it all the time. Some problems are solvable by being written out, but others are intractable in words. Closet arranging or book arranging is very useful; what to keep, what to throw out, what to give away, what to get are significant thinking issues. I end up with a result—a collection of sweaters, a shelf of books—and light dawns. Aha! This is what I am after. After my most recent bout of closet arranging I laughed at myself: "There you go again, thinking with things." The phrase stuck: That is exactly what we do. The "thinking" of this process is at a deep level not available to consciousness, as if there is an inner self smarter than the conscious one—a self whose mode of operation is nonverbal and on things (or animals, as in the case of totemism). This thinking deals with crucial issues of identity and relation to others and the cosmos, and it is definitely problem-solution oriented. I have often pondered, why the involvement with things? Could not the mind think through all that by itself? Why did I have to carry the frames around? It would seem that the thinking process needs projections on and manipulations of things to work itself through to consciousness or to demonstrate itself to itself.[17] In that sense it could be said that my picture rearranging was a form of magic ritual. I reorganized the world by manipulating symbols. My means were aesthetic (what looked right), but my urgent concern was cognitive (what was right and matched certain sets of data). Things are needed to think with, in order to manage problems of cognitive dissonance.[18]

The connecting link is visuality: once the intractable cognition in the mind is made visible, the processes of vision seems to link it to the verbal and conscious part of the mind. We make things visible so we can understand them.

NATURE VERSUS HUMAN-MADE

Clearly, we think both with things and with nature. The natural world offers a wide range of possible classifications in form and behavior useful to humans (e.g., "foxy lady"). Many animals are almost universal symbols: felines and raptorial birds representing power, lambs as vulnerability, snakes and butterflies as transformation. Natural images have an intrinsic power because they belong to the same incomprehensible and mysterious universe of which we are a part. But they are a given. Things are tailor-made by humans for their purposes and are thus in some ways superior to nature. This is how Barthes explains it.

> We must not forget that an object is the best messenger of a world above that of nature: one can easily see in an object at once a perfection and an absence of origin, a closure and a brilliance, a transformation of life into matter (matter is much more magical than life), and in a world a *silence* which belongs to the realm of fairy-tales.[19]

One can think with the most utilitarian objects in the world, but most things made by humans serve a dual function in which "thinking with" plays a significant part. Some objects are made largely to think with. They are all meant to be experienced visually (or to have descriptions given of them) at least some of the time, but touch and sound may be just as significant. Visuality, however, even with its pleasures, is a means to a cognitive end. The pleasure is also to think with.

CONSCIOUSNESS

I was quite aware that my experience with things was similar to one's subliminal understanding of body language, and I resort to this metaphor to explain our

interpretation of things. Recently I found the studies of consciousness to be dealing with this issue at least tangentially. Steven Pinker, Nicholas Humphrey, and Daniel Dennett analyze extensively the complex interaction of the brain with sensory data.[20] Particularly fascinating to most authors are experiments such as those of Benjamin Libet, in which the body seems to know what is happening before it registers in consciousness, thus indicating an unconscious cognitive system that is faster, more sensitive, and more "correct" than the conscious.[21]

Tor Norretranders sums up the study of the "subliminal" in *The User Illusion: Cutting Consciousness Down to Size*.[22] Before drowning in primitivism—in which the subliminal mind is once again correlated with primitive man and consciousness with Western thinking—he gives an excellent survey of what we know about this subliminal faculty that he calls "non-conscious," which he considers different from the hidden closet of repressions and impulses that is Freud's "unconscious." It is very clear from current research that the mind with its consciousness, subliminal, and unconscious zones is still very much a mystery. None of the descriptions live up to the complexity of the operations of the system, and moreover they are heavily weighted by the ideological baggage of the researcher. (There are Republican and Democratic theories of the mind!)[23] The cautious view I am taking here is that people possess consciousness, nonconsciousness, and unconsciousness and have done so from at least the time of language. It is currently argued by some that animals possess consciousness as well.[24] I agree with Joseph Weiss who wrote, "It seems that the cognitive capacities of the unconscious mind have been underappreciated and that human beings can unconsciously carry out many intellectual tasks, including developing and executing plans for reaching certain goals."[25]

Most relevant to my discussion is the idea that a large percentage of human thinking takes place in the nonconscious, and that ballplayers and artists seek to tap into that resource for instantaneous response and intuitive insight. This is not news to the readers of *Zen and the Art of Motorcycle Maintenance*.[26] However, consciousness is still required to act on and

further interpret positively or negatively the cognitive inspiration of the subliminal self.

Whether this un(non)consciousness is structured like a language is hard to determine from recent analysis and is experimentally not all that clear, nor am I qualified to decide the issue. Certainly the cognitions of the unconscious are often hard to put into words, and most people are unable to express their thoughts and feelings about art unless specially taught the "right" language. With some exceptions, artists are notoriously nonverbal and react to art by making art and not words.[27]

Can nonverbal thought be considered thinking? My answer is experiential and yes. Just because we do not know how the causal and interpretive relations come to be, it does not mean they are not there. Sometimes these conclusions stand as they are, sometimes the conscious mind looks them over and reworks them. Things made to think with are made for both the subliminal and conscious mind, but I suggest that they are a special province of the subliminal mind. Things contain multiple and multivalent messages that, like body language, are the special strength of interpretation of the subliminal mind. As there is a match in the human sensory apparatus and the world "out there," there is a match between the language of things and the nonconscious mind. We make our things to match both our physical and mental needs, and because of that they resemble us. They are concretizations of our thoughts. "The car engine has exactly the coarseness people have when we describe the world."[28]

PLEASURE

At least since the eighteenth century, writers on art have made the assumption that the aim of art is to give pleasure. This pleasure was a "common sense" as defined by Kant, and to his universalist mind was evoked equally by Maori tattooing (to the Maori) or classical art (to a Westerner).[29] The emphasis on the pleasure generated by the aesthetic sense obscured the question of what might be the purpose of such pleasure. It is an accepted notion that one of life's great pleasures, sexual pleasure, is related to the

function of reproduction. But visual aesthetic pleasure has been seen as something "free" and not governed by the needs of the organism. As modern research on sight makes clear, visual perception is not a simple translation of sensory data from the shapes and colors of the world. The mind creates these out of whatever is out there to make it more comprehensible for itself. The recent interpretation is that there are no colors in nature—they are the creation of the human mind for classification purposes.[30] We find the nature we have thus created "beautiful" because it fits our needs and criteria. That we should find pleasure in the aesthetic contemplation of both nature and human-made artifacts, is, I think a reward for examining things minutely from the points of view of what we need and what we like (which are conflated). These are as valuable in survival as sexual pleasure is in reproduction.[31]

It has recently been suggested by Komar and Melamid, on the basis of a worldwide opinion poll, that the favorite painting of people cross-culturally is a blue/green landscape with a few small people and a wild animal or two. They proceeded to paint such a picture and exhibited it as a form of conceptual art and a great postmodern joke.[32] There may be more to this story than worldwide kitsch. Such a picture may be an interior mind-fantasy and not something based on sense experience. If it is pleasurable it must be very important. It is ironic that aesthetic pleasure has always been considered trivial and "feminine," when in fact aesthetic judgment is a constant and crucial everyday activity both men and women engage in nonverbally. Everyone is a master of formal analysis. Teenagers notice length, pattern, and bagginess of clothes to the millimeter and interpret it instantaneously. Minute details in school uniforms are accorded great significance by the students wearing them. This game, enjoyed by all, is the game of survival, an intensely pleasurable activity comparable to a more or less competitive sport.

FORMAL ANALYSIS

Everybody is an art historian in daily life without knowing it. (We can quarrel about taste, as Kant puts it, but this merely proves that we have grounds in common.) The analysis, however, is nonverbal and rarely surfaces. Verbalizing this tacit formal analysis is, for most people, a difficult process. Most cultures do not have a language to describe their things, or even if they do, they are metaphoric. In Chinese discourse on figure painting, comparisons are made to homologous natural forms: it is said that an eyebrow should be shaped like a "leaf."[33] Only the West has developed a language to deal with images, perhaps from about the time of Vasari, in which line and form are abstracted out of the entire context. This may well be because of the importance of geometry and perspective in Renaissance writing on architecture and painting.[34] Suffice it to say that this is a language that was used by the sciences in the description of things and species, and was borrowed from them and applied to images. Eighteenth- and nineteenth-century art history weighted these terms with psychological significance.[35] As a classificatory, geometric, scientific, and psychological language, formal analysis has to be taught and learned. Sometimes it goes against the grain: some people do not want to dissect a painting whose meaning they feel they intuit rightly or wrongly. Formal analysis is a useful tool of interpretation, but it leaves things almost as mysterious and impenetrable as they were before. No matter how much I can verbalize about a Maya relief or a Rembrandt self-portrait, and I can verbalize a lot, I have not really captured it. Dissecting a hawk does not explain it.

It is precisely this lack of connection between the visual and the verbal that is at the heart of the debate about modern visual media such as television, film, and advertising that encourage a passive, intuitive, but nonverbal interpretation of the world. It is assumed by critics that communication via nonverbal media is accepted uncritically and may be exploited by totalitarian regimes and corporations. Visuality is in some views the province of the primitive and of the modern mass media, both of which encourage "group think." Therefore these concepts are not neutral but have political and ideological overtones.

I will argue that things and images of various sorts have existed at all times in all societies but their

significance has varied depending upon the particular types of sociopolitical contexts in which they were found. Moreover, I will suggest that the nature of things is determined on the basis of whether they are central, slightly displaced, or marginal as communicative technologies within society. Formal analysis, especially as practiced in the open, metaphoric, and allusive way of Barthes, is a useful tool in bringing to light what is usually subliminally understood but not verbalized. Thinking of things as having cognitive rather than purely visual value is to release them from the low position in which technologies such as writing have placed them. It may be that thinking with things is a constant activity rather than just a form of leisure. The recognition that things are necessary for cognitive activity helps to destroy the imaginary differences that are supposed to exist between peoples at various stages of evolution. It might also allow us, "rational" Westerners, a subliminal sense of our own, so we do not have to borrow it from "primitive" peoples.

NOTES

1. James G. Fraser, *Totemism and Exogamy,* 4 vols. (London: Macmillan, 1910).

2. Emile Durkheim, *The Elementary Forms of Religious Life,* 1915 (New York: Free Press, 1965).

3. Sigmund Freud, *Totem and Taboo: Some Points of Agreement between the Mental Lives of Savages and Neurotics* (London: Routledge, 1913).

4. Claude Lévi-Strauss, *Totemism* (Boston: Beacon Press, 1962). His initial dedicatory quote is from Comte, *Cours de philosophie positive:* "The laws of logic which ultimately govern the world of the mind are, by their nature, essentially invariable; they are common not only to all periods and places but to all subjects of whatever kind, without any distinction even between those we call the real and the chimerical: they are to be seen even in dreams . . ."

5. Claude Lévi-Strauss, *The Savage Mind* (Chicago: University of Chicago Press, 1966).

6. Lucien Lévy-Bruhl, *Les Fonctions mentales dans les sociétés inférieures* (Paris: Presses Universitaires de France, 1951), and *La Mentalité primitive* (Paris: Presses Universitaires de France, 1960). ". . . les primitifs (ont) une aversion décidée pour le raisonnement, pour ce que les logiciens appellent les opérations discursives de la pensée." (. . . primitives have a decided aversion to reasoning, for what logicians call the discursive operations of thought.) Lévy-Bruhl, *La Mentalité primitive,* 1.

7. Fry, Hauser, and Kubler are among many who express some of these ideas.

George Kubler, "Eidetic Imagery and Paleolithic Art," *Journal of Psychology: Interdisciplinary and Applied* 119, no. 6 (1985): 557–565.

Arnold Hauser, *The Social History of Art,* vol. 1 (1957; New York: Vintage Books, 1985). "The painters of the Paleolithic age were still able to see delicate shades with the *naked eye* which modern man is able to discover only with the help of complicated scientific instruments" (Hauser, *Social History,* vol. 1, p. 6; italics mine).

Roger Fry, "The Art of Bushmen," in *Vision and Design* (1920; New York: Meridian Books, 1956), 85–98. "It would seem not impossible that the very perfection of vision, and presumably of the other senses with which the Bushmen and Paleolithic man were endowed, fitted them so perfectly to their surroundings that there was no necessity to develop the mechanical arts beyond the elementary instruments of the chase. We must suppose that Neolithic man, on the other hand, was less perfectly adapted to his surroundings, but that his sensual defects were more than compensated for by increased intellectual power." Fry, "Art of Bushmen," 94–95.

8. Eliade was the guru of the split in the mindset of West and non-West in many popular books. *The Sacred and the Profane* in particular sets out the dichotomy between secular Western and religious non-Western culture, with a nostalgic preference for the religious. These works are attacks primarily on Western modernity and the cultures that led up to it. Mircea Eliade, *The Sacred and the Profane: The Nature of Religion* (New York: Harcourt Brace Jovanovich, 1959).

9. Franz Boas, *Primitive Art* (1927; New York: Dover, 1955).

10. It is the linguistic structure "that assures us that there is, beneath the term unconscious, something definable, accessible and objectifiable." Jacques Lacan, *The Four Fundamental Concepts of Psychoanalysis,* ed. Jacques-Alain Miller (New York: W. W. Norton, 1978), 21.

11. Lacan, *Four Fundamental Concepts of Psychoanalysis,* 20.

12. Roland Barthes, *Mythologies* (1957; New York: Hill and Wang, 1982), 88.

13. Roland Barthes, *Empire of Signs* (1970; New York: Hill and Wang, 1982), 15–18.

14. Roland Barthes, *Image-Music-Text* (New York: Hill and Wang, 1977), 38.

15. Barthes, *Mythologies*, 54.

16. Esther Pasztory, *Aztec Art* (New York: H. N. Abrams, 1983), chap. 2.

17. As Csikszentmihalyi and Rochberg-Halton put it in *The Meaning of Things* (London: Cambridge University Press, 1981): "Therefore, in the Freudian scheme, things per se do not help a person to change or grow. What they do is to lend their semblance to the preconscious which projects meanings into them to neutralize part of the repressed energy of the psyche . . . One gets the sense that the entire panoply of natural and cultural phenomena are nothing but projections of the inner travails of the psyche" (pp. 23–24). These analyses assume that thinking with things is primitive or neurotic and one should grow out of it into "art" which is spiritual—play the violin (ibid., 225–249). "At the lower end, the goal is to prove one's individual existence, one's control over the environment. At this level, flow joins the element of one's self into active participation with a domain of challenges: toys, sports equipment, books, tools, and musical instruments are some of the concrete signs through which this goal may be achieved. The next level usually is the one in which the self grows to include—or be included in—the network of family relationships . . . Finally, one might reach the level of what we have called 'cosmic' goals. Here one perceives objective relationships between the self and the wider patterns of order: the community, the species, the ecology as a whole, and practices like one's occupation, or craft, art, music, or religion" (ibid., p. 249).

18. Cognitive dissonance is psychological distress caused by an inconsistency in one's ideas or beliefs. Leon Festinger, *A Theory of Cognitive Dissonance* (Palo Alto: Stanford University Press, 1957). We discover our own attitude by observing the things we do. See Sacha Bem and Huib Leoren de Jong. "The body has a fundamental epistemological function in our *background knowledge,* we do not learn explicitly and just do not think about." *Theoretical Issues in Psychology* (London: Sage Publishers, 1997), 14.

19. Barthes, *Mythologies*, 88.

20. Steven Pinker, *How the Mind Works* (New York: W. W. Norton and Co., 1997). Nicholas Humphrey, *A History of the Mind* (New York: Harper Perennial, 1992). Daniel C. Dennett, *Consciousness Explained* (Boston: Little Brown, 1991).

21. Benjamin Libet, "Unconscious Cerebral Initiative and the Role of Conscious Will in Voluntary Action," *Behavioural and Brain Sciences* 9 (1985), 529–566. Benjamin Libet et. al., "Subjective Referral of the Timing for Conscious Sensory Experience," *Brain* 102 (1979), 193–224.

22. Tor Norretranders, *The User Illusion: Cutting Consciousness Down to Size* (New York: Viking, 1998).

23. Richard Rorty criticized Dennett's interpretation of consciousness for his stance of scientific objectivity and intrinsicality. Richard Rorty, "Holism, Intrinsicality, and the Ambition of Transcendence," in *Dennett and His Critics,* ed. Bo Dahlbom (Oxford: Blackwell, 1993), 184–202.

24. Humphrey, *A History of the Mind,* 202–206.

25. Joseph Weiss, "Unconscious Mental Functioning," *Scientific American* 262, no. 3 (1990): 75.

26. Robert M. Pirsig, *Zen and the Art of Motorcycle Maintenance* (New York: William Morrow, 1974). Pirsig discusses the motorcycle in a Barthian spirit.

27. College educated, artist-teachers of the contemporary era are unusually articulate about what they are doing. This is not necessarily a universal situation.

28. Norretranders, *The User Illusion,* 31.

29. Immanuel Kant, *Critique of Judgment* (1790; Indianapolis: Hackett Publishing, 1987). The following quotation indicates Kant's problem with the ideas of purpose and pleasure. He argued that art has "purposiveness without purpose" because purpose indicates interest and personal involvement that do not exist in a "free" aesthetic judgment. Though he wrote about art, he got more pleasure from nature than from things made by people. "Consider flowers, blossoms, even the shapes of entire plants or consider the grace we see in the structure of various types of animals which is unnecessary for their own use but it selected, as it were, for our taste. Consider above all the variety and harmonious combinations of colors . . . their sole purpose is to be beheld from the outside." Pp. 221–222.

30. "Colors are the result of computation: the colors we see do not exist in the outside world. They arise only when we see them. If the colors that we see were properly of the outside world, we would not be able to see the illusion of colored shadows . . . What we experience when we see a red fire engine is the result of a computation in which the brain tries to ascribe the same experience to the same object, even if the information it receives changes." Norretranders, *The User Illusion,* 189.

31. I do not wish to exaggerate the importance of the visual. Thinking with things is possible for the blind and the visually impaired by the use of the evidence of their

other senses. As the following chapters make evident, we have placed an excessive emphasis on visuality.

32. *Painting by Numbers: Komar and Melamid's Scientific Guide to Art,* ed. Jo Ann Wypijewski (New York: Farrar, Strauss and Giroux, 1998).

33. Robert Harrist, personal communication, 1997.

34. Leon Battista Alberti, who wrote on both, is one of the codifiers of Western formal language. Leon Battista Alberti, *On Painting* (1435–1436; New Haven: Yale University Press, 1956).

35. Art history was created by Joachim Winckelmann, who studied with Alexander Baumgarten, the philosopher who coined the term "aesthetics" in 1750. Winckelmann combined aesthetics with the practical, antiquarian, stylistic classification characteristic of the organization of collections of objects such as intaglios. His *History of Ancient Art* is the basis of subsequent art history. A psychological attribute to form was given especially by Wölfflin. Heinrich Wölfflin, *Principles of Art History* (1922; New York: Dover, 1970).

LEVELS OF SOCIAL INTEGRATION

Figure 3.1 Seydou Keita, two African women on a motorbike. Photo from *Seydou Keita* © 1997 Scalo Publishers.

THE DEVELOPMENT OF ART

Because art history emerged in the West with the appreciation of Greek art as formulated by Johann J. Winckelmann in the middle of the eighteenth century, naturalism has been considered the apogee of art and a characteristic of high civilization. Winckelmann contrasted Greek and Egyptian art and saw the development of art as naturalism out of abstraction. This model of the evolution of art persisted to the twentieth century.[1] In this model, the turn toward abstraction in modernism has been something of a mystery and simply proved art to be erratic. To my knowledge art historians have not tried to create a global evolution of art, on the assumption that this is not possible.

Social scientists, on the other hand, have been creating evolutionary typologies of people and their cultures at least since Giambattista Vico in the seventeenth century.[2] Some have also tried to integrate art into the picture but often ran into problems because of a lack of a serious consideration of what "art" is—or rather, because of the uncritical acceptance of the mystique of art as a spiritually uplifting experience.[3]

Art historians such as Arnold Hauser have long ago tried to relate "high" art to society, but this endeavor was considered "Marxist" and believed to be tainted by a political agenda.[4] Until the rise of "social history" in art history in the 1970s, it was considered inappropriate to discuss social context. At present, there is a conflict between poststructuralist philosophical issues and social history as approaches. "Primitive" art, however, emerged in anthropology, in which social context was always considered essential and not seen as "political." It is therefore not surprising that theories of the evolution of art came from the primitive rather than the modern end of art and culture history. Moreover, most of these studies limit themselves to a premodern past or make claims about the general universality of art.[5] Jean Duvignaud is one of the few to suggest an evolution of art from earliest times to the present.[6]

My study falls into the category of anthropological studies envisioning the evolution of art in relation to social stages but working with a different theory of art. For such a hypothesis to be a useful "tool of thought," it must encompass, explain, or map the entire terrain from early humans to the present.

NEOEVOLUTIONISM

In nineteenth-century social Darwinism, human societies were typed and put in a progressive sequence ending with Western culture.[7] As late as 1942, the respected archaeologist V. Gordon Childe referred to the various stages of human development as "Savagery (Paleolithic), Barbarism (Neolithic), Higher Barbarism, and Civilization (Urbanism)."[8] In his pioneering work on aesthetics, Hegel began discussion with the civilization of the Orient, which he considered the "beginning," and dismissed entirely the Americas and Africa as not even worth mentioning.

Civilization for the West has always begun with urbanism, monument building, and writing.

The twentieth century reevaluated the primitive as positive and posited unspoiled and idyllic Edens with exotic finds and ripe native women, in contrast to the stone magnificence of civilization and its descendants, the sooty modern cities touted by earlier scholars.[9] Schemes such as Childe's have collapsed and it is no longer appropriate to talk about evolution at all. Societies are presented as equally valuable, with none more or less "advanced" than any other. In recent decades, societies began being presented as merely "different." The ideological investment in this attitude is particularly strong now that members of these various native cultures have been integrated into modern life, speak on behalf of their own cultures, and would be laughable if they referred to themselves as being on the level of "savagery" or "higher barbarism." On the other hand, the lack of some nomenclature means that scholarly discussion deals with vast generalities such as the West versus the non-West (thus lumping Australian Aborigines and Chinese peoples together in one category), or sticks to local minutiae without trying to make broader statements.

There was a period in the 1960s and 1970s when many American anthropologists and archaeologists (Barbara Price, Julian Steward, Elman Service, Marshall Sahlins) revived the concepts of evolution, sanitized with new names, and concerned not with progress but with the sociocultural integration characteristic of each.[10] The terms, now sociological, were not praise or blame: Bands (hunter-gatherers), Tribes (villages), Chiefdoms, and States. Yet they were nonetheless the modern equivalents of the old terms. Their aim was partly typology, to apportion the vast variety of cultures in these four categories, and partly processual. They were interested in finding out what might have been the mechanism of change that moved a group from one level of integration to another, especially from egalitarian to inegalitarian societies. As a democratic culture, we are endlessly fascinated by the question of why and how inegalitarianism arises. Insofar as they were interested in such change, they were of course, still working in an evolutionist framework.

The neoevolutionist theory has been heavily criticized. Poststructuralist thought is strongly relativist and against "systems" as a whole and generally against the theory of evolution. As Gilles Deleuze and Felix Guattari state, "We no longer believe in the dull gray outlines of a dreary, colorless dialectic of evolution aimed at forming a harmonious whole out of heterogeneous bits by rounding off their rough edges. We believe only in totalities that are peripheral."[11] Anthropologists, belonging to the same zeitgeist, have attacked evolutionist theory in detail. The primary argument mentioned by nearly every critic is that the social types so clearly formulated on paper rarely exist in the field.[12] Cultures appear to be combinations of types and not pure examples. Another strand of criticism attacks the typology as not being precise—or vague—enough to account for all examples. Various anti-evolutionist authors sidestep the terms by using new ones, for example, Steadman Upham's use of "middle range cultures" for chiefdoms and Norman Yoffee's "social complexity."[13]

A third major critique concerns the question of the independent unity and coherence of individual cultures that make up the types. Eric Wolf[14] and Yoffee both argue that societies have never been independent but always existed in complex symbiotic relationships with other types of societies, and thus interactive dynamics are more important than types. This argument leads to the fourth critique, that the evolutionist typology disregards history. Most scholars of the latter half of the twentieth century believe that anthropological truth resides in idiosyncratic history rather than generalization. For example, Yoffee points out that chiefdoms are a development of their own and do not lead to states.[15] Once history is taken into account, it may be discovered that similar societies have had very different trajectories. As Robert Denton states: ". . . grouping modern and Paleolithic bands together as "band level" societies on an "evolutionary" ladder rests on analogies as superficial as those that permit grouping whales and fish together."[16] James Zeidler summarizes the position by writing that "explanatory weight" should be placed on the "internal dynamics properties of a social system, where behaviour is studied as a specific historical process."[17]

A fifth critique concerns process. All recent authors following Morton Fried argue that these are not evolutionary stages but processes that are often reversible and the result of history.[18] Following revisions in thinking about biological evolution, Charles Spencer suggests that what evolution there is, is punctuated and not gradual, and that the most interesting developments occur in the rapid periods of transformation.[19] Similarly, George Cowgill argues that states are unstable structures usually on the verge of collapse, so that social forms, rather than being stable types, constantly oscillate between one form and another.[20]

I do not claim to have read all critiques, but the above is a fair sample. One can add to these issues modern political concerns such as "tribalism." The term "tribe," imprecise as it is, is indelibly linked with "tribalism," a derogatory term indicating the inability of modern non-Western peoples to govern themselves.[21] More interesting in some ways than the battle over terms and processes is what is behind them. Explaining Jurgen Habermas' sociological theory, Thomas McCarthy states that "[s]ociological concepts are 'second level-constructs,' the 'first-level constructs' are those through which social actors have already prestructured the world prior to its scientific investigation."[22] In other words, the battle between the neoevolutionist and historicist positions is in part generational, and as much a matter of the zeitgeist as of the actual superior merit of either system. There is much in both that is valuable as well as overzealous.

What solutions have been suggested for this problem? Robert Carneiro, a defender of evolutionist theory, believes that by fine-tuning the system the types and specific data will match up better.[23] But in fact, I do not think that it can be done. It is like the chaos theorists example of mapping: no map can be entirely accurate unless it is as large as the original terrain, when it ceases to be a map. It is useless to expect that any categories will fit the cultural data precisely. Cowgill suggests an intermediate approach:

One style in the study of human affairs is the formulation of grand, sweeping general theories . . .
A contrasting style is the rich, meticulous, and

often fascinating examination in depth of events in a certain time and place. Between these styles is a wide gulf. It is scarcely seeing the forest versus seeing the trees. Often users of the first style have trouble seeing the forests because of the continents, whereas followers of the second have trouble seeing the trees because of the twigs. We urgently need studies that lie between these extremes . . .[24]

Some scholars opt for generalized terms; Habermas, for instance, uses "Neolithic Societies," "Early Civilization," "Developed Civilization," and "the Modern Age."[25] Others, such as Yoffee, believe in avoiding them altogether. As a nonanthropologist I am struck by the fact that everyone uses these concepts whether they admit to it or not. These terms structure the discourse even when they are disputed. The outsider in me is amused that a volume critical of the term and concept of "chiefdom" is entitled *Chiefdoms of the Americas*. Compared to this, art history is indeed historicist and often flounders about in dealing with nonmodern cultures. I often wish we had such terms to dispute! Regarding Cowgill's sensible suggestion of a middle course, I still value likely-to-be-wrong grand theories. Maybe he is right that they are continents rather than forests, but for some purposes globes with continents are useful too. We do not try to find Route 46 to Morristown, New Jersey, on a globe, nor do we look for the relationship of Europe to Greenland on a New Jersey map. Each of these has its own uses and limitations.

The whale and fish metaphor used to privilege history over evolution by Denton[26] is also instructive. While whales and fish are different in history and structure, they are in fact very similar due to their adaptation of living in water. This is known as convergence. The main point of the neoevolutionist theory is that socioeconomic context (like water) determines the nature of society—regardless of where you come from. Similarly, whatever their origin, people in bands or chiefdoms have come up with homologous practices and things because of the nature of the social context. This is what makes it possible to draw some parallels between modern and ancient times. (William Golding made use of this idea in *Lord*

of the Flies.) Whether anthropologists are pro or con evolutionary theory, it structures their thinking. The very intensity of the debate indicates its importance.

Art historians at this time were also undergoing their own debate between lawlike development of form versus historical causes, except the art historical unfolding of form was envisioned outside of a social context. Early art historical theorists talked about the gradual and independent development of art in stages—such as archaic, classical, and baroque—found in styles from Gothic to rococo, still based on Winckelmann, and proceeding cyclically.[27] As in anthropology, historicism seems to have won out.

It is hardly surprising that as soon as I encountered the neoevolutionist literature in the works of Elman Service and William Sanders in anthropology, I found it very exciting. It amazed me that more scholars did not follow that direction. Cecelia Klein, my classmate at Columbia University, did in an exhibition in 1980 based on these categories, but she subsequently abandoned this approach.[28] The Western art historical schemas were frustrating in being limited to brief periods in Europe and had no global applicability. Historicism was fine as far as it went, but it did not map the continents. The anthropological system did, and I could see immediately where things not usually discussed by anthropologists fit in. In the end, I opted for a simple scheme close to that of Habermas.[29] It is essentially based on three parts: things in the center of life in archaic societies, things halfway from the center in textual societies, and things at the margins in technological societies. Archaic societies are subdivided into bands (hunter-gatherers), tribes (villages), chiefdoms, and states, as in the anthropological literature, and extensively discussed as this is my area of expertise and it is here that I can best show the development of my theories. Moreover, it also seemed to me that this was one way to acquaint a Western audience with different types of non-Western cultures, rather than either lumping them together in one category labeled "primitive" or leaving them in their confusing multiplicity. My interpretation of the structural history of things was born somewhere between the works of Lévi-Strauss, Service, and Barthes-like totem animals—the evolutionary categories are good

to think with. As an introduction to the discussion of things in the following chapters, I will sketch each social type very briefly.

BANDS (HUNTER-GATHERERS)

The term "band" is being used for the simplest forms of society known.[30] The population of bands is small, often under one hundred, all interrelated. The societies are mostly egalitarian, and the relationship of women and men is close to equal. Bands are usually nomadic and travel within a customary area, depending on the seasons. Several bands come together at certain times for rituals, feasting, and marriage. Such bands have been idealized recently as the most perfect forms of human society.[31]

Historically, colonizing Europeans came mostly in contact with settled agricultural peoples. Hunters and gatherers were to be found in harsh and isolated areas of the world, such as the Arctic, the tip of South America, or desert areas of Africa. Although their way of life was presumably similar to that of early humans, modern hunters and gatherers did not have the run of the best and richest lands and may have had less complex social organization in certain areas. Modern bands and early humans may be compared primarily through their extreme ingenuity in having adapted to difficult conditions.

TRIBES (VILLAGES)

Tribes, usually living in villages (although there are also nomadic tribes), are mostly sedentary and agricultural. As Service succinctly observes: "It may be stipulated that domesticated plants and/or animals made possible (though they did not *cause*) a much higher level of economic productivity and, importantly, a much more stable, consistent productivity than at the hunting gathering level. Much larger aggregations of people were possible, therefore, and in a much reduced territory."[32]

We have to think of modern tribal villages as located in isolated places not favored by cultures that went on to develop nation states. Though they are often considered the equivalent of "Neolithic"

archaeological cultures and sites, they differ from similar ancient villages in the greater scarcity of their resources.[33] Villages are occupied by a larger population (in the thousands), with women often being the horticulturists. Social relations are still roughly egalitarian, with some power in the hands of older men. Highly defined masculine and feminine gender roles and symbolism are often characteristic of such societies.[34]

Because of the tribe's larger size, kinship is not adequate to unify the group and thus various associations or sodalities ("secret societies," medicine societies) exist which serve the village as a whole. Usually boys, but sometimes also girls, are "initiated" and learn customs and rituals from the elder men and women who run these societies. Occasionally there are women's societies as well. Societies often have their own building, spectacularly ornamented as in some areas of New Guinea, and a frequent ritual is the masquerade in which ancestors and/or nature spirits are impersonated. As Harley suggested long ago, at least one aspect of these masks is social control—in a society without centralized power, order is maintained by humans in spirit form.[35]

CHIEFDOMS

There is no simple cutoff point between villages and chiefdoms. Some villages have "big men" who are in transition to becoming chiefs. As defined, chiefdoms can range from a small group to a powerful center erecting stone monuments. The essential definition of a chiefdom is the presence of stratification and hereditary rank, not size. Villages can be bigger than a chiefdom, although some chiefdoms are very large. Every individual is ranked in some relation to the chief who is at the top of the social pyramid, but there are no social classes. Chiefs usually combine sacred and secular functions and rule through ceremonial activity. Their actual power may be relatively weak—they do not have the resources of absolute power and must rule with the consent at least of other titled individuals. The wealth of chiefs is acquired from tribute and often from long-distance trade in exotic and precious materials. But chiefs are

expected to redistribute some of this in the form of feasts and gifts. Large chiefdoms have had the power and resources to erect stone architecture and monuments like the Easter Island heads.[36]

We know a great deal about chiefdom formation, paradoxically because of European contact. Coming from a centrally organized culture, Europeans assumed wherever they met natives that they had "chiefs" and, even if they did not, they designated one particular person as their special contact. (They did not want to deal with groups of contentious elders.) If trade was established, as in some areas of West Africa, these families became rich, and sometimes an egalitarian society was indeed transformed into a chiefdom.[37] From at least the sixteenth century, wherever Europeans went they encouraged the growth of chiefdoms. This indicates also the important role that trade in scarce resources plays in the development of stratification. It also indicates that societies may fluctuate between chiefdoms and egalitarian villages at various times in their history, depending on circumstances. There is no evolution in a straight line.

STATES

There has been much debate as to where chiefdoms end and states begin. According to most definitions, a state is qualitatively different from a chiefdom in having a ruler who has economic resources (tribute, taxation, labor service) and military power (police, armies) to back up executive decisions that no longer have to be approved by a wide segment of society. This power is believed to be evident in building projects—such as irrigation, road systems, or colossal architecture—that are beyond the resources of chiefdoms. Rulers in such contexts are seen as managerial elite directing public works, rather than ceremonial figureheads.[38] States are defined as having a lower class of agricultural workers and a middle class of artisans and professionals. Various types of record keeping and writing are common in states.

In the traditional view, there have only been six pristine (i.e., original) states in the world: China, India (Mohenjo Daro), Mesopotamia, Egypt, Mesoamerica, and the Andes. The rarity of the development of the

state is attributed to the stringent requirement for its existence: circumscription. Where there is plenty of open land, if villages or chiefdoms get too big or have factional quarrels, they split off and move to a new place and remain at the same level of integration. States emerged, according to Carneiro's widely accepted theory, when conditions were such that it was impossible to move to anyplace new because the settlement was surrounded by barriers, such as deserts or high mountains or even other populations, making a lower status preferable to the inability to survive.[39] Most of these six ancient civilizations are irrigation agriculture systems surrounded by inhospitable territory. A great surrounding population can also be considered circumscription.

Mann has argued that states are aberrations and not the natural evolutionary developments earlier anthropologists imagined. "Civilization was an abnormal phenomenon" is his view.[40] He suggests that they occurred within a fortuitous set of overlapping power networks in which irrigation agriculture, ideological power and organization, and interaction with peripheral networks created "caged" mechanisms.[41] Pristine states are believed to have stimulated the growth of secondary states, just by interacting with chiefdoms or on the analogy of Europeans interacting with selected villagers in the contact period.

There has been a dissatisfaction with the state category as too narrow, especially by Africanists who would like to readjust the criteria of the state so it can accommodate the West African kingdoms, such as Benin.[42] Many African rulers are called "kings" rather than "chiefs." The term "king" is vague enough to fit both chiefdoms and states. Despite a century of admiration for the "primitive," status still belongs to the ancient state as Hegel saw it, and there is a general desire in the anthropological literature either to raise the level of a particular culture or to erase the boundaries between levels entirely. Some other cultures, such as Angkor in South East Asia or the Maya in Mesoamerica, are difficult to classify as being chiefdoms or states.

The concept of the state is more or less coeval with the concept of civilization, and in the last few hundred years Westerners have been quite ambivalent about it. With its theory of progress, the nineteenth century generally thought the state to be the apogee of human development. With its primitivist ideology, the twentieth century tends to see the state as evil.[43] Service has sections on the "negative" and "positive" aspects of states in his conclusion.[44] The negative issues have to do with militarism and internal repression. These have now come to be called the "conflict" and "integration theories."[45] In the conflict theory, the state is not only created by conflict, it exists with continuous conflict and repression within it. According to the integration theory, the state performs the managerial functions of internal organization to everyone's benefit and more or less approval. In the twentieth century, with Nazism and Communism, these concepts cannot help but relate to the ideas of "totalitarian" and "democratic" governments. Problems arise as to what is actually totalitarian both in the present and projected back into the past. For example, in the minds of many Europeans, the "democratic" United States is really "totalitarian" as a result of soft commercial brainwashing. Some have gone so far as to suggest that the mind is "freer" in a totalitarian context.[46]

THE AMERICAS

The great significance of the Americas in anthropology is that they developed outside the Old World and are a test case of the relationship of evolution to ecology and society. In fact, the modern interpretations of universal human development occurred because of the discovery of the Americas with the states of the Aztec and Inca, which could not be related to Old World texts. The data from the Americas matches that of the rest of the world. In the geographic areas that were open and homogeneous, such as the Eastern Woodlands, the Plains of North America, and the tropical forests of South America, the populations consisted of scattered agricultural villages and low-level chiefdoms. The areas that were circumscribed, Mesoamerica and the Andes, had high-level chiefdoms and states. These levels of culture did not depend on tool technology—the Americas had no metal tools and were Neolithic. They had few beasts

of burden or other domesticated animals. They did not use the wheel. Nevertheless, they built pyramids, as well as irrigation and road systems, and had writing and recording devices. Clearly the crucial variable was sociopolitical organization and not technology.

OLD WORLD TEXTUAL ERA

Anthropologists usually close their typology of levels of integration with the state, assuming that everything after that is "history" and not anthropology. Sociologists usually discuss the early modern and modern eras.[47] With the level of the pristine state, comparisons with the Americas cease, since the Americas did not develop beyond that. The reasons for the greater advance of Eurasia are uncertain. It may have to do with the domestication of plants and animals. Old World plants were easier to domesticate, there were more animals that could be domesticated, and these domestications occurred earlier; the New World had a slow start and fewer resources. A second possible reason often mentioned is that the New World only had two areas in which to exchange ideas and inventions (Mesoamerica and the Andes), whereas the Old World had at least four, which are known to have been interconnected in very early times (Egypt, Mesopotamia, India, China). For whatever reason, when encountered by Europeans the Americas were a paradox: Neolithic states.

Prior to the Industrial Revolution—which may be considered the next level of complexity—and after the pristine states, the cultures of the Old World had a long period of interconnected development. Trade routes crisscrossed Asia, North Africa, and Europe, so that exotic goods and ideas found their way from one corner to the other.[48] Travelers like Marco Polo and Ibn Khaldun reported on foreign cultures. In the year 1500 there was a great similarity in the level of cultures from Japan to Spain. This type of culture has no name—it is not exactly a nation-state as yet. Habermas called it "developed civilization" and saw it in part as a "break with mythological thought, development of rationalized world views";[49] and it has also been called the Axial Age.[50] It is not my task

here to suggest a sociopolitical or economic term and/or to give an explanation beyond the needs of this thesis.

From the point of view of what happens to the interpretation and use of things, two factors seem to be the most significant in this era: the culturally high valuation of texts and the spread of the historical religions, which were related phenomena. Most historical religions used sacred texts as their sources of divine authority, and some, such as classical and Chinese cultures, had more or less secular texts fulfilling the same role. Most importantly, the technology of writing replaced the previous emphasis on things and images and perhaps ushered in a different way of thinking. It is characteristic of most world religions that at one time or another they denounced the image as evil or unnecessary. While some writing was known in Mesoamerica, there is no documented case of a text-based civilization in the New World. For lack of a better term, I will consider the time of these complex states a textual era and assign to this category all of the states of the Old World prior to the Industrial Revolution and colonialism on a large scale. It is important to note that these states are not just a type but are also strongly historically related.

THE TECHNOLOGICAL ERA

Robert Carneiro noted that sociopolitical evolution seems to develop in the direction of fewer and larger units.[51] There have been many more bands in history than tribes or chiefdoms or states. Each category gets smaller until eventually we are likely to get to a single state and/or culture. Alarming as that is to all of our notions of diversity, to a certain extent this has come to pass, without as yet the politically dire consequences so feared—or perhaps, as some would say, we have already accepted them. This modern culture, which originated in Western Europe as a result of the Industrial Revolution, is a level of integration in itself.[52] It was for a while imposed on many of the world's people by colonialism but now seems to be voluntarily accepted globally as a result of world capitalism. Many, such as Anthony Giddens, see a

greater difference between modernity and all traditional societies than between any two types of traditional societies.[53]

Why should only one place in the world, and Europe in particular, have been the originator of this technological civilization? Wolf describes the geographic and political advantages of Europe by around 1400: the miles of waterways, the centuries of trade, the many weak polities that allowed mercantile cultures competing with each other to flourish.[54] He suggests that culturally, in terms of the secular thought inherited from antiquity, and ecologically Europe suited the needs for an emerging capitalist society better than any other place in the world. The development of this form of society may have needed even more stringent criteria than the development of the state, since it occurred only once.

Technological civilization adds media to the earlier communication technologies of things and writing. Media resemble things in their visual image components but are distinguished by endless replication and the lack of an authentic tactile reality.[55] They have been called "simulacra" by Baudrillard, who writes extensively about the United States.

> Disneyland is presented as imaginary in order to make us believe that the rest is real . . . It is no longer a question of the representation of a false reality (ideology) but of concealing the fact that the real is no longer real . . . Disneyland . . . is the first great toxic excrement of a hyperreal civilization.[56]

The media's effects on thinking are widely debated and generally considered to be negative. None of the technologies of visual thinking used by early humans have disappeared—things, writing, and now media coexist. However, the significance of things underwent major changes once the other communications technologies were introduced. In the ensuing analysis I will discuss the role of things in the various types of societies listed above. I will suggest that things were the central form of communication technology in bands, tribes, chiefdoms, and states, and have forms and subjects appropriate to each. Writing, especially in literate states, moves things away from their central location by privileging text. Things do not necessarily disappear but acquire new aspects such as aestheticism. There is a complex interaction between texts and things. The concept of art is born at the beginning of the technological age and "art" becomes associated with aestheticism. Under technological capitalism, art is both worshipped and marginalized as mass media take a central position in society. Having no direct function in economic and social life, older "art" is collected and worshipped in museums or contemporary art is made for a very small audience. Contemporary art seeks to make philosophical statements about the nature of art or critical ones about the nature of society. It seeks to avoid the aestheticism of the textual era and turns for nostalgic inspiration to the deeply centered things of bands, tribes, chiefdoms, and archaic states.

NOTES

1. Ernst H. Gombrich, *The Story of Art* (New York: Phaidon, 1972). Gombrich called Greek art "revolutionary," a "great awakening," and a "miracle."

2. Until the seventeenth century, all people of the world were linked historically to the Bible and classical texts by Europeans. They were generally believed to have originated in one place, and that was ancient Egypt. Giambattista Vico was the first to create a history based on social type that was meant to be universal and consisted of stages of development. His stages were an initial bestial condition, an age of gods, myth, and ritual, a heroic age of feudal aristocracy, and a fully rational human age. When this point was reached, the cycle began again. In the eighteenth century most theories of art and culture were cyclical; in the nineteenth they became progressive. In various ways terminology based on stages is still being used. Leon Pompa, *Vico: A Study of the "New Science"* (Cambridge: Cambridge University Press, 1975).

3. This is even true of Claude Lévi-Strauss who cut through so much anthropological myth to fall for the myth

of art. Claude Lévi-Strauss, *Look, Listen, Read* (1993; New York: Basic Books, 1997).

4. While Hauser starts out with "Prehistoric" and "Ancient/Oriental" cultures, the rest of the work is conventionally Western. Arnold Hauser, *The Social History of Art* 4 vols. (New York: Vintage Books, 1957).

5. Alexander Alland, *The Artistic Animal* (New York: Anchor Doubleday, 1977).

6. Jean Duvignaud, *The Sociology of Art* (New York: Harper and Row, 1972) (1967). His divisions are as follows: tribal and clannish societies, magical-religious theocratic societies, patriarchal communities, city-states, feudal societies, centralizing bourgeoisie, liberal societies, and industrial societies.

7. The names associated with evolutionary theory are Louis Henry Morgan, Sir Henry Maine, E. B. Tylor, and Herbert Spencer. Morgan's work grew out of his acquaintance with the Iroquois and used the Enlightenment categories of savagery, barbarism, and civilization. Marx and Engels relied heavily on Morgan, and the twentieth-century evolutionists relied heavily on Marx. The most influential nineteenth-century thinker was Spencer (*Principles of Sociology*). Employing as many as three secretaries at one time, he compared in great detail the material, social, and ideological traits of hundreds of cultures. Classification by trait was still being done in the twentieth century by G. P. Murdock in the Human Resources Area Files, in which 250 cultures are analyzed in terms of 900 categories. Spencer named his society types the simple, compound, doubly compound, and triply compound. While he described the process as complexity out of simplicity, Spencer argued that higher-level integration creates new simplicities, and he planned to prove the law of evolution in a ten-volume work that covered everything from psychology, biology, and sociology to astronomy. Herbert Spencer, *First Principles* (London: William and Norgate, 1863). Also, *Principles of Sociology* (New York: D. Appleton, 1888–1887) and *The Evolution of Society,* ed. Robert L. Carneiro (Chicago: University of Chicago Press, 1967). Robert L. Carneiro, "Herbert Spencer as Anthropologist," *Journal of Libertarian Studies* 2 (1981), 153–210. "Instead of civilization being artificial, it is a part of nature, all of a piece with the development of the embryo or the unfolding of a flower. The modifications mankind have undergone and are still undergoing result from a law underlying the whole organic creation." Spencer, as quoted by Carneiro, "Herbert Spencer," 159.

8. V. Gordon Childe, *What Happened in History* (New York: Penguin Books, 1942).

9. See books such as Miles Richardson and Malcolm C. Webb, eds., *The Burden of Being Civilized* (Athens: University of Georgia Press, 1986), to say nothing of Sigmund Freud, *Civilization and its Discontents* (New York: Norton, 1962).

10. At the beginning of the twentieth century, evolutionism became unfashionable as a result of Franz Boas' relativist influence. Evolutionist ideas were revived by Leslie White, who influenced both Marshall Sahlins and Elman Service. (White was influenced by Marx, but in the midst of the cold war he did not celebrate Marx.) The particular part of the world that was significant in this analysis was Polynesia, because the process of stratification could be studied there. Leslie A. White, *The Evolution of Culture* (New York: McGraw-Hill, 1959). Marshall D. Sahlins, *Social Stratification in Polynesia* (Seattle: University of Washington Press, 1958). This basic scheme was organized in the vast undertaking of the *Handbook of South American Indians, Bureau of American Ethnology,* 7 vols., ed. Julian H. Steward (Washington, DC: GPO). Elman R. Service is known in part as a systematizer of these ideas. Elman R. Service, *Primitive Social Organization* (New York: Random House, 1962). Elman R. Service, *The Hunters* (Englewood Cliffs, NJ: Prentice-Hall, 1966). Elman R. Service, *Origins of the State and Civilization* (New York: Norton, 1975).

Evolutionary theory has had a profound impact in archaeology, especially in the work of Sanders and Price and Timothy Earle. William T. Sanders and Barbara J. Price, *Mesoamerica: The Evolution of a Civilization* (New York: Random House, 1968). Jonathan Haas, *The Evolution of the Prehistoric State* (New York: Columbia University Press, 1982). Grant D. Jones and Robert R. Kautz, eds., *The Transition to Statehood in the New World* (New York: Cambridge University Press, 1981). Allen W. Johnson and Timothy Earle, *The Evolution of Human Societies: From Foraging Group to Agrarian State* (Palo Alto: Stanford University Press, 1987). Timothy Earle, *How Chiefs Came to Power* (Palo Alto: Stanford University Press, 1997).

11. Gilles Deleuze and Felix Guattari, *Anti-Oedipus* (1972; Minneapolis: University of Minnesota Press, 1983), 42. This attitude has not only affected archaeology in the work of Ian Hodder, for example, but also biological evolution itself in the work of Stephen Jay Gould.

12. Steadman Upham, "A Theoretical Consideration of Middle Range Societies," in *Chiefdoms in the Americas,* ed. Robert D. Drennan and Carlos A. Uribe (Lanham, MD: University Press of America, 1987), 345–367.

13. Norman Yoffee, "The Decline and Rise of Mesopotamian Civilization: An Ethnoarchaeological Perspective on the Evolution of Social Complexity," in *American Antiquity* 44, no. 1 (1979): 5–35.

14. Eric R. Wolf, *Europe and the People without History* (Berkeley: University of California Press, 1982).

15. Norman Yoffee, "Too Many Chiefs? Or, Safe Texts for the '90s" (American Anthropological Association Symposium, Washington, DC, 1989).

16. Robert Knox Denton, "Band-Level Eden: A Mystifying Chimera," in *Cultural Anthropology* 3, no. 3 (1988): 276–284.

17. James A. Zeidler, "The Evolution of Prehistoric Tribal Systems as Historical Process: Archaeological Indication of Social Reproduction," in *Chiefdoms in the Americas,* ed. Robert D. Drennan and Carlos A. Uribe (Lanham, MD: University Press of America, 1987), 325–343.

18. Morton H. Fried, "On the Concept of Tribe," in *Essays on the Problem of Tribe,* ed. June Helms (Seattle: University of Washington Press, 1968), 3–22.

19. Charles S. Spencer, "Rethinking the Chiefdom," in *Chiefdoms in the Americas,* ed. Robert D. Drennan and Carlos A. Uribe (Lanham, MD: University Press of America, 1987), 369–389. Punctuated evolution has been popularized in biology by Stephen Jay Gould, "The Episodic Nature of Evolutionary Change," in *The Panda's Thumb* (New York: Norton, 1980), 179–185.

20. George L. Cowgill, "Onward and Upward with the Collapse," in *The Collapse of Ancient States and Civilizations,* ed. Norman Yoffee and George L. Cowgill (Tucson: University of Arizona Press, 1988), 244–276.

21. Morton H. Fried, "On the Concept of Tribe."

22. Thomas McCarthy, Introduction to *Communication and the Evolution of Society,* ed. Jurgen Habermas (1976; Boston: Beacon Press, 1979).

23. Robert Carneiro, "The Calusa and the Powhatan, Native Chiefdoms of North America," *Reviews in Anthropology* 21 (1992): 27–38. Carneiro has mentioned that he has other typologies for chiefdoms, based on where they are located: impacted, dispersed, riparian, and insular. Personal communication, 1999.

24. Cowgill, "Onward and Upward with the Collapse," 248–249.

25. Jurgen Habermas, *Communication and the Evolution of Society* (Boston: Beacon Press, 1979), 157–158.

26. Denton, "Band Level Eden."

27. Heinrich Wölfflin, *Principles of Art History* (1922; New York: Dover, 1970). As late as 1962, George Kubler went over some of the same terrain. *The Shape of Time* (New Haven: Yale University Press, 1962).

28. Cecelia F. Klein, ed., *Mother, Worker, Ruler, Witch: Cross-Cultural Images of Women,* UCLA Museum of Cultural History Pamphlet Series 9 (Los Angeles: UCLA Museum of Cultural History, 1980).

29. Habermas' scheme is based on Marx: primitive communal bands and tribes, ancient slave-holding cultures, feudal, capitalist, Asiatic, socialist.

30. Eleanor Leacock and Richard Lee, eds., *Politics and History in Band Societies* (New York: Cambridge University Press, 1982). Susan A. Gregg, *Between Bands and States,* Occasional Papers 9 (Carbondale: Center for Archaeological Investigation, Southern Illinois University, 1991).

31. "A truly communal life is often dismissed as a utopian ideal, to be endorsed in theory but unattainable in practice. But the evidence for foraging peoples tells us otherwise. A sharing way of life is not only possible but has actually existed in many parts of the world and over long periods of time." Richard Lee, in Leacock and Lee, *Politics and History in Band Societies,* 56. The idealization of the nomad is built into poststructuralist literature. Deleuze and Guattari consider the "nomad," the "schizophrenic," and the "orphan" as metaphors for people "free" of controlling totalitarian (oedipal) forces. Deleuze and Guattari, *Anti-Oedipus.*

32. Service, *Primitive Social Organization,* 101.

33. Tribal villages also differ from peasant villages embedded in larger states. Critchfield estimates that around 1980 there were two million villages in the world. "History suggests that there may be no adequate substitute for this universal village culture, which, for all its old restraints, religious conventions, and patterns of obedience, seems necessary in small communities living off the land." Richard Critchfield, *Villages* (Garden City, NJ: Doubleday, 1983), 346. See also Eric R. Wolf, *Peasants* (Englewood Cliffs, NJ: Prentice Hall, 1966).

34. Margaret Mead, *Sex and Temperament in Three Primitive Societies* (New York: Mentor Books, 1935). Margaret Mead looked at gender definitions in non-Western cultures as models for our own.

35. G. W. Harley, *Masks as Agents of Social Control in Northeast Liberia,* Papers of the Peabody Museum, vol. 32, no. 2 (Cambridge, MA: Peabody Museum, 1950). Harley coined the concept, but it is Roy Sieber who developed the ideas. Roy Sieber, "Masks as Agents of Social Control," in *The Many Faces of Primitive Art,* comp. Douglas Fraser (Englewood Cliffs, NJ: Prentice-Hall, 1966).

36. The concept of chiefdom is mid-twentieth century and has an enormous literature. Studies of Polynesia are central to the definition. See Patrick Vinton Kirch, *The Evolution of the Polynesian Chiefdoms* (Cambridge: Cambridge University Press, 1984). Christine Ward Gailey, *Kinship to Kingship* (Austin: University of Texas Press, 1987).

37. I first came across this phenomenon in G. I. Jones, *The Trading States of the Oil Rivers* (London: Oxford,

1963), and used it in my first essay, which dealt with the issue of society determining artistic composition. Esther Pasztory, "Hieratic Composition of West African Art," *Art Bulletin* 52 (1970), 299–306.

38. It is not my purpose here to enter the debate of whether a managerial group creates building projects to glorify itself or whether the building projects result in the creation of a managerial group. See Wittfogel for a seminal study. Karl A. Wittfogel, *Oriental Despotism: A Comparative Study of Total Power* (New Haven: Yale University Press, 1957).

39. Robert L. Carneiro, "The Chiefdom: Precursor of the State," in *The Transition to Statehood in the New World,* ed. George A. Jones and Robert R. Kautz (New York: Cambridge University Press, 1981), 37–79. It is significant that this theory was developed by a scholar whose specialty is the Amazon area and who is familiar with dispersion patterns and their effects, rather than someone working on an ancient state.

40. Michael Mann, *The Sources of Social Power,* vol. I (New York: Cambridge University Press, 1986), 124.

41. Mann, *The Sources of Social Power,* 127.

42. Graham Connah, *African Civilization* (New York: Cambridge University Press, 1987). Connah argues against definitions of the state that require writing and monumental architecture, so that many sub-Saharan cultures could qualify. This, of course, would expand the concept to a much wider scope.

43. Richardson and Webb, *The Burden of Being Civilized.*

44. Service, *Origins of the State and Civilization.*

45. Jonathan Haas, *The Evolution of the Prehistoric State* (New York: Columbia University Press, 1982).

46. Jean Baudrillard, *America* (London: Verso, 1988). ". . . conformity makes American society close to primitive societies, in which it would be absurd to distinguish oneself morally by disobeying collective ritual." Baudrillard, *America,* 94. Hungarian friends fresh out from under communism agreed. Zsolt Farkas, "Letter from New York to Pécs," in *Mindentöl ugyanannyira* (Budapest: Pesti Szalon, 1994), 169–211.

47. French scholars, and especially poststructuralists, often divide history into a modern era and a traditional or classic era, which usually does not go much earlier than the Renaissance and is quite vague.

48. Jerry H. Bentley, *Old World Encounters* (New York: Oxford University Press, 1993).

49. Habermas, *Communication and the Evolution of Society,* 157.

50. The Axial Age concept was developed by the philosopher Karl Jaspers and was popular in the middle of the twentieth century. Lewis Mumford, *The Transformations of Man* (New York: Collier Books, 1956).

51. Robert Carneiro, "Political Expansion as an Expression of the Principle of Competitive Exclusion," in *Origins of the State: The Anthropology of Political Evolution,* ed. Ronald Cohen and Elman R. Service (Philadelphia: Institute for the Study of Human Issues (ISHI), 1978), 212–214.

52. Habermas calls this the "Modern Age" and associates it with democracy, capitalism, and the "rational use of natural law." Habermas, *Communication and the Evolution of Society,* 157.

53. Anthony Giddens, *The Consequences of Modernity* (Palo Alto: Stanford University Press, 1990). Some of the aspects of modernity noted by Giddens are separation of time and space from cultural context, the development of disembedded mechanisms or institutions from a local context, and the reflexive appropriation of knowledge, moving social life away from tradition. (P. 53).

54. Wolf, *Europe and the People without History.*

55. Walter Benjamin, "The Work of Art in the Age of Mechanical Reproduction," in *Illuminations,* ed. H. Arendt (New York: Schocken Books, 1968), 217–252.

56. Jean Baudrillard, *Simulacra and Simulation* (Ann Arbor: University of Michigan Press, 1994), 12–13.

Figure 4.1 Hummingbird geoglyph, San José pampa near Ingenio Valley. PGA0513. Courtesy South American Pictures. Photograph: Tony Morrison.

Figure 4.2 Apollo Belvedere, marble, second century AD, 7 ft. 4 in. Collection Vatican Museums, Rome. Copyright SCALA / Art Resource, NY.

TRADITION

Looking back on the twentieth century, it is clear that a major preoccupation of scholarship has been to find a people's or an era's special way of doing things that is not reducible to their level of social integration but is rather a kind of idiosyncrasy related to, if not causally derived from, their history. Whether it is the Englishness of English art or African Pende criteria for masks, such unique characterizations have appealed to us, creating a mosaic of individual cultures much like individual people.[1]

Gertrude Stein's concept of "insistence" seems to describe this kind of characterization very well. She derives insistence from repetition. "When you first realize the history of various civilizations, that too makes one realize repetition, at the same time the difference of insistence. Every civilization insisted in its own way before it went away."[2] This passage was quoted by Marcia and Robert Ascher who coined the term "insistence" to describe the unique aspects of Inca and Andean culture.

> To sense that the objects of one culture are airy and light while in another similar objects are dense and massive, is a step toward the idea of insistence; in fact that is what defines a culture. The quipu is an interesting and important object, worthy of attention to itself. But it also serves to express Inca insistence in one compelling and concrete image.[3]

Insistence has nothing to do with levels of social integration but the two are often confused. Insistence is more like the content of cultures, while levels of social integration are its structure. This can be well illustrated by the two state-level cultures of the Americas, the latest of which were the Aztec and the Inca. Both areas had Neolithic states, with the cultures dating to about 2000 BC and ended with the Spanish conquest in the sixteenth century. Both were comparable technologically and as state economies and societies. The approach to things in the two areas was, however, vastly different. In Mesoamerica, relatively naturalistic images of humans were carved in stone as early as 1500 BC, many incorporated glyphs and dates. In the Andes, by contrast, stone sculpture was rarer and naturalistic rendering even more so. The insistence in Andean things was on conceptually complex textiles and on various real and imaginary networks such as road systems and shrine arrangements. One could say that Mesoamerican insistence is theatrical and anthropomorphic, while Andean insistence is structural and abstract. Insistence in things correlates with sociopolitical factors that are local in character. An example might be the small warring states of Mesoamerica in contrast to the large, well-organized states of the Andes. Anthropomorphism might relate to the idealization of human conflict and individual power, while complex networks might relate to organization and representations of order. It is quite clear, since the West has an insistence that is similar to Mesoamerica's, that Mesoamerican art should have been appreciated prior to that of Andes, and that is exactly how it was.[4]

That which is often thought to be the advanced "level" of European art, its naturalism and anthropomorphism, is really European insistence; not its structure but its content. Baudrillard has a similar confusion with the technological era manifested through American insistence in his diatribe against Disneyland. Is Disneyland a manifestation of technological era structure or is it U.S. content? If the answer is both, which aspects are which? It is very hard to separate what insistence is from what a level is when there are few other similar cultures for comparison. Jun'ichiro Tanizaki is one of the few who understood this division between level and insistence instinctively and has pointed out how it might have been possible to have a high level of scientific culture, like that of Europe, with a different insistence, perhaps that of Asia:

. . . how different everything would be if we in the Orient had developed our own science. Suppose, for instance, that we had developed our own physics and chemistry: would not the techniques and industries based on them have taken a different form, would not our myriad everyday gadgets, the products of our industrial art—would they not have suited our national temper better than they do? In fact, our conception of physics itself would probably differ from that of Westerners; and the facts we are now taught concerning the nature and function of light, electricity and atoms might well have presented themselves in different form . . . The Orient quite conceivably could have opened up a world of technology on its own . . .[5]

Insistence is thus a basic feature of the content and things of a particular culture, and in that sense it is historic. Our historically inclined studies of the last half-century have brought this out very well. This is how Norman Yoffee puts it, using the term "tradition" for what I am calling "insistence":

Tradition denotes those practices that seek to inculcate certain values and norms which imply continuity with the past. In the face of constant change and innovation, tradition structures certain parts of life as unchanging and invariant. Indeed, it is this imposed invariant fossilization of the past—including a past that may be fictitious—that is the intent of tradition.[6]

The origins of cultural insistence are often very deeply buried in a particular tradition, and it is difficult to know what individual factors account for it. Both Mesoamerican and Andean insistence are clearly evident from the moment we can define the cultures archaeologically. It is possible that the initial insistence is simply kept as a "tradition" by subsequent cultures as passive receptors. However, both in Mesoamerica and the Andes one culture went against the grain of its basic tradition (Teotihuacán in Mesoamerica and the Moche in the Andes). It would appear that insistence does not have a stranglehold on a particular tradition, but opposing it is the exception rather than the rule. European insistence is generally naturalistic and "classical," even though there have been periods of more abstract representation in medieval and modern times. Far Eastern insistence, by contrast, has been on a more stylized representation focusing less on the human figure, despite some periods of realistic rendering. The earliest Chinese things are mostly non-anthropomorphic representations on bronze vessels, suggesting a great antiquity to this insistence.

Is insistence created by the environment, by accident, or by a repeated social pattern? The question cannot be answered in such a simple form and perhaps does not matter. The important fact is that the levels of social integration determine forms only in a very general sense and they are expressed through the insistence of a particular culture. For example, chiefdoms seem to like shiny things, but those shiny things could come in any material, iconography, and style. States often build monuments, but the actual monuments vary from culture to culture and no two are ever identical. The similarities—such as between pyramids in Egypt and pyramids in Mesoamerica—are due to the structural factors of levels of social integration and are generic. The levels of social integration determine the forms of things, like a skeleton. The "flesh" is the insistence of a particular tradition. This book is concerned with the skeleton.

NOTES

1. Nikolaus Pevsner, *The Englishness of English Art* (London: Architectural Press, 1956). Z. S. Strother, *Inventing Masks: Agency and History in the Art of the Central Pende* (Chicago: University of Chicago Press, 1998).

2. Gertrude Stein, *Lectures in America* (1934–1935; New York: Random House, 1975).

3. Marcia Ascher and Robert Ascher, *The Code of the Quipu: A Study in Media, Mathematics, and Culture* (Ann Arbor: University of Michigan Press, 1981), 38.

4. Esther Pasztory, *Pre-Columbian Art* (New York: Cambridge University Press, 1998). This short book contrasts the insistence of Mesoamerica and the Andes. Not surprisingly, the European editors of the book preferred the Mesoamerican illustrations and made them larger than the Andean ones. Mesopotamian things suffer from a similar lack of nonrecognition by contrast to the highly anthropomorphic tradition of Egypt.

5. Jun'ichiro Tanizaki, *In Praise of Shadows* (1933; New Haven, CT: Leetes Island Books, 1977), 7. See also the subsequent comparison of brush and pen. The bathrooms are good too.

6. Norman Yoffee, "The Late Great Tradition in Ancient Mesopotamia" (paper presented at College Art Association meeting, New York, 1990).

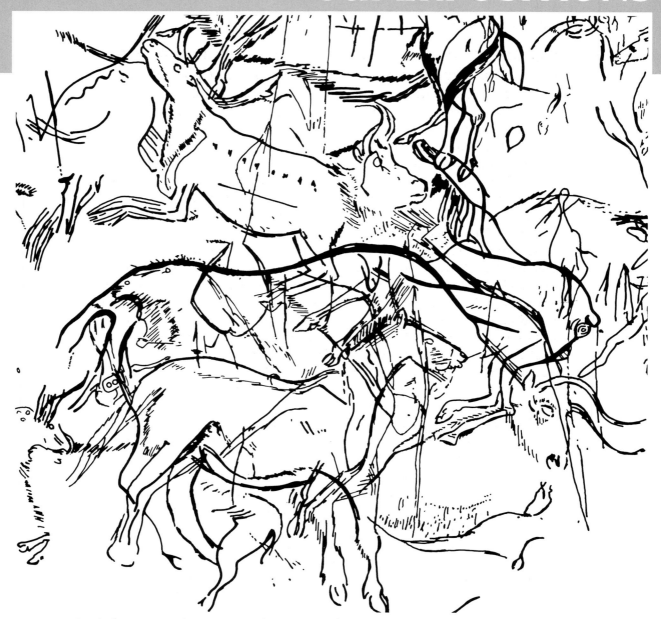

Figure 5.1 Panel of superimposed engravings in the Sanctuary of Les Trois Frères, Ariège, France. Drawing: Janice Robertson.

LIVING FOSSILS

The notion that our hunting and gathering ancestors lived a life similar to historically known hunter-gatherers is quite old and, although currently entirely unacceptable in scientific discourse, is impossible not to think. The entire construct of the life of early humans is visualized through modern peoples like the Australian Aborigines and the San (Bushmen) of Southern Africa. It is argued, quite correctly, that these people are not "living fossils" but have had long histories since Paleolithic times. Nevertheless, where are we to get our ideas of hunter-gatherer life if not from hunter-gatherers? Herodotus' Scythians or Ibn Khaldun's Bedouin?

This conundrum is unresolvable and further complicated by recent discoveries in the archaeology of early humanity. Some groups prior to the development of agriculture (circa ten thousand years ago) lived in settlements of stone or mammoth bone houses, and, as evident from beads and dress, had social hierarchies similar to chiefdoms.[1] In the Americas, burial mounds have been found in the context of hunter-gatherer culture, which is a total surprise.[2] On the surface these discoveries seem to upset the evolutionist tenet that social complexity emerges with agriculture. On the other hand, however, they support the idea that social context determines the nature of things. Living in areas of rich resources, not available to most modern hunter-gatherers, these groups behaved in effect as if they had the equivalent of agriculture. This situation has been used to explain the case of the Northwest Coast of America, where the groups were hunter-gatherers but they had a social structure closer to a chiefdom. Similarly, in the Andes, rich marine resources in the Humboldt current led to settled life and the building of monumental architecture prior to agriculture. Such a social differential in Paleolithic times might have accounted for the unusually highly developed European cave paintings. What all these examples indicate is that social stratification is more dependent on wealth than on a particular type of food procurement or tool technology.

The hunter-gatherer type of society was therefore variable. Many groups, however, were likely to be small and there are certain similarities in the things of modern hunter-gatherers and ancient ones. The primary issue is that insofar as people are even partly nomadic, they cannot have too many big and heavy things to cart about and do not make such things.

Hunter-gatherer images have some general characteristics: they are usually on rock or cave surfaces, except for small items they are largely two-dimensional, images are superposed on one another, both naturalism and abstraction occur, and because of the probable multivalence of meanings for the same forms, iconography is hard to interpret. I do not think that the "hunting magic" theory so popular in books is of much use in explaining why these objects and images were made.

I propose an approach to hunter-gatherer images in terms of their structural features and will suggest modest conclusions based on them.[3] While there were

undoubtedly many forms of expression, such as body decoration or basketry, rock carvings and paintings were the most permanent and are found throughout the world, indicating this was common practice. Rock markings vary from what we consider magnificent to what we see as insignificant. While they are difficult to date, they range anywhere from Paleolithic to recent times. There is, however, a correlation with hunter-gatherer peoples. (At times other types of societies create rock carvings too—for example, Mount Rushmore.) The second type of image I consider characteristic and important is storytelling maps, known only from historic groups but, I suggest, a major feature of the cognitive approach of hunter-gatherer imagery in general.

ROCK MARKINGS

Insofar as hunter-gatherers had a minimum amount of things—nets, baskets, weapons, and clothing—the emphasis was presumably on efficiency. None of these objects are without style or were meaningless to their owners, although we tend not to value them much. Some groups, such as the Pygmies, had no decorations or figurations recognizable to Westerners as "art" and are said to have no "art." I have never yet heard of a people without oral literature and especially without music. What is infrequent among hunters and gatherers is objects made to embody concepts—such as ancestor statues. They are simply impractical.

Rock markings both inside and outside caves, however, are abundant in the context of hunter-gatherer societies. It is quite clear that these natural places, in certain fixed locations, were the centers where image-making was concentrated. In hunter-gatherer life there is a pattern of alternating movement with sedentary lifestyles. In historic times, groups of fifty to one hundred people presumably wandered over a traditional route in a particular landscape and convened at certain places. Rather than taking their objects of meaning with them, they kept them in a specific location, so to speak.

As for the markings, they are very hard to interpret because, as Whitney Davis notes, we have been obsessed by issues from later Western art projected particularly onto Paleolithic images.[4] It is the naturalism of depiction in the caves, especially Lascaux, that awes us and the idea of having found the "origins" of art. Davis himself plays at the game of origins, suggesting that representations began with abstract maskings such as lines that were later interpreted symbolically as representations.[5] He refers to the use of color at archaeological sites as another "origin." The search for ultimate "origins" disappears if we consider all things, including representations in the same category. Like modern hunter-gatherers, early humans are also likely to have had bodypainting and markings on perishable objects. It only requires one invention to initiate a representational tradition. The important issue is not the ability to represent but rather the motivation to do so.

Meyer Schapiro noted that there were no flat surfaces in early art; all forms and images were applied on the curving and irregular shapes of bodies, containers, and rock surfaces.[6] Considering how much of early marking is two-dimensional, the nature of the irregular surface to which it is applied is highly significant. While nowhere are rocks smoothed down, and protuberances and depressions are often incorporated cleverly into the images, in fact, as photographs make clear, the surface is imagined as flat. This suggests an ability to imagine figures and designs regardless of the surface to which they are attached and then to apply them to any surface. Such a high level of abstraction is similar to the currently much admired ground lines (geoglyphs) of the Nazca in the Andes, which are clearly visible only from the air. It is also related to the making of maps.

I have been especially impressed by the habit of Inuit (Eskimo) and Aborigine storytellers of drawing designs on the ground while telling their tales.[7] The drawings are elaborated and erased as necessary. Many of these drawings are maps and diagrams—entirely rational and cognitive aids to the story. It is by no means accidental that maps—real or mental—are important to nomadic hunter-gatherers. Many of the Aborigine acrylic paintings that look abstract to us are meant to be maps.[8] In the storytelling context the image is a temporary aid, complex though it may be in mapping a segment of the world.

Figure 5.2 Eskimo sketching in the ground. After Hans Himmelheber, *Eskimokünstler*, Eisenach, E. Röth, 1953. Drawing: Janice Robertson.

SUPERPOSITION

Much of the literature on rock markings is obsessed with the question of function and meaning. I take these as unanswerable in the way in which they are usually posed, and I am more interested in what might be discernible, i.e., what is coded into the images. The most striking aspect of rock figures, from the point of view of later "art," is their superposition and markings made one on top of the other. At no other cultural stage do people habitually do this to their images (they do occasionally paint over them but usually cover the earlier images completely). Such superposition is common in rock markings the world over and suggests a relationship to image and thing that is not shared by later cultures, except perhaps in modern graffiti.

One possible explanation for superposition is that the rock or cave is significant ("sacred"), the image has to be there, and thus superposition is unavoidable. A well-known Aborigine custom was the repainting of images on certain ritual occasions, which resulted in changing overlapping series of more or less the same images. Superposition and repainting suggest that for hunter-gatherers the image is not the same valued, inviolable, and "authentic" thing that it is for other cultures. It has also been suggested that the purpose of rock markings was the process and not the finished result—as in modern action painting.

Rock markings may have been seen as "temporary aids" in ritual and other contexts and not as permanent "relics" to be treasured in themselves. Generally

speaking, what strikes the modern observer is the casual way in which hunter-gatherers seem to have treated what we see as "beautiful things." I suggest that they saw them without the aestheticizing desire to "keep" them characteristic of more settled cultures. All that wonderful stuff was easy come, easy go, and it is related to the nomadic outlook which does not emphasize holding on to things beyond their necessary use. It would appear that the image is treated like a temporary thing. What may be more significantly venerated is the natural rock or cave that plays a role in myth and ritual. Hunter-gatherers value their necessary things but do not appear to have the attachment to things that other cultures have. Their ability has never been in question; it is their attitude that is different.

Moreover, my argument is that to hunter-gatherers their images were not embodiments but mental maps and they had no problem reading one map over another. The common practice of showing the inside organs of animals in representation is a further indication of unconcern with its outer physical appearance and a drive to map the interior.[9]

NATURALISM VERSUS ABSTRACTION

As the images of early, primitive, and ancient cultures were accumulating in the nineteenth century, European scholars, with their linear evolutionist outlook, naturally debated the question of whether art began as naturalism or abstraction and in what direction it developed. A major group of anthropologists believed in a theory of degeneration from the representational to abstraction.[10] Art historians, following the Winckelmann paradigm of Egyptian to Greek art, suggested that art began as abstraction and became naturalistic only in the West through Greek representation. This theory was cyclical and it was expected that an archaic period would return. The things of "primitives," by which was meant the chiefdoms and tribal villages of the colonized world, were generally seen as abstract and crude and fitted well into the "archaic" stage of the schema. The Paleolithic cave paintings and San (Bushmen) rock art, however, were remarkably realistic. Neither unilinear evolution could really account for them all. Most astonishing

were the San paintings which showed animals in perspective, with light and shade, which were generally thought to be characteristic of advanced European representation.[11]

As late as 1960 Gombrich was still working out a developmental schema of art based on a particular "vision" of a culture. He suggested that most people represent what they imagine and named that "conceptual art." A few, especially in the West, developed naturalism by matching the image in their minds to reality, which he named "perceptual art."[12] The essential point of Gombrich's argument is that these are two different ways of looking at the world, and that perceptual art and the European scientific attitude necessarily go together. According to this view, only people with a "rational" attitude to the world can create naturalistic images. As I have suggested in the discussion of insistence, naturalistic depiction is so much a part of European identity, at least since the Renaissance, that it is assigned to Europe alone and used to signify a cultural assessment of value that confuses level of integration with insistence.

The world may indeed be a "vast ocean of conceptual art" broken here and there by a few "islands" (Greece, China) of "perceptual art," as Gombrich states,[13] but the fact remains that remarkably realistic images exist in contexts for which Gombrich's view does not account. Two, for example, from very different cultural contexts are the colossal Olmec heads of Mesoamerica and the San paintings of Southern Africa. One might also add that the famous Lascaux painting in which the mastodon is realistic is positioned next to a human stick-figure that is not (Fig. 5.3). Clearly both "visions" are possible simultaneously. As far as I can see from the study of non-Western images, realism is always possible and crops up in certain situations. When it does, within a known chronology, it is clear that it does not require a very long period of development or a particular "vision." It does require a particular need for verisimilitude. Such a need is evidently found in some (not all) hunter-gatherer animal images and some (not all) chiefdom/state ruler portraits.[14] When the charge, in Michael Baxandall's sense, is there, so is the mastery.[15] Just as man at lower levels of social integration is "rational," he or she can "match"

222222222222222 22222

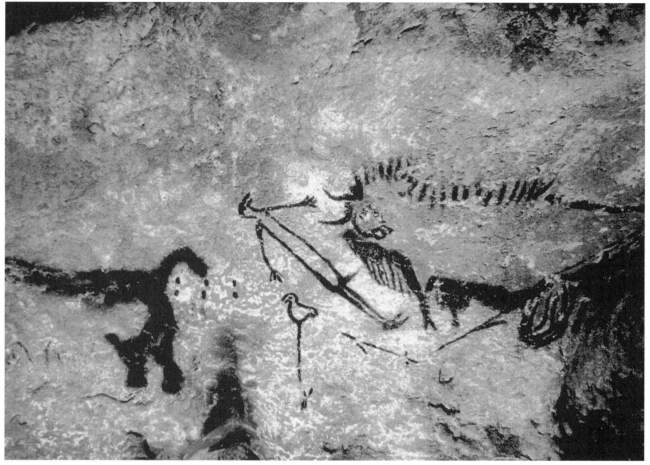

Figure 5.3 Painting of a wounded bison and a fallen man with rhinoceros, Cave of Lascaux, Dordogne, France. Photograph: Mario Ruspoli © Centres des monuments nationaux, Paris.

images to reality when the need or desire or charge is there. Gombrich is correct in noting that for the art of most of the world, naturalism is not the aim. Yet this is not the result of low advancement, vision, or ability but rather of choice.

MULTIVALENCE

While on the one hand studies on rock markings have been obsessed by questions of function, on the other hand they have been appreciated as "art." Bataille eulogized Lascaux as the creative "play" of early humans in contrast to his dull "work" (is hunting dull?) and created a conceptual gulf between "tools" related to work and "art" related to creativity.[16] André Leroi-Gourhan analyzed the placement of various animals in the cave, as though he were talking about the iconography of the Sistine Chapel.[17] None of these art studies of Paleolithic images have really been anything more than fantasies. The most useful studies have come out of the anthropology of modern hunter-gatherers, some of whose ideas can be adapted to earlier times.

Recent work on Aborigine iconography, especially that of Nancy Munn, has shown that decoding the meaning of designs without information from their makers is almost impossible.[18] In the story, drawings of the same symbol—a circle or a line—may stand for many things as the story unfolds—the sun, a watering hole, a path, a fishing rod. It is the same with the other images. The symbol system is not set but fluctuating and multivalent. These images were created

for the needs of a small group of people who understood them specifically in relation to their myths and maps or they were explained as they were in the process of being made. Hunter-gatherer representation does not seek to communicate with a large group of strange people, and no attempts are made to help the non-kin viewer understand it. The images do not appear to be propaganda even in the sense that a painting of the Madonna is. Generally there is no suggestion of a self-conscious aesthetic attitude, of making things pretty or extra expressive. Paleolithic images have been aestheticized by photographers and publishers, who have turned the images into modern art and fitted them into modern theory. Or, as Bataille put it about Lascaux, " . . . the essential impetus behind this art [is] that [it] springs not from routine habit, but from the spontaneity of genius."[19] As Whitney Davis showed, Paleolithic representation is forced into the late Western theory of art as a point of origin. My attempt to include it with the representations of hunters and gatherers in general is to focus not on their unique aspects—for which I assume unique circumstances—but the general features they share. Superposition, multivalence, stylization, and occasional realism are perhaps some of the most important of these features. I suggest removing the images from the exclusively visual interpretation favored by Western insistence and suggest discovering their sophisticated cognitive conceptualizations. These are not "art" in the sense of treasure but blueprints of thought.

NOTES

1. Douglas T. Price and James A. Brown, eds., *Prehistoric Hunter-Gatherers: The Emergence of Cultural Complexity* (New York: Academic Press, 1985).

2. John Noble Wilford, "Ancient Indian Site Challenges Ideas of Early American Life," *New York Times*, September 19, 1997, late ed., sec. A: 26.

3. This approach has been demonstrated in detail in my book on Teotihuacán. Esther Pasztory, *Teotihuacán: An Experiment in Living* (Norman: University of Oklahoma Press, 1997).

4. Whitney Davis, *Replication, Archaeology, Art History, Psychoanalysis* (University Park: Pennsylvania State University Press, 1996). " . . . it is obvious that a single received view has dominated the 'Figure 1' slot in the textbooks (of art history), namely, the Axial Gallery at Lascaux . . . Lascaux has been reproduced as an artwork possessing several very familiar properties of artworks, as recent tradition . . . has established them. With its long cumulating frieze of apparently interrelated figures, the Axial Gallery resembles Egyptian tomb paintings, Greek pedimental reliefs, medieval nave mosaics or the Sistine Chapel-making the appropriately "primitive" exception that animals occupy the places of human figures." Pp. 132–133.

5. This is not unlike Piaget's idea of the development of markings in the drawings of children and is the often made link between early and children's art. Jean Piaget, *The Language and Thought of the Child* (New York: World Publishing, 1955).

6. Meyer Schapiro, "On Some Problems in the Semiotics of Visual Art: Field and Vehicle in Image-Sign," in *Theory and Philosophy of Art: Style, Artist, and Society* (1974; New York: George Braziller, 1994), 1–32.

7. Himmelheber illustrates a child making a drawing while telling a story to herself. Hans Himmelheber, *Eskimokunstler* (Eisenach: Roth Verlag, 1953), pls. 2–5.

8. Peter Sutton, ed., *Dreamings: The Art of Aboriginal Australia* (New York: George Braziller and Asia Society Galleries, 1988). See fig. 80, p. 141; 121–125 on maps.

9. Himmelheber, *Eskimokunstler*, fig. 11. Sutton, *Dreamings*, 104. While superposition is common in European Paleolithic renderings, internal organs are rarer and the animals are usually seen whole. This is an aspect of special circumstances of these paintings.

10. The earliest writings on primitive art were not on figures but on their most admired feature in the nineteenth century: ornament. The debate about the evolution of art in a scientific context emerged from a discussion of ornament. A widespread evolutionist theory was degeneration from a representational original to an abstract pattern. This was based on the idea that a primitive person copies a design but does so imprecisely and therefore the original figures are garbled into ornamental designs. Haddon describes how Pitt-Rivers, the originator of the idea, gave a drawing

for someone to copy and the copy to someone else to see what happens, in imitation of the biologist who rears generations of animals. Haddon believed in degeneration and in the relationship of the quantity and quality of art to wealth. Alfred C. Haddon, *Evolution in Art* (London: W. Scott, 1895), 7–8, 311. Other influential theorists of degeneration included Marsh, Balfour, and Stolpe. An abstract to naturalistic theory was propounded by Semper and Boas, who thought art and decoration began with toolmarks, especially those of the adze, which were later shaped and refined. H. Balfour, *The Evolution of Decorative Art* (1893; Stockholm: Aftonbladets Tryckeri, 1927). Hjalmar Stolpe, *Collected Essays in Ornamental Art* (1891–1892, 1896; Stockholm, 1922) (1891–1892, 1896). H. Colley Marsh, "Polynesian Ornament a Mythography or a Symbolism of Origin and Descent?" in *Journal of the Anthropological Institute of Great Britain and Ireland* (London, 1893), 307–333. ". . . the dismal and confused phantasmagoria of savage art in the South Seas is at once resolved into dignity and order: and the broad conclusion can be reached that (Polynesian) mythography is a vast symbolism of origin and descent." P. 332. Gottfried Semper, *Der Stil in den Teknischen und Tektonischen Kunsten oder praktische Aesthetik* (Munich: Friedr. Bruckman Verlag, 1878). Franz Boas, *Primitive Art* (Oslo: Aschehoug, 1927). Franz Boas, *Decorative Designs of Alaskan Needlecases,* in *Proceedings of the United States National Museum,* vol. 34, 321–344. Washington, DC: GPO, [1908]. The ordering of designs in a developmental series has been inherited in archaeology in the practice of "seriation" as a tool for dating, a method that has become controversial only recently but is still widely accepted. Stephen Plog, "Sociopolitical Implications of Stylistic Variation in the American Southwest," in *The Uses of Style in Archaeology,* ed. Margaret W. Conkey and Christine A. Hastorf (New York: Cambridge University Press, 1990), 61–72.

11. Helen Tongue, *Bushman Drawings* (Oxford: Clarendon Press, 1909). See especially plate 19, photo 49. Fry commented on the Tongue volume: ". . . what strikes one most is the fact that extremely complicated poses are rendered with . . . ease and that momentary actions are treated with photographic verisimilitude." Roger Fry, "The Art of Bushmen," in *Vision and Design* (1920; New York: Meridian Books, 1956), 89–90.

12. Ernst H. Gombrich, *Art and Illusion,* Bollingen Series 35 (Princeton: Princeton University Press, 1960).

13. Ernst H. Gombrich, *Meditation on a Hobby Horse* (Chicago: University of Chicago Press, 1963), 9.

14. Esther Pasztory, "The Portrait and the Mask: Invention and Translation," in *Olmec Art and Archaeology in Mesoamerica,* edited by John E. Clark and Mary E. Pye, 265–276 (Washington, DC: National Gallery of Art, 2000).

15. Michael Baxandall, *Patterns of Intention* (New Haven: Yale University Press, 1985), 12–40.

16. Georges Bataille, *Lascaux; or, The Birth of Art* (Geneva: Skira, 1955).

17. André Leroi-Gourhan, *Treasures of Prehistoric Art* (New York: H. N. Abrams, 1967).

18. Nancy D. Munn, *Walbiri Iconography* (Ithaca: Cornell University Press, 1973). Nancy D. Munn, "Visual Categories: An Approach to the Study of Representational Systems," *American Anthropologist* 68, no. 4 (1966): 936–950.

19. Bataille, *Lascaux; or, The Birth of Art,* 129.

IMPERSONATION

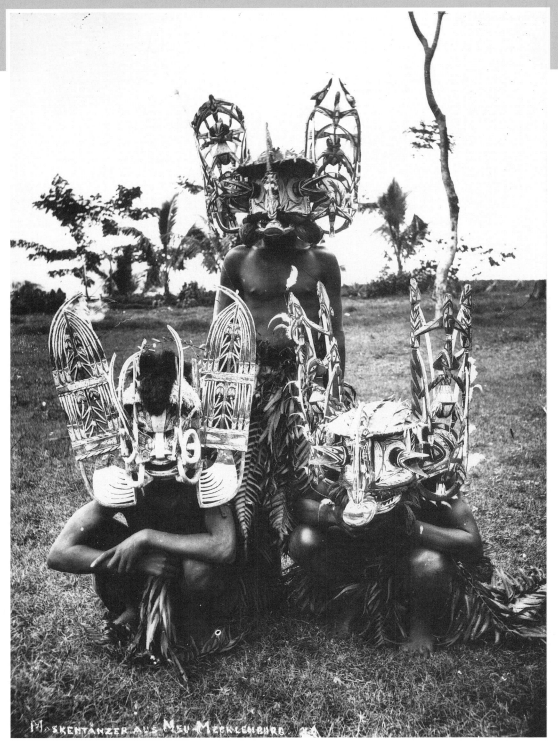

Figure 6.1 New Ireland masked men. © The Field Museum, #CSA27340.

THREE-DIMENSIONALITY

While hunting and gathering bands seem to picture the universe as a landscape of fixed places through which they journey—a cosmic map—villages imagine the world concentrically with the village as the central place of human life and culture, surrounded by untamed nature, which in Africa is given the evocative name of the "bush." The village and the "bush" create a sharp spatial and conceptual dichotomy in tribal thought. Supernatural spirits often live somewhere in the realm of nature and only come to visit the village. Hunters and gatherers modify nature, whereas villagers create an alternative to it. The village already has within it some of the traits of the city. The process of agriculture marks a similarly radically different relationship to nature than hunting and gathering. It indicates and even celebrates control. Village societies have much more effective means with which to control both human and natural forces. Things are crucial in this process of control that is both technological and ideological.

In comparison to the meager amount hunters and gatherers have, villages have things in great abundance, as any ethnographic museum collection indicates: extensive tools and household utensils, and ritual paraphernalia. These things are objects, not just tracings or paintings. One major change that seems to have occurred as hunter-gatherers became agriculturists was a change from the two-dimensional to the three-dimensional—from images as a temporary aid to those as a relatively permanent embodiment. While the two-dimensional images are conceptually fascinating diagrams, three-dimensional things provide powerful sensuous experiences. The village is now full not only of people but of their things, each one of which is potentially symbolic. The quantity and three-dimensional presence of things in a village reminds me of how we live with multiple household machines in a complex symbiotic relationship—toasters, microwaves, washing machines, computers, cameras, Walkmans, and so on. Village cultures are similarly loaded down with masks, ancestor figures, feast dishes, ceremonial house posts, lintels and pillars, divination trays, musical instruments, funerary figures, etc.

A large majority of these objects are carved in wood, which lends itself to a three-dimensional treatment out of the cylindrical form. Even when things are made out of more pliable materials, however, such as bark cloth and basketry, as among the Baining and Sulka of New Guinea, they take on the kind of dramatic three-dimensional forms characteristic of wood carvings.[1] Wood carvings are usually sculpted with the edge of an adze, which naturally blocks out geometric forms that subsequently can be made as smooth and detailed as desired. The style of most village rendering is in what Robert Farris Thompson calls "mimesis at midpoint," neither completely naturalistic nor completely abstract.[2] There is always a sense of form dramatically blocked out without fussy detail; even when detail is present, it is handled in a dramatic manner. Aestheticism is present but does not dominate, as in the representation of chiefdoms.

Wood, as a medium, is highly significant. It is relatively permanent, lasting even in tropical areas as long as most human lifetimes. If well cared for, it can endure for much longer. In terms of history, however, wood is perishable. Nothing remains of the splendor of village things archaeologically except for some tools and things in ceramic. All that remains is what has been collected primarily in the late nineteenth and early twentieth centuries and now fills our ethnographic museums. These are probably fairly representative of the types of village things, but cannot indicate either their history or variety.

Village styles are often considered to be conservative, remaining static for hundreds or even thousands of years. This I believe to be untrue for several reasons. Since most material such as wood is perishable, old styles do not necessarily survive to serve as models for new ones. Moreover, field research makes it abundantly clear that even when existing forms are imitated, the imitation is very loose. The astonishing conclusion is that villages live with largely contemporary objects, allowing them great freedom to innovate from generation to generation.[3] Furthermore, cults and their things are bought, sold, and abandoned with great frequency, indicating a state of flux and variability in cultural life rather than stasis. What we have in our museums as "primitive art" is an accidental collection at a particular time, as if we had a slice of the Renaissance after 1520, including the later Michelangelo but not Raphael. Wonderful—but not everything.

Village things have often been compared to the Neolithic stage of development, especially by European scholars. There is a general opinion that there was a falling off of "art" from the Paleolithic "realism" to Neolithic "stylization." What I am suggesting is that there is not just a change in style but a complete change in medium, technique, and way of life. You cannot derive village things from the things of hunter-gatherers simply on the basis of stylistic change. Three-dimensionality as a value suggests that things are accorded the same reality as persons and the objects in the natural world. They are not images of something more real than they are but an alternate reality created by humans. They have a separate exis-

tence and are the foci of action and interaction. One can also think of them as being symbolic exchanges between humans in their various endeavors. In that sense they are Binford's "idiotechnic" and "sociotechnic" tools. Three-dimensionality suggests embodiment—some being or concept accorded corporeal reality and a relative degree of permanence.

THE MASK

Most hunter-gatherers do not have masks and masquerades, or if they do the masks are two-dimensional in a material such as bark cloth or skin. Initiation rituals, in which masks often perform, are characteristic of the various societies that run the much larger complex of village life. All tribal villages do not have masks, but enough of them do to suggest a very close conceptual correlation between the mask form and village society. The general idea of the masquerade is that various spirits—nature spirits, ancestors, or a combination—are invited to the village from their natural abode and appear in masked members of the society. The significant point is that the masked spirits are multiple, like the elders who rule the village de facto. They express supernatural sanctions that no mortal person has the power to express. They are an arm of government, as well as of religion and entertainment. The mask is a mask—it is necessary to cover one reality with another one. One of the major things initiates learn is that the masks are actually worn by humans which they are not to reveal to non-initiates—that is, women and children. Presumably, the women generally know.

Hunter-gatherers seem to go to certain natural places to encounter the supernatural—villagers bring them into the village via the masks. In most instances, it is believed that the wearer of the mask becomes the spirit that is being impersonated—some violent "spirits" have to be physically restrained by retainers from harming the audience. Z. S. Strother has pointed out that an impersonation is not just the mask but the whole costume, dance, music, and songs.[4] Nevertheless, the mask has a privileged place in that it covers the face of the wearer—and is the principal creation of another identity. As Herbert Cole puts it:

This *is* and *is not* a human being. So transformed, the being is saying: "I am not myself." Ambivalence and ambiguity exist in the presence of maskers who are often behaviourally ambiguous, for example, being both playful and serious.[5]

The mask (in its performative totality) is the quintessential thing used to mediate between people and spirits.

Masks may represent human, animal, composite, and non-natural forms. Human masks, especially those that represent women, are often smooth and neatly carved, often naturalistic, and appear to embody social values such as self-control. Animalistic and abstract masks are usually more "cubistic" and tend to represent wilder, cosmic, irrational, masculine forces. Groups may have series of masks ranging through several types. The dichotomy of the two is illustrated especially by the so-called Beauty and the Beast masks of the Ibo, from Nigeria, in which the smooth and feminine is contrasted to the angular animalistic.[6]

It is clear in village style that forms have generic meanings in terms of power and the sacred. There is an inverse relationship between power and naturalism. Power is rendered in bulging projecting forms and predatory animal references (snouts, teeth, horns, etc.). Ultimate power actually resides beyond the object, so to speak. The most sacred and powerful Bamana mask, the Komo, is made up of natural substances—earth, sacrificial blood, etc.—over a mask framework.[7] In a number of cultures, the most important holy things are not human-made but natural things such as rocks (the Kaaba of Mecca, the

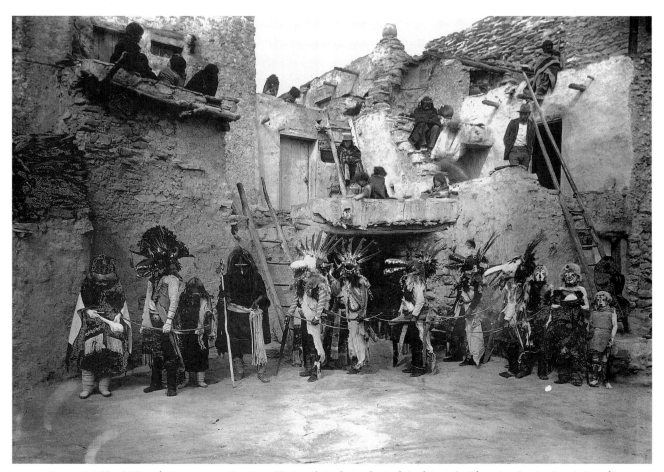

Figure 6.2 Hopi Natacka ceremony. Courtesy National Anthropological Archives, Smithsonian Institution (1824-d).

Rock of Jerusalem). There seems to be an understanding that human-made things can express the supernatural only to a point, and ultimate power or meaning is found largely in natural objects. There is this imaginary stylistic series from beautiful people to beautiful things, to grotesque things, to some special features of nature. Masks exploit the language of this imaginary series to tell specific stories. The smooth and beautiful is both gender and status related and refers more to the social world. The rough or grotesque is also gender related but refers more to the sacred world. On the Northwest Coast of the United States, shamanic things were generally rougher and cruder than things associated with family and status.[8] As I have written before, although its subjects are often religious, art is, more correctly, a handmaiden of society.[9]

A masquerade is usually more than one mask, and each mask plays off the others formally, even without the specificity of their personae. One of our meanings of the word "masquerade" emphasizes nontruth, or the hiding of the truth. Masks hide and reveal; on the simplest level they conceal the impersonator and reveal the spirit. But as a human-made construction, including the accompanying dance and costume, they both reveal and hide the power relations of the social world. The translation is through the things and the image depicted. Masquerades are distancers in a village in which everyone knows one another. The rigid masks bring strange faces and "strangers" and destroy normal relations of intimacy. At the same time, masquerades create a carnivalesque atmosphere with the openness of festival time. No stationary image has the power of a wildly dancing, stone-faced masquerader.

IDENTITY

Villages do not exist in isolation; they are usually near other villages whose inhabitants speak the same

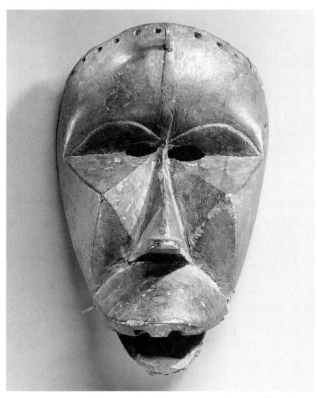

Figure 6.3 Oval face mask, African, Ivory Coast. All Rights Reserved, © Metropolitan Museum of Art. Gift of Mr. and Mrs. Bernard Leyden, 1983 (1983.558).

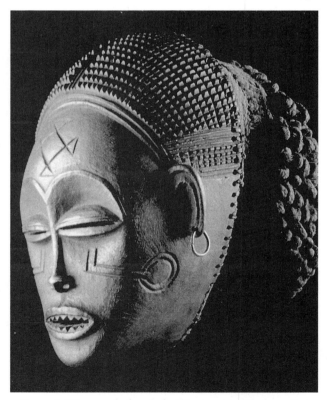

Figure 6.4 Pwo mask, female fertility ancestor. Chokwe, East Angola, and Democratic Republic of Congo, Bandundu, West Kasai, and Shaba wood, pigment, fiber, metal. Private collection.

language or belong to the same ethnic group, or else they border villages of differing ethnic and linguistic backgrounds. Since no rules or governing agent had unified power over villages in the past, most were in various hostile or feuding relationships with some of their neighbors.[10] In some areas, such as New Guinea, feuding focused on the taking of heads, which was a major cultural preoccupation and necessitated making many carved things. Hostility, rivalries, and ancient enemies were common in village contexts, defining their identity in terms of similarities to and differences from their neighbors.

One of the striking aspects of village things is that their style is remarkably distinctive by locality, which has led to many classificatory studies in the early days of fieldwork. Body type, eye shape, and surface design are as standardized and as distinctive as the logos of designer sportswear or as the markings of birds and fish. This is quite in contrast to the more vague and amorphous styles of hunter-gatherers. These distinctive styles appear to function as visual symbols of group identity in a relatively hostile environment. They represent the group to itself and distinguish it from others. The development of a particular style is the result, not of isolation, but of the interaction of groups who are using visual cues to indicate who they are. In isolation people do not develop highly inflected styles.[11]

In villages, things take center stage. They are used in transacting, distorting, and explaining power relations; as embodiments of identity; and as repositories of memory.[12] They function this way within a more recent context not preoccupied by ancient history. Many cultures function successfully in the present despite acculturation and having ceased making their brand-name objects. Other things often taken from modern culture, like cigar boxes and plastic laundry baskets, have been found interesting and useful by village cultures. This suggests that context determines the use of things, but that quite variable looking things can fulfill the same role. Villages are quite ready to discard the old and take on the new.[13] Much as we deplore our own acculturative role in ending

traditional village life, villagers are interested in the outside world and in change.

Village life has been either idealized as harmonious community life or damned as excessively rule-oriented, outlawing the freedom of the individual, as in marriage and kinship rules. Things called primitive art by the West were first vilified as inadequate naturalistic representations and later extolled as beautiful abstractions. Much of twentieth-century Western art has been inspired by the things of villages and has often felt inadequate in relation to village art. This inadequacy seems to result from the unself-consciousness and authoritative appearance of village things, next to which modern art often looks tentative and hesitating.[14] This is usually nostalgically attributed to the sense of community and anonymity of the artist in the village. As a number of fieldworkers have shown, artists are quite well known to their society, and only anonymous at great historical distances or because early collectors failed to ask about them.[15] Given the usual jealousies also typical of small towns and the common practice of witchcraft, no village was as harmonious a community as the idealists would have it.

What, then, accounts for the "authority" manifested in the things so envied in the West? There is no doubt in my mind that this stems from the fact that in villages things were the major medium of communication and central to the functioning of the village. The masquerade was not tangential but a crucial and necessary part of village life. The objects appear to have authority because in fact they did. Like only children, these figures exude the social centrality their makers believed they had. A mask that actually pronounces judgments in legal cases or enhances the power of a certain person is very different in its intention from a modern carving intended as "art" for the market. This weighty sense of importance is carved into every self-assured bulge and projection of village works. These things not only "work," they work at the very core of their culture. It is in village cultures that things were placed at the center and their potential for a technology of communication was explored.

NOTES

1. George Corbin, *Native Arts of North America, Africa, and the South Pacific* (New York: Harper and Row, 1988), 232–244. Douglas Fraser had noted that simple villages, closer to hunting and gathering life, had more two-dimensional types of masks for initiation ceremonies. Such conical masks were found in Melanesia and South America, and he also related them conceptually to the flat skin masks of the Inuit. Douglas Fraser, *Primitive Art* (New York: Doubleday, 1962), 126–127, fig. 62. Also Fraser, class lectures at Columbia University, 1967.

2. Thompson describes the Yoruba, whose aesthetic ideal is "'mimesis at midpoint'—i.e., the location of art at a point somewhere between absolute abstraction and absolute likeness." Robert Farris Thompson, "Aesthetics in Traditional Africa," in *Art and Aesthetics in Primitive Societies*, ed. Carol F. Jopling (New York: E. P. Dutton, 1971), 376.

3. Strother chronicles in great detail the invention of Pende masquerades in Africa. Z. S. Strother, *Inventing Masks: Agency and History in the Art of the Central Pende* (Chicago: University of Chicago Press, 1998).

4. Strother, *Inventing Masks.*

5. Herbert M. Cole, *I Am Not Myself: The Art of African Masquerade* Monograph 26 (Los Angeles: Museum of Cultural History, UCLA, 1985), 16.

6. Suzanne Blier, "Beauty and the Beast," in *African Art as Philosophy*, ed. Douglas Fraser (New York: Interbook, 1974), 107–113.

7. Sarah Brett-Smith, "The Masks of the Komo," *Res* 31 (1997): 71–96. "The fear surrounding the *Komo* stems . . . from the society's precolonial role as the highest known judicial authority within a village . . ." P. 72.

8. Esther Pasztory, "Shamanism and North American Indian Art," in *Native North American Art History: Selected Readings*, ed. Aldona Jonaitis and Zena Pearlstone Mathews (Palo Alto, Stanford University Press, 1982), 7–30.

9. Esther Pasztory, "Pre-Columbian Aesthetics," in *Encyclopedia of Aesthetics*, ed. Michael Kelly, vol. 4 (New York: Oxford University Press, 1998), 80.

10. "In its broadest terms the contrast between tribe and civilization is between War and Peace. A civilization is a society specially constituted to maintain 'law and order.' Lacking these institutional means and guarantees, tribesmen live in a condition of War . . . In *fact,* tribesmen live in kin groupings and communities within which feuding is usually suppressed and they have the benefit too of economic, ritual and social institutions conducive to good order . . . Primitive anarchy is not in the appearance of things, it is the unconscious of the system." Marshall D. Sahlins, *Tribesmen* (Englewood Cliffs, NJ: Prentice-Hall,
1968), 5–7. Because of colonialism, the very influence of anthropological study, and the modern world, war is not a subject that can be easily assessed, nor can it be evaluated without ideological biases.

11. Esther Pasztory, "Identity and Difference: The Uses and Meanings of Ethnic Styles," in *Cultural Differentiation and Cultural Identity in the Visual Arts,* ed. S. J. Barnes and Walter S. Melion, Studies in the History of Art 27 (Washington, DC: Center for Advanced Study in the Visual Arts, National Gallery of Art, 1989), 15–38.

12. "Africans tell, sing, produce (through dance, recitation, marionette puppets), sculpt and paint their history. Just like other peoples, they have always sought to master their past . . ." Bogumil Jewsiewicki and V. Y. Mudimbe, as quoted in Mary Nooter Roberts and Allen F. Roberts, *Memory: Luba Art and the Making of History* (New York: Museum for African Art, 1996), 18.

13. Giancarlo Scoditti is quoted about the Kitawa islanders of Melanesia now: "They are attracted to plastic—which I despise—in an almost morbid fashion, because it is strong and lasts." Alexander Stille, "The Man Who Remembers: Profile of Giancarlo Scoditti," *New Yorker* (February 15, 1999), 50–63. This comment proves Scoditti a romantic and the Kitawans sensible.

14. This was the general opinion of critics at William Rubin's show, "'Primitivism' in 20th Century Art," at the Museum of Modern Art in 1984. Hal Foster describes how the primitive pieces, more "immediate" and "magical" (and therefore with greater aura), were claimed as sources of renewal by modern artists "rendered somewhat marginal or academic by mass culture." Hal Foster, "The 'Primitive Unconscious' of Modern Art, or White Skin Black Masks," in *Recodings* (Port Townsend, WA: Bay Press, 1985), 193.

15. Originally, primitive and non-Western arts were believed to be the collective creations of a "folk," not of individual artists. Starting in the 1920s and from the 1960s increasingly to the present, fieldworkers and other scholars have been working hard to recover the individual artist both historically and archaeologically. The study of the artist now forms a major branch in the non-Western art fields. A sampling of titles follows. Recently, the Metropolitan Museum presented an exhibition of the work of individual African artists called "Master Hand," organized by Alisa LaGamma. Other studies include: Hans Himmelheber, *Negerkunstler* (Stuttgart: Strecker and Schroder, 1935); Robert Farris Thompson, "Abatan: A Master Potter of the Egbado Yoruba," in *Tradition and Creativity in African Art*, ed. Daniel P. Biebuyck (Berkeley: University of California Press, 1969), 120–182; Raymond

Firth, "The Maori Carver," *Journal of the Polynesian Society* (Wellington, New Zealand), 1925; Adrian Alexander Gerbrands, *Wow-Ipits: Eight Asmat Carvers of New Guinea* (The Hague: Mouton, 1967); Giancarlo M. G. Scoditti, *Kitawa* (Berlin: Mouton, 1990); Ruth Bunzel, *The Pueblo Potter* (New York: Columbia University Press, 1929); Marvin Cohodas, *Basket Weavers for the California Curio Trade: Elizabeth and Louise Hickox* (Tucson: Arizona University Press, 1997); and Marvin Cohodas, "Transformations: Relationships between Image and Text in the Ceramic Paintings of the Metropolitan Master," in *Word and Image in Maya Culture,* ed. William F. Hanks and Don S. Rice (Salt Lake City: University of Utah Press, 1989), 198–232.

ENHANCEMENT

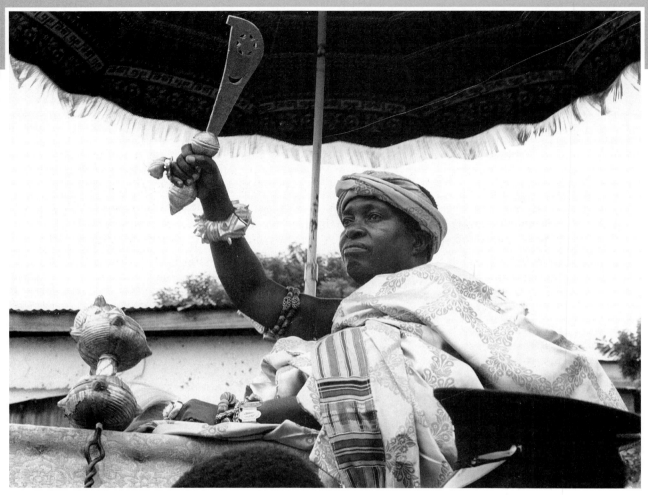

Figure 7.1 Akan (Fante) chief riding in a palanquin, Cape Coast, Ghana, 1972. Photograph: Herbert M. Cole.

STATUS

A chiefdom may be very large or the same size as a village. Its objects, however, differ in kind and in form. If the quintessential activity of villages is the masquerade, the chiefdom equivalent is the *tableau vivant* of the chief sitting in state with his insignia, surrounded by titled individuals with theirs. Masquerades that represent dispersed authority are either not found in chiefdoms or are linked in some fashion to the chief. The forces of both practical and ceremonial life lie in a specific person who contains sacred elements evident already in his genealogy, which give him the right to his position. There is no need to hide the face of the chief and usually he has no mask. What chiefs have instead are enhancers of their persona. Stools and thrones elevate the chief literally, while swords, staffs, and other objects extend his reach figuratively. Sumptuous costume—dress, headdress, and jewelry—makes him a repository of wealth. An elaborate residence may distinguish him architecturally, and his burial may be marked by a structure containing goods and offerings and including precious objects.

It is quite clear that there can be no simple and easy evolution of forms between villages and chiefdoms—masks and ancestor figures do not become stools, staffs, and house posts gradually. An entirely different category of things is needed in chiefdoms than those found in villages, just as villages have different types of things than hunter-gatherers. The difference is in the type of object, the preferred material, and the style of representation. Since in a chiefdom there are many titled individuals ranked higher or lower in relation to the chief, a series of subtle differences in object, material, form, and iconography indicate the differences in status. The aim of things is to make status visible.

GLITTER

High status is often indicated by rare and costly materials acquired by trade, sometimes from long distances. These include things like gold, silver, copper, greenstone, jade, ivory, coral, amber, bear's teeth, mica, etc. A basic significance of rare and imported materials is that very few have access to them and there may be rules as to who may own what. Although their rarity may be significant in itself, it is also striking that all of these materials are hard and shiny and it is their glitter that seems to give them their meaning as signifiers of status. Barthes describes his Citroen as smooth and shiny and sees that as a marker of status for the despised lower-middle class. (Barthes, of course, has a modernist aesthetic with an inversion of these values.) European explorers exploited glitter's inherent significance of value in giving glass beads to natives all over the world. Natives were generally delighted with what to them were rare, exotic, hard, shiny, and precious objects. The trick was that they had no way of knowing that these were common and cheap. We are still attached to glitter, from the precious stones in royal tiaras to sequined dresses worn in festive (i.e., expensive) contexts.

Precious metals and hard stones are nonperishable compared to wood. They can be passed on from generation to generation as heirlooms, and fortunately for us, when placed in tombs they last long enough for looters or archaeologists to find them. The archaeological remains of villages are meager, but the remains of chiefdoms are often very rich.

VIRTUOSITY

Some of the things made out of precious materials require special techniques of manufacture, much more complex than the wielding of an adze. Metalwork, in particular, requires learning complex techniques handed down from master to pupil. (Metalwork by itself is not an indicator of chiefdoms—many villages have iron or other metals but are structurally similar to villages using stone tools. The distinctions are not technological but sociological.) Not only do chiefdoms have craftsmen able to make objects in metal, they particularly prize virtuosity—difficult techniques to create elaborate objects. The things of chiefdoms are not necessarily very big, but they are complex and intricate. Virtuosity and intricacy are the equivalent of rare materials in the realm of craft.

A virtuosity particularly prized was the making of textiles, another labor-intensive, complicated craft. The Akan of Ghana unraveled European silk to make cloth such as *kente,* worn by titled individuals. The imported silk (shiny) and the unraveling and reweaving made of it a very high status object. Complex tie-dyeing (*ikat*) in Indonesia and the Andes falls into the category of textiles in which virtuosity of craft is prominently featured.[1] In many areas fancy textiles are a form of wealth like gold.

The value of craft virtuosity also suggests a certain attitude of aestheticism. In ranked societies there is a general preoccupation with how things look and a comparison of status in terms of visual appearance. While things may range from the naturalistic to the stylized, there is a tendency to have a sleek, polished, self-consciously designed look. Elegance is a word that comes to mind. Many tribal village objects such as masks also have this kind of elegant, polished look. However, much of that polish turns out to have

been applied by European collectors and dealers, whose taste is generally closer to that of chiefdoms. The West places high value on the things of chiefdoms in particular and considers them to be "art" without too much difficulty. We also like shiny things.

CHIEFDOMS IN TIME AND SPACE

One of the contributions of Neoevolutionist theory was the definition of a chiefdom. Earlier thinking often lumped it together with tribal villages or the state, and initially simply contrasted the state or "civilization" with the "primitive." The intermediate category of chiefdom has been extensively studied in the field, and archaeologically the interest focuses on how inegalitarian systems emerge out of egalitarian ones. How do people give up equality? Timothy Earle suggests that all cultures have men seeking prominence and power, which under certain circumstances can be buttressed by economic and military control, along with ideological justification, leading to the institutionalization of a chiefdom.[2] Splendor serves both to separate and to elevate the chief from others, as well as to provide a cultural display for the audience, which can have a vicarious sense of participation. Without moralizing it too much, it may be considered a form of seduction. One Hawaiian exhibition demonstrated the apparent ease with which native prestige objects of feather and ivory were exchanged for European court dress, sword, scepter, and ring and portraits in oils.[3] The fascination with royalty and status did not begin with Princess Diana.

Most current analyses of chiefdoms focus on Polynesia, whose chiefdoms are seen as models for the type. Although Polynesia lacked metals, pottery and textiles, splendor was created by featherwork and shells. Besides impressive wood carvings of deities and decorated war canoes, many islands erected stone sculptures, of which the best-known are the Easter Island heads.[4] Again, with limited technology but with the sociological power of the chiefdom, Polynesians harnessed labor for building projects.

Chiefdoms were quite widespread in the world. The nonclassical ancient culture of Europe (Stonehenge, Hallstadt), the island cultures of

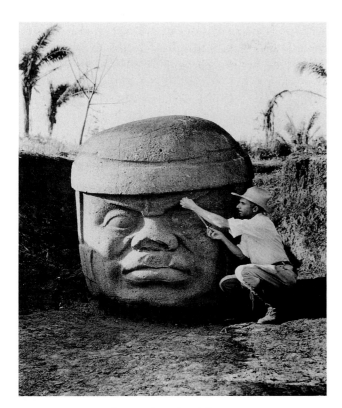

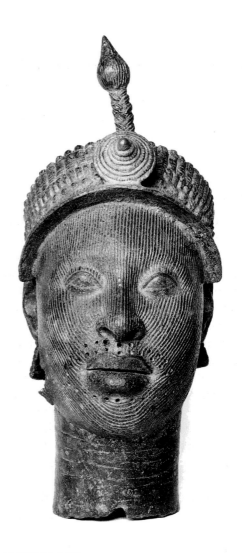

Figure 7.2 *(above)* Olmec head from Tres Zapotes, discovered in 1939 by Matthew Stirling. Courtesy National Geographic Society.

Figure 7.3 *(right)* Brass head from Ife, c. 1200 AD. © Copyright The British Museum.

Indonesia, the kingdoms of Africa (Kuba, Benin, Akan, Yoruba), the cultures of Central America from Honduras to Ecuador and Colombia, and the Moundbuilders of the United States are all usually considered examples. One may include "intermediate" cultures such as the Northwest Coast of America, which seems to be a cross between village and chiefdom in organization. Part of the reason chiefdoms appear so numerous is because we are not relying only on a limited set of nineteenth- and twentieth-century anthropological data—archaeology has revealed many ancient chiefdoms going back several thousand years.[5] In fact, in most areas significant archaeological remains are necessarily those of chiefdoms because elaborate building and nonperishable goods are only found in that context.

THE PORTRAIT

The portrait may be considered the opposite of the mask; the mask is generic, the portrait individual.[6] Ancestor images in village contexts are sometimes individualized by scarification marks or named, but usually they are not carved to resemble a specific person.[7] Portraits are rare, but they do occur in the context of chiefdoms. Both major instances—the Ife of Nigeria and the Olmec of Mexico—are archaeological, and thus precise data and explanation are lacking. While historic portraits may be considered portraits even if they do not look like a person, archaeologically only images with a high degree of verisimilitude are considered portraits. The Ife heads are in brass or clay and some appear to have been attached to something, while the colossal Olmec heads were

probably set up on platforms like the Easter Island heads.[8] All investigators believe that the portraits represent rulers and that somehow portraiture has something to do with rulership in complex chiefdoms. The faces are a combination of an idealized facial type, with details in the features or modeling that vary from one head to the other, suggesting specific individuals within a family. Some heads smile![9] Generally the expressions suggest power or dignity, or both.

It makes perfect sense that the chiefdom should be the context in which portraiture emerges. The chief is a unique individual whose social persona is significant in itself, and who is best commemorated with an individual feature such as his face. Portraiture is subsequently found sporadically in various states and later cultures. Great interest greeted the recent find of a Paleolithic (c. 26,000-year-old) head in mammoth ivory that was billed as the "Oldest Realistic Human Portrait" in the *National Geographic*.[10] My argument is that portraiture and naturalism are always possible should the social circumstances be ripe for them. Although I think the appearance of portraiture is highly significant in chiefdoms, their actual number is very rare. The Easter Island heads are colossal but stylized. Most chiefdoms represent chiefs with smooth and stylized images but not portraits.

The issue of portraiture raises the question of why most cultures at most times have shied away from realism, although it clearly has been within their ability to create had they so desired. David Freedberg noted in talking about European wax figures that most viewers even in the European realistic tradition experience them as uncanny and frightening. "Of course we marvel at the skill of the maker, at mechanical contrivance, and the artistry that makes objects seem real; but at the same time,

fear of the lifelike haunts the warring perceptions of the image as reflection and the image as reality."[11]

Realism obliterates the difference between the person depicted and the person herself or himself. With a realistic image, we feel we are in the presence of the actual person, even if we know intellectually that this is not the case. It is no coincidence that statues of offending rulers or dictators (such as Stalin) are smashed as surrogates for the real person. There would be little satisfaction in doing this if they looked like Calder mobiles. The realistic image therefore works as a way of subliminally attracting the viewer and inviting him or her to experience it as real. Evidently most cultures most of the time prefer images that allow a greater distance between the viewer and the object. But in certain specific instances this rule of distance has been lifted to create images with the kind of immediacy that we read as portraiture. Following Freedberg, I have suggested that such images of naturalism were in their own times perhaps seen as more awesome and frightening in their realistic seduction than "beautiful," as we tend to imagine them.[12]

Stylization is reassuringly crafted, while realism blurs the distinction between the real and the crafted. The portrait seems to live, perhaps even from beyond the grave. Thus, very special circumstances seem to have existed at certain times and places that decided rulers to demand portraiture of their carvers and brasscasters. The craftsmen seem to have been able to comply with such a commission, adapting their own technology and craft techniques to the new requests. Like most objects of cultures communicating important social and religious values through things, portraits are as much about power as are crowns and thrones. The question about realism is not how but why.

NOTES

1. Textiles have been generally undervalued in the West until recently. For the Akan and Indonesian traditions see the following: Mattiebelle Gittinger, *Splendid Symbols: Textiles and Tradition in Indonesia* (Washington, DC: Textile Museum, 1979). Excellent field photos; note especially plate 12. Peggy Stolz Gilfoy,

Patterns of Life: West African Strip-Weaving Traditions (Washington, DC: National Museum of African Art, 1987). The invention of weaving is attributed to royalty in legends.

2. Timothy Earle, *How Chiefs Came to Power* (Palo Alto: Stanford University Press, 1997).

3. Adrienne Kaeppler, *Hawai'i: The Royal Isles* (Honolulu: Bishop Museum Press, 1980).

4. J. Halley Cox, *Hawaiian Sculpture* (Honolulu: University Press of Hawaii, 1974). Steven Roger Fischer, ed., *Easter Island Studies,* Oxbow Monograph 32 (Oxford: Oxbow Books, 1993).

5. Among many studies note these: William N. Morgan, *Prehistoric Architecture in the Eastern United States* (Cambridge, MA: MIT Press, 1980). Frederick W. Lange, ed., *Wealth and Hierarchy in the Intermediate Area* (Washington, DC: Dumbarton Oaks, 1992). (See especially the paper by Mary W. Helms.)

6. "Individual" portraits may of course be "generic" in spirit, as portraits of Alexander or Napoleon were. The political aspect of portraiture is indicated by its frequent presence on coins. Richard Brilliant chronicles the varied ways in which portraits were intended to be recognized as such and the ways in which we read them. Richard Brilliant, *Portraiture* (Cambridge: Harvard University Press, 1991).

7. Jean Borgatti has analyzed the various ways in which an image that may or may not look like the sitter can be marked as a portrait. Jean M. Borgatti and Richard Brilliant, *Likeness and Beyond: Portraits from Africa and the World* (New York: Center for African Art, 1990).

8. Frank Willett, *Ife in the History of West African Sculpture* (New York: Thames and Hudson, 1967). Henry John Drewal, "Ife: Origins of Art and Civilization," in *Yoruba: Nine Centuries of African Art and Thought,* ed. Allen Wardwell (New York: Center for African Art and H. N. Abrams, 1989), 45–76. Beatriz de la Fuente, "Olmec Sculpture: The First Mesoamerican Art," in *Olmec Art and Archaeology in Mesoamerica,* ed. John E. Clark and Mary E. Pye (Washington, DC: National Gallery of Art; New Haven: Yale University Press, 2000), 253–264.

9. There is one smiling Olmec colossal head and one smiling Moche portrait vessel from the Andes. This is very rare. ". . . few portraits at any time, even so-called realistic portraits, ever show anyone smiling or talking or moving . . . Most portraits exhibit a formal stillness . . ." Brilliant, *Portraiture,* 10.

10. Alexander Marschak, "An Ice Age Ancestor, *National Geographic* 174, no. 4 (1988): 478–481.

11. David Freedberg, *The Power of Images: Studies in the History and Theory of Response* (Chicago: University of Chicago, 1989), 221.

12. Esther Pasztory, "The Portrait and the Mask: Invention and Translation," in *Olmec Art and Archaeology in Mesoamerica,* ed. John E. Clark and Mary E. Pye (Washington, DC: National Gallery of Art, 2000), 265–276.

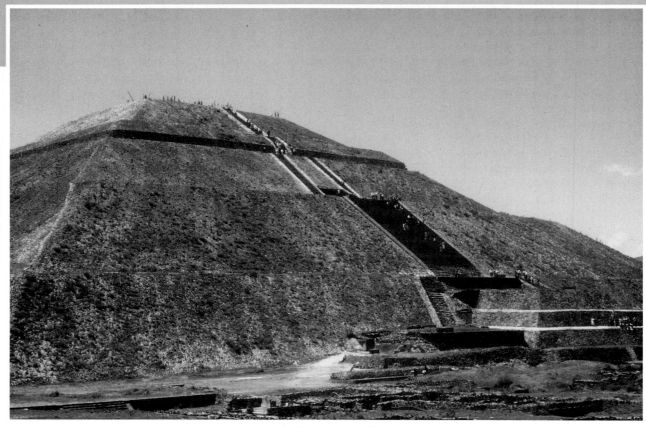

Figure 8.1 Pyramid of the Sun, Teotihuacán. Photograph: Esther Pasztory.

GIGANTISM

The apotheosis of things as means of communication is in the archaic state. Although states are defined sociologically, they are almost always thought of in terms of monuments: states built in order to use labor service (corvée labor) and they instituted labor service in order to build. For this purpose it is not necessary to separate the practical from the ceremonial—the 3,000-mile Inca road system was as much a symbol of the state as a practical measure. States build on a scale unimaginable to chiefdoms because of their control of the population. Whether it is irrigation systems or pyramids, their scale and extent is always also an advertisement of the power of the state.

Our admiration for this is mixed. Georges Bataille, for example, compares all monumental architecture to prisons and suggests that they all represent totalitarian force.

> . . . Church and State in the form of cathedrals and palaces speak to the multitudes, or silence them. It is obvious that monuments inspire social and good behaviour in societies and real fear. The storming of the Bastille is symbolic of this state of affairs: it is hard to explain this mass movement other than through the people's animosity (animus) against the monuments that are its real masters.[1]

This is also the popular imagination: slaves are whipped to carry those gigantic blocks of stone in myriad cartoons and Hollywood movies. In the Steven Spielberg animated film *The Prince of Egypt* (1998), the cruelty of the Egyptians is manifested in whipping the Hebrews, specifically to build their temples.

The fact is, we know of the six basic archaic states (Egypt, Mesopotamia, India, China, Mesoamerica, Andes) largely through archaeology and thus do not have adequate sources to know how labor was actually used. Moreover, four of the six cultures were described or referred to by European cultures with religions inimical to pagan religions, polytheistic gods, and sacrifices to which the monuments were usually related. In addition, these religions still exist and are a major part of the education and ideology of current public opinion. It is therefore impossible to consider the monuments of the archaic state without noting an element of hostility or at least ambivalence in much of the literature.

One recently found factual detail from Egypt suggests a less violent situation. It has been suggested that workers were divided into gangs and worked in cooperation and competition, writing their results on the walls of barracks housing them. Kurt Mendelssohn suggested as early as 1971 that they worked during the dry season, when no agricultural labor was needed.[2] It would have been prudent of any state to use its labor efficiently and to reward rather than to punish. Some building projects may have been ideologically attractive and the source of some enthusiasm. Some clearly were not: the Aztecs had one causeway built as tribute by the people of a conquered city.[3]

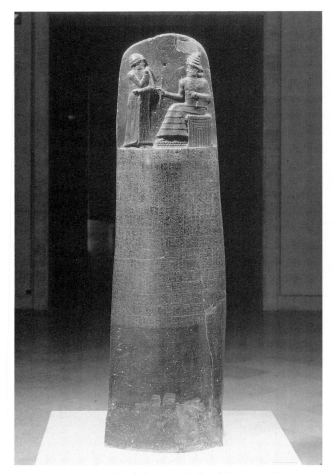 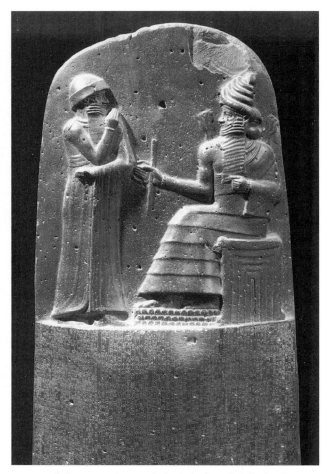

Figure 8.2 Stela of the Law Code of Hammurabi, c. 1792–1750 BC: a (left), view of entire stela; b (right), detail of top. Photographs: Herve Lewandowski. Louvre, Paris, France. Copyright Réunion des Musées Nationaux, Art Resource, NY.

Whether their builders were whipped, rewarded, or both, gigantic monuments are symbols of centralized power by their very size, regardless of their actual form. The archaic state was the first to build on the scale of nature with its mountains and rivers. This rivalry with nature that the state proposes with its alternative reality of solid stone geometry is a far cry from the hunter-gatherers' veneration of rocks and caves, modified slightly on the surface by paintings and engraving. States build their own mountains, caves, and rocks.

ANTHROPOMORPHIC PRESENCE

A city is in many ways but a village writ large. Instead of things in wood, the preferred material for objects is stone, although bronze, glass, ceramics, and other nonperishable materials may also occur. There is a bewildering quantity and variety of things made for many different uses. As states are often divided into classes, different types of things in different materials and styles may be made for different social groups. Among the Aztecs I could distinguish several types of images based on social context: the iconographically complex and often colossal stone images of the ruling elite, the simpler stone images ranging from elite style to a rough provincial style, and the small clay figurines found mainly in rural hamlets. The differences included iconography; each type of work had different deities and, in contrast to the horrific imagery of the elite, the imagery of the lower segment of society focused on benevolent themes such as fertility. States

are socially complex and their things are not necessarily in a single style or iconography.

Egyptian, Mesoamerican, and Near Eastern sites of ancient cities are remarkable, not only for their architecture, but for the great quantity of sculpture (sometimes painting) that adorned the walls or punctuated city space. These figures "populate" the ancient cities for us twenty-first century tourists wandering through archaeological sites or museum collections. We imagine what people wore, what they did, even what they thought on the basis of these figures. I have seen "reconstructed" dances and dramas from both Mexico and Egypt based entirely on the poses and gestures on the monuments.

The actual subjects of these images usually deal with power; rulers, gods, and conquests are common. In the context of a large state, the ruler may often have been less visible to his subjects than in a chiefdom, sometimes even purposefully invisible and mysterious. The monuments took the place of ceremonials people may never have seen. The monuments were also intended to be public documents of official acts and history. Many states also had a large enough elite group so that some monuments communicated exclusively with them and not with the "people" at all. A number of states had writing systems, and written texts add specificity and truth-value to images. They may or may not have been understood by the population or even by the elite, but that does not hinder their value as "documentation" within their own cultures.

The images of states are striking for their impersonality, noted best by Davis in discussing the standardized canon in Egypt.[4] Although somewhat naturalistic, there usually isn't an emphasis on portraiture or spontaneity. Official distance characterizes everything. The portraits in a chiefdom context indicate an intimacy usually lacking in the art of states. The well-known story of Akhenaten's change of style toward greater naturalism and personal idiosyncrasy illustrates several issues. First of all, it indicates that a single powerful person *can* change a style by a mandate, which *can* then be carried out by the artist with no difficulty. Akhenaten's story is the model that might explain the sudden appearance of monuments like the Olmec and Ife heads. The second issue indicated

by the Akhenaten story is that his innovations were not felt to be appropriate to the context of royal depiction by his court, and the old style was subsequently restored. We make a hero of Akhenaten and his rebellious individualism, but in a way he was ignorant of the constraints of the times under which he lived.

For me one of the quintessential state monuments is the Stela of Hammurabi. The laws written on the lower part indicate a characteristic state interest in impersonal codification of rules, rather than a personality cult.[5] On the top, Hammurabi is represented in profile presenting his laws to the sun god, Shamash. The pairing of ruler and god is common in state representations and indicates the god's protectiveness of his or her people and the ruler's performance of the rites proper to the god. The clear figural demonstration of these relationships is the purpose of state monuments. They foreshadow the greater separation of church and state in the textual era.

ABSENCE OF THE ANTHROPOMORPHIC

Not every state filled its architecture with "stone inhabitants." No figure mars the miles of splendidly built Inca masonry in the Andes. The major remains from two ancient Chinese cultures, Shang and Chou, are bronze vessels with the images of real or supernatural animals on them. Most extreme of all are the Harappan cities such as Mohenjo Daro with only a few small, stylistically and materially varied figures and without an "image system" at all. Because Western insistence is figurative and prefers naturalism, these cultures have played less of a role in its imagination of the ancient state. The norm for us is Egypt, Mesopotamia, and Mesoamerica. We simply cannot imagine these cultures as well as the ones making human figures. A lesser emphasis on humans and anthropomorphic image-making is found generally in the Andes, culminating in the Inca. (For example, in the movie *Raiders of the Lost Ark*, the opening setting is in South America, but because "idols" are not common there, the filmmakers used an Aztec image from Mesoamerica as their idol. We must have idols in a pagan state.) A similar situation exists in China and Japan, where even when images do appear

on paintings, the privileged subject is not the human figure but the landscape. Abstraction and conceptual thought are more characteristic of cultures like the Andes and China, and we are simply less used to such cultures.[6] A major difference is to be found in India, where later Buddhist and Hindu cultures had a rich anthropomorphic tradition of representation, partly related to Hellenistic Greek art. Precisely because of the lack of human imagery, Mohenjo Daro culture is the most enigmatic to us of all the archaic states. Nowhere in the archaic state is it suggested that there is a ban on things and images, as in the textual era. The archaic state works through and with objects. Emphasizing the human or not is a matter of insistence, that is, cultural preference.

MATERIALITY

A great quantity of things of various types characterizes the archaic state. Judging from the materials used, permanence was a significant value, thus making them archaeological Edens. Perhaps the most extreme example is Egypt, whose abundant things fill many museums around the world and continue to be unearthed. People in the archaic state seem to have had great faith in objects. As in some chiefdoms, great quantities were buried with the dead. While we do not know the precise meaning in every area, generally speaking the burial of objects suggests the survival of some aspect of the dead, who can partake of the food and drink offered and enjoy the company of soldiers, retainers, and women buried with them. The concept is literal and material. Again, the most extreme example is Egypt, where the very survival of the soul depended on the survival of a material representation. There can be no higher valuation of things. In the archaic state, things create not just permanence but may confer immortality. And, as we have excavated them and enshrined them in museums, this immortality is quite literally the case. Tutankhamen, Pacal, Assurbanipal, and Shang Ti live for us through their monuments and burials. The museum is a great cemetery in which the past comes alive.

Writings existed in five of the six major areas (all except the Andes), although without an indication of widespread literacy (except, perhaps, in the Near East) and without the all-important sacred texts characteristic of the textual era. Writing appears to have been treated as a label that pinned down meaning. It adds to the power of images, but there is no conflict between them. Both are part of a very literal material attitude. Things rule; writing is an accessory.

Materiality is particularly evident in the practice of human sacrifice, which was a custom mainly in chiefdoms and states. (Villages are more likely to have had feuding, head hunting, and scalping customs.) Human sacrifice is related to the use of things in the presence of literal thinking. The victims buried with the ruler at Chan Chan, Peru, or Shang, China, were probably imagined as literally transferred to the other world. The victims whose hearts were offered to the sun by the Aztecs gave their energy to keep the cosmos alive. In many parts of the world, it was believed buildings would collapse if there were no sacrifice in the foundation. In every case only death could release the human energy for the tasks determined by the ruling elite. Such energy transferal could not be effected symbolically (by markings on a piece of paper, for example); it required literal immolation. Most sacrificial deaths occurred in theatrical settings as parts of public spectacles, including funerals. Sacrifices were common usually in societies larger than those of kin-based groups and perhaps functioned in the creation of community cohesion in ways difficult to understand today.

Like sacrificial victims whose soul energy could be tapped for the public good, things had a kind of soul energy (*mana*) in them that gave them power and allowed them to perform their tasks. This is as true of village masks as of the stone sculptures of deities. The textual cultures that called such images "idols" and claimed that people worshipped stones or gold (the golden calf) were right in focusing on the high valuation of materiality, but were wrong in not seeing that these images had indwelling spirits and it was the spirits that mattered.[7] Few of the many things in human or animal form were actually worshipped; generally they were aids, ritual accessories, or "stage sets" used to deal with spirit powers rather than "worshipped" as deities themselves. This is indicated by the willingness of people to replace sacred images

with new ones. It is we, in fact, with our museological insistence on authenticity, who worship the "relics" of the past even in fragmentary form.

POWER

There is a widespread concept in the West going back to classical times that art is an "imitation of nature"—mimesis, by which naturalism in style is often implied. Although they are not usually naturalistic in the European sense, the things of villages, chiefdoms, and states may be considered mimetic. They are not so much a literal imitation as the creation of a new and artificial nature based on natural form;[8] artificial people, animals, and landscapes are created in progressively larger scale and more and more permanent media. Things—whether stools, thrones, masks, or colossal gods—are classifications of the social world, the way plants and animals could be seen as classifications of the natural world. The entire corpus of things in a given culture is a symbolic totality, and individual things in it are comprehensible only in relation to the whole. One has to understand all things of Teotihuacán, Mexico, in order to understand why Thin Orange ceramic was its favorite pottery and Thin Orange ceramic in the context of other things expresses the nature of Teotihuacán aesthetics beyond just itself. In cultures in which things dominate and have a privileged place in communication, meaning is established in the entire web of things and is not restricted to a particular object or even class of objects. This is true even for us. Impressionist painting, for example, is meaningful not only in terms of academic painting, photography, kitsch and souvenirs, residence furnishings, salons and museums, and so on, in its own time, but especially of all "things" in our time. Its meaning is context-based and not inherent in the paint on canvas. The entire context of things functions as a kind of code which prefigures and includes other codes such as writing, in and of itself often derived from things and images.[9] But the code of things functions more subliminally than writing. We may not know consciously that we are comparing and contrasting and how much. Watch a silent movie and see how differently your mind works in comparison to a movie with speech. You look for meaning all over the field and cannot keep conscious track of your interpretations. I am therefore against the use of the metaphor of the book or language for things which work in a different way.

Many of the things of villages, chiefdoms, and states embody, represent, and classify forms of power—both supernatural and human. The language of power that is coded in things is decoded formally: smooth or rough surfaces, naturalism or abstraction, frontality versus side view, overlapping versus visibility, and so on, and a myriad of details that make sense in relation to other things. Because Western aesthetics has been so obsessed by naturalism and beauty, this focus on the subliminal expressions of power has not been adequately addressed.[10] Power may be represented by beauty but very often is not. A preoccupation with power also explains why such archaic figures are predominantly shown immobile and the representation of movement is the exception rather than the rule. Immobility captures best the notions of strength, rootedness, even eternal existence.

That things express cognitive codes is especially evident when cultures imitate the styles and objects of other cultures, and by juxtaposing styles comment both on the exotic other and themselves. Such juxtapositions are known from many parts of the world. Contemporary cultures make such "juxtapositions" especially in Western and non-Western objects, or in "high" art and popular art.

There is no stylistic evolution in a particular direction overall from hunters and gatherers to states. (There may be, however, evolution in an individual culture, such as Assyrian or Maya.) As will be discussed later, significant evolution is especially relevant when there is a change in the level of social integration. Western authors often complain about the lack of "development" in pre-Columbian or African traditions, and to some extent they are right in their observation. With the exception of small-scale developments, there are few artistic cycles. Paradoxically, this is due more to the willingness to change than to the imagined stasis. There may be such dramatic changes between dynasties and periods due to local desires that there is no overall change. It may also be due, as the next chapter will suggest, to the lack of

writing and other traditions that make the past more available to the present. In archaic things there is a lot of change in a variety of unexpected directions.

Textual traditions have sometimes been violently opposed to cultures based on things, with the pejorative words "idol-worshipping" and "idolatry" given to them. We are still the inheritors of the Judeo-Christian tradition, which sees the material as lesser or even evil and looks for transcendence beyond this world, to which the key is writing. The code of things and later of "art" is seen as secondary, primitive, clumsy, incoherent, and imprecise. This is often indicated by a pejorative feminization of both things and art. These qualities actually come to be seen as desirable in our recent cultures and have been projected back into the early ones. The feminized interpretation of archaic art, usually concerned with power, is one of the most ludicrous. Nineteenth-century travelers, for example, saw "queens" in many of the male images and imagined harems, and at present the popular imagination sexualizes sacrifice, with female victims in some kind of exciting and transgressive S-M ritual. By applying our interpretation of art to ancient works, we miss their messages entirely.

The mystery of the meaning of non-Western things is often exaggerated as part of our exotic titillation. If we, even after great gaps of time or culture, can grasp their meanings reasonably well, in their own time they were perhaps not always all that obscure. In fact, as fieldwork often demonstrates, in their own contexts the code of things was clear, specific, and elegant, in the mathematical sense of being simple and appropriate without unnecessary digressions. The code was more than adequate as forms of communication and memory. Our own projection of what "art" is gets in the way of our understanding the cognitive power of things in contexts with little or no writing.

NOTES

1. Georges Bataille, quoted in Denis Hollier ed., *Against Architecture: The Writings of Georges Bataille* (Cambridge, MA: MIT Press, 1989), ix–x.

2. Kurt Mendelssohn, "A Scientist Looks at the Pyramids," in *The Rise and Fall of Civilizations*, ed. Jeremy Sabloff and C. C. Lamberg-Karlovsky (Menlo Park, CA: Benjamin Cummings Publ., 1974), 390–402. ". . . in order to enforce unwilling labor, a very sizable army would have had to be employed to control a hundred thousand workers and their disgruntled relatives . . . When enquiring about the labor force used for large projects in present day China, I learned that a sufficient number of volunteers is always available. The pay is good, there is sporting rivalry between work gangs, and when workers return, they are the heroes of their village, telling evening after evening 'how we built the dam' stories. Inscriptions on the pyramid blocks give the name of working groups such as Vigorous Gang, and Enduring Gang. Moreover, the cooperative effort of villagers, brought together from a great number of different tribal communities, some with traditional enmity, must have played an important part in the creation of a centralized state." P. 400.

3. Esther Pasztory, *Aztec Art* (New York: Abrams, 1983).

4. Whitney Davis, *The Canonical Tradition in Ancient Egyptian Art* (New York: Cambridge University Press, 1989).

5. Irene Winter, "Art in Empire: The Royal Image and the Visual Dimensions of Assyrian Ideology," in *Assyria 1995,* ed. S. Parpola and R. M. Whiting (Helsinki: The Project, 1997), 359–381. ". . . the images of Assyrian rulers take their place alongside those of Augustus of Rome . . . or even those of Louis XIV of France, all conveying a highly idealized notion of the qualities of rule . . . like official art in any political system, the overall output functions to represent the state as its governors would wish it to be seen" (ibid., 373–374, 376).

6. I have discussed this issue in Esther Pasztory, *Teotihuacán* (Norman: University of Oklahoma Press), 240–248, and more extensively in *Pre-Columbian Art* (New York: Cambridge University Press, 1998).

7. Irene Winter discusses the outer form and indwelling spirit in Mesopotamian sculptures. Irene Winter, "'Idols of the King': Royal Images as Recipients of Ritual Action in Ancient Mesopotamia," *Journal of Ritual Studies* 6, no. 1 (1992), 13–42.

8. Such a philosophy is remarkably similar to Frank Lloyd Wright's idea of creating organic architecture that

does not actually imitate the forms of nature but is inspired by them.

9. I am quite opposed to the idea of expanding the concept of "writing" to all cultures as Jacques Derrida does in *Of Grammatology* (Baltimore: Johns Hopkins University Press, 1974). That anachronism perpetuates a text-driven view of the world not applicable to all times and places.

10. The idea of power as the meaning of things is well known to anthropologists in the fields of Africa, Oceania, and the Americas but usually discussed in specific terms, as in Paula Ben-Amos and Arnold Rubin, eds., *The Art of Power, The Power of Art Studies in Benin Iconography* (Los Angeles: University of California Press, 1983), and Clifford Geertz, "Centers, Kings, and Charisma: Reflections on the Symbolics of Power," in *Culture and Its Creators: Essays in Honor of Edward Shils,* ed. Joseph Ben-David and Terry Nichols Clark (Chicago: University of Chicago Press, 1977), 150–171.

Figure 9.1 Ch'en Shun, *Mountains in Clouds,* 1535, section of handscroll, ink on paper, 12 in. Courtesy Freer Gallery of Art, Smithsonian Institution, Washington, DC: Purchase, F1953.79.

Figure 9.2 Iranian Mihrab, c. 1354. All Rights Reserved, © Metropolitan Museum of Art. Harris Brisbane Dick Fund, 1939 (39.20).

Figure 9.3 Raphael, *Madonna of the Finch,* 1507, oil on canvas, 107 cm by 77 cm. Uffizi, Florence, Italy. Copyright Alinari, Art Resource, NY.

AN INTERCONNECTED OLD WORLD

All the states of what I am calling the textual era are to be found in the Old World. None of these were isolated from the rest: traders, warriors, missionaries, and travelers crisscrossed the entire area. Ideas spread despite the long-standing enmities between Christian and Moslem, as well as Chinese and Japanese, culture areas. One of the mechanisms that tied China, India, Persia, and Europe together was the Silk Route, which existed from about 200 BC[1] and was based on archaic routes that went back to perhaps a thousand years earlier.

Interaction between cultures in Eurasia was intensified by the presence of mounted nomadic cultures—chiefdoms and states—that pressured and threatened settled civilized life from China to Europe. Although nomads everywhere have played the role of intermediaries between settled groups, the historic significance of mounted nomads of Eurasia surpassed that of all others. This phenomenon had no parallels in the New World. The nomads were wealthy middlemen in long-distance trade who, like the Mongols, sometimes created their own empires.[2] Despite their reputation for cruelty and disruption, the nomads played a major role in disseminating ideas across a vast area.

It is not imaginable for an Aztec to have traveled to Inca Cuzco or to have written about it the way Herodotus, Marco Polo, and Ibn Batutta wrote accounts of faraway places in their time. As a result of extensive and intensive interaction, cultures from east to west were on a relatively similar level of development at least until 1600 AD. This was a cosmopolitan world in which people of different backgrounds and races mingled. It is these people to whom the new, universal religions appealed. The great "world," "universal," or "historic" religions were similarly interconnected. The relationships between Judaism, Christianity, and Islam are well known, but it has also been suggested that Christianity was inspired by Buddhism.[3] Religions were quite syncretistic: Manicheans, for example, selected Zoroaster, Jesus, and Buddha as their three major prophets.[4]

THE HISTORIC RELIGIONS

These religions were different from those of the early state in both theological and sociopolitical respects. Ancient religions usually dealt with the gifts or fury of the gods in a literal fashion. Prayers, rituals, and sacrifices were for rain, abundant harvest, success in war, and other generally material benefits. There was often no life expected after death except perhaps for the select few with lavish offerings. The afterworld was neither a place of reward nor of punishments. As the Aztec poem puts it, life is here on earth and meant to be enjoyed, while death is probably the end of everything and comes all too soon.

Remove trouble from your hearts, oh my friends,
As I know, so do others:
only once do we live.
Let us in peace and pleasure spend our lives;
come, let us enjoy ourselves ! . . .
Oh! that one could live forever!
Oh! that one never had to die![5]

The historic religions offered no material goods—
their benefit was immaterial: life after death or nir-
vana. They were more involved with the soul than
with the body. They forbade sacrifices, especially
human ones, but they instituted punishments. While
the old religions were concerned with plenty and
scarcity, the new ones were concerned with the moral
issues of good and evil. The old religions were
promiscuously polytheistic and tolerant; the new
ones were monotheistic and intolerant, each claiming
to be *the* world religion. As a result, there were many
religious wars over the centuries and severe religious
intolerance exists to the present.

One of the most important aspects of the historic
religions is that they were institutions separate from
the state. Most ancient, pre-textual religions were
state religions, and their activities were indistinguish-
able from politics. The separation of church and state
is a separation of the worldly and the moral. The
state is allowed a less stringent, secular code of
morality in its operations, while the church stands for
absolute transcendent moral values that are an ideal
rather than reality. Many a "primitive" people con-
quered by Europeans noted that Europeans did not
behave according to the impressive moral code
taught by missionaries. To them, this arrangement
was hypocritical. At this particular stage of Eurasian
history, the preoccupation was more with absolutes
than with consistency. The separation of church and
state allowed great latitude to the state while pre-
serving the patronage of higher values in the church.
Histories are full of the accounts of the sudden con-
version of rulers and their people to Christianity,
Islam, or Buddhism when the rulers saw the benefit
of transcendental religions. Goodness, however
defined, is located mostly within religion and evil
mostly within the world. Previously these categories
were mixed. It is noteworthy that the world religions

have lasted into modern times, while the various
polities related to them were short lived.

Since the world religions offer transcendence, they
must devalue physicality in all forms, things, or sac-
rifices. This era has sometimes been called the Axial
Age and lauded for its philosophical and humanitar-
ian greatness.[6] The new religions' vaunted superiori-
ty to those of pagans is rooted in the abolition of sac-
rifice and the establishment of faith in an immaterial
hereafter. In Axial Age thinking, a series of black-
and-white splits was made between secular/religious,
good/evil, body/soul, reason/faith, writing/things,
indicating an obsession with oppositions and duality.
One from each pair is exalted, the other demonized.
As this thinking is still with us, I would add
Western/non-Western to the other currently wide-
spread dualisms.

IDOLATRY

You shall not make for yourself a graven image, or
any likeness of anything that is in heaven above,
or that is in the earth beneath, or that is in the
water under the earth; you shall not bow down to
them and serve them; for I the Lord your God am
a jealous God . . .[7]

The great world religions were all based on sacred
texts and at one time or another despised images as
sinful. In early Christianity, Christ was represented
only by nonhuman symbols such as a fish. For a cen-
tury, 726–843 AD, the Eastern Church forbade
images and wars were fought for and against repre-
sentation. The issue of iconoclasm reverberated in
Western Christianity for about a thousand years.[8] In
Islam the representation of the deity and figurative
representation are mostly forbidden to the present
time. The injunction is not specifically in the Koran
but is an interpretation of the Hadith.[9] In early
Buddhism, in India, the Buddha was represented by
symbols rather than a man (a tree, a footprint, an
empty throne, or a wheel).

Iconoclasm, the opposition to representational art,
is not imaginable in archaic civilizations. Objects
may be intentionally destroyed after a ceremony, as
in the New Guinea Hevehe masquerade, to send the

spirits on their way. Objects may be mutilated for other religious reasons, such as ending and renewal ceremonies. Objects may be mutilated by conquerors or by factions. But they are not destroyed for being representations.[10] Some cultures are more object oriented than others, but none are anti-image. Generally there is no opposition to the image for being an image. As Freedberg suggests, there is a universal "tendency to conflate image and prototype, as all image theory, from its very beginning, has either explicitly or implicitly acknowledged."[11] This conflation is interpreted in a positive way by archaic societies and negatively by textual ones.

Opposition to the image appears only when writing becomes the central communicative medium in society fostering a rivalry. For Moslems, "God did not send his Image down in the form of a Man, but rather he sent down the Law, in the form of a Book."[12] The world religions named images "idols" and created the concept of idolatry. Just as in archaic cultures, there was no iconoclasm in this sense, neither was there idolatry. The archaic state's world of temples, palaces, and tombs stocked with marvelously crafted things was pronounced evil by Jews, Christians, and Moslems. To the Buddhists, the valuation of material things was simply misguided. This was done in the name of greater spirituality that transcends material forms and values. Most significant, this spirituality was codified and made permanent in another medium—writing. These religions do have *sacra,* but they are scriptures, not things.

IMMATERIALITY

Almost everywhere in the world writing first appeared as a form of image making, incorrectly but graphically summed up in the concept of "picture writing." There is no apparent conflict between the two in their origins. Both writing and image are often made by the same person, and the formal and iconographic relations of image to text may remain intertwined for a long time. So much is indicated by Maya hieroglyphs and Chinese calligraphy. Representation, in its multivalence, welcomes the text. But writing ultimately fulfills its potential by cutting itself off from representation and mounting a crusade against

it as something false. It need not be religion. Danto has suggested that from Plato to the present the task of philosophy in the West has been the destruction of the power of representation and the enthronement of abstract thinking, that is, philosophy.[13]

Writing emerges in stratified societies—chiefdoms and states. It is often assumed to have developed because of its practical value in recording everything from business transactions to dynastic histories in large, complex societies. Its symbolic value is, however, equally great. While an image can be decoded, at least on a simple level, by anyone in society, writing must be mastered in its entirety in order to read a text. Writing is the most effective symbol of the power of the elite—regardless of whether they read—because they employ those who do.[14]

This power is not material like the pyramids, however. Power does not reside in the individual works or letters of a text; textbooks are interchangeable (a Bible is a Bible). The meaning is separate from the material form from which it is read. Writing creates the existence of immaterial history. It is thinking with signs rather than with things. Thinking with things is thinking, at least partly, with the body. Meanings appear immanent in the things and may not be analyzed linguistically or in concepts.[15] Writing is the confluence of the linguistic and conceptual par excellence. Some of the characteristics of writing are due to its linguistic character and exhibit logic and reason. It has been argued that all *Homo sapiens* are rational and thus the rational is not the exclusive domain of Western culture, nor of language or writing.

Nevertheless, writing does intensify the rational aspects of language. It encourages linear reading, thinking, and arguing. There is greater concern with logical consistency than in multivalent image systems. Goody has called writing the "technology of the intellect."[16] Writing creates abstraction and distance from the material world. It is suggested that the critical evaluation characteristic of philosophic inquiry seems to require the distancing that writing provides. Thinking with things is implicit; thinking with signs is explicit. As a form of communication technology, books are superior to images. A book can codify a specific and detailed text in a way that a

carving, with its lack of linear sequence and reference to the nonmaterial, never can. A book can codify the past in a way objects rarely can. The presence of the past in the present acts as a great force of stability and continuity.

In the culture of books, the metaphor of book, language, and reading is applied to things and images routinely, both anachronistically and retroactively. In the Middle Ages, Leo, bishop of Neapolis, wrote quite naturally that "[t]he representations of the Saints are not our Gods, but books which lie open . . . ,"[17] a topos close to that of Stewart Culin, the 1900s collector of Southwest American Indian things, who insisted that "we must learn the language of things," but then stated that a medicine bag is to the ethnologist "an open book of Indian life and history."[18] The result of seeing images and things as "books" is not to see them at all as things. Textual cultures look for the same information in a thing that they would find in a book and thereby completely distort the meaning of things. Books and things are not merely different in methods; they communicate different sorts of information.

The technology of writing transformed ancient cultures, as did the development of new types of religions. The entire tradition of things as central to society was undermined, destroyed, and transformed by writing. Not simply by writing but by the emergence of sacred texts. The texts may be literary like the Homeric epics, philosophical like Confucius' Analects, or scriptural like the Bible, the Koran, or the Buddhist sutras. The texts tend to extol themselves as the only form of truth and turn a sharply critical eye on the entire realm of the early state. Secular texts like Herodotus' *History* may find this world an acceptable realm of beautiful or monstrous curiosities. Both the sacred and the secular point of view trivialize the world of objects made by man. In their fury against objects, the sacred traditions continue to recognize their importance. Why rail against images if indeed they are only empty forms?

The removal of the power of the image has not always succeeded. As Freedberg suggests, our response to images may be biological and would therefore always be there.[19] The Christian church, which allowed the image, has found it necessary to caution time and again against the worship of saints or a particular Madonna as idolatry. The church goes on to reiterate the image's purely symbolic, immaterial existence, as an aid to the text.

TEXT/IMAGE

Despite the iconoclastic tendencies of the world religions, the image did not disappear entirely. Images remained, returned, came and went. They were often still seen as "real"; they cried and they were kissed. References to the primary truth-bearing value of the image were accompanied by the problematization of the image in oral and written discourse. The image was no longer central; it existed in competition with writing. In fact, the image remained by some form of written permission. A deal was made. Forms found a place in this new world in two main opposite ways, either by trying to express transcendence visually or by aestheticism. This aestheticism existed as an appeal to visual pleasure rather than to truth. Transcendence and aestheticism are not mutually exclusive and coexisted in various combinations.

Once truth came to reside in the text, images were turned into illustrations or metaphors.[20] Christian works often "illustrate" the life the Christ much as Buddhist works "illustrate" the life of the Buddha. Narratives and stories are much rarer in earlier times since early images, even if they allude to stories, do not illustrate a verbal form. The works of the ancient state were concerned mostly with embodiments of power and not with narratives. Because we are so used to images that illustrate, we are always looking for stories in ancient monuments, even though they are not there.[21] Images may even be said to be books for those who can't read, as in the European Middle Ages. The association of images with illiteracy indicates that they are seen as a lesser, simpler, more primitive form of communication than writing. As an illustration, the image is merely a symbol—almost the way letters are symbols of the concepts they spell out. Images, in this sense, become words and concepts and are aligned with texts in their structures. In cultures where texts, sacred or

secular, predominate, images are used to illustrate other texts (myths, histories, and stories). Whether it is *The Tale of Gengji*, a Shahnama, or the *Iliad*, the relationship of text and image is similar.

The changed power relations of the image are evident in the new insistence on vulnerability in religious symbolism of the textual era. The fish is a common image in the early Christian images of the catacombs and refers to Christ and the miracle of the loaves and fish. Fish also refer to souls fished from the pagan sea by apostles like St. Paul. The fish is a curious symbol for a great religion. The animals represented in chiefdoms and states were lions, tigers, jaguars, dragons, crocodiles, eagles, snakes, and other powerful raptorial creatures. The fish is an image that is almost the opposite of everything powerful—it is soft, capable of life only in water. Other Christian symbols such as the lamb, Christ in the form of a child, or a sacrificial victim on the cross continue this emphasis on vulnerability. A similar feature is evident in Buddhist representations where the Buddha is shown as vaguely androgynous, fat, and with closed eyes suggesting meditation or sleep. There has been a complete reversal from the power imagery of the archaic state to a new imagery of transcendence symbolized by weakness. The powerlessness of the image and the symbols of powerlessness reinforce one another.

Islamic representation, on the other hand, developed toward ornament to avoid figuration. Flowers and interlace are as much symbols of powerlessness as fish and children. The strategy of allowing what is usually border and minor area ornament to fill the zone normally accorded to the image is to invest ornament with the powerful message of iconoclasm. Ornament, then, is never "mere ornament" but always imbued with the significance of what it is not—i.e., the figure. The ornamental surface of things is like the curtain covering a stage that is never revealed. The power of Islamic ornament lies in this denial. It is never empty ornament. It is the visible conquest of image making by writing. An elegant text often winds its way among the flowers of design, like a conquering hero relaxing in a garden.

Things associated with textual traditions offer a field day for the art historian, because almost everything in the images can be related to, explained by, or accounted for in texts. Such a relationship provides "rational" corroboration for what the body presumably experiences subliminally. Image and text are, then, a joint enterprise. In archaic traditions where things and images were the primary forms of expression, there is no such external corroboration. Fieldworkers have tried to press ritual and oral tradition into service as substitutes for texts. This is highly questionable, in that it forces a very different set of data into a textual mold. When things become textualized, placed in a context in which texts predominate, texts denote the privileged subjects for things, prescribe their appearances, and determine their symbolism. From the paradigm of archaic cultures, images lose their authority and freedom in the textual era.

IDOLATRY

Aestheticism, that is, the conscious manipulation of aesthetic means, may always occur when using aesthetic means to create concepts and effects.[22] I am applying the term to any objects, or aspects of objects, that have been made to be consciously admired as beautiful, or where such an admiration is an important goal of the object. This definition is close to the concept of mannerism in Western art history, which is itself based on self-consciousness in artist and audience. Of course, we flatter ourselves if we think we can tell the difference between the studied and the spontaneous or the conscious and the unconscious. We might assign irregular and haphazard forms to the unconscious and associate the precisely delineated and patterned ones to the conscious; crudeness to naiveté, polish to sophistication. But as the paintings of Paul Klee make clear, the irregular, haphazard, and childlike can all be highly conscious. The images of the mentally ill, presumably close to the unconscious, are usually highly structured.[23] Aestheticism, then, is not a style but an attitude we either know from the makers of the objects or deduce, more or less well, from their effects. By this broader definition of aestheticism I mean a self-conscious appeal to a sense of visual and

sensory beauty. Aestheticism can crop up in anything made by humans from earliest times, because it is a fundamental aspect of the making, interpreting, and evaluating of things. This narrative suggests that aestheticism is particularly associated with distinctions of status and value, and hence plays particularly important roles in social life, in ranked society, and in periods in which there is something close to a concept of art. I argue that aestheticism develops particularly strongly when images and things are no longer crucial for society's functioning but nevertheless are worshiped as icons of creativity, like the Mona Lisa.

Paradoxically, it doesn't matter whether a religion based on sacred texts in iconoclastic fury denounces images as "idolatry" or a more secular intellectual tradition praises and adores the aesthetic experience. In both, the world of things is displaced, demonized, or set on a pedestal. Being beautiful may not be quite as powerful as being important, but for the realm of things it opens up exciting and unexpected new areas of development. The potential of aestheticism is rich in its own very different terms. Eventually, in most areas of the textual era, representation was channeled in that direction.

What is noteworthy about the classical world and the Far East is that a textual era emerged without a transcendental religion. Instead, both were based on ethics with a social philosophy of a humane and secular form. Confucian philosophy parallels many classical concerns. While the political ideals were different—a democratic Greek ideal versus the benevolent ruler ideal of China—they both reflect a focus on humans and on reason.[24] Greek and Chinese art developed strongly in the direction of aestheticism along with its accompanying connoisseurship. From being taken for granted as essential objects like our 747s (spectacular in their way but an integral part of life), objects became more removed from everyday life and more consciously "worshiped" for their formal qualities. In that sense they become idols, not of religion but of aestheticism. The makers of aestheticizing objects have a new and different mandate from what governed things in the past—they are to make new, spectacular forms that outdo the objects of the immediate past, including their own past

works. This invention should provide an interesting visual experience for patrons and viewers. This competition in creating visual interest leads to linear stylistic developments in which works appear to have been made in a reconstructable series. Self-consciousness and a coherent "fast" development go together.[25]

Take, for example, the issue of contrapposto, the shifting of the figure's weight to one leg, allowing the other to touch the ground lightly, and requiring a set of asymmetrical realignments in the body—the buttocks, the waist, the shoulders. This is supposed to be the great artistic invention of the Greeks. From Winckelmann to our current art history survey books, the story begins with how the Greeks breathed life into the rigid forms of Egyptian representation by using contrapposto. The Egyptian is presented as lacking the proper knowledge, the Greek as having discovered how to create lifelike form. These are also associated with political forms, as Winckelmann suggested: the rigid Egyptian forms are seen to reflect oppressive theocracy; the freely moving Greek ones are attributed to democracy. Actually, in the analysis here, the focus on humans and naturalism indicates the secondary status of images in relation to texts, with a compensatory development of the aestheticizing pleasures of representation.

Although not necessarily following the muscular logic of Western representations, Indian and Far Eastern traditions of the textual era also show figures in asymmetrically balanced positions.[26] This use of a kind of contrapposto is very striking in contrast to the images of the archaic state: Assyrian, Egyptian, Aztec, or Chimú figures are usually evenly balanced. This does not mean that asymmetrical balance was unknown—it was sometimes used to a limited extent on major figures and more frequently on minor ones.[27] The selection of posture is not indicative of technical know-how or genius but of social context. Plato preferred Egyptian figures with their monumental grandeur (ideal form) to the representations of his time, which focused too much on casual and momentary appearance for his philosophical taste. That contrapposto is a tendency toward trivialization, rather than power, is evident in the

Yes, but not in India!

exaggerations of Hellenistic statuary. The later manifestations go hand in hand with minor subject matter, such as an old market woman. Such an image seems to have no purpose other than the aesthetic appreciation of the carver's virtuosity.

While the human figure is the key image in the West, landscape paintings are more characteristic of Chinese and Japanese insistence.[28] In a traditional painting, trees and rocks are usually in the foreground, while mountain peaks often rise behind mists in the background. Small human figures may be present, suggesting that humanity is in and a part of the cosmos but not its major subject. Many of these works were painted by the literati, wealthy, educated intellectuals who were poet-painters. Still-present inscriptions and seals indicate histories of the ownership of the paintings. Along with collection went connoisseurship. This expertise had a strong influence on the style of a painter, relating him to other, earlier painters' styles. Retroactively, it seems that the artists were solving visual problems, resulting in the kind of linked series attributed by George Kubler to art in general. To us, being a part of a linked series enhances enormously the appreciation of a work, since it is seen in relation to other, related works and they can all be enjoyed and contrasted as a group. European art history developed in the nineteenth century particularly by focusing on linked series. Though such series belong only to a portion of the history of things, they have been written in as basic principles. They are basic indeed to the works of the textual era.

PAINTING

While the privileged medium of the archaic state was stone sculpture, the privileged medium of the textual era is painting. Paintings existed in ancient Egypt, Mesoamerica, and elsewhere, usually on walls or in books. These same locations are common in the later state, with the addition of independent panels or scrolls. The painting becomes the aestheticizing object par excellence, perhaps because it has only two dimensions and it is very much the skill of the painter that determines the result. It becomes visually more exciting to see the three-dimensional world reduced

to two dimensions than in three. Three dimensions are seen as more literal; two-dimensional painting, more imaginative. The power of the text is indicated by the presence of books on painting. There are many treatises on painting in both Europe and the East that codify practice.[29] Perhaps the preference for two-dimensionality in painting is related to the transcendent and immaterial values encouraged by writing.

One of the main problems in painting is how to render three-dimensional objects and a sense of space. This is not an issue that greatly concerned the painters of the archaic state. Generally, they were satisfied with metric perspective, in which aspects are shown in their broadest view with relations between parts close to how they really are. Hagen describes metric perspectives as having multiple station points; that is, the viewer is imagined moving along the object depicted.[30] Although metric perspective is often considered not to be perspective, she argues that it is and defines it as a systematic rendering of objects in space that distorts the least natural relationships of forms. Other types of perspective, called "similarity" and "affine" by Hagen, are occasionally used and known in archaic contexts, but there appears to be no interest in developing them until the textual era. She suggests that metric perspective is chosen in archaic state art because it creates the most monumental forms.

The creation of a sophisticated scene on a two-dimensional surface seemed to require experiments in other types of perspective. "Similarity perspective," which is another name for the characteristic one-point perspective of the West, assumes a single-station point for the viewer that results in a cone-shaped depth of field. While perhaps—there are contrasting views on this—visually closer to how we experience reality, it distorts actual sizes and relationships much more. This type of perspective is sometimes used in Asia in minor sections of a painting, while an affine perspective is usually chosen for the rest. Affine perspective is similar to isometric rendering, and in Asian art the scenes are often rendered as if seen from above, from a bird's eye perspective. The choice of perspectives appears to be a matter of local insistence rather than one of development.

Similarity perspective is one of those core features of Western insistence that generations of scholars have sought to explain. Marshall McLuhan, who pioneered so many of the ideas of communications technology, related literacy to visuality. "Literacy gives people the power to focus a little way in front of an image so that we take in the whole image or picture at a glance. Nonliterate people . . . scan objects and images, as we do the printed page, segment by segment."[31] Panofsky had pointed out that classical perspective, despite an overall similarity and a historical relationship, never used the vanishing point so important in the Renaissance, thus indicating either differences in insistence or technology (printing?) that are not yet clear.[32]

The simple conclusion is that more elaborate renderings of space seem to have been necessary for painting in the context of the textual era. Unlike the two-dimensional renderings of most hunter-gatherers who thought of images as cross-sections or diagrams, in the paintings of the textual era things and people are imagined as solids that need to be convincingly rendered as such with perspective and light and shade. This illusion of reality is just as evident in Asian as in European representation. There is a progression from the diagram to actual things to images of things—a drive to imaging eventually fulfilled in film by moving images, or in computers by interactive images. I am not suggesting that this drive is teleological, merely that it pertains to social conditions.

Paintings, be they Persian miniatures, Chinese scrolls, or European panels, are eventually seen as the equivalents of treasures. As Goethe wrote of a painting by Wilhelm Kalf, "One must see this picture in order to understand in what sense art is superior to nature and what the spirit of man imparts to objects when it views them with creative eyes. There is no question, at least not for me, if I had to choose between the golden vessel or the picture, that I would choose the picture."[33] The facsimile of things, landscapes, and people acquires greater value than the things themselves. The painter is thus a special person who can transmute ordinary paint into a treasure that is the equivalent of things having significant monetary value. Given these aspects of painting and

some intellectualizations of the practice in handbooks formed East and West, it seems possible that these might lead to a concept of art and aesthetics.[34]

BEAUTY

In the eighteenth century when the concept of art was being created in Europe, it was assumed that the purpose of art was the creation of visual beauty. Kant was very conscious of the fact that beauty for a Maori and a Westerner may have meant very different things, but thought that beauty judged by taste was the goal of aesthetics universally. I would argue that this is not the case. As I have suggested above, the aim of archaic things was the expression of power rather than beauty. In many non-Western cultures, an object that is appreciated is called "good" in the sense of "right" or "appropriate"—which is what "beautiful" is—as often as it is described as "beautiful." George Preston and Susan Vogel have suggested that that kind of appreciation is closer to ethics than aesthetics.[35] In the desire to eradicate the differences between Western and non-Western art, there has been an attempt to show that all aspects of Western art—the role of the artist, the judgment of beauty, and aestheticism—are all found in all other cultures. That is, in order to accord value to other cultures they have to be identical to our own! It is my argument that there are significant differences, not between West and non-West, but between levels of social integration and communications technologies.

An emphasis on visual beauty as the goal of image making makes sense when things lose the centrality of their social function to writing but acquire a new function: the creation of pleasure. Things and images are moved into a sideline that proves to be enormously fertile and profitable. There are markets and connoisseurs for the clever, mannered, virtuoso performances of sculptors and painters, whose work is often signed and named as a "brand." Our museums are especially full of this kind of object; and when the concept of art was defined, these are the things that the various authors had in mind as "art." From the point of view of aestheticizing cultures, the things of power in archaic times were generally thought of as

ugly: ungainly, monstrous, unrefined. Like the aestheticizing taste of chiefdoms, the aestheticizing taste of the textual era prefers the smooth, slick, refined, elegant to the dramatic and harsh.

Even though things and images lose their centrality as communications technology with the arrival of writing, they don't disappear. A new meaning and function is found for them that is rich and satisfying. This suggests that even if thinking with things is superseded, it remains valid and significant and adjusts to social circumstances. However, it moves from the necessary to the more optional and desired. New mechanisms of desire have had to be grafted onto it, and there are changes in the audience that are involved. In this emphasis on beauty and pleasure,

the cognitive aspect of things seems deemphasized, although it is still there and a part of the pleasure. But the tendency is to approach things in a more overtly sensory and sensual manner. This is because the cognitive is generally assumed to be writing, and a split is created between reason and the senses, between writing and visuality. Things become irrevocably associated mainly with the senses, which are considered somewhat less than the non-sensory. Aestheticization is a gain, but at a significant cost. When ritual is turned into theater, there is a gain in artistry but a loss in seriousness. However, given the importance of writing, there was no other option available for the technology of things.

NOTES

1. Jerry H. Bentley, *Old World Encounters* (New York: Oxford University Press, 1993). Herbert Härtel, and Marianne Yaldiz, *Along the Ancient Silk Routes* (New York: Metropolitan Museum, 1982).

2. Bertold Spuler, *History of the Mongols* (New York: Dorset Press, 1988).

3. Bentley, *Old World Encounters*, 47.

4. Ibid., 56.

5. Miguel León-Portilla, *Aztec Thought and Culture* (Norman: University of Oklahoma Press, 1963), 131. See also León-Portilla, p. 129:

What are you meditating?
What are you remembering, oh my friends?
Meditate no longer!
At our side the beautiful flowers bloom:
so does the Giver of Life concede pleasure to man.
All of us, if we meditate, if we remember,
become sad here.

6. The era of the new religions and philosophies has been called the "Axial Age" by Karl Jaspers and Shmuel Eisenstadt. In a study, not surprisingly based on texts, the authors in the Eisenstadt volume eulogize the new tenets as "progressive." These ideas were popular in the middle of the twentieth century, as seen also in Lewis Mumford. Karl Jaspers, *Von Ursprung und Ziel der Geschichte* (Munich: R. Piper, 1949). S. N. Eisenstadt, ed., *The Origins and*

Diversity of Axial Age Civilizations (Albany: State University of New York Press, 1986). Lewis Mumford, *The Transformations of Man* (New York: Collier Books, 1956).

7. Ten Commandments, Exodus 20.

8. Hans Belting, *Likeness and Presence* (Chicago: University of Chicago Press, 1994).

9. The 48th saying says, ". . . I heard the Prophet say: 'God said: Who is more wicked than he who sets out to create as I have created? Let them create a tiny particle, or let them create a seed or a grain of barley!'" This saying of the Prophet was on a day when he came upon a man sketching a picture. William A. Graham, *Divine Word and Prophetic Word in Early Islam* (The Hague: Mouton, 1977), 171. "The ban on human figures was not complete, but the fact that there are no figures on the Dome of the Rock or at Damascus does suggest that in mosques the dictum was already in force by about 690." David Talbot Rice, *Islamic Art* (New York: Frederick A. Praeger, 1965), 18

10. Hevehe masks, F. E. Williams, *Drama of Orokolo* (New York: Oxford University Press), 1940. David. C. Grove, "Olmec Monuments: Mutilation as a Clue to Meaning," in *The Olmec and Their Neighbors*, ed. E. P. Benson (Washington, DC: Dumbarton Oaks, 1981), 49–68.

11. David Freedberg, *Iconoclasts and Their Motives* (Maarssen: Gary Schwartz, 1985), 33.

12. Erica C. Dodd and Shereen Khairallah, "On the Prohibition of Images and the Image of the Word," in *The*

Image of the Word (Beirut: American University of Beirut, 1981), 17.

13. Arthur C. Danto, *The Philosophical Disenfranchisement of Art* (New York: Columbia University Press, 1986). "... since Plato's theory of art *is* his philosophy, and since philosophy, down the ages, has coexisted in placing codicils to the platonic testament, philosophy itself may just be the disenfranchisement of art" (Danto, *The Philosophical Disenfranchisement of Art*, 7).

14. Most Assyrian rulers were illiterate. Allison K. Thomason, *Capturing the Exotic: Royal Ivory Collecting and the Neo-Assyrian Imaging of North Syria,* Ph.D. dissertation, Columbia University, Department of Art History, 1999.

15. In a very interesting study of language versus thought, Glucksberg argues that not only do our concepts exist in a specific language but that many mental operations are solved nonverbally. He suggests that thinking may be done with visual and abstract codes. Sam Glucksberg, Robert J. Sternberg, and Edward E. Smith, *The Psychology of Human Thought* (New York: Cambridge University Press, 1988), especially 214–241.

16. Some of the elements Goody sees in writing, as opposed to oral traditions, are greater use of abstract terms, greater choice of words, less personalized and contextualized usage, greater explicitness, greater elaboration, greater formality, and greater reliance on a dead language. Jack Goody, *The Interface between the Written and the Oral* (New York: Cambridge University Press, 1987), 264. He argues further that the processes associated with writing are "critically dependent upon the presence of the book." Jack Goody, *The Domestication of the Savage Mind* (New York: Cambridge University Press, 1977), 150.

17. Dodd and Khairallah, "On the Prohibition of Images."

18. As quoted in Diana Fane, ed., *Objects of Myth and Memory* (New York: Brooklyn Museum, University of Washington Press, 1991), 24–25.

19. David Freedberg, *The Power of Images* (Chicago: University of Chicago, 1989).

20. Illustration in Greece is admired by Elkana: "The first products after the Dorian invasion excelled in their geometric style, . . . only to give way, from the Homeric period onward, to the realistic figures of the black-figure and then the red-figure period. The artists of these last in all probability had read Homer and were actually 'illustrating' the Odyssey and the Iliad." Y. Elkana, "Emergence of Second-Order Thinking in Classical Greece," in *The Origins and Diversity of Axial Age Civilizations,* ed. S. N. Eisenstadt (Albany: State University of New York Press, 1986), 61.

21. In the field of Maya art, everything has been related to the one surviving textual myth, the Popol Vuh. Dennis Tedlock, trans., *Popol Vuh* (New York: Simon and Schuster, 1985). This is also my experience in TV productions and popular magazines. Editors were unhappy with my material if there were not enough "stories."

22. Technically, aestheticism was a movement in Victorian England to create a socially elevating and utopian art based on "beauty and simplicity in design, sincerity in materials, craftsmanship as execution of beauty and functionality in use." The modernists accused it of "beauty mongering." Lisa Dowling, "Aestheticism," in *Encyclopedia of Aesthetics,* ed. Michael Kelly (New York: Oxford University Press, 1998), vol. 1, 32–36.

23. Roger Cardinal, *Outsider Art* (New York: Praeger, 1972). "L'art brut" which the art of the mentally ill was first called, has of course been associated with the art of "savages."

24. Despite these traditions, the world religions eventually conquered these areas and the classical world became Christian, the Far Eastern, Buddhist.

25. George Kubler analyzed this phenomenon of "fast" changes, which he related to the urban and advanced societies and contrasted to the "slow" changes in archaic and provincial culture. Fast change is the province of the art historian, by tradition. George Kubler, *The Shape of Time* (New Haven: Yale University Press, 1962). Anthropologists and archaeologists have been interested in "slow" change, otherwise known as "stylistic drift," which is presumably unconscious or no more conscious than change in fashion. Alfred L. Kroeber, *Style and Civilization* (Berkeley: University of California Press, 1963), 7–24. Margaret Conkey and Christine Hastorf, *The Uses of Style in Archaeology* (New York: Cambridge University Press, 1990), 105–112. Roland Barthes suggests long-term and short-term developments in fashion trends. Roland Barthes, *The Fashion System* (1967; Berkeley: University of California Press, 1983).

26. See, for example, Benjamin Rowland's parallel images. His entire book argues for convergence rather than historical relationships. Benjamin Rowland, *Art in East and West* (Boston: Beacon Press, 1954), 25–26.

27. In Maya representations prisoners are usually shown in more varied and fluid postures than the conquering rulers. Western observers have particularly admired one reclining prisoner in the murals of Bonampak because it is most like Western art, or even Michelangelo. Mary Ellen Miller, *The Murals of Bonampak* (Princeton: Princeton University Press, 1986), 113.

28. James Cahill, *Chinese Painting* (New York: Rizzoli, 1977).

29. Examples include the following. Cennino Cennini, *Il libro del'arte, o Trattato della pittura* (1933; Milan: Longnesi, 1984). Leon Battista Alberti, *On Painting* (1435–1436; New Haven: Yale University Press, 1956). Mai-Mai Sze, *The Mustard Seed Garden Manual of Painting* [Chieh Tzu Yuan Hua Chuan, 1679–1701] (Princeton: Bollingen, 1956) (part of a larger work, *The Tao of Painting*). Stella Kramrisch, *The Vishnudharmottara: A Treatise on Indian Painting and Image-Making*, part 3 (Calcutta: Calcutta University Press, 1924).

30. Margaret Hagen, *Varieties of Realism: Geometries of Representational Art* (New York: Cambridge University Press, 1986).

31. Marshall McLuhan, *The Gutenberg Galaxy: The Making of Typographic Man* (Toronto: University of Toronto Press, 1962), 50. It is easy to underestimate McLuhan because so much of what he said was an exaggeration. However, his *Understanding Media*, with its short and pithy chapters on everything from clocks, typewriters, and of course radio and television were quite to the point. Too bad he did not live into the computer era. I have not thought about McLuhan until looking for these notes unearthed heavily underlined and yellowing paperbacks from the sixties. I had to admit that he was a more important source in my thinking than I gave him credit for. I will have to place McLuhan's "motorcar" next to Barthes' "Citroen."

32. Erwin Panofsky, *Perspective as Symbolic Form* (1927; New York: Zone Books, 1991). In the West, similarity perspective has had a high status because of its association with mathematics and geometry, as Alberti's book on painting is mainly about perspective. In 1999 Michael Kimmelman selected perspective as the best invention in art in the last thousand years. Michael Kimmelman, "Everything in Perspective," in "The Best Ideas, Stories, and Inventions of the Last Thousand Years," *New York Times Magazine,* April 14, 1999, 86. Panofsky notes with irony that Plato condemned perspective for distorting true proportions with the arbitrariness of appearances, while for aesthetes in 1927 perspective had become a symbol of limited rationalist thinking. P. 71. Because of its association with science and rationalism in Europe, perspective has been associated with "high" civilization.

Recently, Damisch has related perspective to language and suggested that because of it painting is cognitive. ". . . the formal apparatus put in place by perspective paradigm is equivalent to that of the sentence, in that it assigns the subject a place within a previously established network that gives it meaning, while at the same time, opening up the possibility of something like a statement in painting . . ." Hubert Damisch, *The Origin of Perspective* (Cambridge, MA: MIT Press, 1995), 446. Needless to say, all these scientific interpretations of perspective seem to me to be a part of Western insistence.

33. Jacob Rosenberg, Seymour Slive, and E. H. ter Kvile, *Dutch Art and Architecture, 1600–1800* (New York: Penguin Books, 1972), 340.

34. The linguistic terms for "art" in Asia were introduced by the American Ernest F. Fenollosa, who lectured in Tokyo at the end of the nineteenth century. The Chinese and Japanese terms were developed at the Vienna exposition of 1873. The concepts were based on the German philosophical definitions of art. Prior to that, the visual arts such as painting were classified as the gentlemanly arts relating to skills including riding and to calligraphy. David Sensabough, lecture, Columbia University, 1994.

35. "I think I can speak of an ethic/aesthetic, but not an aesthetic for the Akan." George Preston, "Akan: In Search of a People's Aesthetic," University Seminar, "The Arts of Africa, Oceania and the Americas" (New York: Columbia University, March 25, 1998). Susan M. Vogel, "African Aesthetics," in *African Aesthetics: The Carlo Monzino Collection* (New York: Center for African Art, 1986), xi–xvii. "When the beautiful and the good overlap as they do in African belief, the *aesthetic content* of a work of art (the signification of something good) may be a source of aesthetic pleasure although this pleasure is not primarily visual" ibid., xvi.

Figure 10.1 Jackson Pollock, *Autumn Rhythm,* 1950, oil on canvas, 8 ft. 9 in x 17 ft. 3 in.
All Rights Reserved, © The Metropolitan Museum of Art. George A. Hearn Fund, 1957 (57.92).

WHOSE ERA?

So far, the technological era has been associated with the culture of Europe and America. While its roots go back at least to the sixteenth century, its major impact was after 1800 AD. This is not the place to discuss the hegemony of Europe, capitalism, or the political structures that made this era possible, since they are widely known and discussed. The point relevant to my theme is that the technological era is the last level of social integration so far, in which the American aspect has become global, and indicates some degree of global unification, as suggested by Carneiro. Technological media are characteristic of this level, but the actual form and content are dictated by Euro-American insistence on features such as realism and certain types of stories, such as Hollywood fables. A technological era by another type of culture might have had different content. Because so far there has been only this one dominant technological culture, albeit with various "dialects," it is not possible to compare it to other technological cultures.[1]

It is a historic aspect of this era that it is conceptually divided between an imaginary West and non-West—the technologically advanced and aggressive versus the rest of the world frozen, so to speak, in amber at their various lower levels of integration. The history of the late twentieth and early twenty-first centuries consists of the various ways in which these cultures have been catching up and the paradox of their longing to be technological powers while at the same time maintaining their special traditional identity. The "West," in the meantime, feels that it has lost its identity ("soul") in becoming modern and searches for it among the exotics of the Nonwest.[2] West and non-West are therefore locked in a material, cultural, and spiritual exchange whose repercussions are not totally clear except in some degree of homogenization and resistance lauded or panned by pundits.

Francis Fukuyama suggested the peaceful resolution of a unified world without further "history" after the fall of the Berlin Wall in 1989.[3] Others, however, have seen rising conflicts between the West and its old enemies in the East—Islam, Japan, and China. Bernard Barber sees the U.S. corporate "McWorld" goal as eventually victorious over local reactionary jihad tendencies.[4] In the 1980s, with Japan's economic successes, many popular books dealt with the fear of Japan. With Japan's economic slump and China's economic rise and authoritarian government, the fear of the East has centered on China. Against such momentary ups and downs, Andre Gunder Frank analyzes the relationship of Asia to Europe since 1500 and concludes that the dominant power at all times has been Asia in general and China in particular, and that European hegemony is an "accident" of history and power will eventually return to China. He suggests that the usual histories have been too Eurocentric and not taken into account all of Eurasia at all times.[5] There are many other ideas about the future, such as the fanciful one by Brazilian Alfredo Valladao, who thinks that the Americas as a whole will construct a universal democratic empire.[6] Scenarios

also include dire predictions of the power of multi-national corporations whose control is not under any particular state and whose ultimate role is unpredictable.

All of this means that there is a sense that politically and/or economically one power does or will rule the earth, though there is no agreement which it is and plenty of room for utopian or satanic fantasies. The ease with which authors put together their scenarios indicates that we are now all thinking globally. It is not my aim to predict, only to note process.

This chapter, therefore, deals with a part of what I am calling the technological era, which is as yet unfinished and has not moved to another level of complexity, whatever that might be. It also deals with the hegemony of Europe and America as it has developed historically, regardless of where the shift of power goes in the future. The major characteristic of this era is a belief in "art" as an aesthetic, intellectual, and spiritual practice akin to religion practiced by the wealthy and educated. Most of the population experiences visual communication through the technological media, which have global distribution. The previous chapter discussed what happened to things when they were in rivalry with and secondary to writing but still very important (halfway from center to margin). The issue discussed here is what becomes of the nature of things when they have been pushed to the margins by another medium and are now considered "dead,"[7] or talking from the beyond.[8]

REAL SIMULACRA

In the early twenty-first century there is a widespread feeling that this culture is rooted more in images than in texts. W. J. T. Mitchell has called this the "pictorial turn" following a "linguistic turn" posited by Richard Rorty. (By "turn" he means something like paradigm.)[9] This is not just a scholarly construct. I have been in the habit of asking college students whether they think they are living in a textual- or image-based world, and they generally feel images are more important to them than texts. Mitchell and Jonathan Crary both make the important point that in this visual world people are spectators and observers more than participants.[10] The pervasiveness

of images is believed to increase in the future, as science fiction movies indicate. In the film *Brazil*, no matter what activity people are engaged in, a TV screen is in front of their faces.

All the powerful visual modes of the last century go back to photography, developed around 1850. Everyone writing on the visual media sooner or later quotes Walter Benjamin, whose essay contrasting the duplicability of the photo process with the "aura" of the unique work of art divides our era from the past.[11] This essay is profoundly nostalgic and sets the tone for the negative evaluation of the media, as exemplified most recently by Jean Baudrillard. Photography itself, the oldest medium, has now largely earned the venerability of being considered an "art," which is likely to happen in time to mainstream movies and TV, although at present they are watched by everyone but demonized by intellectuals. Media images are criticized for being "fake" and "soulless," for pretending warmth and community that aren't there, and for functioning as cultural pacifiers. Baudrillard considers the screen image positively evil:

> In its present endeavours cinema increasingly approaches, with ever increasing perfection, absolute reality: in its banality, in its veracity, in its starkness, in its tedium, and at the same time in its pretentiousness, in its pretention to be the real, the immediate, the unsignified, which is the maddest of enterprises . . . No culture has ever had this naive and paranoiac, this puritanical and terrorist vision of signs. Terrorism is always the real.[12]

The media are also accused of having "killed" real art by usurping its functions as a communications agent in society. This is how Jimmy Durham, the Native American artist, puts it: "Gabriel Orozco, a Mexican artist . . . says that we cannot make thrilling art anymore, that Disneyland, the movies, or just Benetton advertisements can do it much better."[13]

A second major complaint against the media is built into photography, from which they derive. The whole point and nature of photography is to be "realistic," that is, to reflect what the camera lens—created to match our vision—"sees."[14] Although

there are surreal, absurd, and abstract films or parts of films, generally the media are realistic from the point of view of the public, and work ever harder at creating special effects that make them more and more so. This is a game the audience appreciates and through which Oscars are won. The realism of plots and stories is often debatable, but the authenticity of the visual surround is expected.[15]

It cannot be a coincidence, although it is not the only factor, that "art" began to move in the direction of stylization and abstraction as photography, with its easy realism, became an important part of visual culture. Rendering the world had become a pointless exercise for "art." "Art," which has now been redefined as something mystical, has turned toward rendering less the real than the imagined or spiritual world, often offering a critique of the society that is excluding it and of photography that is usurping its position. The cry of "art" is that it is a higher "truth" and artists have become prophets crying in the wilderness of a growing consumer society. Besides this grand mission, lacking a social mandate, "art" does not know what to render or how except in negatives. This is how Jimmy Durham puts it:

> I ask what sort of art can one make, and strike from the list art that is instructional, confrontational (people would just pretend to be confronted), "puzzle" art, in which one has only to find the answer and then one need not look at it any more, intellectual art that cancels sensuality, sensual art that cancels intellectuality, art that attempts only the smallest ambition or complexity, art that tries too hard, "properly balanced" art, and most certainly "delightful" art, and as I've said earlier art that is simply a gesture within the art world.[16]

There are, therefore, two competing visual systems with two opposing styles that are locked in combat—a huge world of media and a small world of "high art." Combat notwithstanding, they borrow from each other and continually intersect. Pop art lets the world of commerce into "high art" while the media strive to become "high art" on their own. In fact, everything from folk art to comic books is claimed to

be "art" by someone or other.[17] There is an indistinguishable line between collectibles such as kewpie dolls and Van Gogh. It is hardly a surprise that one of the questions sounded by most authors on culture deals with what is art.

The United States has been the economic and cultural arbiter for the last half century. The nation is associated with both modes of visualization that have had global impact: the Hollywood film, which has reached every corner of the globe and is usually preferred to local cinema, and abstraction, especially as in the work of the abstract expressionists that has become a lingua franca of modernist art. Instead of the separate nations and cultures that existed in the past, there is a growing common culture with regional variants. American rock lyrics provide a common thread—everyone knows them—and then each area also raps in its own language about its own concerns, for itself alone.

ON THE MARGIN

> So the metaphysical pedestal upon which art gets put . . . is a political translocation as savage as that which turned women into ladies, placing them in parlors, doing things that seemed like purposive labor without specific purpose—viz., embroidery, watercolor, knitting: essentially frivolous beings, there for the oppressor's pleasure, disguised as disinterested.[18]

Danto's astute comment is without the historical or sociological context that helps to explain this situation. Curiously but not accidentally, the Western concept of art emerges about the time when images and things considered art begin to play less of a role in society. Society can exist fine without art. It is coeval with the Industrial Revolution and the power of machinery—machines are a growing category of things developed in the nineteenth century, until recently and usually not considered art but so much a part of everyday life that we can't do without them.[19] The concept of art emerges at an interesting time in Western art history. Cycles of archaic (sometimes called primitive),[20] classical, baroque, and rococo, as subsequently chronicled by Wölfflin, had

completed themselves; and in fact by 1800 a new era was beginning in which the search was on for some outside source of inspiration, signaling a kind of poverty or inability to connect with the central powers and functions of society from within.

Danto and others put this break closer to 1960 and at the end of "master narratives." I see a major change with the neoclassic because the neoclassic is the first truly "borrowed" style, one borrowed in a very different sense than did the Renaissance. To Winckelmann and his contemporaries, Greek things were austere, alien, and new—quite different from the well-known Roman ones. To the late eighteenth century, the Greek was a kind of primitive that rid European visual culture of the excesses of its own rococo. The first outside source, in my view, was the Greek in neoclassicism, followed by exoticisms of increasingly distant and intense kinds, from Orientalism to the South Seas and eventually to the discovery of the African primitive around 1900. The twentieth century continued the pattern of exoticism, turning to more and more extreme expressions of it such as holes in the earth, fat, felt, and fern. This progressively wider search for new global "ancestors" and authenticity for "art" that can't be found at home is probably nearing exhaustion. In the technological era art has been inextricably bound up with the exotic. The avant garde is associated with this process. Each generation rejects more of the tradition of the past in the search for something new for "art" to do and progressively leaves the majority of the population with its textual era ideas of art behind. This process is already evident in the nineteenth century and quite speeded up in the twentieth. The avant garde literally takes art to the margins of society.[21]

The eighteenth-century concept of art removed all traces of the craftsman—painter, sculptor—and in the generic term "artist" suggested a supersensitive person or genius whose role was as much spiritual as aesthetic.[22] Duchamp articulated the idea that in fact the artist's life was as or more important than his art: "I now believe that you can quite readily treat your life, the way you breathe, act, interact with other people, as a picture, a tableau vivant or a film scene so to speak."[23] The artist's task was now to embody both in life and work transcendent values

formerly associated with religion. Art becomes a religion celebrating creativity, recognized as originality, at a time when actual religion is on the decline.[24] If ever art served religion, now religion serves art. The new role of art as a symbol of creativity, originality, and uniqueness becomes progressively a critique of the Industrial Revolution with its machinery replicating things. Since there is no need for the artist as defined above in the technological world, artists create a new world for themselves on the margins. Industrial designers, thought of as craftspeople, take on many of the design tasks of industrialization. There is, then, a major split in the approach to things: the old-fashioned images and things are being produced as sacred objects, while the ever-growing technological things are being produced as practical commodities.

Until recently, art has been a lucrative investment and has therefore been in danger of commodification. This may be good for the artist but presents a problem for the "mystique" of art. Many artists have been creating earth art, video art, installations, or self-destructing art in order to make their work uncollectible and outside the system. The absurd conclusion of the mystique of art is non-art. The spiritual/genius artist is a critic by necessity—having no apparently "useful" work to do for his culture, his or her role is to comment on what the mainstream does, usually in a negative light. Even when mainstream things and ideas are borrowed, they are translated critically.

The eighteenth-century concept of art was created to give things that in traditional societies needed no justification a philosophical ideology which would provide for their existence in an era when economic and social forces no longer did. As such things required education to be appreciated, they were progressively more limited to an elite. At present artists like Kosuth are "philosophers" and their works are meaningless visually without the theory.[25] In effect, conceptual art writing has finally overcome the image in something of a pyrrhic victory, since the media have pushed writing to the side. It is reasonable to state that most ordinary (even college-educated) people are estranged from modern and contemporary art, especially abstraction, and prefer

nineteenth-century art, particularly impressionism. Thus the world of this marginalized "high" art is very small. Tom Wolfe's satire added it up thus:

> . . . if it were possible to make a diagram of the art world, we would see that it is made up of (in addition to the artists) about 750 culturati in Rome, 500 in Milan, 1750 in Paris, 1250 in London, 2000 in Berlin, Munich and Dusseldorf, 3000 in New York and perhaps 1000 scattered about the rest of the known world. That is the art world, approximately 10,000 souls—a mere hamlet!—.[26]

ABSTRACTION

The marginalized art of late capitalism and the technological era has gradually turned against the aestheticism that gave things a new life under the dominion of writing. Aestheticism as a goal was declared bankrupt, perhaps because the media had taken it over so successfully. It happened over time—it is now suggested that the last throes of aestheticism were in modernist art. The understanding that "art" did not exist except insofar as someone designated it as such was brilliantly demonstrated as early as 1917 by Duchamp's urinal exhibited as *Fountain*. If at any time "art" died, that was it. Nevertheless, almost a century of artists have taken the Duchamp idea and explored the question of "art" to the satisfaction of those interested in contemporary things. As it is generally noted, art has turned inward to explain and explore itself. Similarly, abstraction began as stylization but through nonobjective representation, because it was a study of the means of art (line, color, size, etc.) without external references, and ended in absolute statements, such as all black, red, or white paintings lauded by some critics.[27]

Although abstraction had its own aesthetic underpinning, it was also a political gesture referring to the total "freedom" of the artist under capitalism, in contrast to communism which favored a realistic style as being more popularly comprehensible. Serge Guilbaut has argued that abstraction became the favored art of the United States to express neutrality and freedom of expression, which were a part of the ideology of the cold war.[28] While conceding artistic freedom, the person on the street in the West sees nothing in abstraction, and the comment that their five-year-old daughter can do as well is repeated by journalists ritualistically every decade or so.[29] That comment is based on the old aestheticist idea that a work should show skill. The attractive abstract paintings of chimps, such as Betsy's made in the 1950s, have added to the public's disdain and to the philosophical debate about "art."[30]

Regardless of the ideological issues about abstraction within the West, that mode of making images has conquered the world almost as successfully as Coca-Cola and Adidas without a penny being spent on advertising. The phenomenon of the global acceptance of abstraction as a visual lingua franca is one of the most interesting aspects of the twentieth-century art world. One of the things it signifies is that there is now one global art style with many local variants but all ultimately related. While the attitude to the United States politically and economically is often negative, it is positive to its much maligned mass culture. This ambivalence is illustrated by Mexicans who call Coca-Cola "las aguas negras del imperialismo" (the sewage of imperialism) while sipping it cheerfully.

PRIMITIVISM

Primitivism is a phenomenon coeval with industrial capitalism, both in art and general culture. In general it is a search for roots, authority, and authenticity outside the recent past or present culture. On one level it is a disenchantment with the Judeo-Christian religion and a search for a pagan or non-Western alternative. This once included the Greeks, and as suggested above I will consider neoclassicism a primitivist move. At the same time, in later European art primitivism was often a move against classical art, seen as the dominant tradition (insistence) of the West, to which African and Gothic art were contrasted.[31] Primitivism is a complicated phenomenon in which the relations of styles and their significance vary depending on the context at a given moment. (Traditional African "art" is now so accepted that it is called classical and even extinct and no longer inspires transgressive passions.)[32]

The earlier primitivist attitude of Henry Moore is typical, in that he sees the various exotic styles as commodities in a market from which he picks and chooses—he prefers the underused Mexican past to what he sees as the overused African as a strategy of influence:

> But then I began to find my own direction, and one thing that helped I think, was that Mexican sculpture had more excitement for me than Negro sculpture. As most of the other sculptors had been more moved by Negro sculpture, this gave me the feeling that I was striking out on my own. Mexican sculpture, as soon as I found it, seemed to me true and right, perhaps because I at once hit upon similarities in it with some eleventh century carvings I had seen as a body on Yorkshire churches.[33]

Finding his own special source in Mexican art is a colonizing attitude of spiritual conquest that will make him great and special. Connecting it with Yorkshire churches and his boyhood suggests that all this already existed once in Europe or in the European mind, and the Primitive is really needed only as a catalyst to get back to some more ideal ancient culture of one's own. In another passage he describes modern art as a process of stripping:

> Since the Gothic, European sculpture had been overgrown with moss, weeds—all sorts of surface excrescencies which completely concealed shapes. It had been Brancusi's special mission to get rid of this undergrowth and to make us once again more shape conscious.[34]

Primitivism is thus a critique of industrial technological society, which is stripped away to reveal a more perfect archaic world. The West is defined largely as Renaissance to 1850, with the medieval periods seen as its local "primitive." Greek art plays the role of stripping off the "excrescencies" of the rococo, but is later lumped with the despised aestheticizing classical styles. Or, to put it another way, the primitive has to be more and more primitive to work, like a drug. Greek worked in 1800, but

African was needed by 1900. I have seen a steady process of the appreciation and collection of rougher and cruder works from the 1960s to the present. While collectors preferred nicely carved and polished statuettes from Africa in the first half of the century, messier materials, like the fern images of Melanesia were chosen by the adventurous during the second half of the century. Primitivism is thus always courting the overdose that is completely non-art, shapelessness, meaninglessness, death.

Primitivism is not merely a matter of form, but a matter of political and religious connotation. Although most artists were not interested in ethnography and cultural context, using the images as projection rather than study, there are very clear ideas associated with them. The first is of images that have work to do in their social context. Even if the idea was as simple-minded as "magic," it suggested a necessary function that the modern artist no longer had but longed for.

The second concept is community: there is a vague idea that in archaic and medieval times people belonged to a civic and religious community, in which they were participants rather than spectators, quite different from the alienation of the modern individual in mass society. Western people see an imaginary freedom in primitive life without constitutions or dogmatic sacred texts and their officiating bureaucrats and priests. Being closer to nature and to the land has always been an aspect of primitivism, but it has been particularly pronounced during the second half of the twentieth century. The various archaic petroglyphs and lines in the desert became models for an earth art in the 1970s and 1980s.[35]

Primitivism is a nostalgic longing for the social and natural connectedness archaic humans are supposed to have had with the functioning centrality of its objects of power. It is mostly the reverse of the feeling of modern disconnectedness and is in no way related to actual archaic conditions. How many could live with the many rules of tribal society like those governing cross-cousin marriage or practices like witchcraft? How many imagine utopias that were not there? Gauguin's highly idealized Tahiti, once a complex, stratified chiefdom, was by his time in a state of social collapse due to Westernization.

Modern art has classified primitive things as art, so that primitive art could be its source of authenticity. Therefore primitive and modern art are a part of the same phenomenon and have been exhibited in the same museums by the same cultural entrepreneurs. Primitivism has been until recently an ideology of the elite. Some nonartistic aspects of it have become a part of popular New Age beliefs that are mainstream. There has been a rash of Hollywood films recently with Indian wise men protecting the land from technological depredation. For most people, even those taking "Indian" herbal medicines, primitive art is as weird and hermetic as modern art, and it has an even smaller museum audience.[36] In its intense and artistic form, primitivism has been on the margins with the elite of the art world.

The modern artist is quite consciously conceptualized as a primitive healer called a shaman in Siberia. In various parts of the world, native healers go into a trance to get in touch with the supernatural and bring back the soul of an ill patient or find the source of game.[37] In the earlier part of the twentieth century they were described as insane and having a special malady: "arctic hysteria." By the mid-twentieth century the concept of the shaman had been transformed into a metaphor for the artist; the artist is now identified as someone on the edge of madness who can ascend or descend into realms of unconsciousness unavailable to others and bring back gifts for the community in the form of works of art. The shaman was seen as the "first artist."[38] The concept of the shaman blended well with the idea of the extraordinary gifts of the genius. The contemporary artist is defined as a marginal person who risks his own sanity for the benefit of the group. While this does not describe all artists, some of whom are practical businesspeople, it is a general idea widespread especially since Van Gogh's madness and artificially fostered by some like Joseph Beuys.[39]

What is striking in this model is that the primitive prototype of the artist is a religious practitioner who usually doesn't make objects. The artist is thus given a spiritual vocation, in lieu of a practical one.[40] While rituals may prescribe the making of objects in archaic societies, religious specialists are rarely carvers or painters. Native shamans usually commission their costumes and objects. The shamanistic spiritualism of the artist in the modern era is another construct to confer high status on someone whose works are of only marginal importance to the group as a whole.[41]

HIDDEN TEXT

The millions who go to see Impressionist exhibitions every year experience the paintings visually and need no explanations of poppy fields, women with umbrellas, or breakfast tables in the garden. It is unlikely that most are familiar with Choiseul's theory of color that lies behind some of the painterly experimentation. The paintings are being experienced as visual beauty. Much twentieth-century art cannot be visually experienced as beauty and requires a knowledgeable viewer who is familiar with a variety of texts, the most critical being the naming and analyzing of various art movements, often the theories of the artists, and even the various movements and artists in relation to each other and their interconnected moves. Such texts existed in earlier works too, but they were visually enjoyable without them. A canvas with squares of variously shaded blacks is, however, more of a theoretical than a visual delight. Since people uneducated in modern art assume that art is beauty, as defined in the textual era, they are at a loss with contemporary art that is theory, such as conceptual art.

A hidden text also operates in non-Western works, which are rarely available simply as "beauty" unless they can be related to something already classed as "beautiful" in Western art.[42] Museological custom affixes notes to labels, such as "Mask used in initiation rites" so the viewer can create a mental context and meaning for the object. Only a small proportion of "art" is available to the Western viewer through its visuality, most of it from the Renaissance to 1960s. All the rest of the things operate with texts, some explicit, some hidden. Contemporary art is particularly text driven and, unlike the case of the ethnographic mask, the text not included in the label, thus challenging would-be viewers to do their homework before looking.

It goes without saying that, by contrast, the visual media are quite explicit in providing "beauty" (even

bad films often have good cinematography) and adequate textual references. They are user-friendly. Much criticized for the passiveness they create in their viewers, they are opposites of the hermetic arts on the margin that challenge by difficulties. But the media also know the power of subliminal visuality and emphasize that rather than focusing on text. These strategies have the predictable result of the mass media having a mass audience, with the "arts" restricted to a small, elite, intellectual cult whose price of admission is education in the literature of the cult.

TALKING BACK

Cults operate by exclusion. In an ironic twist of fate, while Western artists have been turning to the primitive—however defined—for inspiration and authority, artists in the non-Western world have been busy assimilating modern art.[43] Modern art and especially abstraction work well as a global style, since they have no culture-specific content and are not strictly bound to a traditional Asian or older European culture. Since the end of the cold war, the Americanism of abstract art is less apparent than its temporal aspect; for the non-West it operates as a symbol of the modern against the traditional. In that sense non-Westerners understand that it is associated more with a level of social integration in which they too can participate, rather than the local insistence of a particular culture. While the West has been nostalgic for the archaic, the non-West has been progressively adopting the modern and casting off some of its traditions. Modern art is an important visual symbol in that process.

In 1976 I visited an exhibition of the Santa Fe School of Indian Art expecting to see native crafts and paintings of rituals. Instead I saw abstractions and modernist paintings with native titles in the company of an angry curator who blasted whites for wanting Native Americans to be segregated in their "traditional" arts while they wanted to join the mainstream of contemporary art. They wanted the chance to be Picasso. This was my introduction to the world of Native Americans apart from the nostalgia of

archaeology. The trouble was, my guide explained, there was only a market for traditional crafts and none for contemporary native art. No one bought the Indian abstractions. For Anglos the good Indian remains the traditional Indian. This complaint is voiced over and over again by third world artists who do not wish to be considered regional but mainstream. Rashid Araeen, editor of *Third Text,* has written eloquently and extensively about this wish not to be classified into a traditional style.

> Somehow I began to feel that the context or history of modernism was not available to me, as I was often reminded by other people of the relationship of my work to my own Islamic tradition . . . Now I am being told, both by the right and the left, that I belong to the "Ethnic Minority" community and that my artistic responsibility lies within this categorization . . . you can no longer define . . . classify or categorize me. I am no longer your bloody objects in the British Museum. I'm here right in front of you, in the flesh and blood of a modern artist. If you want to talk, let us talk. BUT NO MORE OF YOUR PRIMITIVIST RUBBISH.[44]

There is of course no single third world voice, and there are also traditionalists too eager to cooperate with the many agencies and institutions that have been set up by the West to maintain native traditions. The majority probably want a little of both. But anyone ambitious who wants to break out of the regional category and become a "universal" artist finds that outside of the West this is impossible.[45]

The problem, as it was set up in the eighteenth century, is in a way unsolvable. Western culture described itself as rational and scientific (not that it really was) and ascribed to other cultures—primitives and non-Westerners—the irrational, creative, as well as violent, passions it denied to itself.[46] In Freudian terms it can be said that feelings are repressed in the West, projected onto non-Western others. They are "repossessed" through the collection, study, identification, and even intercourse with the others. As Malraux's French hero writes to his imaginary

Chinese correspondent: "How can I find myself except in an examination of your race?"[47] The desire to possess something of the primitive—art, drumming rituals, etc.—is to be in touch with a denied aspect of one's own self that is projected onto others. One of the century's great primitivists, Bataille, actually planned to enter into another era's emotional mindset by performing a human sacrifice and even had a willing victim. Westerners are brought up to think that "primitives" have a greater access to cosmic truth and must somehow be contacted to get in touch with it. Therefore, there is an absolute need for these others to exist and to go on existing. If the native people become modern and join the West, the other is lost. For different reasons Europe and the United States have had a great vested interest in keeping the culture of other natives going, as the many well-meaning art schools started by Westerners in third world areas indicate.[48] We are always trying to preserve arts in danger of "dying" out. Primitivism is the inner self of many in the West, and the primitive needs to exist as a separate entity for the West to feel whole.

Modernism is the longing of the non-Western world to belong to the ruling level of social integration. Even in remote areas of Melanesia, natives have used planes in "cargo cults" to join modernity symbolically and have fashioned the detritus of Western material culture, pink curlers, into new creations either disdained as nontraditional or accepted with amusement as the play of children in National Geographic photographs taken by Westerners. Non-Westerners have been appropriating the West in great gulps seriously, comically, critically. We all know about the all too successful U.S. Native American casinos, but even the remote Amazon Indians are savvy in filming themselves on video cameras to raise funds from foundations, and have figured out the visual taste of their targets.[49] Moreover, non-Westerners are also interested in each other and taking over the pleasures and tasks of exotic travel and ethnography.[50] What native or regional artists want so badly is to be members of the marginal, elite, exclusive club of high art, with its spiritual seal of approval and prestige. They want to

augment Tom Wolfe's art world of ten thousand by being included in it as well.

Although there is still resistance to non-Western modern art, shows such as contemporary African art exhibits are beginning to happen, and in time there should be no difficulty in making contemporary art global.[51] It causes enormous problems of classification in museums, which are organized by periods in the West and by geographic areas in the non-West. Malraux once observed that "Primitive Art does not break into the museum, it burns it down."[52] But in fact traditional non-Western things fit in quite well with the rest of the material. It is non-Western contemporary art that blows the fuses.

MELTDOWN

The lithograph *Indian in Paris* (1976) by Fritz Scholder has long represented for me the meltdown in ethnic or national identity in contemporary art. It's

Figure 10.2 Fritz Scholder, *Indian in Paris*, 1972.
Courtesy Fritz Scholder.

not a romantic nineteenth-century Indian painted by Catlin or Müller. The figure is heavy and bedecked in the requisite paint and feathers. He eclipses in size the Eiffel Tower in the background. Does it say, "We have finally taken over the world [Paris: the world of art]; primitivism has won"? Or is it Paris and the system of art that have won with the print medium and representational style? These meanings cancel each other out. Scholder's Indianness is complex. He is one-fourth Luiseño but has also French, German, and English ancestry. He says his lithograph is based on an old photo of an Indian chief in Paris.[53] This representation is not a case of Orientalism with its voyeuristic evocation of a mysterious exotic, but an assertion that the primitives are here in our cities and they are us. Ruskin hoped that the "Red Indian" in us could be held in check. But the Red Indian is in Paris and primitivism and modernism have blended to such an extent that it is impossible to tell where one stops and the other begins.

Since the 1970s the categories West/non-West have begun to fuse—curiously enough, in the form of photography, with which this chapter began. Beyond the global language of abstraction, photography creates a seamless medium to blend cultures and also high and low art. Lucy Lippard is there with Native Americans commenting on photographs of themselves in both native and Western dress.[54] Since we now know how a "pure" nativeness was constructed with photography at the turn of the century, native dress begins to look like costume and modern dress reality. We prefer the "authenticity" of the modern hybrid to the nostalgic reconstructions of the past.[55] In fact, the current nostalgia is precisely for natives in modern dress or modern contexts in photographs by native photographers (Fig. 3.1). Whether it is the African Seydou Keita[56] or the Peruvian Martín Chambi,[57] the search is on for native photographers photographing themselves in the process of transformation from a traditional to a modern culture. Collectors, dealers, and auction houses are interested in such photography, at the expense of the earlier, entirely traditional native arts. Both West and non-West are thus beginning to focus on a universal medium, handled in universal terms throughout the world. This seems to be a welcome hybridization or cosmopolitanism to some

intellectuals, who are likely to debate the extent and dangers of globalism to the strength and value of resistance against it for some time to come.[58]

LOCALIZATION

The crude uniformity of a modern or future world pictured in science fiction is a hard-core vision that does not correspond to current reality. Diversity is in fact created not just from the "bottom" but also from the "top" by the corporate world. When products are marketed internationally, the process does not stop at linguistic translation. The product is "localized," in corporate terminology, by being fitted into local tastes and prejudices. This is as true of soup flavors as of video games. Diversity is also created by the corporate world. I am suggesting that a process of localization also exists in the art world, creating various niches for different products. Take modern Australian Aborigine art—within that there is country art and city art. The country art idealizes "traditional" Aborigine life. Uta Uta Tjangala's painting (Fig. 10.3) is one of the good examples of "country" art. The city art is a critical modernist depiction of the fate of the Aborigine in modern society. The consumer can choose which image she or he prefers to own or look at. I imagine Aborigine photography is not far behind.

POSITIONS

Before writing or with early writing, things and images dominate communication and there is no problem about their necessity as technologies. Some cultures use them more, some less, but image systems are taken for granted like tool systems. They are neither deified nor demonized, although the things may have within them powers for life or death that affect their makers and users. Primitivist romantics are correct in diagnosing a very special role for the makers of things in archaic society—something that is visible to us too in the objects. It is hard to imagine that we will ever not be nostalgic for the self-assured centrality of those things. I can look at the fantastic New Ireland masks (see Fig. 6.1) and weep—the conditions for their creation are gone forever.

Figure 10.3 Uta Uta Tjangala, *Untitled,* 1971. Australian Aborigine, polymer powder paint on composition board. Courtesy Fine Arts Museums of San Francisco, Gantner Myer Aboriginal Art Collection, 2002.70.1.

At all subsequent times, painting, sculpture, and whatever is called "the arts" coexist with other, more powerful communications media. The effect of writing is to create a dualism between the rational and the emotional and the relegation of the visual media to the realm of the irrational, the feminine, the sick—in effect, the other. Geniuses themselves may bring forth their cultural gifts out of sickness. Iconoclasm and aestheticism are in textual cultures the two sides of the coin—one forbidding representation, the other demanding merely that it be beautiful. Works still have cognitive power, but this is less obviously utilized by the culture at large. Works are feminized into evil or desirable seductiveness. I have always felt that the tradition of the female nude in Western art expresses the pathos of the condition of image making in a textual world—voyeurism.

Postindustrial conditions are even more complex, in that the visual and textual worlds are still opposed as before, but the visual world is split by the technological media. The technological media threaten

both the textual tradition and the traditional "artist" tradition. The artist tradition is now culturally unnecessary and has turned itself into a minor, esoteric cult in order to survive on the margins of society. The media have perhaps acquired a position of centrality and don't seem to be fazed by attacks in texts or form the artistic margins. They may be close to defining cognitive communication for us in a subliminal way. The marginal arts imitate the archaic and envy its former centrality. The media do not imitate the archaic; they repeat their self-assurance. Perhaps I need not weep for the New Ireland masks: Oscar spectacles on TV are structurally in a similar place, and whether I like them or not I cannot help knowing something about them with the rest of my society and belong through them.

Although divided by internal conflict, the present era has a strong visual culture with the centrally located media and the marginally located critical arts. Each is rich in itself and in their interactions. What there isn't at the current time is a duality of text and

image resulting in the aestheticization of things we associate with many traditional, royal, aristocratic cultures. We have, in effect, the world of the Balinese gamelan and the world of the Grateful Dead, but we do not have the world of Mozart. We do not have things midway between the center and the margins. The things of that past are embalmed in our museums and concert halls. If indeed these are a matter of "positions" in society, there is no reason why future situations might *not* bring forth other types of things.

What I am suggesting is that the position of things and images in society determines their basic form and significance. Although world history indicates a beginning in the center and a progressive move to the margins, the media indicate that central positions can be retaken by different visual traditions. Similarly, therefore, there is no teleological reason for not having visual traditions in any position at future times. Art does not evolve in a certain direction; it has certain positions with certain possibilities that can be exploited.

NOTES

1. I always marveled at Carl Sagan's naive assumption that outer space technological cultures would recognize the European style outline of the male and female figure on the message sent to the universe.

2. Malraux puts this malaise in an imaginary correspondence between a Frenchman and a Chinese, echoing Montesquieu's *Lettres persanes,* as a critique of European civilization. ". . . Rome, I am unable to hide my disgust . . ." André Malraux, *The Temptation of the West* (1927; Chicago: University of Chicago Press, 1992), 28.

3. Francis Fukuyama, "The End of History," *National Interest* 16 (1989): 1–18.

4. Bernard Barber, *Jihad vs. McWorld* (New York: Random House, 1995.

5. Andre Gunder Frank, *ReOrient: Global Economy in the Asian Age* (Berkeley: University of California Press, 1998).

6. Alfredo G. A. Valladao, *The Twenty-first Century Will Be American* (London: Verso, 1996).

7. There are many references to the death of art, but also to the death of history, art history, and science, written in an apocalyptic fin de siècle mood. Characteristically, everything is considered "post." Lewis Mumford has a "post-historic man" as early as 1956. Lewis Mumford, *The Transformations of Man* (New York: Collier Books, 1956). Arthur C. Danto, "The End of Art," in *The Philosophical Disenfranchisement of Art* (New York: Columbia University Press, 1986), 81–115. Hans Belting, *The End of the History of Art* (Chicago: University of Chicago Press, 1987). (The original title was "Der Tod des Kunstgeschichte.") Gianni Vattimo,

"The Death or Decline of Art," *The End of Modernity: Nihilism and Hermeneutics in Post-Modern Culture* (Cambridge: Polity Press, 1988), 51–64.

8. Arthur C. Danto, *After the End of Art,* A. W. Mellon Lectures in the Fine Arts, Bollingen Series 35-44 (Princeton: Princeton University Press, 1997).

9. W. J. T. Mitchell, "The Pictorial Turn," in *Picture Theory* (Chicago: University of Chicago Press, 1994), 11–34.

10. Jonathan Crary, *Techniques of the Observer* (Cambridge, MA: MIT Press, 1992). "The simplest way to put this is to say that, in what is often characterized as an age of 'spectacle' (Guy Debord), 'surveillance' (Foucault), and all pervasive image-making, we still do not know exactly what pictures are, what their relation to language is, how they operate on observers and the world, how their history is to be understood, and what is to be done with or about them." Mitchell, "The Pictorial Turn," 13.

11. Walter Benjamin, "The Work of Art in the Age of Mechanical Reproduction," in *Illuminations,* ed. H. Arendt (New York: Schocken Books, 1968), 217–252.

12. Jean Baudrillard, *The Evil Demon of Images,* Power Institute Publication 3 (Sydney, Australia: Power Institute of Fine Arts, 1987), 33.

13. Jimmy Durham. "A Friend of Mine Said that Art Is a European Invention," in *Global Visions: Towards a New Internationalism in the Visual Arts,* ed. J. Fischer (London: Kala Press, 1944), 117.

14. That this "realism" is not truly the "real" has of course been brought out by writers on photography for a

long time. I am using the term "realistic" in its everyday common sense and not in a critical sense.

15. This process of increasing realism is evident also in the new genre of computer games, which began looking like stylized cartoons and now have "realistic" film footage. Realism seems to be a drive of Western insistence and the fact that the technological era is manifesting itself in Western form. The drive toward creating artificial life—of which realism is a part—is also evident in the search for artificial intelligence, human-machine interaction, and robotics. I imagine all these may mix in the future in new media.

16. Durham, "A Friend of Mine Said," 117.

17. Jean Lipman, *Provocative Parallels* (New York: E. P. Dutton, 1975). The process of authenticating one "art" by its resemblance to another is illustrated by books such as Lipman's, in which nineteenth-century folk art is justified as art by comparing it to twentieth-century art. Another process is reclaiming art formerly considered "bad" as "good" art. Wyeth, Rockwell, Bouguereau, and Disney are all being reclaimed, according to a recent article by Solomon. Deborah Solomon, "In Praise of Bad Art," in *New York Times Magazine* (January 24, 1999), 32–35.

18. Arthur Danto, *The Philosophical Disenfranchisement of Art* (New York: Columbia University Press, 1986), 12–13.

19. When antiques, or when futuristically designed, machines are considered "art" too. There have been much publicized motorcycle and bicycle exhibitions in art museums recently, among others. See, for example, Richard Guy Wilson, Dianne H. Pilgrim, and Dickran Tashjian, *The Machine Age in America, 1918–1941* (New York: Brooklyn Museum in association with Harry N. Abrams, 1986).

20. As in the "Italian Primitives" or the "Northern Primitives" of the early Renaissance.

21. Critics sometimes think that it is the heroic artist who leaves society, but in fact it is society that makes the artist useless. See Clement Greenberg, *Art and Culture: Critical Essays* (Boston: Beacon Press, 1961): ". . . the avant-garde succeeded in 'detaching' itself from society." P. 5.

22. The concept of the genius is essential to Kant's idea of the aesthetic, and was developed especially by Schopenhauer. The genius is someone who can perceive ideas in things more broadly and deeply than others. Nietzsche contrasted and advocated a Dionysian type to the more Apollonian genius conception of earlier times. This Dionysian type is eventually conceptualized, not just as emotionally excessive, but as self-destructive as well.

23. Duchamp interview with Jean Antoine, *Art Newspaper* 22, April 1993, 17.

24. Rosalind Krauss argues convincingly about the cult of originality and authenticity in modernism that necessarily coexists with copies and duplication. I am suggesting that this phenomenon in a broader sense exists prior to modernism, since about 1800. Rosalind Krauss, *The Originality of the Avant-Garde and Other Modernist Myths* (Cambridge, MA: MIT Press, 1986).

25. Josef Kosuth, *Art after Philosophy and After: Collected Writings, 1966–1990* (Cambridge, MA: MIT Press, 1993). "There is nothing wrong *per se* with using objects in art—if they as *tools* can cope with the continuing enlargement of the complexity of issues in art. And it is for this reason . . . that *texts* are the necessary result of 'Conceptual Art' activities." P. 84.

26. Tom Wolfe, *The Painted Word* (New York: Bantam, 1976), 27.

27. Greenberg, *Art and Culture.* "Retiring from the public altogether, the avant-garde poet or artist sought to maintain the high level of his art by both narrowing and raising it to the expression of an absolute . . . subject matter or content becomes something to be avoided like the plague." P. 5.

28. Serge Guilbaut, *How New York Stole the Idea of Modern Art* (Chicago: University of Chicago Press, 1983). "Just as Guggenheim had argued in 1944, when the world was fighting fascism, that merely to do modern painting was to take political action against Hitler, so now in 1948 Fiedler argued that modern artistic expression served to defy communism" (p. 187).

29. Julian Schnabel occasioned the last one I remember.

30. Desmond Morris, *The Biology of Art: A Study of the Picture-Making Behaviour of the Great Apes and Its Relationship to Human Art* (New York: Knopf, 1962).

31. This is a late move in that at their inception the Gothic and classic revivals happened at the same time.

32. Susan Vogel, "Extinct Art: Inspiration and Burden," in *Africa Explores: 20th Century African Art* (New York: Center for African Art 1991), 230–239.

33. John Russell, *Henry Moore* (Harmondsworth, Middlesex, England: Penguin Books, 1968), 28–30.

34. Russell, *Henry Moore,* 63.

35. Lucy Lippard, *Overlay: Contemporary Art and the Art of Prehistory* (New York: New Press, 1983). Lippard is an enthusiastic chronicler of all imagined native "precursors." The connection is sometimes very specific: one well-known earth art artist, Michael Heizer, is the son of a Mesoamerican archaeologist who excavates ancient sites.

36. A recent advertisement on TV showed great works of art one after the other, including a Michelangelo, the *Mona Lisa,* and for last a pre-Columbian sculpture. The

Western works were photographs of the authentic pieces. The pre-Columbian carving was a crude invention that evidently was included because the assumption is that the audience did not know and did not care.

37. Shamanism received its canonical description in Eliade, who based it in part on the Indian philosophy of yoga and wrote it in a French intellectual climate deeply imbued with primitivism. Marcel Mauss lectured on the subject and it interested Georges Bataille. Mircea Eliade, *Shamanism: Archaic Techniques of Ecstasy* (1951; Princeton: Princeton University Press, 1964).

38. Andreas Lommel, *Shamanism: The Beginnings of Art* (New York: McGraw-Hill, 1967).

39. Beuys spread a legend about himself that was "shamanistic"—how after the crash of his World War II plane in Russia nomadic Tartars saved him by covering his body in fat and felt and thus he emerged as an artist making things out of fat and felt. While the authenticity of this story is doubted by many, it indicates the primitivist origin myth the artist chooses to create for himself. Caroline Tisdall, *Joseph Beuys* (New York: Solomon R. Guggenheim Museum, 1979), 16–17. For the critique, see Benjamin H. D. Buchloh, "Beuys: Twilight of the Idol, Preliminary Notes for a Critique," *Artforum*, January 1980.

40. It is obvious that this model is close to psychoanalysis with the concept of entering the unconsciousness to effect a cure and emerge healthy. But then, a lot of the language of psychoanalysis is anthropological.

41. Shamanism became especially popular during the drug culture of the 1960s, since some shamans use drugs to get into trances. There are probably more shamans outside of Siberia these days than inside. Schools teach shamanizing on the East and West Coasts of the United States, and "drumming" is a popular way to get in touch with mystical forces. The word "shaman" is now applied to any spiritual practitioner outside organized religion.

42. In the 1998 Exhibition of Native American Art from the collection of Val and Chuck Diker at the Metropolitan Museum in New York, the owners gave out a leaflet explaining how they see their collection. A Northwest rattle was described as a "'Calder' of American Indian art," a Wishram figure was reminiscent of Egyptian sculpture, a Washo basket was made by Datsolalee (the "Picasso" of basketmakers), a Crow shirt was for them an abstract painting—there were also a "Miro," a "Reinhardt," and a "Jackson Pollock." It is worth noting that the museum labels were exclusively anthropological and avoided such comparisons.

43. Deborah Willis, "Talking Back: Black Women's Visual Liberation through Photography," in *Transforming the Crown: African, Asian & Caribbean Artists in Britain, 1966–1996*, ed. Mora J. Beauchamp-Byrd and M. Franklin Sirmans (New York: Caribbean Cultural Center, 1997), 63–68.

44. Rasheed Araeen, "From Primitivism to Ethnic Arts," in *The Myth of Primitivism*, ed. Susan Hiller (London: Routledge, 1991), 162, 172.

45. This is not merely a problem of the ethnic artist, but also of the "regional" artist within the West. Artists in the Southwest and Maine are supposed to paint local scenes and landscapes and not to impinge on the "universal" themes of Metropolitan artists. Edgar Allen Beem, *Maine Art Now* (Gardiner, ME: Dog Ear Press, 1990). "To the extent that the best Maine artists participate in the national and international art dialogue, they may be losing their regional identity, but that is not necessarily a bad thing." P. xviii.

46. Malraux attributes this division of "intellect" and "feeling" to Western and Chinese traditions. As a Westerner torn by "anguish," he desires the "calm" and "wisdom" of the East. *The Temptation of the West* (Chicago: University of Chicago Press, 1992).

47. Malraux, *Temptation of the West*, 39–40.

48. Dorothy Dunn was one of the first to form the idea of having natives represent themselves and their "art" in forms accessible and salable to Westerners in the American Southwest. Dorothy Dunn, *American Indian Painting of the Southwest and Plains Areas* (Albuquerque: University of New Mexico Press, 1968). Geoffrey Bardon played a similar role among the Australian Aborigines. Geoffrey Bardon, *Papunya Tula: Art of the Western Desert* (South Yarra, Victoria, Australia: McPhee Gribble, Ringwood, 1991). See also James Houston, *Confessions of an Igloo Dweller: Memories of the Old Arctic* (Boston: Houghton Mifflin, 1995). The phenomenon of Western entrepreneurs in native art was first discussed cross-culturally in Nelson H. H. Graburn, ed., *Ethnic and Tourist Arts: Cultural Expressions from the Fourth World* (Berkeley: University of California Press, 1976).

49. James Clifford, lecture, Columbia University, 1998.

50. Tete-Michel Kpomassie's book about his trip among the Eskimo is an indication of a new world not strictly divided between West and non-West. Tete-Michel Kpomassie, *L'Africain du Groenland* (Paris: Flammarion, 1981).

51. Vogel, *Africa Explores.*

52. André Malraux, *The Voices of Silence,* Bollingen Series 24 (1953; Princeton: Princeton University Press, 1978), 543.

53. Fritz Scholder, personal communication, 2003.

54. Lucy Lippard, ed., *Partial Recall* (New York: The New Press, 1992).

55. James Clifford illustrates a famous photo of Franz Boas and George Hunt holding up a blanket to cut out the view of a white picket fence and other elements of modern life from a Northwest Coast native woman and a child to be photographed. James Clifford, *Predicament of Culture* (Cambridge, MA: Harvard University Press, 1988), 186.

56. André Magnin, *Seydou Keita* (New York: Scalo, 1997).

57. Martín Chambi, *Martín Chambi Photographs, 1920–1950,* foreword by Mario Vargas Llosa, introduction by Edward Ranney and Publio López Mondéjar (Washington, DC: Smithsonian Institution Press, 1993).

58. Timothy Brennan, *At Home in the World: Cosmopolitanism Now* (Cambridge, MA: Harvard University Press, 1997).

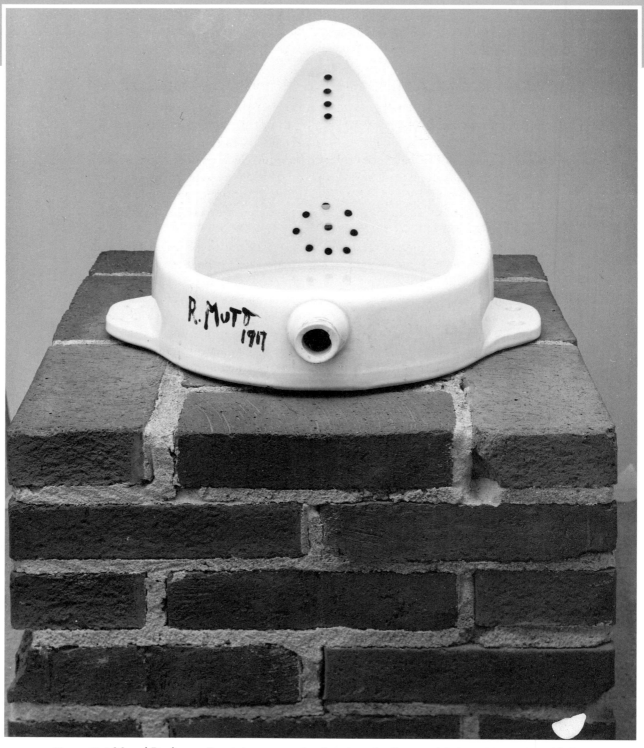

Figure 11.1 Marcel Duchamp, *Fountain*, 1917, assisted readymade. Courtesy Moderna Museet / Stockholm.

Everything made now is either a replica or a variant of something made a little time ago and so back without break on to the first morning of human time.[1]

All things are related to each other in a vast chain of formal transformations. It is not as simple as the nineteenth-century writers thought, developing from naturalism to abstraction or vice versa. It is not as simple as Winckelmann, Wölfflin, and even Kubler thought as cycles of archaic, classical, and baroque. Such tendencies are evident at different times, but on the whole there is no such simple trajectory. How could there be? How could rock paintings turn into chief's thrones and those in turn into painted scrolls? There are interconnections, but they are more structural than visual in nature.

Between levels of different social integration there are major dislocations and reformulations in material culture. I suggest that two processes are at work: translation and innovation. Innovation is almost always necessary at times of change and may effect both the type of object and its style. Innovation can be very sudden and very dramatic. Translation is the term I prefer for the continuous reinterpretation of forms which have in them at least as much change and innovation as is often necessary to translate a statement from one language and context to another. Through a process of translation, a form may last many hundreds of years, but the relationship may be unrecognizable in terms of its appearance.[2]

The mask is an interesting form by which to analyze change through translation, because it existed for such a long time in a variety of cultures. The beautiful and grotesque masks of village cultures do not emerge easily out of the two-dimensional rock images of hunter-gatherers. It has been mentioned above that the earliest masks may have been more planar-conical bark cloth or skin face masks and that only in certain village contexts did they become three-dimensional. It is possible that there is a connection between the various spiritual beings—the persons impersonated by the masks may have been related to the images in the rock but transformed through a process of translation into something almost entirely new. Chiefdoms generally repress masking societies, but they often appropriate the mask forms of the former village. The mask forms are translated by them into new media and new types of objects. The chief may wear headdresses and pectorals in the form of masks in materials like jade and ivory. Figures with masklike heads may represent deities. In the Mesoamerican state of Teotihuacán, stone masks were not meant to be worn by humans but were probably a part of deity/ancestor images. Funerary masks are common in ranked societies. Many Maya glyphs are in the form of masklike faces that can be related to earlier deity masks.

While this evolution of the mask by translation is purely hypothetical, it indicates the nature and magnitude of change in the use and appearance of things across social systems. I am suggesting that the masked impersonator could once

have been represented in a rock image, and that its later forms could include things like sumptuary arts, deity images, and even glyphs. This is not to say that the mask as such does not also survive with reinterpretations in modern theater, Carnival, Halloween, and living room decor. I am more interested in the creative reinterpretations of the image and the creation of new functions for old ideas.[3] In the realm of things and how things are manipulated, there is a great desire to hold on to the objects and their associated meanings from the past. I am always astonished by the images of Paris couture, in which theoretically designers do their best to innovate and shock. Nevertheless, they are all variations on the theme of Western dress—there is nothing even as dramatically different in dressing concepts as the Indian sari or Japanese kimono. Things allow us, or perhaps force us, to connect with the past. With various recyclings and reinterpretations all things are thus interconnected to the beginning of time. It seems to me that translation is appreciated, enjoyed, and applauded, while dramatic innovation is probably unsettling, feared, and perhaps incomprehensible.

My favorite examples of innovation are the Olmec colossal heads. These are among the earliest monumental forms in Mesoamerica. Because of the "realism" of the faces, they have been considered portraits of Olmec rulers. There is no gradual development of naturalism; in fact, the earliest heads are the most naturalistic and the late ones the more conventionalized.[4] These heads coexist with figures with masklike heads in a different style, probably representing deities and relating to earlier tradition. Clearly realism was specified for some images and not others. As I have argued above, naturalism can appear dramatically and suddenly if there is a need for it. In the case of the Olmec, I suppose the technical problem was solved by making a clay model of the face and transferring it to stone, since there is much evidence for earlier clay modeling. I have also suggested that such colossal realism was frightening in its time. Most people prefer what Thompson has called "midpoint mimesis," a kind of stylized, idealized representation that is neither too real nor too abstract. The very real is horrifying even to Westerners used to realism, according to Freedberg. Innovations may, of course,

also be in the direction of abstraction or the minimal. Duchamp's 1917 *Fountain* may be considered such a shocking innovation—so far ahead of its time that it still sums up much of the conceptual art of the twentieth century. By contrast, the development of Cubism seems more like a series of gradual translations. Innovations may be incorporated into traditions, but often they do not last—neither the realism of the Olmec heads nor Akhenaten's style of realistic portrayal lasted very long in their own contexts.

In the history of things, one of the most dramatic changes is not of form but of attitude: the development of aestheticization and the formulation of the category of "art." These mental changes were responsible for formal ones, but it is their cognitive aspect that is most noteworthy, not the sensual one. I have suggested that there have been three categories of objects that have evoked such changes of attitude: objects used as forms of communications technology, objects used as aesthetic treasures, and objects used as sources of transcendence. While all three may have had some aspects of the others, the definition is a matter of emphasis. An era necessarily reinterprets the objects of the past in terms of its own agenda. The eighteenth century saw Rembrandt's art as muddy and messy,[5] while the twentieth century sees it as spiritual and profound. There is no one interpretation of things; it depends on what system of "art" one is working with. In my own taste I find that I move between all three main attitudes quite easily, like Lévi-Strauss's bricoleur. Things do not require you to stay in systems with the consistency of verbal media like philosophy. The world of things is as elastic as Ezra Pound's poetry. The world of things is one colossal flea market containing the most amazing objects, all of which are or were of value and meaning to somebody some time, functionally, aesthetically, and spiritually. How to deal with it theoretically is totally bewildering.

On some level the modern concept of "art" is atrophying because of the progressive inclusion of things in it. The Guggenheim Museum exhibited a motorcycle show; why should not objects of transportation be as exciting to look at as figuration? If the culture decides to broaden the concept of art, the word, as a particular category of things, will have no meaning.

If everything is art, nothing is art. That does not mean the end of things—things go on proliferating in their myriad forms, meanings, and uses. It is only our classification of them that changes. The "art" classification has run its course and things may have to be subdivided in new ways to fit new times.

There seems to be no abatement in concepts of quality, usually expressed as something being "artistic" or not, which affects all things. Large segments of society are involved in discriminating things: museums, dealers, auction houses, art critics, department stores, and kids in school. The ranking of things by designers and brand name artists is built into consumer society and is one of the main avenues of expressing one's identity. The notion of things being better or worse is nearly inescapable. This leads to ludicrous situations, such as one painting having become the most famous and often considered the best in Western art—the *Mona Lisa,* representing the capstone of the pyramid of values. The *Mona Lisa* has become an icon representing the "ultimate" in art and is treated as a religious relic in a glass shrine, almost invisible to the crowds with their videocameras. It is worth noting that its actual visual appearance is irrelevant, since it is known in endless copies. It is the absolute quintessence of ARTness, and in it "art" has reached a point where it is a matter of faith—religion? Why do we need the *Mona Lisa,* as evidently we do?

Altogether, "things" need to be reevaluated against other technologies such as writing and media. In fact, they all need to be looked at together as parts of a systemic and changing whole. This raises basic questions about things and how we relate to them biologically, functionally—and, yes, even aesthetically. Humankind has existed without writing and media for a long time, but thinking with things goes back to Kubler's "first morning."

NOTES

1. George Kubler, *The Shape of Time* (New Haven: Yale University Press, 1962), 2.

2. Esther Pasztory, "The Portrait and the Mask: Invention and Translation," in *Olmec Art and Archaeology in Mesoamerica,* ed. John E. Clark and Mary E. Pye (Washington, DC: National Gallery of Art, 2000), 265–276. This portion of the chapter is based on that article, in which further detail is given.

3. Various scholars have charted the relationship of old and new and what I am calling the process of translation in the study of individual areas. See Michael Grillo, *Symbolic Structures: The Role of Composition in Signaling Meaning in Italian Medieval Art* (New York: Peter Lang, 1997).

4. Various scholars, including George Kubler, made the "Winckelmannian" assumption that the naturalistic heads had to be the later ones, but archaeological context indicates that they are the earliest. Susan Milbrath, *A Study of Olmec Sculptural Chronology,* Studies in Pre-Columbian Art and Archaeology 23 (Washington, DC: Dumbarton Oaks, 1979).

5. Claude Lévi-Strauss, *The Savage Mind* (Chicago: University of Chicago Press, 1966), chap. 1.

BIBLIOGRAPHY TO PART ONE

Alberti, Leon Battista. *On Painting*. 1435–1436. New Haven: Yale University Press, 1956.

Alland, Alexander. *The Artistic Animal*. New York: Anchor Doubleday, 1977.

Appadurai, Arjun, ed. *The Social Life of Things: Commodities in Cultural Perspective*. London: Cambridge University Press, 1986.

Araeen, Rasheed. "From Primitivism to Ethnic Arts." In *The Myth of Primitivism*, edited by Susan Hiller. London: Routledge, 1991.

Ascher, Marcia, and Ascher, Robert. *The Code of the Quipu: A Study in Media, Mathematics, and Culture*. Ann Arbor: University of Michigan Press, 1981.

Balfour, Henry. *The Evolution of Decorative Art*. Stockholm: Aftonbladets Tryckeri, 1927.

Barber, Bernard. *Jihad vs. McWorld*. New York: Random House, 1995.

Bardon, Geoffrey. *Papunya Tula: Art of the Western Desert*. South Yarra, Victoria, Australia: McPhee Gribble, Ringwood, 1991.

Barthes, Roland. *Empire of Signs*. New York: Hill and Wang, 1982.

———. *The Fashion System*. 1967. Berkeley: University of California Press, 1983.

———. *Image-Music-Text*. New York: Hill and Wang, 1977.

———. *Mythologies*. New York: Hill and Wang, 1957.

Bataille, Georges. *Against Architecture: The Writings of Georges Bataille*. Edited by Denis Hollier. Cambridge, MA: MIT Press, 1989.

———. *Lascaux; or, The Birth of Art*. Geneva: Skira, 1955.

Baudrillard, Jean. *America*. London: Verso, 1988.

———. *The Evil Demon of Images*. Power Institute Publication 3. Sydney, Australia: Power Institute of Fine Arts, University of Sydney, 1987.

———. *Simulacra and Simulation*. Ann Arbor: University of Michigan Press, 1994.

Baxandall, Michael. *Patterns of Intention*. New Haven: Yale University Press, 1985.

Beem, Edgar Allen. *Maine Art Now*. Gardiner, ME: Dog Ear Press, 1990.

Belting, Hans. *The End of the History of Art*. Chicago: University of Chicago Press, 1987.

———. *Likeness and Presence: A History of the Image before the Era of Art*. Chicago: University of Chicago Press, 1994.

Bem, Sacha, and Huib Leoren de Jong. *Theoretical Issues in Psychology*. London: Sage Publishers, 1997.

Ben-Amos, Paula, and Arnold Rubin, eds. *The Art of Power: The Power of Art Studies in Benin Iconography*. Los Angeles: University of California Press, 1983.

Benjamin, Walter. "The Work of Art in the Age of Mechanical Reproduction." In *Illuminations*, edited by H. Arendt, 217–252. New York: Schocken Books, 1968.

Bennett, Tony. *The Birth of the Museum*. London: Routledge, 1995.

Benson, Elizabeth P., and Beatriz de la Fuente. *Olmec Art of Ancient Mexico*. Washington, DC: National Gallery of Art, 1996.

Bentley, Jerry H. *Old World Encounters*. New York: Oxford University Press, 1993.

Binford, Lewis. "Archaeology as Anthropology." *American Antiquity* 28, no. 2 (1962): 217–222.

Birkerts, Sven. *Readings*. St. Paul, MN: Graywolf Press, 1999.

Blier, Suzanne. "Beauty and the Beast." In *African Art as Philosophy*, edited by Douglas Fraser. New York: Interbook, 1974.

Boas, Franz. *Decorative Designs of Alaskan Needlecases*. In *Proceedings of the United States National Museum*, vol. 34, 321–344. Washington, DC: GPO, [1908].

———. *Primitive Art*. Oslo: Aschehoug, 1927. New York: Dover, 1955.

Borgatti, Jean M., and Richard Brilliant. *Likeness and Beyond: Portraits from Africa and the World*. New York: Center for African Art, 1990.

Bourdieu, Pierre. *The Love of Art: European Museums and Their Public*. Cambridge: Polity Press, 1990.

Braun, Barbara. *Pre-Columbian Art and the Post-Columbian World*. New York: H. N. Abrams, 1993.

Brennan, Timothy. *At Home in the World: Cosmopolitanism Now.* Cambridge, MA: Harvard University Press, 1997.

Brett-Smith, Sarah. "The Masks of the Komo." *Res* 31 (1997): 71–96.

Brilliant, Richard. *Portraiture.* Cambridge, MA: Harvard University Press, 1991.

Buchloh, Benjamin H. D. "Beuys: Twilight of the Idol, Preliminary Notes for a Critique." *Artforum,* January 1980.

Bunzel, Ruth. *The Pueblo Potter.* New York: Columbia University Press, 1929.

Cahill, James. *Chinese Painting.* New York: Rizzoli, 1977.

Cardinal, Roger. *Outsider Art.* New York: Praeger, 1972.

Carneiro, Robert L. "The Calusa and the Powhatan, Native Chiefdoms of North America." *Reviews in Anthropology* 21 (1992): 27–38.

———. "The Chiefdom: Precursor of the State." In *The Transition to Statehood in the New World,* edited by George A. Jones and Robert R. Jautz. New York: Cambridge University Press, 1981.

———. "Herbert Spencer as Anthropologist." *Journal of Libertarian Studies* 2 (1981): 153–210.

———. "Political Expansion as an Expression of the Principle of Competitive Exclusion." In *Origins of the State: The Anthropology of Political Evolution,* edited by Ronald Cohen and Elman R. Service, 212–214. Philadelphia: Institute for the Study of Human Issues (ISHI), 1978.

Cennini, Cennino. *Il libro del'arte, o Trattato della pittura.* 1933. Milan: Longnesi, 1984.

Chambi, Martín. *Martín Chambi Photographs, 1920–1950.* Foreword by Mario Vargas Llosa. Introduction by Edward Ranney and Publio López Mondéjar. Washington, DC: Smithsonian Institution Press, 1993.

Childe, V. Gordon. *What Happened in History.* New York: Penguin Books, 1942.

Clifford, James. Lecture on contemporary Brazilian Indians. Columbia University, 1998.

———. *Predicament of Culture.* Cambridge, MA: Harvard University Press, 1988.

Cohodas, Marvin. *Basket Weavers for the California Curio Trade: Elizabeth and Louise Hickox.* Tucson: Arizona University Press, 1997.

———. "Transformations: Relationships between Image and Text in the Ceramic Paintings of the Metropolitan Master." In *Word and Image in Maya Culture,* edited by William F. Hanks and Don S. Rice, 198–232. Salt Lake City: University of Utah Press, 1989.

Cole, Herbert M. *I Am Not Myself: The Art of African Masquerade.* Monograph 26. Los Angeles: Museum of Cultural History, UCLA, 1985.

Conkey, Margaret, and Christine Hastorf. *The Uses of Style in Archaeology.* New York: Cambridge University Press, 1990.

Connah, Graham. *African Civilization.* New York: Cambridge University Press, 1987.

Conway, William M. *The Literary Remains of Albrecht Dürer.* London: Cambridge University Press, 1889.

Corbin, George. *Native Arts of North America, Africa, and the South Pacific.* New York: Harper and Row, 1988.

Cowgill, George L. "Onward and Upward with the Collapse." In *The Collapse of Ancient States and Civilizations,* edited by Norman Yoffee and George L. Cowgill, 244–276. Tucson: University of Arizona Press, 1988.

Cox, J. Halley. *Hawaiian Sculpture.* Honolulu: University Press of Hawaii, 1974.

Crary, Jonathan. *Techniques of the Observer.* Cambridge, MA: MIT Press, 1992.

Critchfield, Richard. *Villages.* Garden City, NJ: Doubleday, 1983.

Csikszentmihalyi, Mihaly, and Eugene Rochberg-Halton. *The Meaning of Things: Domestic Symbols and the Self.* London: Cambridge University Press, 1981.

Damisch, Hubert. *The Origin of Perspective.* Cambridge, MA: MIT Press, 1995.

Danto, Arthur C. *After the End of Art.* A. W. Mellon Lectures in the Fine Arts. Bollingen Series 35-44. Princeton: Princeton University Press, 1997.

———. "The End of Art." In *The Philosophical Disenfranchisement of Art,* 81–115. New York: Columbia University Press, 1986.

———. *The Philosophical Disenfranchisement of Art.* New York: Columbia University Press, 1986.

Davis, Whitney. *The Canonical Tradition in Ancient Egyptian Art.* New York: Cambridge University Press, 1989.

———. *Replication, Archaeology, Art History, Psychoanalysis.* University Park: Pennsylvania State University Press, 1996.

Deleuze, Gilles, and Felix Guattari. *Anti-Oedipus.* Minneapolis: University of Minnesota Press, 1983.

Dennett, Daniel C. *Consciousness Explained.* Boston: Little, Brown, 1991.

Denton, Robert Knox. "Band-Level Eden: A Mystifying Chimera." *Cultural Anthropology* 3, no. 3 (1988): 276–284.

Derrida, Jacques. *Of Grammatology.* Baltimore: Johns Hopkins University Press, 1974.

Dodd, Erica C., and Shereen Khairallah. "On the Prohibition of Images and the Image of the Word." In *The Image of the Word.* Beirut: American University of Beirut, 1981.

Dowling, Lisa. "Aestheticism." In *Encyclopedia of Aesthetics,* edited by Michael Kelly, 1:32–37. New York: Oxford University Press, 1998.

Drewal, Henry John. "Ife: Origins of Art and Civilization." In *Yoruba: Nine Centuries of African Art and Thought,* edited by Allen Wardwell. New York: Center for African Art in association with H. N. Abrams, 1996.

Duchamp, Marcel. Interview with Jean Antoine. *Art Newspaper* 22 (April 1993): 17.

Duncan, Carol. *Civilizing Rituals.* London: Routledge, 1995.

Dunn, Dorothy. *American Indian Painting of the Southwest and Plains Areas.* Albuquerque: University of New Mexico Press, 1968.

Durham, Jimmy. "A Friend of Mine Said That Art Is a European Invention." In *Global Visions: Towards a New Internationalism in the Visual Arts,* edited by J. Fischer, 113–119. London: Kala Press, 1944.

Durkheim, Emile. *The Elementary Forms of Religious Life.* 1915. Translated by Joseph Ward Swain. New York: Free Press, 1965.

Duvignaud, Jean. *The Sociology of Art.* New York: Harper and Row, 1972.

Earle, Timothy. *How Chiefs Came to Power.* Palo Alto: Stanford University Press, 1997.

Eisenstadt, S. N., ed. *The Origins and Diversity of Axial Age Civilizations.* Albany: State University of New York Press, 1986.

Eliade, Mircea. *The Sacred and the Profane: The Nature of Religion.* New York: Harcourt, Brace and Jovanovich, 1959.

———. *Shamanism: Archaic Techniques of Ecstasy.* 1951. Princeton: Princeton University Press, 1964.

Elkana, Y. "Emergence of Second-Order Thinking in Classical Greece." In *The Origins and Diversity of Axial Age Civilizations,* edited by S. N. Eisenstadt. Albany: State University of New York Press, 1986.

Fane, Diana. *Objects of Myth and Memory: American Indian Art at the Brooklyn Museum.* New York: Brooklyn Museum in association with University of Washington Press, 1991.

Farkas, Zsolt. "Letter from New York to Pécs," in *Mindentöl Ugyanannyira,* 169–211. Budapest: Pesti Szalon, 1994.

Festinger, Leon. *A Theory of Cognitive Dissonance.* Palo Alto: Stanford University Press, 1957.

Firth, Raymond. "The Maori Carver." *Journal of the Polynesian Society* (Wellington, New Zealand), 1925.

Fischer, Steven Roger, ed. *Easter Island Studies.* Oxbow Monograph 32. Oxford: Oxbow Books, 1993.

Foster, Hal. "The 'Primitive Unconscious' of Modern Art, or White Skin Black Masks." In *Recodings,* 181–210. Port Townsend, WA: Bay Press, 1985.

Frank, Andre Gunder. *ReOrient: Global Economy in the Asian Age.* Berkeley: University of California Press, 1998.

Fraser, Douglas. *Primitive Art.* New York: Doubleday, 1962.

Fraser, James G. *Totemism and Exogamy.* 4 vols. London: Macmillan, 1910.

Freedberg, David. *Iconoclasts and Their Motives.* Maarssen: Gary Schwartz, 1985.

———. *The Power of Images: Studies in the History and Theory of Response.* Chicago: University of Chicago, 1989.

Freud, Sigmund. *Civilization and Its Discontents.* New York: Norton, 1962.

———. *Totem and Taboo: Some Points of Agreement between the Mental Lives of Savages and Neurotics.* London: Routledge, 1913.

Fried, Michael. "Art and Objecthood." In *Art and Objecthood,* 148–172. Chicago: University of Chicago Press, 1998.

Fried, Morton H. "On the Concept of Tribe." In *Essays on the Problem of Tribe: Proceedings of the 1967 Annual Spring Meeting of the American Ethnological Society,* edited by June Helms, 3–22. Seattle: University of Washington Press, 1968.

Fry, Roger. "The Art of Bushmen." In *Vision and Design,* 85–98. 1920. New York: Meridian Books, 1956.

Fuente, Beatriz de la. "Olmec Sculpture: The First Mesoamerican Art." In *Olmec Art and Archaeology in Mesoamerica,* edited by John E. Clark and Mary E. Pye, 253–264. Washington, DC: National Gallery of Art; New Haven: Yale University Press, 2000.

Fukuyama, Francis. "The End of History." *National Interest* 16 (1989): 1–18.

Gailey, Christine Ward. *Kinship to Kingship.* Austin: University of Texas Press, 1987.

Geertz, Clifford. "Centers, Kings, and Charisma: Reflections on the Symbolics of Power." In *Culture and Its Creators: Essays in Honor of Edwards Shils,* edited by Joseph Ben-David and Terry Nichols Clark, 150–171. Chicago: University of Chicago Press, 1977.

Gerbrands, Adrian Alexander. *Wow-Ipits: Eight Asmat Carvers of New Guinea.* The Hague: Mouton, 1967.

Giddens, Anthony. *The Consequences of Modernity*. Palo Alto: Stanford University Press, 1990.

Gilfoy, Peggy Stolz. *Patterns of Life: West African Strip-Weaving Traditions*. Washington, DC: National Museum of African Art, 1987.

Gittinger, Mattiebelle. *Splendid Symbols: Textiles and Tradition in Indonesia*. Washington, DC: Textile Museum, 1979.

Glucksberg, Sam, Robert J. Sternberg, and Edward E. Smith. *The Psychology of Human Thought*. New York: Cambridge University Press, 1988.

Gombrich, Ernst H. *Art and Illusion*. Bollingen Series 35. Princeton: Princeton University Press, 1960.

———. *Meditation on a Hobby Horse*. Chicago: University of Chicago Press, 1963.

———. *The Story of Art*. New York: Phaidon, 1972.

Goody, Jack. *The Domestication of the Savage Mind*. New York: Cambridge University Press, 1977.

———. *The Interface between the Written and the Oral*. New York: Cambridge University Press, 1987.

Gould, Stephen Jay. "The Episodic Nature of Evolutionary Change." In *The Panda's Thumb*, 179–185. New York: Norton, 1980.

Graburn, Nelson H. H., ed. *Ethnic and Tourist Arts: Cultural Expressions from the Fourth World*. Berkeley: University of California Press, 1976.

Graham, William A. *Divine Word and Prophetic Word in Early Islam*. The Hague: Mouton, 1977.

Greenberg, Clement. *Art and Culture: Critical Essays*. Boston: Beacon Press, 1961.

Gregg, Susan A. *Between Bands and States*. Occasional Papers 9. Carbondale: Center for Archaeological Investigation, Southern Illinois University, 1991.

Grillo, Michael. *Symbolic Structures: The Role of Composition in Signaling Meaning in Italian Medieval Art*. New York: Peter Lang, 1997.

Grove, David. C. "Olmec Monuments: Mutilation as a Clue to Meaning." In *The Olmec and Their Neighbors,* edited by E. P. Benson, 49–68. Washington, DC: Dumbarton Oaks, 1981.

Guilbaut, Serge. *How New York Stole the Idea of Modern Art*. Chicago: University of Chicago Press, 1983.

Haas, Jonathan. *The Evolution of the Prehistoric State*. New York: Columbia University Press, 1982.

Habermas, Jurgen, ed. *Communication and the Evolution of Society*. Boston: Beacon Press, 1979.

Haddon, Alfred C. *Evolution in Art*. London: W. Scott, Ltd., 1895.

Hagen, Margaret. *Varieties of Realism: Geometries of Representational Art*. New York: Cambridge University Press, 1986.

Harley, G. W. *Masks as Agents of Social Control in Northeast Liberia*. Papers of the Peabody Museum, vol. 32, no. 2. Cambridge, MA: Peabody Museum, 1950.

Härtel, Herbert, and Marianne Yaldiz. *Along the Ancient Silk Routes*. New York: Metropolitan Museum, 1982.

Hauser, Arnold. *The Social History of Art*. 4 vols. New York: Vintage Books, 1985.

Hegel, George Wilhelm. *Philosophies of Art and Beauty*. Edited by Albert Hofstader and Richard Kuhns. Chicago: University of Chicago Press, 1964.

Himmelheber, Hans. *Eskimokunstler*. Eisenach: Roth Verlag, 1953.

———. *Negerkunstler*. Stuttgart: Strecker and Schroder, 1935.

Houston, James. *Confessions of an Igloo Dweller: Memories of the Old Arctic*. Boston: Houghton Mifflin, 1995.

Humphrey, Nicholas. *A History of the Mind*. New York: Harper Perennial, 1992.

Janson, H. W. *History of Art*. Rev. and enl. Englewood Cliffs, NJ: Prentice-Hall; New York: Abrams, 1969.

Jaspers, Karl. *Von Ursprung and Ziel der Geschichte*. Munich: R. Piper, 1949.

Johnson, Allen W., and Timothy Earle. *The Evolution of Human Societies: From Foraging Group to Agrarian State*. Palo Alto: Stanford University Press, 1987.

Jonaitis, Aldona. *Chiefly Feasts: The Enduring Kwakiutl Potlatch*. Seattle: University of Washington Press, 1990.

———. *From the Land of the Totem Poles: The Northwest Coast Indian Art Collection at the American Museum of Natural History*. Seattle: University of Washington Press, 1988.

Jones, G. I. *The Trading States of the Oil Rivers*. London: Oxford University Press, 1963.

Jones, Grant D., and Robert R. Kautz, eds. *The Transition to Statehood in the New World*. New York: Cambridge University Press, 1981.

Kaeppler, Adrienne. *Cook Voyage Artifacts in Leningrad, Berne, and Florence Museums*. Honolulu: Bishop Museum Press, 1978.

———. *Hawai'i: The Royal Isles*. Honolulu: Bishop Museum Press, 1980.

Kant, Immanuel. *Critique of Judgment*. 1790. Translated by Werner S. Pluhar. Indianapolis: Hackett Publishing, 1987.

Kimmelman, Michael. "Everything in Perspective." In "The Best Ideas, Stories, and Inventions of the Last Thousand Years," *New York Times Magazine*, April 14, 1999, 86.

Kirch, Patrick Vinton. *The Evolution of the Polynesian Chiefdoms.* Cambridge: Cambridge University Press, 1984.

Klein, Cecelia F., ed. *Mother, Worker, Ruler, Witch: Cross-Cultural Images of Women.* UCLA Museum of Cultural History Pamphlet Series 9. Los Angeles: UCLA Museum of Cultural History, 1980.

Kosuth, Josef. *Art after Philosophy and After: Collected Writings, 1966–1990.* Cambridge, MA: MIT Press, 1993.

Kpomassie, Tete-Michel. *L'Africain du Groenland.* Paris: Flammarion, 1981.

Kramrisch, Stella. *The Vishnudharmottara: A Treatise on Indian Painting and Image-Making.* Part 3. Calcutta: Calcutta University Press, 1924.

Krauss, Rosalind. *The Originality of the Avant-Garde and Other Modernist Myths.* Cambridge, MA: MIT Press, 1986.

Kristeller, Paul Oskar. "The Modern System of the Arts." In *Renaissance Thought and the Arts,* 163–227. Princeton: Princeton University Press, 1990.

Kroeber, Alfred L. *Style and Civilization.* Berkeley: University of California Press, 1963.

Kubler, George. "Eidetic Imagery and Paleolithic Art." *Journal of Psychology: Interdisciplinary and Applied* 119, no. 6 (1985): 557–565.

———. *The Shape of Time: Remarks on the History of Things.* New Haven: Yale University Press, 1962.

Lacan, Jacques. *The Four Fundamental Concepts of Psychoanalysis.* Edited by Jacques-Alain Miller. New York: W. W. Norton, 1978.

Lange, Frederick W., ed. *Wealth and Hierarchy in the Intermediate Area.* Washington, DC: Dumbarton Oaks, 1992.

Lavin, Irving. "The Art of Art History: A Professional Allegory." *Art News,* 1983.

Leacock, Eleanor, and Richard Lee, eds., *Politics and History in Band Societies.* New York: Cambridge University Press, 1982.

León-Portilla, Miguel. *Aztec Thought and Culture.* Norman: University of Oklahoma Press, 1963.

Leroi-Gourhan, André. *Treasures of Prehistoric Art.* New York: H. N. Abrams, 1967.

Lévi-Strauss, Claude. *Look, Listen, Read.* 1993. New York: Basic Books, 1997.

———. *The Savage Mind.* Chicago: University of Chicago Press, 1966.

———. *Totemism.* Boston: Beacon Press, 1962.

Lévy-Bruhl, Lucien. *Les Fonctions mentales dans les sociétés inférieures.* Paris: Presses Universitaires de France, 1951.

———. *La Mentalité primitive.* Paris: Presses Universitaires de France, 1960.

Libet, Benjamin. "Unconscious Cerebral Initiative and the Role of Conscious Will in Voluntary Action." *Behavioral and Brain Sciences* 9 (1985): 529–566.

Libet, Benjamin, Elwood W. Wright Jr., Bertram Feinstein, and Dennis K. Pearl. "Subjective Referral of the Timing for Conscious Sensory Experience." *Brain* 102 (1979): 193–224.

Lipman, Jean. *Provocative Parallels.* New York: E. P. Dutton, 1975.

Lippard, Lucy. *Overlay: Contemporary Art and the Art of Prehistory.* New York: New Press, 1983.

Lippard, Lucy, ed. *Partial Recall.* New York: New Press, 1992.

Lommel, Andreas. *Shamanism: The Beginnings of Art.* New York: McGraw-Hill, 1967.

Lubar, Steven, and W. David Kingery, eds. *History from Things: Essays on Material Culture.* Washington, DC: Smithsonian Institution Press, 1993.

Magnin, André. *Seydou Keita.* New York: Scalo, 1997.

Malraux, André. *The Temptation of the West.* Translated by Robert Hollander. Chicago: University of Chicago Press, 1992.

———. *The Voices of Silence.* 1953. Bollingen Series 24. Princeton: Princeton University Press, 1978.

Mann, Michael. *The Sources of Social Power,* vol. 1. New York: Cambridge University Press, 1986.

Marschak, Alexander. "An Ice Age Ancestor." *National Geographic* 174, no. 4 (1988): 478–481.

Marsh, H. Colley. "Polynesian Ornament a Mythography or a Symbolism of Origin and Descent?" *Journal of the Anthropological Institute of Great Britain and Ireland* (London, 1893): 307–333.

McCarthy, Thomas. Introduction to *Communication and the Evolution of Society,* edited by Jurgen Habermas. 1976. Boston: Beacon Press, 1979.

McEvilley, Thomas. "Art/Artifact: What Makes Something Art?" In *Art/Artifact: African Art in Anthropology Collections,* introduction by Susan Vogel. New York: Center for African Art, 1988.

McLuhan, Marshall. *The Gutenberg Galaxy: The Making of Typographic Man.* Toronto: University of Toronto Press, 1962.

Mead, Margaret. *Sex and Temperament in Three Primitive Societies.* New York: Mentor Books, 1935.

Mendelssohn, Kurt. "A Scientist Looks at the Pyramids." In *The Rise and Fall of Civilizations,* edited by Jeremy Sabloff and C. C. Lamberg-Karlovsky, 390–402. Menlo Park, CA: Benjamin Cummings Publ., 1974.

Milbrath, Susan. *A Study of Olmec Sculptural Chronology.* Studies in Pre-Columbian Art and Archaeology 23. Washington, DC: Dumbarton Oaks, 1979.

Miller, Daniel, ed. *Material Cultures: Why Some Things Matter.* Chicago: University of Chicago Press, 1998.

Miller, Mary Ellen. *The Murals of Bonampak.* Princeton: Princeton University Press, 1986.

Mitchell, W. J. T. "The Pictorial Turn." In *Picture Theory,* 11–34. Chicago: University of Chicago Press, 1994.

Morgan, William N. *Prehistoric Architecture in the Eastern United States.* Cambridge, MA: MIT Press, 1980.

Morris, Desmond. *The Biology of Art: A Study of the Picture-Making Behaviour of the Great Apes and Its Relationship to Human Art.* New York: Knopf, 1962.

Mumford, Lewis. *The Transformations of Man.* New York: Collier Books, 1956.

Munn, Nancy D. "Visual Categories: An Approach to the Study of Representational Systems." *American Anthropologist* 68, no. 4 (1966): 936–950.

———. *Walbiri Iconography.* Ithaca: Cornell University Press, 1973.

Newberry, Timothy J., George Bisacca, and Laurence B. Kanter. *Italian Renaissance Frames.* New York: Metropolitan Museum, 1990.

Norretranders, Tor. *The User Illusion: Cutting Consciousness Down to Size.* New York: Viking, 1998.

Panofsky, Erwin. *Perspective as Symbolic Form.* 1927. New York: Zone Books, 1991.

Pasztory, Esther. "Andean Aesthetics." In *The Spirit of Ancient Peru,* edited by Kathleen Berrin. London: Thames and Hudson, 1997.

———. *Aztec Art.* New York: H. N. Abrams, 1983.

———. "Hieratic Composition of West African Art." *Art Bulletin* 52 (1970): 299–306.

———. "Identity and Difference: The Uses and Meanings of Ethnic Styles." In *Cultural Differentiation and Cultural Identity in the Visual Arts,* edited by S. J. Barnes and Walter S. Melion, 15–38. Studies in the History of Art 27. Washington, DC: Center for Advanced Study in the Visual Arts, National Gallery of Art, 1989.

———. "Masterpieces of Pre-Columbian Art." In *Actes du XLII^e Congrès International des Américanistes* (1980), vol. 7, 377–390.

———. "The Portrait and the Mask: Invention and Translation." In *Olmec Art and Archaeology in Mesoamerica,* edited by John E. Clark and Mary E. Pye, 265–276. Washington, DC: National Gallery of Art, 2000.

———. "Pre-Columbian Aesthetics." In *Encyclopedia of Aesthetics,* edited by Michael Kelly, vol. 4, 80–85. New York: Oxford University Press, 1998.

———. *Pre-Columbian Art.* New York: Cambridge University Press, 1998.

———. "Shamanism and North American Indian Art." In *Native North American Art History: Selected Readings,* edited by Aldona Jonaitis and Zena Pearlstone Mathews, 7–30. Palo Alto: Stanford University Press, 1982.

———. "Still Invisible: The Problem of the Aesthetics of Abstraction for Pre-Columbian Art and Its Implications for Other Cultures." *Res* 19/20 (1990/1991): 105–136.

———. *Teotihuacán: An Experiment in Living.* Norman: University of Oklahoma Press, 1997.

———. "Three Aztec Masks of the God Xipe." In *Falsifications and Misreconstructions in Pre-Columbian Art,* edited by E. H. Boone, 77–106. Washington, DC: Dumbarton Oaks, 1982.

Petridis, Constantijn. "In Pursuit of Beauty: Cults, Charms, and Figure Sculpture among the Luluwa." Lecture, University Seminars, Columbia University, April 15, 1998.

———. "Of Mothers and Sorcerers: A Luluwa Maternity Figure." *Museum Studies* 21, no. 2 (1997): 182–195.

Pevsner, Nikolaus. *The Englishness of English Art.* London: Architectural Press, 1956.

Piaget, Jean. *The Language and Thought of the Child.* New York: World Publishing, 1955.

Pinker, Steven. *How the Mind Works.* New York: W. W. Norton, 1997.

Pirsig, Robert M. *Zen and the Art of Motorcycle Maintenance.* New York: William Morrow, 1974.

Plog, Stephen. "Sociopolitical Implications of Stylistic Variation in the American Southwest." In *The Uses of Style in Archeology,* edited by Margaret W. Conkey and Christine A. Hastorf, 61–72. New York: Cambridge University Press, 1990.

Pompa, Leon. *Vico: A Study of the "New Science."* Cambridge: Cambridge University Press, 1975.

Preston, George. "Akan: In Search of a People's Aesthetic." University Seminar, "The Arts of Africa, Oceania and the Americas," Columbia University, March 25, 1998.

Price, Douglas T., and James A. Brown, eds. *Prehistoric Hunter-Gatherers: The Emergence of Cultural Complexity.* New York: Academic Press, 1985.

Rice, David Talbot. *Islamic Art.* New York: Frederick A. Praeger, 1965.

Richardson, Miles, and Malcolm C. Webb, eds. *The Burden of Being Civilized.* Athens: University of Georgia Press, 1986.

Roberts, Mary Nooter, and Allen F. Roberts. *Memory: Luba Art and the Making of History.* New York: Museum for African Art, 1996.

Rorty, Richard. "Holism, Intrinsicality and the Ambition of Transcendence." In *Dennett and His Critics,* edited by Bo Dahlbom, 184–202. Oxford: Blackwell, 1993.

Rosenberg, Jacob, Seymour Slive, and E. H. ter Kvile. *Dutch Art and Architecture, 1600–1800.* New York: Penguin Books, 1972.

Rowland, Benjamin. *Art in East and West.* Boston: Beacon Press, 1954.

Rubin, Arnold. *Art as Technology.* Edited by Zena Pearlstone. Santa Ana, CA: Hillcrest Press, 1989.

Russell, John. *Henry Moore.* Harmondsworth, Middlesex, England: Penguin Books, 1968.

Sahlins, Marshall D. *Social Stratification in Polynesia.* Seattle: University of Washington Press, 1958.

———. *Tribesmen.* Englewood Cliffs, NJ: Prentice-Hall, 1968.

Sanders, William T., and Barbara J. Price. *Mesoamerica: The Evolution of a Civilization.* New York: Random House, 1968.

Schapiro, Meyer. "On Some Problems in the Semiotics of Visual Art: Field and Vehicle in Image-Sign." In *Theory and Philosophy of Art: Style, Artist, and Society,* 1–32. 1974. New York: George Braziller, 1994.

Scoditti, Giancarlo M. G. *Kitawa.* Berlin: Mouton, 1990.

Semper, Gottfried. *Der Stil in den Teknischen und Tektonischen Kunsten oder praktische Aesthetik.* Munich: Friedr. Bruckman Verlag, 1878.

Sensabough, David. Lecture on Chinese art. Columbia University, 1994.

Service, Elman R. *The Hunters.* Englewood Cliffs, NJ: Prentice-Hall, 1966.

———. *Origins of the State and Civilization.* New York: Norton, 1975.

———. *Primitive Social Organization.* New York: Random House, 1962.

Sieber, Roy. "Masks as Agents of Social Control." In *The Many Faces of Primitive Art,* compiled by Douglas Fraser. Englewood Cliffs, NJ: Prentice-Hall, 1966.

Solomon, Deborah. "In Praise of Bad Art." *New York Times Magazine,* January 24, 1999, 32–35.

Spencer, Charles S. "Rethinking the Chiefdom." In *Chiefdoms in the Americas,* edited by Robert D. Drennan and Carlos A. Uribe, 369–389. Lanham, MD: University Press of America, 1987.

Spencer, Herbert. *The Evolution of Society.* Edited by Robert L. Carneiro. Chicago: University of Chicago Press, 1967.

———. *First Principles.* London: William and Norgate, 1863.

———. *Principles of Sociology.* New York: D. Appleton, 1887–1888.

Spuler, Bertold. *History of the Mongols.* New York: Dorset Press, 1988.

Stein, Gertrude. *Lectures in America.* 1934–1935. New York: Random House, 1975.

Steward, Julian H., ed. *Handbook of South American Indians.* 7 vols. Bulletin (Smithsonian Institution Bureau of American Ethnology) 143. Washington, DC: GPO, 1946–1959.

Stille, Alexander. "The Man Who Remembers: Profile of Giancarlo Scoditti." *New Yorker,* February 15, 1999, 50–63.

Stolpe, Hjalmar. *Collected Essays in Ornamental Art.* 1891–1892, 1896. Stockholm: Aftonbladets Tryckeri, 1922.

Strother, Z. S. *Inventing Masks: Agency and History in the Art of the Central Pende.* Chicago: University of Chicago Press, 1998.

Sutton, Peter, ed. *Dreamings: The Art of Aboriginal Australia.* New York: George Braziller in association with Asia Society Galleries, 1988.

Sze, Mai-Mai. *The Mustard Seed Garden Manual of Painting: Chieh Tzu Yuan Hua Chuan, 1679–1701.* Bollingen Series 49. Princeton: Princeton University Press, 1963.

Tanizaki, Jun'ichiro. *In Praise of Shadows.* 1933. New Haven, CT: Leetes Island Books, 1977.

Tedlock, Dennis, trans. *Popol Vuh.* New York: Simon and Schuster, 1985.

Thomason, Allison K. *Capturing the Exotic: Royal Ivory Collecting and the Neo-Assyrian Imaging of North Syria.* Ph.D. dissertation, Columbia University, Department of Art History, 1999.

Thompson, Robert Farris. "Abatan: A Master Potter of the Egbado Yoruba." In *Tradition and Creativity in African Art,* edited by Daniel P. Biebuyck, 120–182. Berkeley: University of California Press, 1969.

———. "Aesthetics in Traditional Africa." In *Art and Aesthetics in Primitive Societies,* edited by Carol F. Jopling, 374–381. New York: E. P. Dutton, 1971.

Tisdall, Caroline. *Joseph Beuys.* New York: Solomon R. Guggenheim Museum, 1979.

Tongue, Helen. *Bushmen Drawings.* Oxford: Clarendon Press, 1909.

Upham, Steadman. "A Theoretical Consideration of Middle Range Societies." In *Chiefdoms in the Americas,* edited by Robert D. Drennan and Carlos A. Uribe, 345–367. Lanham, MD: University Press of America, 1987.

Valladao, Alfredo G. A. *The Twenty-first Century Will Be American.* London: Verso, 1996.

Vattimo, Gianni, "The Death or Decline of Art." In *The End of Modernity: Nihilism and Hermeneutics in Post-Modern Culture.* Cambridge: Polity Press, 1988.

Vogel, Susan M. "African Aesthetics." In *African Aesthetics: The Carlo Monzino Collection.* New York: Center for African Art, 1986.

———. "Extinct Art: Inspiration and Burden." In *Africa Explores: 20th Century African Art,* 230–239. New York: Center for African Art, 1991.

Weiss, Joseph. "Unconscious Mental Functioning." *Scientific American* 262, no. 3 (1990): 75.

White, Leslie A. *The Evolution of Culture.* New York: McGraw-Hill, 1959.

Wiessner, Polly. "Style and Social Information in Kalahari San Projectile Points." *American Antiquity* 48, no. 2 (1983): 253–276.

Wilford, John Noble. "Ancient Indian Site Challenges Ideas on Early American Life." *New York Times,* September 19, 1997, late ed., sec. A: 26.

Willett, Frank. *Ife in the History of West African Sculpture.* New York: Thames and Hudson, 1967.

Williams, F. E. *Drama of Orokolo.* New York: Oxford University Press, 1940.

Willis, Deborah. "Talking Back: Black Women's Visual Liberation through Photography." In *Transforming the Crown: African, Asian & Caribbean Artists in Britain, 1966–1996,* edited by Mora J. Beauchamp-Byrd and M. Franklin Sirmans, 63–68. New York: Caribbean Cultural Center, 1997.

Wilson, Richard Guy, Dianne H. Pilgrim, and Dickran Tashjian. *The Machine Age in America, 1918–1941.* New York: Brooklyn Museum in association with H. N. Abrams, 1986.

Winckelmann, Joachim. *History of Ancient Art.* New York: F. Ungar, 1969.

Winter, Irene. "Art in Empire: The Royal Image and the Visual Dimensions of Assyrian Ideology." In *Assyria 1995,* edited by S. Parpola and R. M. Whiting, 359–381. Helsinki: The Project, 1997.

———. "'Idols of the King': Royal Images as Recipients of Ritual Action in Ancient Mesopotamia." *Journal of Ritual Studies* 6, no. 1 (1992): 13–42.

Wittfogel, Karl A. *Oriental Despotism: A Comparative Study of Total Power.* New Haven: Yale University Press, 1957.

Wölfflin, Heinrich. *Principles of Art History.* 1922. New York: Dover, 1970.

Wolf, Eric R. *Europe and the People without History.* Berkeley: University of California Press, 1982.

———. *Peasants.* Englewood Cliffs, NJ: Prentice-Hall, 1966.

Wolfe, Tom. *The Painted Word.* New York: Bantam, 1976.

Wypijewski, Jo Ann, ed. *Painting by Numbers: Komar and Melamid's Scientific Guide to Art.* New York: Farrar, Strauss and Giroux, 1998.

Yoffee, Norman. "The Decline and Rise of Mesopotamian Civilization: An Ethnoarchaeological Perspective on the Evolution of Social Complexity." *American Antiquity* 44, no. 1 (1979): 5–35.

———. "The Late Great Tradition in Ancient Mesopotamia." Paper presented at College Art Association meeting, New York, 1990.

———. "Too Many Chiefs? Or, Safe Texts for the '90s." American Anthropological Association Symposium, Washington, DC, 1989.

Zeidler, James A. "The Evolution of Prehistoric Tribal Systems as Historical Process: Archaeological Indication of Social Reproduction." In *Chiefdoms in the Americas,* edited by Robert D. Drennan and Carlos A. Uribe, 325–343. Lanham, MD: University Press of America, 1987.

Part TWO

I never intended to become a formalist. When I was in graduate school, formalism was a bad word. It referred to analyses in which the "blue patches on the left" balanced the "red patches on the right," creating visual harmony and the aesthetic experience. Formalism was what we hated. My generation was interested in the social context of art, and primitive and pre-Columbian arts were attractive to some of us precisely because they had always been studied in a social context. We defected to anthropology. We prided ourselves that we were doing social history decades before social history became popular in Western art.

But as I look over my writings, starting with my master's degree on African art, it is clear that the questions I have always posed are formalist and I might as well own up to it. I look for the answers in an anthropological terrain. I don't use formal analysis as I was taught, to praise forms in a style I still dislike, but formal issues have become both my problems and my solutions. The question I sought to answer from the very beginning is "Why do forms look the way they do?" or "Why are certain compositions and shapes chosen?" The answer I usually found, especially in the early years, was "The social context." If once people saw art as the handmaiden of religion, I have seen it as the handmaiden of society. Later on, especially in the work on Teotihuacán, I reversed the proposition and suggested that an insightful analysis of form could actually reconstruct the nature of a society, especially one known only archaeologically. I "read" the forms as if they were social documents unconsciously left behind, knowing full well that this path could be very clever or inane. I had become a formalist beyond what I could even imagine in graduate school.

In suggesting that forms had coded in themselves the social structures that produced them, I was well on the way to seeing them more as having cognitive rather than aesthetic value. In *Thinking with Things* I conclude that people make all kinds of things to think with on a nonconscious level. The process of developing these ideas began in the study of African art, where I first saw that multi-figure compositions and flanking figures were found only in inegalitarian societies and always signified status.[1] In my article on "Shamanism and North American Indian Art," I considered the question of whether religion or society determined the forms and concluded that religious belief required little art, while social competition was responsible for much elegance and elaboration. In my writings on Teotihuacán ("Still Invisible"), I present a hypothesis that Teotihuacán had a corporate ideology—an issue still hotly debated—based on the image system that is especially distinctive in avoiding the human figure. In this article, as well as in "Andean Aesthetics," I began a theme that occupies me

to the present: how we have difficulty seeing the forms of non-Western art because we tend to see them unconsciously through Western aesthetic filters current at the time. For instance, much of pre-Columbian art is appreciated as a form of modernist art, and different traditions are appreciated depending on our artistic movements such as earth art, minimalism, or conceptual art. This complicates the analysis of form, in that things cannot be seen in a neutral or scientific mode. I am deeply involved in examining this issue and feel at this point that self-awareness is the only solution to this problem. An interest in form naturally led me to the analysis of fakes ("Three Aztec Masks of the God Xipe"). The ones that I discuss are quintessentially representative of what their makers and buyers thought, through their various cognitive filters, was an alien style, although now they look more like European styles of a certain period than pre-Columbian ones. The Maya ("Identity and Difference") have always fascinated me because of the special circumstances that gave rise to their many refined local styles, as well as to their development of self-conscious aestheticism ("Aesthetics and Pre-Columbian Art"). I saw these as signs of extreme competition using art as symbols of identity. The issues of competition, identity, and art are deeply related.

I have thus found African and pre-Columbian material an ideal corpus to analyze issues of form and society outside Western art, the source of most theory thus far. As the full title of one chapter—"Still Invisible: The Problem of the Aesthetics of Abstraction for Pre-Columbian Art and Its Implications for other Cultures"—indicates, I hoped to bring the lessons learned from pre-Columbian art to other fields dealing with similar issues. I never felt that the aim of studying pre-Columbian art was merely to explain it in its own terms, but rather to create a dialogue with other fields. Pre-Columbian art, as distant from Old World art as from something on another planet, provides unusual instances of, and correctives

to, received theory. For example, a theme that has been built into Western art since Winckelmann contrasted Egyptian and Greek art in the eighteenth century is the issue of naturalism and abstraction, including its various valuations in the West and its meanings in other cultures. The Olmec article "The Portrait and the Mask," a counterpart on realism to the abstraction in "Still Invisible," seeks to explain the functions of naturalism in a global context. Realism and abstraction are explained as strategies chosen either to create closeness with or detatchment from the viewer in a particular social context. This article was a tryout for some of the ideas in *Thinking with Things*.

Thinking with Things is an attempt to map forms and their social contexts globally. It is meant to be an alternative to the linear histories that dominate the current literature and in which cultures and things seem totally idiosyncratic and noncomparable. I suggest that various types of societies have certain parameters in place for the kind of things they need, and these parameters account for many of the convergences that have been noted, which are broad enough to include a wide variety of styles that, superficially, are very different. Perhaps the least satisfying portion of Part One deals with the present, which is never easy to encapsulate. As I write this, I am especially struck by the way the forms of Western modern art, from abstract expressionism to conceptualism, have been adopted by the artists of the rest of the world, leveling the playing field in a very different and unprecedented way from anything known historically. I hope to have more to say on that in the future. As it is, *Thinking with Things* is my attempt to create a single discourse on art, one in which European arts can be discussed together with arts from the rest of the world. Formalism is not the answer to all art historical questions, but forms have a great deal of information packed into them that reveals their identity, and over the years that has been my story.

NOTE

1. "Hieratic Composition of West African Art," *Art Bulletin* 52 (1970): 299–306. (This was my first article and the first article on African art in the *Art Bulletin*.)

STILL INVISIBLE

The Problem of the Aesthetics of Abstraction for Pre-Columbian Art and Its Implications for Other Cultures

I. THE WESTERN CLASSICIST AND MODERNIST ENCOUNTERS WITH PRE-COLUMBIAN ART

In 1520 the German artist Albrecht Dürer saw the objects that were sent to Europe from Mexico by the conquistador Cortez. These were displayed at the Town Hall of Brussels on the occasion of the celebration of the installation of Charles V as Holy Roman Emperor. Dürer went to the Netherlands in order to see Charles V about his pension and to find new patrons for his paintings, prints, and sketches (Panofsky 1955a: 205). Dürer wrote in his travel diary:

> I saw the things which have been brought to the king from the new land of gold (Mexico), a sun all of gold a whole fathom broad, and a moon all of silver of the same size, also two rooms full of the armour of the people there, and all manner of wondrous weapons of theirs, harness and darts, very strange clothing, beds, and all kinds of wonderful objects of human use, much better worth seeing than prodigies. These things were all so precious that they are valued at 100,000 florins. All the days of my life I have seen nothing that rejoiced my heart so such as these things, for I saw amongst them wonderful works of art, and I marveled at the subtle Ingenia of men in foreign lands. Indeed I cannot express all that I thought there. (Conway 1889:101–102)[1]

This passage is usually cited to affirm the beauty and artistic quality of pre-Columbian art, since it was written by a European artist of great stature. It is found, as a seal of approval, on the frontispiece or in the introductory essay of many books on pre-Columbian art (Nicholson with Keber 1983:29).[2]

But what exactly does Dürer note in this passage? Perhaps what is most striking is his enthusiasm, yet in the next paragraph he is just as enthusiastic about a huge fish bone: "At Brussels I saw many other beautiful things besides, and especially I saw a fish bone there, as vast as if it had been built up of squared stones. It was a fathom long and very thick, it weighs up to 15 cwt, and its form resembles that drawn here" (Conway 1889:102). Apparently, this was curious enough for him to draw it. In the next paragraph he speaks of another curiosity, a great bed that could sleep fifty. In the paragraph before the Mexican antiquities, he describes the town hall and the king's house in equally laudatory terms: "And I saw out behind the King's house at Brussels the fountains, labyrinth and Beast garden; anything more beautiful and pleasing to me and more like Paradise I

have never seen" (ibid.:101). Read in context, then, Dürer's enthusiasm for the Mexican objects is not particularly remarkable.

What he actually says about the Mexican objects is that they are of unheard-of value—a hundred thousand florins. Perhaps value in this context has to do with the actual worth of so much gold and silver. He lists what these objects seem to be, such as weapons and strange clothing, but he says nothing about their appearance. Although he notes that some of these were wonderful works of art and especially commends their subtle *Ingenia,* or inventiveness (a category much valued in sixteenth-century theories on art), his last remark is very telling: "Indeed, I cannot express all that I thought there." This suggests that Dürer had difficulty verbally expressing his experience of these objects. He did not have this problem with Roman columns that he saw in Aachen, which he describes as "well-proportioned" and "correctly made according to Vitruvius's writings" (ibid.:106), nor with a Jan van Eyck painting that he calls "full of thought" (ibid.:117).

What is also striking is what isn't there: Dürer traveled with his notebook and a sketch pad, and he frequently refers to sketches he made along the way, such as that of the giant fish bone. A surviving sketch of the Beast garden is also mentioned in the same section of the notebook, but nothing about sketches of the Mexican material. The Mexican curiosities were fascinating to see, for Dürer, but they were perhaps too alien to have any significance for his art.

This inability to comprehend an alien culture was not limited to the visual forms of their "curious" material objects. Bucher (1981:32) has suggested that the physical features of the Native Americans who were brought to Europe by various explorers and conquerors, beginning with Columbus, were similarly elusive to Europeans. Attempts to describe or to depict them were generally in terms of their similarity or dissimilarity to Negro or Caucasian types, the only two races widely known at the time. For example, Bucher quotes a passage from Dürer in which he states that there are only two species of mankind, whites and Negroes. Often, however, Indians were simply regarded as "ugly Europeans." Dürer's sketch of 1515 of a Tupinamba Indian, in the margins of a

Book of Hours made for Maximilian I, could just as well be of a European dressed in an Indian feather costume (Fig. 12.1). The conceptualization is similar to what an eighteenth-century costume design for Papageno in Mozart's opera *The Magic Flute* might have been (Chiapelli 1976, fig. 44).

In the many famous books that have been published on the New World by the de Bry family, often there is not even a pretense at representing correctly Native American people, architecture, or works of art. The Incas bringing gold and silver treasures for the ransom of their king (Fig. 12.2) are European classicizing figures walking toward a building with an arched doorway. Their nakedness is meant to indicate their savagery, even though Inca culture was practically obsessive about textiles and clothing was essential in the cold highlands. Bucher has shown

Figure 12.1 Albrecht Dürer, *American Indian Man,* drawing, *Book of Hours of Maximilian the First.* Printed in 1515 by Johannes Schoensperger at Augsburg; from the reprint edition, Walter L. Strauss, ed. (New York: Abaris Books, 1974), p. 81. Courtesy Abaris Books.

how the de Bry illustrations created a fantasy of a sometimes noble and sometimes barbaric "Indian" that remained canonical for European thought for several hundred years without bearing any resemblance to reality. The subtext of much of the de Bry books suggests alternatively a "barbaric (cannibalistic) Indian," thus justifying their conquest by Protestant northern Europeans, or a "noble and moral Indian" tortured unjustly by Catholic southern Europeans, whose right to conquest is therefore ethically less than that of the northerners.

Although there are many long lists itemizing the objects that were brought from the New World, there is not a single illustration from the sixteenth century. This is astonishing in itself. Moreover, though they were much admired as curiosities, these objects were hardly treated as treasures. The gold and silver were melted down, as is well known; other objects simply disappeared. Of the hundreds of Mesoamerican textiles that were sent to Europe and listed in the accounts, not a single one has survived. Some works, such as Aztec feather shields and insignia, were eventually rediscovered in the nineteenth century when they turned up in trunks in attics (Nowotny 1960, Anders 1971). Some were given to children as toys to play with. The Codex Borgia, for example, was saved only after children had burned holes in it (Humboldt 1810:I:248–249). Evidently, after their value as curiosities had worn out, the objects had become worthless, because they had no meaning for the West. Until the nineteenth century, pre-Columbian styles remained largely invisible.

This "invisibility" is also evident in the drawings made of pre-Columbian monuments by travelers, adventurers, and explorers, despite their evident interest in them. In many eighteenth- and nineteenth-century European drawings, these monuments are depicted either in a hesitant, irregular, and childishly

Figure 12.2 Theodor de Bry, *The Indians Bringing Gold Ransom to Free Atahualpa,* engraving. *Great Voyages,* vol. 6, pl. 10, 1596. Reproduced from Victor W. von Hagen, *The Desert Kingdom of Peru* (London: Weidenfeld and Nicolson, 1965), pl. 134.

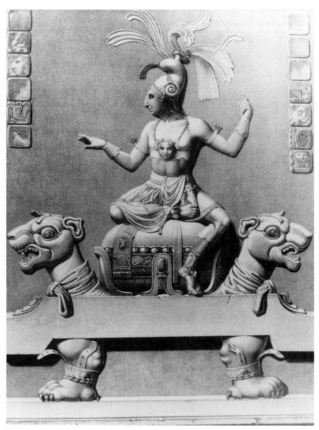

Figure 12.3 Jean Frédéric Maximilien de Waldeck, lithograph of the Palenque Beau Relief. Photograph courtesy of Edward E. Ayer Collection, The Newberry Library, Chicago.

Dürer's description shows that in the sixteenth century even a great artist could only deal with the anomaly of so different an art by focusing on its strangeness, and at best commending it for being inventive. It is impossible to know from the available information to what extent Dürer was aware of the stylistic distinctions of this art, which were not generally appreciated until several centuries later.

A great deal of progress was made in the latter half of the nineteenth century in the scientific study and recording of pre-Columbian antiquities. It is, however, only with the development of modernism in the beginning of the twentieth century that pre-Columbian art received aesthetic affirmation.

Henry Moore had described his discovery of pre-Columbian art in the 1920s in the following words:

> Mexican sculpture, as soon as I found it, seemed to me true and right, perhaps because I at once hit on similarities in it with some 11th-century carvings I had seen as a boy on Yorkshire churches. Its "stoniness," by which I mean its truth to material, its tremendous power without loss of sensitiveness, its astonishing variety and fertility of form-invention, and its approach to a full three-dimensional conception of form, make it unsurpassed in my opinion by any other period of stone sculpture. (Russell 1968:30–31)

naive style, or they have been reinterpreted through a classical style (Pasztory 1982, fig. 12). An 1832 drawing of a now-destroyed relief from Palenque by the adventurer Count Jean Frédéric Maximilien de Waldeck (Fig. 12.3) reduced the Maya ornaments to a few that went well with a classicized body and drapery and left out most of the glyphs. The classicizing of pre-Columbian images may have been a more or less conscious attempt to prettify what seemed less attractive. It is hard to believe that Waldeck spent almost a year sketching the ruins. Certainly, his belief that the Maya derived from the Phoenicians, Chaldeans, and Hindus, while not in accord with his Europeanized drawings, does indicate the persistent assumption that the American Indian was not a unique ethnic or racial type but some kind of a mixture of already known people (Bergh 1985).

This language is familiar in talking about art even today. The modern Western artist's unique ability to see pre-Columbian art is related to the desire to create a nonclassical modern art. Moore wrote that it was important to get rid of the "complete domination of later, decadent Green art as the only standard of excellence" (ibid.:22). This new vision is accompanied by a different verbal system of analysis and a specific descriptive vocabulary. In this system, terms such as "stoniness," "form-invention," and "three-dimensionality" are used as terms of approbation. Dürer, too, had an art theory and vocabulary, but he was concerned with perspective and proportion and classical authors on art, such as Vitruvius, none of which could he use in relation to pre-Columbian art. Nor could the term "full of thought," which he applied to van Eyck, be transferred outside of his

familiar culture. For Henry Moore the primary qualities of sculpture are formal ones, irrelevant of cultural subject, function, time, or place of origin, and they make it possible for him to bring together such unlikely juxtapositions as eleventh-century Yorkshire carvings and a sculpture from Chichén Itzá. The only things these works have in common is that they are nonclassical. This attitude makes it possible for Moore to adopt some aspects of pre-Columbian art. He can borrow a male ritual altar figure and transform it into a reclining female nude within the Western tradition without feeling that this might be inappropriate (Fig. 12.4). Moore visually refers to Mexican sculpture as a new authority for the kind of "universal" art he hopes to create. Mexican sculpture and eleventh-century Yorkshire art now replace Vitruvius as models.[3]

In Henry Moore's twentieth century, the art of the whole world is accessible not only in reality, through travel, books, and museums, but also conceptually, through comparative formal analysis in which all art styles can be described and distinctions drawn between them.[4] Foreign works of art are appropriated through this discourse and incorporated into a global "modern" tradition. Closer analysis shows, however, that the language of modernism is in large part merely an inversion of the classical language of art. The major difference is the decision as to what is perceived as beautiful or meaningful. What was

"tremendous power without loss of sensitiveness" to Moore would have been merely "crude" by classical standards; while Moore dismissed Greek art as "decadent," Dürer would have seen in it "harmony and proportion." The balance of opposites is posited as an ideal by both the modernist and classical points of view, which both assume a three-part development in art, of crude beginnings, a florescence of harmonious balance, and a final fussy deterioration. While the terms of approbation refer to notions of balance and harmony in both systems, the modernists apply them to what had been described as crude beginnings by the classicists and find artistic value primarily in the first third of the three-part system. That first level of development had been particularly derided in the classical view, because classicism emerged, point by point, in opposition to what it defined as "archaic." There can thus be no real agreement between modernists and classicists, although they both operate within the same system of thought. The value system of modernism merely turns classicism on its head without providing a radically different mode of approach.

The role of modernist artists in validating pre-Columbian art, as art, in the first half of the twentieth century is well established. Here I want to emphasize the importance of the language that describes objects in terms of form, that compares the formal properties between objects of different times and

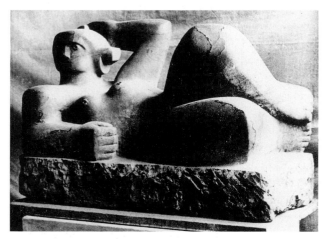 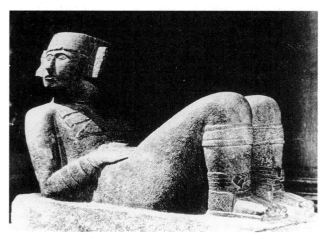

Figure 12.4 Henry Moore, *Reclining Nude*, 1929, stone, 81.28 cm. Courtesy Henry Moore Foundation. Right, Chacmool Chichén Itzá, limestone, 1.48 m. National Museum of Anthropology, Mexico City. Reproduction authorized by the Instituto Nacional de Antropología e Historia.

places, and that places objects in a hierarchy of value, creating greater and lesser works of art out of the traditions of others. Writings on pre-Columbian art begin in this tradition and use European formal criteria in developing a non-Western art history. In this way Covarrubias (1957) and Toscano (1984) defined Maya style as naturalistic and curvilinear (Fig. 12.5), and Teotihuacán as abstract and rectilinear. Covarrubias's "cubistic" drawing of the colossal unfinished sculpture from the quarry of Coatlinchan is in itself a validation of abstraction (Fig. 12.6). The language of European formal analysis has become the basis for a taxonomy to create order out of the varieties of non-Western styles. The problem, however, is that formal analysis defines art on a continuum from abstract to naturalistic, which is primarily of concern to European art history. The naturalistic and curvilinear style of the Maya makes of them the "classical Greeks" of the New World. The ideological rivalries of Europe are thus replayed on new soil.

Today a double standard continues to operate in writings on pre-Columbian art. Although artists such as Henry Moore validated its non-naturalistic traditions, the styles that are most valued aesthetically and

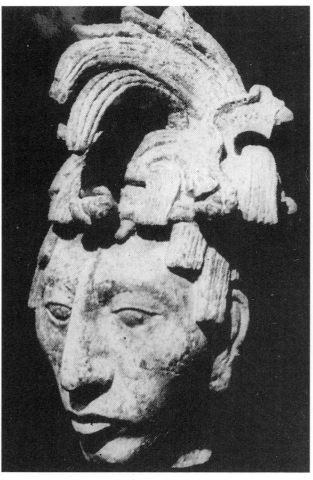

Figure 12.5 Stucco head from Palenque, representing the ruler Pacal in the tomb of the Temple of the Inscriptions, discovered in 1952. National Museum of Anthropology, Mexico City. Photograph by Señora Carmen Cook de Leonard in J. Eric S. Thompson's *The Rise and Fall of Maya Civilization*, 2d ed., enlarged. Copyright © 1954, 1966 by the University of Oklahoma Press.

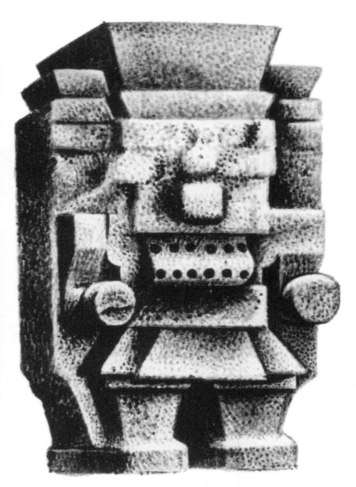

Figure 12.6 Unfinished carving of a goddess in Teotihuacán style found in the quarries in Coatlinchan. Located at the entrance to the National Museum of Anthropology, Mexico City. Height 7 m, width 3.8 m, depth 1.5 m. Drawing: Miguel Covarrubias. From *Indian Art of Mexico and Central America*, by Miguel Covarrubias, copyright © 1957 by Alfred A. Knopf, a division of Random House, Inc. Used by permission of Alfred A. Knopf, a division of Random House, Inc.

monetarily in the marketplace and that confer the highest scholarly prestige in academia are still the most naturalistic ones such as the Maya of Mesoamerica or the Moche of Peru (Fig. 12.7). C. H. Reed who, in 1910, had the chance to select 250 Moche vessels for the British Museum from a private collection of 800, wrote a brief apologetic note about them in *Burlington Magazine*. He begins by asking the reader to forgive him for even bringing up the art of so strange and primitive a people. He agrees with his imaginary reader that most of these pre-Columbian arts are rude, but exempts from these the Moche portrait vessels, which he finds astonishingly similar to the representation of Jean Duc de Berry on his tomb at Bruges, especially as it is known to him through a drawing by Holbein! He assumes as obvious that naturalism should be associated with superior civilizations because it is the art style of the technologically and politically superior West. Because of the association of naturalism with higher civilizations, it is preferred over abstraction for historical as well as aesthetic reasons. In this sense, even when it is valued by modernists, abstraction is associated with primitiveness. What they assert in effect is: "I don't care if it *is* primitive, that is precisely why I like it." In modernist thought, primitive remains—and necessarily must be— "primitive," but it is *relished*. This double standard produces, paradoxically, a great interest in realism wherever it occurs outside of the West: naturalism is considered to be the highest form of art and, by extension, of civilization, whether one likes it or not. Recently, great enthusiasm greeted the discovery of portraiture among the Maya, both among scholars and the public interested in pre-Columbian art (Kubler 1969; Schele and Miller 1986).

Major unspoken distinctions are made between the abstractions of Western and so-called primitive peoples. For the modern artist an important aspect of abstraction is the reaction against the naturalistic classical tradition. In the case of Picasso in particular, there is proof in his early career that he could work in a naturalistic vein. Yet the assumption is that Eskimo artists, for example, cannot produce a realistic image, that abstraction alone is accessible to them. In other words, for the modern artist abstraction is a

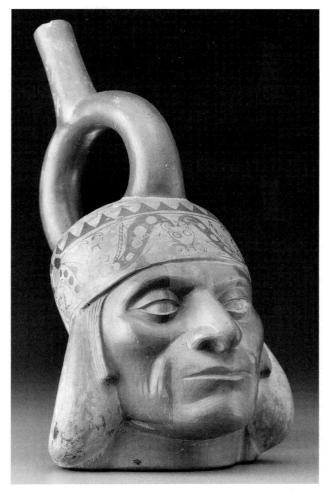

Figure 12.7 Peru, Moche culture, stirrup-spout head vessel from Peru, 100 BC–AD 500, 26 x 17.8 cm, Buckingham Fund, 1955.2341 © The Art Institute of Chicago.

choice, but for the non-Western artist it is a given. Moreover, for the modernist artist abstraction is a great achievement, while for the non-Western artist it is merely an inadequate attempt at representation. This point of view has been expressed most forcefully by Gombrich (1960), who argued that "conceptual" abstract art predates the development of "perceptual" naturalistic art and that the creation of abstraction is easy and comes naturally, while the development of realism is a slow and difficult process comparable to the successive discoveries in Western science. Although Gombrich has been refuted by Bryson (1983) and others, his developmental model is still the dominant one.

Such were the tenets underlying the primitivism show of 1984 at the Museum of Modern Art, in which tribal works of art were exhibited alongside the modern European art that was supposedly influenced by them (Rubin 1984). Several reviewers (e.g., McEvilley 1984; Danto 1984; Ashton 1984; Bois 1985; and Clifford 1985), most of whom were highly critical of the exhibition, pointed out that one of its most striking features was the great contrast between the amount of explanatory texts around the works of modern art and the brief descriptive labels under the "tribal" pieces.[5] In effect, what the exhibit conveyed was that for the modern artist abstraction is a complex visual, philosophical, and intellectual undertaking, while for the "tribal" artist it is something simpler and more natural. The exhibition evoked the following interpretation in the viewer: tribal artists use abstract forms because that is their inherited tradition, and, rather than innovating and experimenting with visual forms, they stick to tradition. *Their* abstraction is a lack of imagination, while *ours* is the height of imagination. Moreover, the captions demonstrated that forms that appear to be unusual in the West are in fact representations of a native's everyday reality. A twisted nose, for example, represents a type of illness and a literal physical deformation on a Pende mask, or the strange protrusions on the side of a Senufo mask represent a woman's coiffure (Fig. 12.8). In this line of reasoning, the tribal artist loses out on "inventiveness" because the images are descriptions of reality after all, though they are not represented in a naturalistic style that would redeem them. Here, too, abstraction was seen as earlier than naturalism and therefore, by a Gombrichian historical definition, developmentally primitive.

By these revaluations European modern art remains superior—because of the historical situation in relation to classical art, because of the verbal and philosophical forms of awareness and analysis associated with it, and because of the element of choice present for the artist. This means that although the original interest that turned Westerners to non-Western art was its conventionalized and abstract character, given the discourses now available, it is still extremely difficult to talk about the less naturalistic traditions in a positive fashion.

Recently, art historian Robert Thompson showed pictures of some modern artworks, including several Picassos, to a group of Africans.[6] They interpreted them not through form but by meaning—a heavy black stripe on the body and the dark circles under Picasso's eyes were interpreted as signs of something powerful, as in witchcraft. This exercise did not primarily show that Picasso's art has universal meaning

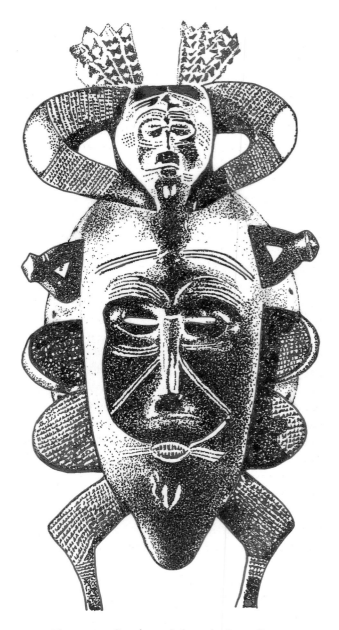

Figure 12.8 Senufo mask from the Ivory Coast. Drawing: Janice Robertson.

that can be intuited by anyone, but rather that all people see foreign art through their own frameworks of significance.

It is the critical discourse developed in the twentieth century that makes it possible to see and analyze pre-Columbian art, but what is lacking is the existence in these traditions of local discourses that could be analyzed together with the works of art. In still existing "tribal" societies it is possible to collect that kind of information and to put objects into historical, ritual, and philosophical contexts. Oral traditions, including information on artists, patrons, and ritual actions, provide what is in effect a text. For cultures that are known exclusively through archaeology and that have no writing systems, the possibility of textualizing seems hopeless. One is left with the images and alien systems of description and analysis.

The archaeological attitude to artifacts is that they are primarily bearers of factual information, much like the illustrations in a lost ethnographic text. The costumes are assumed to be the ones worn, the weapons the ones used, the rituals those reconstructed from the actions shown. Thus the artworks are interpreted: "This is what they did," "This is what they looked like." To some extent this is a reasonable assumption; artworks do reflect many aspects of reality. Generally, however, rather than representing life as lived, they show life from a very specific point of view, much as modern advertising shows daily life from the point of view of those desiring to sell certain products. It is worth contemplating how people from another planet might reconstruct twentieth-century civilization on the basis of advertising images. Some things they would know a great deal about, such as laundry soap, while other things would be a closed book. How would they reconstruct twentieth-century life on the basis of modern art if texts were not available?

Because so many art historians dealing with pre-Columbian art write for their peers who are largely anthropologists and archaeologists, their approach tends to collapse into a "soft" anthropology. In the recently popular exhibition catalog *The Blood of Kings,* Schele and Miller claim that they are not so much interested in analyzing Maya *art* as in reconstructing Maya *ritual.* Their approach to such reconstruction is literal. For example, on the basis of the scene of a victim tied to a scaffold on a pottery vessel from an unknown source (Schele and Miller 1986:pl. 92) and the representation of a ruler shown seated in a niche above a ladder on a stela from Piedras Negras (ibid., fig. II, 4), they have reconstructed a Maya accession ritual that goes something like this: A victim was first sacrificed on the top of the scaffold. The ruler then stepped into his blood and subsequently climbed up into the niche. The footsteps present on the cloth over the ladder of the Piedras Negras stela are thus interpreted as being "bloody" and situated in an imaginary narrative that ties two different types of objects from different places together. Footprints, however, are common signs that are used in a number of Mesoamerican cultures to represent movement in a certain direction, without any indication that feet were dipped in blood or anything else. They are symbolic and allegorical rather than literal.

Aesthetic commentary by Schele and Miller is largely a validation of the skill, aesthetic refinement, and naturalistic representation found in Maya art, which makes it accessible to the Western viewer. These criteria might be a postmodern revival of essentially nineteenth-century concepts of art, as illustrated by Reed's enthusiastic evaluation of Moche art.[7] The agenda of Schele and Miller is in some ways the opposite of Rubin's and that of the Museum of Modern Art exhibit: the naturalism of Maya art is extolled in order to raise the level of Maya civilization in our eyes. (At the same time, its barbaric blood rituals are sensationalized so that we can revel in exoticism without jeopardizing our sense of cultural superiority.)

Whether we favor abstraction or naturalism, the language of aesthetics in twentieth-century Western culture is deeply involved in the "ranking" of traditions and artists against each other, relevant as much for what is taught in schools as for what is bought in galleries and museums. Moreover, even in the most intellectual polemics, such comparative artistic ranking of non-Western traditions is often the justification of various current political postures. According to radical intellectual discourse, there can be no evaluation of the art of any group, whether ours or that of

others, that isn't tainted by various ulterior motives and agendas that are cultural, political, and personal. Without doubt, we are all attracted to the fields we study by mysterious empathies that are best left in the unconscious or on the couch of the analyst. This empathy may in fact be the critical factor that allows us a special insight into our fields of study. I am not assuming that absolute impartiality is available to anyone, nor that it is even desirable, but I am suggesting that in our interpretations we might encourage attitudes of greater detachment. Detachment is gained in comparisons. Perhaps we can cultivate the attitude of a hypothetical natural scientist studying birds and insects, to whom ants and hummingbirds are of equal interest, while trying to fit both ants *and* hummingbirds into some viable intellectual scheme. Perhaps our hypothetical natural scientist can even maintain a reasonably impartial attitude in studying ants, though perhaps preferring to watch hummingbirds, or vice versa. Such a scientific metaphor and model is very much the product of Western civilization and as such is not, by any means, value free. Nevertheless, the analysis of beings other than humans has allowed natural scientists a degree of detachment less available to anthropologists and historians. The following analysis of abstraction in the art of Teotihuacán is presented not to "raise my culture above your culture," but instead in this spirit of natural history.

II. THE TEOTIHUACÁN AESTHETIC OF ABSTRACTION IN CROSS-CULTURAL PERSPECTIVE

It is no accident that what is perhaps the most abstract tradition of Mesoamerican art, the art of Teotihuacán, has so far been the least studied and is the least known. Teotihuacán art has frustrated archaeologists and art historians alike by being resolutely non-narrative and non-naturalistic. Teotihuacán was the first great city in Mesoamerica, with pyramids that compare in size with those of Egypt and a population that was probably over a hundred thousand (Fig. 12.9). Teotihuacán flourished between AD 1 and 750; thus, more than 800 years

intervened between its collapse and the Spanish conquest, when Westerners began the textual recording of pre-Columbian cultures. Because Teotihuacán is located in the same region as the later empire of the Aztecs, early writers tended to see it as an earlier version of Aztec culture. This was not an unreasonable assumption. Actually, the language spoken at Teotihuacán is not known, nor is the ethnic group to which the people belonged. What we have is the ancient city, 50 kilometers northeast of modern Mexico City, with an architecture of gigantic scale—the avenue alone is nearly 1.6 kilometers long and up to 40 meters wide. The Aztecs, who came to power five hundred years after the fall of the city, were greatly impressed by its ruined state, and thought that it must have been built by the gods. Hence, they called it Teotihuacán, meaning "The Place of the Gods," or "Where the Gods are Made" in Nahuatl. They believed that the last creation of the world took place within the shadow of its pyramids. According to the various accounts they gave of it to the Spanish chroniclers, for the Aztecs Teotihuacán was a place shrouded in myth and legend.

Some years ago when I did my dissertation on the mural paintings of Teotihuacán, I, like the others who approach them, wanted to know mainly what they represented in a factual, archaeological way (Pasztory 1976). Using sixteenth-century texts and a contextual analysis of its signs and combinations in art, I identified a rain god, a nature goddess, and, more tentatively, a war god. I suggested that these gods had later Aztec parallels, not in the sense of a specific continuity of gods and cults, but in the sense of belonging to generally similar religious systems and perhaps even comparable ritual traditions. The use of ethnographic analogy in interpretation was firmly in the tradition of pre-Columbian iconographic studies. I also tried to analyze the murals in terms of their style, and to create a stylistic chronology. I then tried to interpret this chronology in a somewhat Wölfflinian way by defining its period styles and eliciting possible cultural meanings from them. This part was less successful; I was plugging pre-Columbian matter into the machine of European art

Figure 12.9 View of Teotihuacán. Photograph: Esther Pasztory.

history. My results were some partial insights and a lot of frustration.

Using Aztec texts to explain Teotihuacán, eventually it became necessary to devote some time to the study of Aztec art. It was a joy and a relief to work with a tradition for which abundant texts are available, but it led to the unexpected conclusion that the texts were not particularly helpful even in the case of Aztec art. Although the texts were very helpful in creating a cultural context, I found that the answers to my most pressing questions about Aztec art resided in the artworks themselves—in their forms and compositional contexts. The textual references to works of art were rarely clear and specific enough to provide meaning. They remained interesting but marginal glosses (Pasztory 1983). My project on Aztec art, paradoxically, resulted in a greater confidence in dealing with the works of art in themselves. I decided to tackle the art of Teotihuacán once more.

In a second encounter with the art of Teotihuacán, what was most astonishing was the feeling that I was discovering it completely anew. It was as though I had really never seen it the first time around, which showed how difficult it is really to see a strange style, how much it is seen through the personal framework of the viewer, and the extent to which seeing is determined by the availability of words to describe it. There is no sure way to account for the change, but through the convergence of contextual studies of pre-Columbian art and semiotic and structural literature, by 1983 Teotihuacán began to emerge for me out of its former obscurity.

One moment of understanding came with the discovery of a rather simple relief fragment (Fig. 12.10). I had known nothing about this relief fragment before I found it in 1983, casually placed, leaning against a wall near the entrance to the Temple of the Feathered Conches. Inquiries led the guard to tell me

that he thought it might have belonged to some unfinished excavations conducted many years before and that it had been part of a heap of worked stones of various sorts piled under a tree. He did not know how or why the relief got to the wall it was leaning against. As far as I could tell, it had not been photographed, cataloged, or studied, which may perhaps be attributed to its severely abstract appearance.

The image on the relief is abstract in the sense of a reduction and simplification of forms.[8] Studies in perception have shown that humans are biologically predisposed to search for meanings even in very vague forms, such as clouds and driftwood. In this Teotihuacán design, one is quick to see something reminiscent of a face. One may then note formal qualities, such as a flat, squarish outline within which, in low, flat relief, there are two circular shapes and a rectangular one represented below a large rectangle subdivided into two sections. Assessing the

organization of these elements, it may be noted further that the forms are kept separate without overlapping, that their organization is bilaterally symmetrical, and that geometric forms and horizontal lines predominate. The irregular hole in the center, which may be due to reuse or to a "killing" of the object, clashes with the sense of order in the design. The irregular upper edge indicates that something has broken off from the top. The language of formalism gets us more or less this far.

The image that is here called abstract is often called conceptual—a term coined by Gombrich. Images that appear to be constructed on the basis of what the artist knows in his or her mind he termed conceptual, in contrast to "perceptual" art that is based more on what the artist sees. Placed next to the Teotihuacán relief, the Olmec head (Fig. 12.11) would be called perceptual. The conceptual/perceptual dichotomy works best, if at all, at the two ends of

Figure 12.10 Stone relief, possibly a roof ornament. Height around 50.8 cm. Teotihuacán Site Museum. Reproduction authorized by the Instituto Nacional de Antropología e Historia. Photograph: Esther Pasztory.

the scale, for it is impossible to define at what precise point a conceptual image becomes perceptual, and vice versa. The terms are therefore comparative. Art historians, discussing European art (a largely perceptual tradition), delight in demonstrating the many arbitrary conventions and patterns they find within naturalistic art (Brilliant 1987). A most telling statement along these lines was made by the seventeenth-century Italian sculptor Bernini, who said that in order to make his portraits look more alive he added projections and depressions to his sculptures that were not actually in the faces of his sitters (Martin 1977:274–275). All art, then, is conceptual, particularly images created on two-dimensional surfaces. The difference is that some seek to give the illusion of reality, while others attempt to create a reality that is not in the visible world, a process interpreted as abstraction.[9]

Much has been made of intentionality in the modern artist's use of abstraction at the beginning of the twentieth century.[10] Is there any evidence in the case of Teotihuacán that would throw light on this question? Monumental art had been made by the Olmec and the Olmec-related Izapan tradition for nearly a thousand years prior to Teotihuacán, starting at about 1200 BC. This tradition was based on naturalistic portraits and life-size figures commemorating dynastic rulers. Such monuments can be found at Chalcatzingo, an Olmec-related site not far from Teotihuacán, which, judging by the remains, was probably known to them. Teotihuacán was contemporary with the Early and Middle Classic Maya who, like the Olmec, had a tradition of naturalistic representation. In both Maya and Olmec art, the primary subject is the dynastic ruler. On Maya monuments historic inscriptions in hieroglyphic texts name the rulers and their families. We know that the people of Teotihuacán and the Maya were in contact with one another, because of borrowings that are evident in their art. Some monuments suggest remarkably close ties. On Tikal Stela 31, the Maya ruler is flanked by an individual dressed in Teotihuacán costume—a shell necklace and big feather headdress—and on the side he carries the frontal face of a Teotihuacán deity on his shield (Fig. 12.12). Mayanists have not yet decided conclusively who this figure is; it might be a

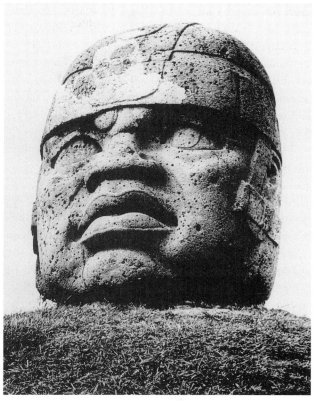

Figure 12.11 Olmec colossal head. Height 1.67 m, width 1.26 m. San Lorenzo Monument I, Xalapa Museum, Veracruz. Reproduction authorized by the Instituto Nacional de Antropología e Historia.

"Teotihuacán ambassador" or possibly even the father of the ruler represented in front. As a system of representation, therefore, some form of naturalism was known and available to the rulers and artists of Teotihuacán. I suggest that abstraction was a Teotihuacán choice and not simply the "norm" of a tradition, and I have argued elsewhere that one of the reasons was precisely to differentiate themselves from neighbors whose cults of dynastic commemoration included individualized representation (Pasztory 1988). Obviously, at this point this refers to collective cultural choices rather than a personal one, but that is merely how it looks from an archaeological vantage point. Although Cézanne, Picasso, and Braque loom large as innovators in modernism, their acceptance and elevation as cultural icons were also collective cultural choices. Conversely, individual patrons and artists, while undocumented, were important in prehistory too. As I will show later, we can sometimes

reconstruct even now the nature of artistic innovation and audience response in some aspects of Teotihuacán mural painting.

What was remarkable initially in the unknown relief lying against the wall was obviously not a richness of imagery or representation but its spartan language of signs, which pulled together all of my previous knowledge about Teotihuacán art. A mural painting from the Tetitla apartment compound came to mind, immediately shedding light on the relief (Fig. 12.13a,b). In comparing these two images, the "face" of the relief turned out not to be a face at all. What was read as "eyes" were actually earplugs and what was read as "mouth" was a nose ornament. The face is, in fact, a set of costume elements (including the rectangular frame headdress) that are the insignia of the nature goddess represented on the Tetitla mural. The significance of this discovery lay not only in the explanation of the image's meaning; more importantly, I had acquired an insight into how Teotihuacán images were constructed. The image was probably meant to be read simultaneously in two ways: both as a face and as the insignia belonging to a face. It suggested an awareness of the absence of a persona, while at the same time implying its presence. This image tells us about faces—evidently their visibility can be unimportant or suppressed—and something about costume, which appears to be all important. The relief is the embodiment of a visual ambiguity and a double meaning, which oscillates between presence and absence. This relief is not the only work that shows the goddess without features. In the Temple of Agriculture mural, small humans are shown making offerings to mountain-shaped forms with the insignia of the goddess of the absent face (see Fig. 12.28).

Figure 12.12 Stela 31, drawing of front and two sides, Classic period, stone relief, 230 cm. Tikal, Guatemala. Reproduced from William R. Coe, "Tikal: Ten Years of Study of a Mayan Ruin in the Lowlands of Guatemala." *Expedition* (1965) 8(1):33. Courtesy Tikal Project, University of Pennsylvania Museum.

Figure 12.13a Mural painting of the goddess from the apartment compound of Tetitla, Teotihuacán. Reproduction authorized by the Instituto Nacional de Antropología e Historia.

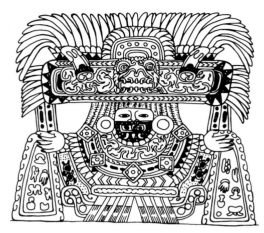

Figure 12.13b Drawing of the goddess in the Tetitla mural of Figure 12.13a. After Laurette Séjournée, *Burning Water: Thought and Religion in Ancient Mexico* (New York: the Vanguard Press, 1956), fig. 80. Drawing: Janice Robertson.

This comparison of the relief and the Tetitla mural dramatizes two processes that are at work in the art of Teotihuacán: the same subject can be shown reduced to a bare minimum of significant details, or it can be expanded to elaborate versions. Compressed images approximate glyphs or emblems and seem to function as denotative verbal equivalents. In its most minimal form, Teotihuacán art seems to approach the forms of written signs. Expanded images may be replete with a multiplicity of redundant signs, whose meaning may add connotative richness and variety to the essential denotative meaning of the emblem. Although the Tetitla image is clearly at the elaborate end of the scale in the representation of "nature goddess" images, here too the human body is suppressed. The only human features of the Tetitla goddess are the yellow hands, which indicate the convention of representing female bodies in yellow that is shared with the Aztecs. The upper half of the face is painted green, presumably to represent a greenstone mask well known among Teotihuacán remains (Fig. 12.14). Instead of the lower half of the mask, the bottom half of the face is partially covered with red paint allowing the yellow color of the face to appear as dots. In effect, except for the yellow dots, the face of the goddess is covered by a variety of means, including a mask or facial paint, or both. All the rest of the figure consists of dress and insignia. One of the evident

conclusions to be drawn is that there is a strong Teotihuacán avoidance of the representation of the body, particularly that of the human body, and that deities are envisioned as consisting primarily of costumes and signs.

This aspect of the Teotihuacán image system has led some scholars, most notably Langley (1986), to see whether Teotihuacán art might have been structured as a system of writing. His aim was made clear in the preface, where he says that "[d]espite all the research directed to Teotihuacán, there was no systematic catalogue of the signs that were incorporated in its art and *constituted the sole vestige of a writing*

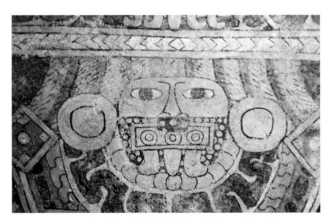

Figure 12.14 Detail of the face of the goddess from Figure 12.13a. Photograph: Esther Pasztory.

system without which it seemed inconceivable that the city could have developed on the grandiose scale to which its remains testified" (italics mine). Langley's exhaustive analysis of signs and sign clustering in Teotihuacán art demonstrates only a few instances of linear or numerical organization that can be considered parts of genuine systems of notation. Indisputable glyphs, very similar to later Mixtec and Aztec ones, occur in several murals (such as the Flowering Trees and Feathered Serpents and the Goggled Figures with Tassled Headdresses formerly in the Wagner collection [Berrin 1988] and on a few vessels and conch shells, etc.), indicating that recognizable writing did exist at Teotihuacán but was generally not incorporated into works of art. The search for evidence of writing at Teotihuacán is motivated in part by the desire to upgrade Teotihuacán to the level of the Mayas and the ancient Egyptians. By treating the entire image system as a step toward the evolution of true writing, the art can only seem like a failed system of writing, rather than an image system presumably adequate to Teotihuacán and successful on its own nonglyphic terms. Paradoxically, the major contributions in Langley's study are the analyses of the nonlinear, multivalent structuring patterns of the signs.

While the art of Teotihuacán is a failed writing system in the view of some, it is a failed representational system in the view of others. Teotihuacán is discussed in terms of lacking the major features of classical and Renaissance European art, such as the representation of depth in perspective, modeling in light and shadow, and in general a "perceptual" approach that creates the illusion that a two-dimensional surface is a "real" segment of the world. Many of these missing features are aspects of the much-noted insistence on flatness in Teotihuacán painting and sculpture (Miller 1973:24; Toscano 1984:123–124). I suggest that what we see as the literal suppression of the human embodiment of the goddess is related to the Teotihuacán insistence on presenting experience in two-dimensional rather than three-dimensional forms. It is interesting to note, in this connection, that the two relatively abstract traditions in Europe—medieval and modern art—are also characterized by this rejection of the primacy of the

human body and the sensory realm in association with a preference for flat surfaces.

Gombrich once commented that the art of the world is a vast ocean of conceptual art, broken up here and there by islands of naturalism (1963:9). Western art history as a discourse began by tracing perceptual art styles from conceptual antecedents: classical Greek style from Egyptian and Renaissance styles from medieval. As a result, in the language of Western art history, conceptual painting styles elsewhere have been defined in terms of their differences from the ideal of classical arts. These descriptions are usually couched in negatives—that is, they don't have perspective, they don't have light and shade and modeling, and so on. A litany of these negative traits can be found in Western descriptions of artistic traditions from Persian miniatures to Mixtec manuscripts (Stchoukine 1959:141–159; Robertson 1959:15–24).[11] This negative tradition of describing nonclassical styles goes back to art history at the turn of the century when art historians were struggling to characterize and explain the "primitiveness" of early Greek art. For example, the following passage from Loewy's essay of 1907 on Greek art was quoted by Robertson in 1959 to explain the nature of Mixtec art:

> The main features of the human body are always shown in their broadest expanse and their most typical aspect . . . all areas within the outline tend to be colored in a flat wash of unshaded color and forms do not overlap more than is absolutely necessary. No attempt is made to represent three-dimensional space in an illusionistic fashion. (Robertson 1959:23)

Discussion of the possibility of what such arts have, rather than what they lack, has been pioneered by Meyer Schapiro, whose interests in medieval and modern art have brought him closest to this issue (1969). Using semiotic analysis, he suggested that the flat field on which an image is made, whether a piece of paper or a wall, already has inherent in it certain properties: it has an edge and a possible frame, as well as a definite center; it implies directions of top

and bottom, right and left, and concepts of above and below. Accordingly, although the inherent structural properties of the flat field are variously exploited in different traditions, unrelated works often show striking structural parallels. Schapiro made the important observation that such flat fields do not seem to be the earliest of human arts, since complex human artifacts such as flat and neatly bounded walls, stelae, and various types of papers, panels, and books are usually coeval with settled civilization (ibid.:486–490).

Taking these ideas further, Summers has discussed the Teotihuacán mural of Tepantitla to demonstrate what he called the "planar structure" of "conceptual order" (1982). His use of the semiotic term "sign" for the various elements of the design, which were previously called symbols or motifs, is very useful since there is no need to make any distinctions in terms of what the signs mean, whether they are symbolic or not.[12] Signs in Teotihuacán art are visually designated by being clearly outlined and are rather freely moved from one image to the next according to

the requirements of iconography. Summers argued that the primary aim of such "conceptual order," and one naturally suggested by the flat field, is a representation of the structural relations of hierarchy. In the case of the Tepantitla mural (Fig. 12.15), that hierarchy consists of the centrality of the large nature goddess shown frontally, while smaller priest figures are shown in profile in relation to her (Fig. 12.16). Still smaller human figures are placed in the scenes below them. Unfortunately, in his article too, the discussion is implicitly arranged in an evolutionary sequence, from abstraction to naturalism: Tepantitla is followed by an Assyrian relief, which is in turn followed by a Jan Van Eyck painting, all of which show variation on a bilaterally symmetrical plan demonstrating "hierarchy." The contribution of Summers' article lies in his notion of "conceptual order," which can be used to bind together art from various times and places without any negative implications.

Almost all "conceptual" traditions in which hierarchic values and size relations are primary lack perspective projection in the rendering of space. It

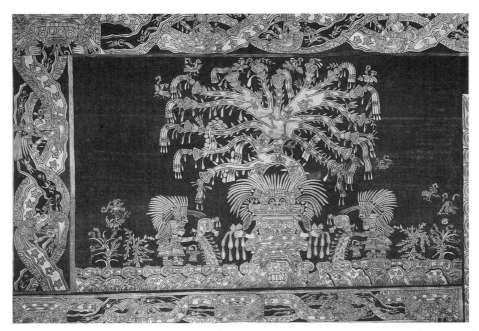

Figure 12.15 Mural painting from the Tepantitla apartment compound at Teotihuacán, left wall, upper portion. Shows the goddess with water drops in her hands and a tree behind her headdress. She is flanked by two elite "priest" figures. The storm deity Tlaloc is shown in the elaborate interlace border of the upper wall mural. Reconstruction copy in the National Museum of Anthropology, Mexico City. Reproduction authorized by the Instituto Nacional de Antropología e Historia.

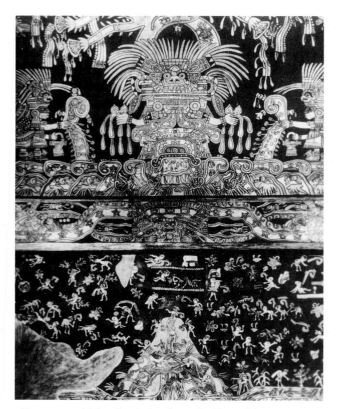

Figure 12.16 Mural painting from the Tepantitla apartment compound at Teotihuacán. Right wall, central section of the upper wall and the lower wall. An interlace border divides the two. The lower wall murals show small human figures in a variety of active poses, some of which may be ritual. Reconstruction copy in the National Museum of Anthropology, Mexico City. Reproduction authorized by the Instituto Nacional de Antropología e Historia.

would, in fact, be inconsistent with them—size differences have contradictory meanings in hierarchic and naturalistic representations. Yet the "flatness" of Teotihuacán art and of most conceptual art is too often taken for granted. Miller's description of Teotihuacán painting is overly emphatic:

A remarkable stylistic feature of Teotihuacán murals is the flatness of the images in painting. The motifs represented in any Teotihuacán mural are invariably shown in an attitude which emphasizes the two-dimensionality of the motif, i.e., the broadest aspect of it which has height and width. It is as if all the motifs represented in the murals are pushed forward, compressed, flattened out against the picture plane by some invisible force behind the images in the painting. If one were to draw a ground plan of the images in a Teotihuacán mural, the space shown would be as thin as a piece of paper. In fact, the paper analogy is particularly appropriate here because much of Teotihuacán painting *looks as if it were composed of motifs which are paper cutouts pasted on a flat surface*. (Miller 1973:24; italics mine)

A more than cursory examination of Teotihuacán painting indicates that this is not quite the case. Many examples can be cited to show that even in such flat conceptual styles the artist is aware of problems of space and of the complexities of translating three dimensions into two dimensions. In the Teotihuacán mural of a coyote dressed in a feather headdress (referring allegorically to a deity) (Fig. 12.17), the torso of the animal, and especially the collar shown looped around its neck, suggests dimensional form. Western art history has dealt with this type of spatial projection only as a "primitive" form of representation, in which the artist nevertheless has some glimmerings of perspective. (Miller's denial of the rendering of space in Teotihuacán art suggests that the strength of the "conceptual-perceptual" paradigm of Western art history might have channeled his vision and interpretation as much as the actual appearance of the murals.)

In a persuasive study of the geometry of projective systems in world art, Hagen has shown that all two-dimensional renderings belong to one of four projective systems (1986). Each of these systems is internally consistent and coherent and is, moreover, related to the "natural perspective" of vision. She terms these the metric, similarity, affine, and projective projections (Fig. 12.18). In the metric, or orthogonal, projection, planes and projection lines are both parallel; such projections assume multiple observer station points. Metric projection characterizes "flat" or "planar" styles such as Egyptian, Teotihuacán, or medieval art. Metric projection has the advantage of preserving more visual invariants, such as angles and parallels, which relate to the way things are, than any other type of projection. In that sense, metric projection is the most realistic.

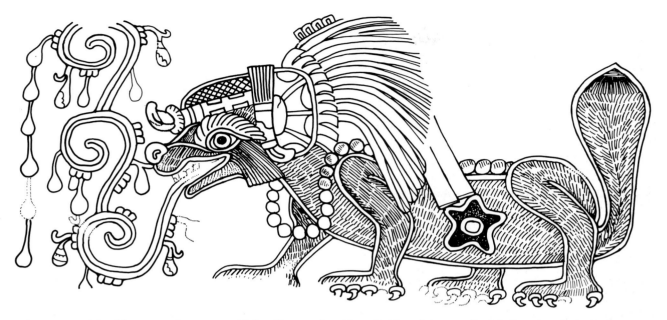

Figure 12.17 Mural fragment of a coyote with headdress and necklace. Reitburg Museum, Zurich. Drawing: Janice Robertson.

In similarity projection, the planes are parallel but the projection is from a single, central station point. Similarity projection is characteristic of one-point Renaissance perspective. There are fewer invariants in this type of projection, because the entire image is reduced in scale and a number of invariants, such as right angles, have to be distorted.

In affine projection, the planes are not parallel to the viewing angle, but the projection lines are parallel. Hagen's example of affine perspective is primarily the Japanese Yamato-e painting, in which multiple station points from a distant viewing point result in a "bird's-eye" perspective. In affine projection, neither people nor structures diminish in size in the distance.

Hagen's last category is projective projection, in which planes are not parallel and the projection is from a central point. Post-Renaissance European art and some types of Chinese painting are her examples. This type of projection distorts information the most and has the fewest invariants, but it appears to us to be the most realistic and has been called perceptual. The reason for this may be that our actual experience of the world is rarely stationary but is always in motion, as we walk about and look in different directions. We are therefore used to making fast spatial appraisals of our situation, in which we pay little

Figure 12.18 Four basic types of spatial projections of three-dimensional objects such as a house in two dimensions. Upper left: metric; upper right: similarity; lower left: affine; lower right: projective. Rearranged from Margaret A. Hagen, *Varieties of Realism* (New York: Cambridge University Press, 1986), figs. 5.6–5.9. Reprinted with the permission of Cambridge University Press.

attention to the invariants important to how things really are and to how they are represented in metric projection. Metric projection assumes a huge, stable world that, in order to be experienced, requires multiple station points for the observer. It is an all-enveloping projection of the world. Similarity projection, by contrast, is human-centered: it shows the cone of vision from a single station point. The view may be "deep," but it is also "small and narrow." In Hagen's view, neither metric nor similarity projection is any more realistic than the other; they simply measure reality differently.

This is a major step forward in the analysis of spatial representation: Hagen analyzes projection systems not as levels of technological or psychological-perceptual developments but as cultural choices. There probably is a relationship between the types of projective systems and the worldview, sociopolitical development, and other aspects of a given culture, but they are not tied irrevocably to cultural levels. Hagen notes, for example, that renderings in projective perspective can be found in Paleolithic and Bushman rock art (ibid.:232–238).

In general, the mural painting of Teotihuacán fits neatly into Hagen's metric division. In the case of the coyote mural (see Fig. 12.17), however, the position of the legs and of the chest are rendered not in metric but in affine projection. Although the coyote mural does not show foreshortening, it suggests space by a combination of metric and affine renderings. (Hagen mentions other instances in which two projective systems are combined. There are other examples where affine details are "nested" [her term] in metric paintings or similarity projection sections "anchor" a painting otherwise mainly in projective projection.) Hassig (1990) notes similar examples of metric projection combined with details in affine rendering in medieval art.[13]

The importance of space in a painting tradition as "flat" as that of Teotihuacán, may be illustrated by one of the most enigmatic creatures in its iconographic repertoire, the so-called net jaguar (Fig. 12.19). This feline has no substantial body at all in many paintings, in that it and the background are often the same color, but the spatial turnings and twinings of the net that defines its body are carefully

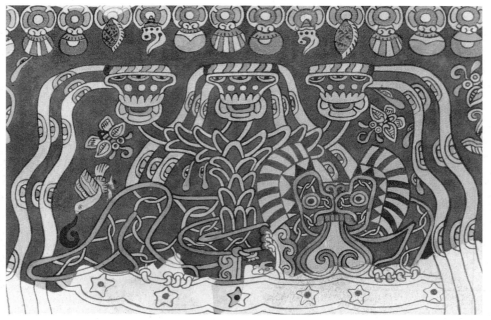

Figure 12.19 Net jaguar holding a stalk of blooming agave. From a palace (?) in front of the Pyramid of the Sun, referred to as Zone 5A. Copy. Reproduced from Arthur G. Miller, *The Mural Painting of Teotihuacán* (Washington, DC: Dumbarton Oaks, 1973), 81, fig. 119. Courtesy Dumbarton Oaks, Pre-Columbian Collection, Washington, DC.

detailed in such a way that once again one is aware of both presence and absence. This is a quintessential Teotihuacán image and is not found in the art of any other Mesoamerican culture. Unfortunately, since it did not outlast the collapse of the city, all that is known of this creature is that it is shown in water, fertility, and military contexts, information that is so generally true of Teotihuacán images as to be of little use. It illustrates, however, that spatial renderings are not only not "missing" in Teotihuacán art, but that in fact Teotihuacán was obsessed by the play between two- and three-dimensional renderings in its mural paintings.

In descriptions of such "conceptual" painting, it is often asserted that composition follows the law of clarity: body parts and elements are arranged so that they offer the greatest visibility in order to display all the necessary information, often in the form of discreet signs. Actually, Hagen has shown that "clarity" is partly the result of the many invariants inherent in the choice of a metric projection mode. Clarity as such, however, does not always appear to be an important or even primary value in representation. This is the case at Teotihuacán, where, despite the clear and heavy outlines and metric projection, murals are often hard to decipher (Fig. 12.20a,b). (Miller [1978:63–64] was the first to note this.) In part, this is due to their color, based essentially on shades of red, green, blue, and yellow with only a rare use of black and white. As a result, the color

values are very close and especially difficult to distinguish in black-and-white photographs. The artist of the Tetitla mural has situated an already spatially confusing net jaguar against an ornate background that is based on diagonal stripes. It is a visual feat to distinguish the road and temple that are located next to and partially "behind" the feline. Deciphering difficulties abound, too, in medieval stained glass or Irish and Persian manuscripts, all of which require considerable familiarity in order to be "read." Clarity is therefore not the key to the understanding of conceptual styles or the choice of metric projection.

As any ordinary person in the street baffled by modern art can testify, such an "abstract" rendering seems to hide as much as it informs. Unlike naturalistic art, which after brief acquaintance with its conventions is readily accessible to a wide public (note the popularity of movies and novels), abstract traditions are inherently more difficult to access. In the Tetitla painting of the net jaguar and the temple, once the eye gets used to the decorative complications, it becomes clear that all the space unfolds in overlapping layers, as in a pop-up book. The one exception is the path with the directional footprints, which takes a turn and moves from the front layer with the feet of the jaguar to the back layer with the temple in a passage that defies the logic of the rest of the painting. This point of disjunction makes it the focus to which the eye returns over and over again. Consequently, the "empty space" at the entrance to

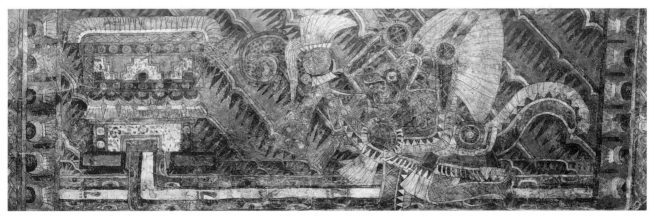

Figure 12.20a Mural of a kneeling net jaguar approaching a temple. From the apartment compound at Tetitla, Teotihuacán, in a room next to the frontal representations of the goddess in Figure 12.13. 72.7 cm by 212 cm. Courtesy Dumbarton Oaks, Pre-Columbian Collection, Washington, DC.

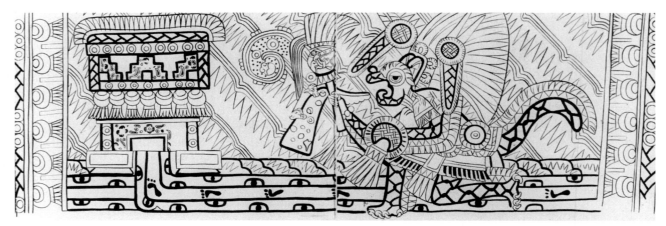

Figure 12.20b Drawing of mural in Figure 12.20a. Reproduction authorized by the Instituto Nacional de Antropología e Historia.

the temple acquires the kind of visual resonance that may correspond to symbolic meaning. Here, too, we may be dealing with an absent presence. In the art of Teotihuacán, space is sometimes denied and sometimes asserted, as the artist explores the possibilities of two and three dimensions for expressive purposes. Particularly evident in this mural is the need for the viewer to explore the mural actively in order to discern what it represents. It requires time, interest, and energy. Such painting assumes a public thoroughly educated into its conventions and willing to play such a game of visual hide-and-seek. One might say, by contrast, that naturalistic representation encourages a more facile and passive viewing.[14]

A description of non-Western conceptual painting that is based on negative factors will result in a definition of an art that lacks life and possibilities unless it is moving toward realism. Non-naturalistic styles, however, do have considerable aesthetic and expressive potentials of their own. One major advantage of a non-naturalistic style is, for example, that it can go into a great variety of formal directions without losing visual coherence. Body parts can be disassembled and reassembled at will as separate signs, without looking as if an organic body has been violently mutilated (Fig. 12.21). The destructive aspect of the nature goddess, for example, can be suggested by her disembodied mouth full of teeth and her hands turned into claws. Her headdress turns into a shield that can also be read as a medallion; as such, it is similar to a glyph-sign, since glyphs may be elaborated

into medallions as well (Fig. 12.22). This kind of image can be described as a diagram, rather than the more coherent and substantial image suggested at Tetitla. Of course, the "coherence" of the Tetitla image is merely one of degree, and is perhaps read into it by those of us who are used to organically coherent European images.

In Teotihuacán art, signs can be composed in a way that results in the visualization of a "naturalistic" scene. In this detail from Tepantitla (Fig. 12.23), a stream, consisting of bands of eyes and fish signifying water, meanders next to vertical and horizontal sections of green and blue that represent cultivated fields, further so designated by squash plants. Trees and plants, including corn and cacao, grow along the banks and a human figure is shown seated under a tree. The double meanings of the image delight the

Figure 12.21 Diagrammatic representation of the goddess with clawed hands, originally from the apartment compound of Techinantitla, Teotihuacán. 66 cm by 107 cm. Courtesy Staatliche Museen zu Berlin, Preußischer Kulturbesitz, Ethnologisches Museum. Photograph: Martin Franken, 2002.

Figure 12.22 Clawed figure with a net glyph or emblem substituted as its "face." Reconstruction drawing. Reproduced from Arthur Miller, *The Mural Painting of Teotihuacan* (Washington, DC: Dumbarton Oaks, 1973), 83, fig. 124. Courtesy Dumbarton Oaks, Pre-Columbian Collection, Washington, DC.

viewer because one sees it as a scene and a set of signs simultaneously, as in some of the poetry of e. e. cummings, where both the words and the shapes of the poem on the page are meaningful. One can readily imagine that the people of Teotihuacán similarly enjoyed this kind of visual play. It is mistaken to read such images as heading toward naturalism in any evolutionary sense. The possibility of unfolding the sign is, apparently, always there; the wavy lines that stand for water can open up to show shell gatherers half in and half out of the water.

Figure 12.23 Scene of stream, trees, figures, and signs composed as a "landscape" from the apartment compound of Tepantitla, Teotihuacán. This segment is a continuation of the right-hand bottom corner of the mural seen in Figure 12.16. Copy in the National Museum of Anthropology, Mexico City. Reproduction authorized by the Instituto Nacional de Antropología e Historia.

In still other contexts, decorative homogeneity takes precedence over natural appearance. One example, originally from an apartment compound called Techinantitla (Fig. 12.25), is a mural of little trees with glyphs above their roots which looters cut up into more than 40 fragments. In trying to reconstruct their original sequence, it has been shown that nine glyphs correspond to nine different flowers. Some of the flowers have been tentatively identified, such as the marigold, which is still considered sacred in Mexican Day of the Dead ceremonies (Pasztory 1988b:137–161). Yet identification is difficult because these engaging plants do not necessarily look like the species they represent. The agave cactus, for example, is represented by the glyph of three cactus spines in the trunk of the tree on the right of this fragment and by the spines hanging from the yellow flowers, which function purely as signs. The function of these trees is to denote "plants" purely as signs. The artists are perfectly capable of rendering cacti and do so on several other murals. The Techinantitla plants, however, are not intended to look like any species but rather as plants in general. This is also indicated by the fact that they have roots; in the "scene" at Tepantitla the plants did not have roots because there the laws of scenic representation required that they be inside the earth. The Techinantitla plants in this context could look like anything from vines to trees, because their appearance was secondary to the desire for symbolic coherence and decorative design.

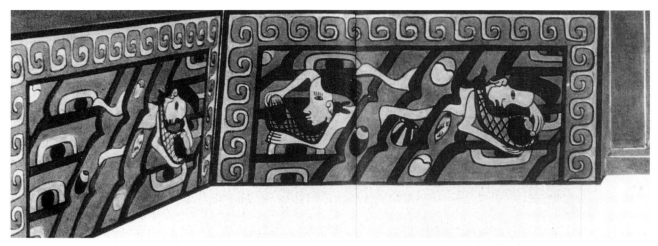

Figure 12.24a Fishermen collecting shells into net bags tied around their necks. From the Tetitla apartment compound in Teotihuacán. Reconstruction painting of two veranda walls. Reproduction authorized by the Instituto Nacional de Antropología e Historia.

Figure 12.24b Drawing of a fisherman placing a bivalve shell into a net bag from the Tetitla apartment compound in Teotihuacán. Reproduction authorized by the Instituto Nacional de Antropología e Historia.

The attitude toward ornament and decorative design has been essentially negative in the twentieth-century West, which seems to be one chapter in a long European polemic for and against ornament that can be traced back to classical Greek authors. Gombrich (1979) summarizes this polemic, and suggests that various classical and Renaissance authors associated ornamental restraint with morality and elegance and ornamental excess with sexuality and vulgarity. In general, therefore, the Western classical tradition has been against ornament, and Gothic and later rococo styles were at times condemned on those grounds as excessive. In the nineteenth century, industrialization and the machine replication of ornamented things

Figure 12.25 Trees with glyphs in their trunks originally from the apartment compound of Techinantitla, Teotihuacán. Milwaukee Public Museum of Milwaukee County. Courtesy Milwaukee Public Museum.

drove many artists and historians in two directions—either into veneration of the handmade work of craftspeople, as in the followers of William Morris, or into the elimination of ornament altogether, as in the work of functionalist modern architects. For a brief period the ornamental arts of exotic non-Westerners such as Muslims were extolled in a reaction against classical values, but basically the anti-ornamental approach exemplified by Adolf Loos came to prevail, primarily in the modernist architecture of the first half of the twentieth century that was largely stripped of decoration. In 1908 Loos published an essay entitled "Ornament und Verbrechen" in which his motto is "Ornament is crime" (cited in Gombrich 1979:60). The twentieth century thus inherited a combination of classical and modern functionalist ideas firmly set against decoration. Ornament has made a comeback in postmodern architecture, curiously in the context of a classical revival, which places bits of classical ornament on essentially modern buildings. The current atmosphere therefore may be more positive for the understanding of decoration.

Decorative art has also been losing out in traditional Western art history because of art historians' preoccupation with meaning. The search for hidden meaning in iconography exemplified by the work of Panofsky (all the more precious when it was hard to find) resulted in a tendency to see ornamental art as literally meaningless and therefore "mere" decoration. There is not much point in trying to find meanings in decorative art and thus provide validation for it.[15] Current art historical attitudes, which see works of art not as having a single intrinsic meaning but as sites for the production of various meanings, and which focus on the function of the work of art, allow for the formulation of functions and meanings for ornament that were not possible in earlier discourses.

It is perhaps not accidental that decorative, formal elaboration appears to go hand in hand with abstract "conceptual" traditions. The real question is not what ornament means but what it does. The illusion of naturalism requires that most of the image be "readable" as a segment of the visible world—even if the representation is of imaginary beings such as dragons or angels. Turning the tables on our usual discourse, one might say that naturalistic art "inhibits" the development of ornament. Ornament is relegated either to areas reserved for it, such as frames and borders outside of the picture field proper, or to costumes and various other details within it. The border designs and the picture field do not and cannot intermingle. When ornament overwhelms the

forms that give dimensional clues, as in the paintings of Gustave Klimt or in Russian icons, the effect of the real is diminished. The relegation of ornament to borders also creates a clear hierarchy of the naturalistic image, seen as superior, in relation to the ornamental frame.

Non-naturalistic traditions, by contrast, find freedom, variety, and excitement precisely in ornament, which they allow to move in and out of the central and privileged places of image making. They thus create an imaginary world that is more unified and interconnected. Since recognizable forms, such as persons or trees, need not be composed according to projective rules of perspective, they can be reshaped, distorted, and adapted in a great variety of ways, while still maintaining the minimal clues that provide an identification.[16] Since these recognizable forms are already usually highly stylized, they fit perfectly with the patterns of stepped frets, interlaces, zigzags, loops, checkerboards, braids, chevrons, and other geometric designs.

Saul Steinberg's wonderful cartoon (in Gombrich, ibid.:194) (Fig. 12.26) visually explores the contrast between naturalistic and abstract image making and results in one of those visual contradictions that evokes laughter. In this cartoon, he put together a "scene" from stylized bits of ornament and renderings of birds, leaves, houses, and design elements that could be at home anywhere from manuscript illuminations to peasant textile embroideries. In the center of this "landscape" a flat, anthropomorphic feline waters a plant in the form of a stylized ornament with a three-dimensionally rendered watering can. It is the inappropriateness of the watering can in the scene that is funny, as well as the idea that an embroidery-style plant could need watering.[17]

Figure 12.26 Drawing by Saul Steinberg. From *The New World* (New York: Harper & Row, 1965). © 2002 The Saul Steinberg Foundation / Artists Rights Society (ARS), New York.

Steinberg's drawing evokes another dimension of ornament. His lively calligraphy suggests that ornament is the work-energy that has gone into the making of something beautiful and intricate. Although decorative designs in most traditions often have names and sometimes limited symbolic meanings, a prime meaning of all ornament is to give a heightened sense of the important, the precious, the valuable, perhaps even the inaccessible, to whatever surface it is on. Ornament is also a clear sign that this is the imaginary realm of image making and not the visible world. There are no hidden meanings or searches necessary beyond what is visible on the surface. Ornament may, therefore, be both exciting and restful.

Most Teotihuacán mural paintings were in apartment compounds, usually on the walls of verandas where roofs protected them from rain and light from the open patios made them visible. Since large expanses of walls had to be covered, various compositional strategies were used. The most common is the repetition of a figure at intervals all along the wall, against a plain red background (Fig. 12.27). Some walls were divided into a decorative trellis, like wallpaper, with figures inside each diamond. Like the net of the net jaguar, the trellis could be rendered as a dimensional design (Miller 1973, figs. 159–162). Multifigure scenes occur, but they are the exception rather than the rule. Doorways and walls are usually framed by ornamental borders of a great variety of designs (see Figs. 12.15, 12.27).

This discussion is not an attempt to show how "complex" these traditions are and thereby equate complexity with aesthetic worth. My aim is really descriptive—neither praising nor diminishing any tradition. The discourse based on the traditions of Western naturalism and Western art and art history is not necessarily wrong, but it has cast a shadow that has made other traditions still invisible and incomprehensible. Although nearly a century of modern art

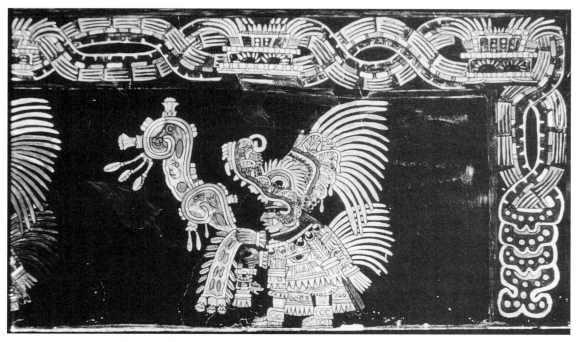

Figure 12.27 One of a procession of elite figures performing ritual tasks, such as possibly pouring libations and singing and praying. From the apartment compound of Tepantitla, Teotihuacán. Of the interlace serpent border the rattles are visible at the lower right. This mural is found in two rooms that open into the courtyard where the mural of the goddess and the little figures in scenic settings are located. See Figures. 12.15, 12.16, and 12.23. Copy, National Museum of Anthropology, Mexico City. Reproduction authorized by the Instituto Nacional de Antropología e Historia. Photograph: Esther Pasztory.

has educated artists and some art historians, many in other fields, including anthropology and archaeology, still deal with art in terms of a nineteenth-century realistic bias. As the conference at the Museum of Modern Art in association with the primitivism exhibit indicated, specialists in modern art also see non-Western art as in many ways simpler and aesthetically less challenging than modern art. In removing the shadow cast by the European tradition, I hope that premodern "conceptual" art, whether exotic or European, might be defined in terms of its own limitations and potentials. It was clear to me, in trying to understand Teotihuacán art, that I needed to look at the art of other cultures. Now that the various local traditions of art are a matter of history in books and museums (and whatever new arts emerge will be global in nature), it may be possible to determine the laws and principles of past image making based on cross-cultural comparison. A willingness to decontextualize works of art is essential to this task. It is hoped that this examination of Teotihuacán art will open a dialogue with scholars working on similar abstract traditions elsewhere in the world. My hypothetical conclusion, which is that such arts seem to combine three approaches that are uniquely blended in every work—arbitrary signs and conventionalized forms, references to reality in terms of projections, and decorative options—needs elaboration from other fields. Clearly, the art of Teotihuacán represents only one possible mixing of these elements. I will conclude this discussion by going in the opposite direction and contextualizing Teotihuacán mural painting by a brief look at the specific archaeological situation.

III. THE TEOTIHUACÁN CONTEXT: COLLECTIVE IDEOLOGY AND THE INDIVIDUAL

Mapping of the ancient city began in 1962. This long-term project, directed by René Millon, has resulted in the first thorough cultural history of the site (Millon 1973). The monumental architecture of Teotihuacán began with the building of two huge pyramids around the time of Christ. At that time the city was laid out with a north-south axis oriented 15°25′ east of true north. The scale of the city plan is overwhelming even in the modern era and must have been staggering in the local context of small chiefdoms and states. Teotihuacán was the first urban state in Mesoamerica. In its first phase the population was already 40,000, and at its height (AD 400–700) the population was estimated at 150,000 to 200,000. Teotihuacán was an irrigation civilization in the sense that the main staple, corn, was grown in irrigated fields. Agriculture, however, was of local importance only. There was not enough for great surpluses: the San Juan River is a brook in comparison with the Nile. What made Teotihuacán the largest and most important city in Mesoamerica for nearly 800 years is not known. Craft activities and trade—in wares such as obsidian, a material necessary for cutting, which is available in mines near Teotihuacán, and in luxury goods, such as Thin Orange pottery—have been suggested as explanations.

What is striking about Teotihuacán is that there are no images of dynastic rulers, nor of conquests or prisoners, no scenes of investiture such as are common in Olmec, Maya, and Aztec art. So far no great burials with dazzling treasures have come to light. This is usually interpreted to mean that at Teotihuacán social integration was achieved through religion directly without the mediation of deified rulers who are nearly as great as the gods themselves. It would seem that at Teotihuacán political and religious rule was vested in the same persons, but they kept a low profile. The importance of religion is suggested by the size of the pyramids, which presumably were temples, and by the small size of the representations of humans in relation to those of the gods, as in the Temple of Agriculture mural (Fig. 12.28). The sumptuously dressed profile figures carrying incense bags that we see on many murals (Fig. 12.27) may be representations of this priestly/ruling/warrior elite. Unlike the named, individualized Maya rulers, all of these Teotihuacán elite individuals are shown in anonymous processions. Indeed, everything at Teotihuacán seems to have been done to depersonalize the appearance of religious and political power in human office holders. As described earlier, the gods are often faceless, the communicating and expressive aspect of their mouths hidden by large nose ornaments (see Fig.

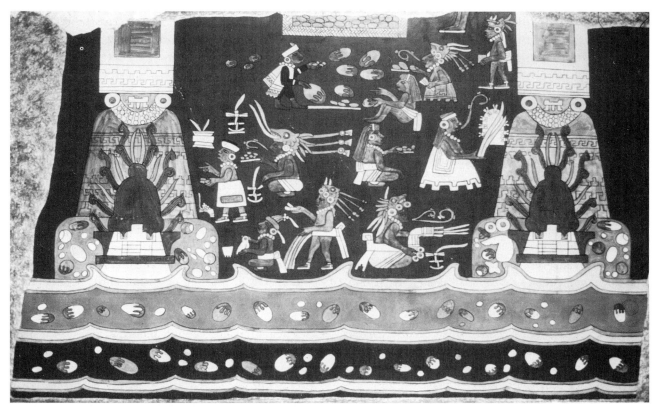

Figure 12.28 Mural from the so-called Temple of Agriculture (a small structure on the avenue near the Pyramid of the Moon) showing two large forms with goddess insignia to whom small human figures make offerings. The original is now mostly destroyed. Copy by A. Villagra, National Museum of Anthropology, Mexico City. Photograph: Esther Pasztory.

12.28). The introduction of mass production in the form of molds resulted in the standardization of objects such as clay figurines and incense burner ornaments after AD 300. Even the most prized greenstone masks look highly standardized (Fig. 12.29). In view of all this, the usual notion of Teotihuacán is of a rigid state controlling all aspects of the life of its citizens. The city itself was built on a grid plan, which too would imply centralized control and order.

While twentieth-century artistic discourse has validated tribal art and found in it individualistic creativity combined with a sense of community, the art of the early states such as Egypt, Mesopotamia, Mesoamerica, and Peru has been seen as authoritarian, if not totalitarian. While it is not my intention to discuss this issue in detail, it is relevant to the interpretation presented here. Standardization of some of the art of Teotihuacán has been seen as a denial of

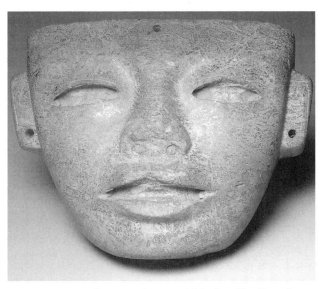

Figure 12.29 Stone mask, central Mexico, Teotihuacán style, 200–750. Stone, 18.90 cm x 23.20 cm x 9.80 cm. © The Cleveland Museum of Art, 2002. Purchase from the J. H. Wade Fund, 1942.1094.

individuality and a curtailment of individual "creative" rights, rather than in any positive light, such as practicality, affordability, or community-mindedness. There is as much evidence at Teotihuacán for state control as there is for individual freedom.[18]

Around AD 250, the relatively insubstantial original dwellings of the Teotihuacán population were torn down and masonry apartment compounds were built (Fig. 12.30). These compounds were standardized in size, about 50 meters square, and housed a number of patrilocal families, sixty to one hundred in a compound. The compound's internal plans were, however, all quite different, with ten to fifteen individual apartments consisting of rooms around patios. The apartment compounds have high walls, one or two entrances, and no windows. Presumably, when in their homes, the people of Teotihuacán spent much of their time in the sunny patios or on the shaded porches. The dark inner rooms must have been largely for storage and sleeping. In the dense concentration of the city, the apartment compound's plan appears to emphasize privacy and separation. A household temple is often built on one side of the central patio, and a shrine or altar may be located in its center. Mural paintings were primarily on the walls of the verandas

facing the patios and courts. It is not known as yet whether mural paintings were found in most apartments or whether they were restricted to certain families, either by caste entitlement or by wealth.

Perhaps the most astonishing fact about Teotihuacán is that this art of mural painting and the apartment compounds in which it appeared did not belong to the rulers. Many of the buildings that have been designated as possible palaces and/or administrative structures lack murals, with a few exceptions. Nor are the murals usually found in temples (except for some early murals such as the so-called Temple of Agriculture murals). There is no difference in quality between murals in apartment compounds and room complexes near major temples, such as the so-called Palace of the Sun near the Pyramid of the Sun. Between AD 500–750, mural paintings appear to have been mainly in the houses of what we might call the upper middle class. The structuring of the city and of its arts tells us something not only about religion but about the nature of the community as well. Along with the denial of naturalism, portraiture, and a personality cult, there is an emphasis on the corporate nature of the city, which is made up of separate, different, but in many ways similar, units. There are

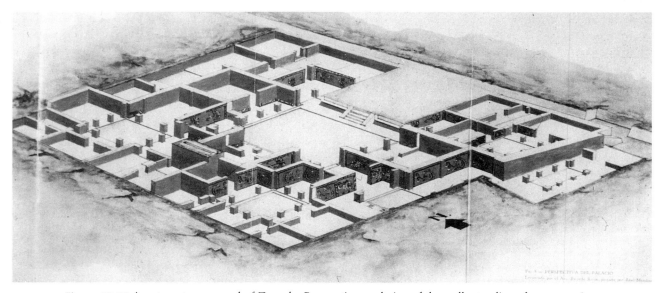

Figure 12.30 Apartment compound of Zacuala. Perspective rendering of the walls standing after excavation. The entrance is at the far right-hand corner. The large central patio and to its right a temple platform with steps are clearly visible. Apartments are grouped around sunken "atriums" with square pillars holding up the veranda roofs. After Laurette Séjournée, *Un palacio en la Ciudad de los Dioses* (Mexico: INAH, 1959), fig. 8. Reproduction authorized by the Instituto Nacional de Antropología e Historia.

approximately two thousand apartment compounds, and, if they corresponded to social units, the heads of each could easily have made up some sort of political body. The exertion of so much labor in housing the general population in itself signifies a degree of commitment to the community as a whole that is unique in Mesoamerican "complex" societies.

A ritual object came into use when the apartments were built, and because it has been found in the central patios or buried with the founder of the compound in several instances, it is presumed to be related to compound ritual. It is a very peculiar ceramic object, called the composite incense burner (Fig. 12.31). The incense is burned in the flowerpot-shaped lower half and the smoke escapes through the chimney in the back of the upper half. It is more significant, however, when it is viewed as an expressive object rather than as a purely functional one. A mask is visible framed by flat pieces of clay; this suggests the glimpse of a deity through a temple doorway. The observer is distanced from the mask, literally, by several layers of clay frames that appear to represent in three-dimensional fashion the spatial world of the murals. Small signs called *adornos* were made in molds and attached to the framework. The analysis of the clay has shown that the framework and the masks were sometimes made of different, better clay than the clay of the *adornos,* which were glued on by stucco (Berlo 1982). The framework and the mask were reused evidently, while different combinations of *adornos* were made for different occasions, persons, and/or rituals. This object is characteristic of Teotihuacán in the clear way it expresses complexity and hierarchy and, at the same time, the possibility of personal variation. The remains of archaeological cultures rarely afford such glimpses into the personal or individual relationship to society and religion as does the Teotihuacán incensario.

As mentioned above, because of the rigid axial layout of the city and because of the religious subject matter, the tendency has been to see Teotihuacán as an authoritarian and theocratic place. This is reinforced by the flat, conceptual art style, which it is assumed connotes minds that are bent on higher matters than flesh and the earth. This bias is not unlike

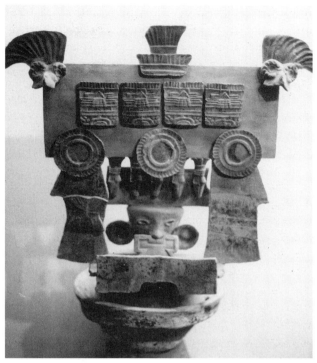

Figure 12.31 Composite ceramic censer. Clay with traces of paint. Teotihuacán Site Museum storeroom. Reproduction authorized by the Instituto Nacional de Antropología e Historia. Photograph: Esther Pasztory.

the usual "religious" interpretation of the entire art of the Middle Ages, despite evidence of the humorous and the playful in capitals and manuscript marginalia (Schapiro 1947).[19] Although no texts survive from Teotihuacán to tell about the individuality of patrons and artists, some sense of that too can be gathered from the mural paintings themselves. Playfulness, in the sense of a secular and possibly humorous creative inventiveness, appears to be an integral part of Teotihuacán art. By extension, it must also have been a value of the citizens by and for whom it was made.

Elaborate borders framing different sections of the wall are characteristic of Teotihuacán mural painting programs. When the murals are well preserved, it is apparent that these borders often combine themes from adjacent walls or from the various personages who are represented on the walls. Evidently, the design of the border called for some kind of creative

fusion of the elements to provide transition from one field to another. In the case of a mural from Atetelco (Fig. 12.32), which consists of a coyote and a net jaguar, the border is in the form of a serpentine creature made up of the intertwining body of a coyote and a net jaguar. The creature has a coyote head and net jaguar legs rhythmically disposed along the interlace. While coyote and net jaguar are standard beings of symbolic and allegorical significance and may represent animal aspects of certain deities, this particular creature—serpent/coyote/net jaguar—is unique to this mural. It is unlikely to have been a separate creature with mythic reality, since no other representations of it have been found. It may have been the artist's way of bringing the two images together into a new design and a new conceit. Whatever their verbal description for this might have been, whether they saw it in terms of form or subject, symbol, or humor, it is easy to imagine the compound headman and the artist delighting in this inventive solution to the border problem.[20]

This brings the discussion full circle back to Albrecht Dürer and Henry Moore, who used the word "inventiveness" to describe pre-Columbian art. "Inventiveness" is also William Rubin's favorite term for both tribal and modern art, although he will not accept it for "court" or "ancient archaic" art, which

he considers excessively "static."[21] Perhaps the postmodern viewer has an easier time seeing inventiveness in the art of early states. "Inventiveness" may be, in fact, the key word in this essay, and perhaps better than Gombrich's "conceptual." The term "inventive" emphasizes the active making of something new, whereas emphasis on the "conceptual" is on rigid schemas in the mind that act as censors. I suggest that the arts defined as conceptual by Summers and Schapiro are characterized, not only by the importance of placement and hierarchy, but also by a protean compositional mode in which an image can be condensed into what is almost a glyph or expanded toward various types of elaborations and complexities, such as scenes and decorative arrangements. Even in the most non-mimetic traditions, artists are always aware of the spatial problems created by the transformation of three-dimensional reality into two-dimensional images, and use this awareness in various ways as they compose figures in depth and create scenes. The principles governing such art are not only, or even necessarily, clarity but the communication of multivalent messages, contradictory presences and absences, visual puns, and many other types of ambiguities. It is mimetic art that is, by comparison, all too clear in the moment, mood, and point of view represented. Non-mimetic arts represent imaginary

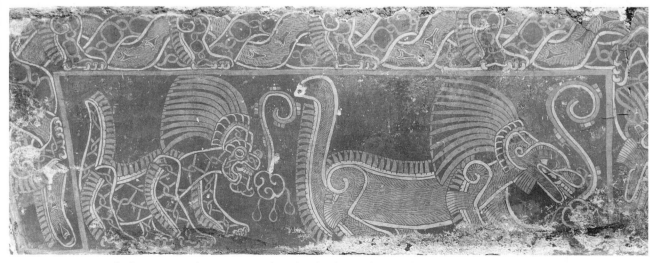

Figure 12.32 Mural of a coyote and net jaguar under a border design that combines net jaguar, coyote, and serpent elements. The head of the serpent is on the right, while its tail is on the left. From the apartment compound of Atetelco, Teotihuacán. Reproduction authorized by the Instituto Nacional de Antropología e Historia.

worlds in which different kinds of things are possible that are impossible in the real world. The term "imaginary" may be opposed to "mimetic" in a way that is less prejudicial to both. In imaginary traditions a decorative matrix is usually devised in which signs and images can be located together and can oscillate between reality and symbol, evoking meanings that range from the profound to the amusing. In mimetic traditions the matrix is a ground-sky convention into which things and figures are placed in arrangements that convey the illusion of a visible world.

Because imaginary artistic traditions require such a thorough familiarity with an arbitrary image system,

as well as a willingness to enter into the serious game of image reading, I suggest that the sociopolitical contexts of such traditions are likely to be societies either small in scale or highly integrated and in some ways closely knit or societies that for various reasons are not concerned with communicating with cultural outsiders, or "others." These arts are in some ways the opposite of advertising: they intrigue and even challenge, but they do not seduce. Even modernism, with its elitist avant-garde, supplies these criteria of an educated and exclusive circle of artists and patrons opposed to a mass culture that is largely involved with realistic modes of representation.[22]

NOTES

A preliminary version of this paper was presented at the Mellon Society of Fellows in the Humanities at Columbia University, November 18, 1986. In several seminars on Teotihuacán art the following students made helpful suggestions and I would like to thank them here: Sue Bergh, Debra Hassig, Joanne Pillsbury, Patricia Sarro, Anne Schaffer, Andrew Shelton, Sarah Travis, and Margaret Young.

1. Dürer carried two little books with him, the contents of which both descended to us either in whole or in part. In one of these books he jotted down items of expenditure and occasional miscellaneous records and impressions. The original volume has been lost, but an old copy of it remains in the Bamberg library. The other was a sketchbook, and many of its leaves may still be seen in the public and private art collections of Europe (Conway 1889:92).

2. Keen's statement is typical: "The genius of Aztec artists and craftsmen had aroused the enthusiasm . . . of a giant of Western art, Albrecht Dürer" (1971:70).

3. For an excellent analysis of Henry Moore's interest in pre-Columbian art, see Barbara Braun, "Henry Moore and Pre-Columbian Art," *Res* 17/18 (Spring/Autumn 1989): 159–178.

4. Describing his days on a scholarship to the Royal College of Art in London, Henry Moore wrote: "And not far away [i.e., from his lodgings], I had the National Gallery and British Museum and the Victoria and Albert with the reference library where I could get any book I wanted. I could learn about all the sculptures that had ever been made in the world" (Russell 1968:22).

5. Although critics Ashton, Bois, Clifford, Danto, and McEvilley cringed from the simplistic art history and

politics of the MoMA exhibit ("The Museum of Modern Art has given us a nineteenth-century model on the most pressing issues of the about-to-dawn twenty-first century" McEvilley 1985:68), the alternatives they suggested were meager. All the authors suggested a deeper contextualization within the individual societies and a broader historicization of the relationship of their societies to ours. They argued against Rubin's formalist aesthetic but had no theory of art with which to replace it.

6. Lecture, Columbia University, 1987.

7. See, for example, the works of Charles Jencks, a tireless promoter of postmodern art and architecture.

8. Although the term "abstraction" is sometimes defined narrowly to include only nonfigurative art, it is used here in the broader sense, to refer to an art in which all subjects are rendered in a strongly conventionalized style that results in a reduction to simple lines and shapes sometimes approximating geometric forms. Teotihuacán art is "abstract" in the sense in which the art of Paul Klee is abstract.

9. Realistic traditions may seek to represent an invisible world as well, as in the portrayal of monsters and imaginary creatures, but the aim of such representations is the creation of the illusion that these might be real, and it is a way of adapting the imaginary to the real world.

10. "Are anthropologists trapped in an outdated intentional fallacy?" asked Kirk Varnedoe and Rosalind Krauss in a position paper at a symposium of art historians and anthropologists in connection with the "primitivism" show at MoMA. Discussion degenerated into a shouting match. I am aware of the current trend that questions the existence of intentionality of modern artists, and sees them as the

vehicle of concepts current in society. However, since intentionality is generally denied to earlier arts on the basis that everything in them is determined by tradition, it is necessary to address this issue. Intentionality may be irrelevant to Western art, which has had a surfeit of it, but needs to be demonstrated in non-Western art, which has had a surfeit of contextualization.

11. Robertson (1959:16) uses the term "horror vacuii" to describe the distribution of elements in Mixtec manuscripts, which he says "we associate with various kinds of so-called primitive art." Nevertheless, he defends pre-Columbian conceptual art by suggesting that the "forms of manuscript signs are controlled by the same general artistic conventions that governed Archaic Greece, Egypt, or even contemporary primitive art" (1959:24).

12. Actually, as early as 1959, Robertson used the term "sign" to analyze the elements of Mixtec art (p. 23).

13. Especially interesting in medieval art is the classical image-making system based on projective projection light and shade, as well as modeling that is adapted to a metric projective system. Bits and pieces of the classical remain in postures and draperies, but the overall system is metric, ornamental, hierarchic, and semiotic, rather than being perceptual. It illustrates the fact that styles do not necessarily progress from metric to projective and that at any point a shift may be made from one to the other.

14. The accessibility of naturalistic images is desired as a mode of communication by certain contemporary artists such as Duane Hanson (Bush 1976) but is condemned in the form of media images by many modern critics as untruthful, precisely because accessibility makes these images "diabolically seductive" (Baudrillard 1987). In an article entitled "Immigrant Writing: Give Us Your Maximalists" (*New York Times Book Review*, August 28, 1988), Mukherjee writes: "I feel that Minimalism [by which she means a sort of abstraction] is nativist, it speaks in whispers to the initiated. As a newcomer, I can feel its chill, as though it were designed to keep out anyone with too much story to tell."

15. At one time it was thought that all ornamental designs in "primitive" art were meaningful and symbolic in the sense of having some "magic" meanings associated with them. However, thorough ethnologists such as Lowie (1954:156–161) have shown that among many, such as the Plains Indians, much of decorative art is named purely for the convenience of the craftsperson, and that names, and occasional symbolic meanings, vary from person to person.

16. Gombrich's (1963:330–358) most interesting observations deal with the fact that an image may be recognized and even considered "realistic" on the basis of very few lines and shapes. Such "minimal clues" must by definition be conceptual, even if they aim to evoke something real.

17. In a conversation subsequent to the completion of this article, Saul Steinberg explained that the stylized designs in the work had been cut out of typography books to make up the houses, furrows, and plants. Besides the feline and the watering can, all the birds and the rabbit were drawn by pen. His intention had been to demonstrate that stylized designs, which derive originally from nature, can be turned back into nature by the artist who is capable of such a double vision.

18. Octavio Paz (1972:87) has decried the "sentimental identification" of Mexico with the pre-Hispanic world. "Our art critics wax ecstatic about the statue of Coatlicue, an enormous block of petrified theology. Have they ever *looked* at it? Pedantry and heroism, sexual puritanism and ferocity, calculation and delirium: a people made up of warriors and priests, astrologers and immolaters." William Rubin rather more coyly dismisses pre-Columbian "archaic" civilizations from his notion of primitivism on the basis that they were "courtly" rather than tribal (1984a:74n14, 3). Varnedoe (1984:665–667), however, approaches the subject head on. Referring to the work of Michael Heizer and Robert Smithson he states:

> Their archeological imagery referred not to the creative handwork of tribal artists but to the vestiges of lost societies that embodied vast collective labor and ambitions to cosmic knowledge . . . the admiration for vast collective feats (such as those of the mound builders, the people of Stonehenge, and the pre-Columbian societies of South and Central America) has been accompanied, implicitly and explicitly, by a fascination for the massive social integration, ritualized behavior, and will to cosmic determinism that seem to lie behind such remnants. Yet at the same time the model of Primitive societies, often in some of the same aspects, has equally been invoked as the source for artistic liberation and personal self-fulfillment . . . a concern with immediate private experience, especially seen as irrational, intuitive, and anti-authoritarian.

19. In this citation, Schapiro takes up the cause of medieval art by trying to link it with modern art:

> The common view [is] that medieval art was strictly religious and symbolical, submitted

to collective aims, and wholly free from the aestheticism and individualism of our age. I shall try to show that by the eleventh and twelfth centuries there had emerged in Western Europe within church art a new sphere of artistic creation without religious content and imbued with the values of spontaneity, individual fantasy, delight in color and movement, and the expression of feeling that anticipate modern art. (1947:1)

20. The deployment of artistic "play" more for its own sake than at the task of expressing something of great collective importance is also found in the "margins" of medieval art. We might consider a great amount of Islamic art as the riot of playful ornament takes center stage, since the important subjects are not represented at all. Ornament in that context represents not only joyful decoration but the absence of deeply meaningful subjects. In Islamic art, ornament becomes a total screen.

21. "The invention just mentioned, which led in some African and Oceanic societies to an often-astonishing artistic multiformity, constitutes one of the most important common denominators of tribal and modern art. Few remaining sculptures of the Dan people . . . are much more than a century old; yet the range of invention found in their work far outdistances that of court arts produced over much longer periods, even millennia" (Rubin 1984a:3).

22. The conflict between office workers and Richard Serra over his abstract sculpture *Tilted Arc* demonstrates these mutually antagonistic image systems in our own times. In 1979 the General Service Administration commissioned a large public sculpture from Serra. The work Serra produced, titled *Tilted Arc,* was a plain, inward-leaning rusted steel band, 60.96 meters long and 3.65 meters high, which bisected a sunken circular plaza in front of Lower Manhattan's federal complex. Complaints by Federal Plaza employees that Serra's sculpture was threatening, obstructive, and ugly led to public hearings on the question of its removal. Well-known figures in the art community spoke on Serra's behalf. The defense included the argument that Serra's use of industrial steel was a deliberate gesture of solidarity with the working class and that the abstract sculpture radically (and positively) reconfigured an institutional space—that is to say, that the work was an implicitly political statement and that its removal constituted censorship. *Tilted Arc* was finally dismantled and removed on March 15, 1989 (Storr 1985, Serra 1989).

BIBLIOGRAPHY

Anders, Ferdinand
 1971 "Las artes menores [Minor Arts]." *Artes de Mexico* 137:4–66, Mexico City.
Ashton, Dare
 1984 "On an Epoch of Paradox: 'Primitivism' at the Museum of Modern Art." *Arts Magazine* 49(3):76–79.
Baudrillard, Jean
 1987 *The Evil Demon of Images.* Power Institute Publication No. 3. University of Sydney, Australia.
Baxandall, Michael
 1985 *Patterns of Intention.* Yale University Press, New Haven.
Bergh, Susan
 1985 "The Palenque Beau Relief: A Reconstruction and Interpretation." Unpublished ms., Columbia University, New York.
Berlo, Janet C.
 1982 "Artistic Specialization at Teotihuacan: The Ceramic Incense Burner," in *Pre-Columbian Art History: Selected Readings,* A. Cordy-Collins and J. Stern, eds., 83–100. Peek Publications, Palo Alto, California.

Berrin, Kathleen, ed.
 1988 *Feathered Serpents and Flowering Trees: Reconstructing the Murals of Teotihuacán.* Fine Arts Museum of San Francisco, San Francisco.
Bois, Yve-Alain
 1985 "La Pensée Sauvage." *Art in America* 73(4):178–189.
Braun, Barbara
 1989 "Henry Moore and Pre-Columbian Art." *Res* 17/18, Spring/Autumn 1989.
Brilliant, Richard
 1987 "Portraits: The Limitation of Likeness." *Art Journal* 46(3):171–172.
Bryson, Norman
 1983 *Vision and Painting: The Logic of the Gaze.* Yale University Press, New Haven.
Bucher, Bernadette
 1981 *Icon and Conquest. A Structural Analysis of the Illustrations of de Bry's Great Voyages.* University of Chicago Press, Chicago.
Bush, Martin H.
 1976 *Duane Hanson.* Wichita State University, Wichita, Kansas.

Chiapelli, Fredi, ed.
 1976 *First Images of America.* University of California Press, Berkeley.
Clifford, James
 1985 "Histories of the Tribal and the Modern." *Art in America* 73(4):164–177.
Conway, William M.
 1889 *The Literary Remains of Albrecht Dürer.* Cambridge University Press, London.
Covarrubias, Miguel
 1957 *Indian Art of Mexico and Central America.* Alfred A. Knopf, New York.
Danto, Arthur C.
 1984 "Defective Affinities." *The Nation* 239:590–592.
Gombrich. E. H.
 1960 *Art and Illusion.* Princeton University Press, Princeton.
 1963 *Meditations on a Hobby Horse and Other Essays on the Theory of Art.* University of Chicago Press, Chicago.
 1979 *The Sense of Order: A Study in the Psychology of Decorative Art.* Cornell University Press, Ithaca.
Hagen, Margaret A.
 1986 *Varieties of Realism: Geometries of Representational Art.* Cambridge University Press, Cambridge.
Hassig, Debra
 1990 "Beauty in the Beasts: A Study of Medieval Aesthetics." *Res* 19/20, 1990/1991.
Humbolt, A. von
 1810 *Vues des cordillères et monuments des peuples idigènes de l'Amérique.* Legrand, Pomey et Crouzet Libraires, Paris.
Jencks, Charles
 1987 *Post-Modernism: The New Classicism in Art and Architecture.* Rizzoli, New York.
Keen, Benjamin
 1971 *The Aztec Image in Western Thought.* Rutgers University Press, New Brunswick, New Jersey.
Kubler, George
 1969 *Studies in Classical Mayan Iconography.* Memoirs of the Connecticut Academy of Arts and Sciences XVIII, New Haven.
Langley, James C.
 1986 "Symbolic Notation of Teotihuacan: Elements of Writing in a Mesoamerican Culture of the Classic Period." *BAR International Series* 313, Oxford.
Loewy, Emanuel
 1907 *The Rendering of Nature in Early Greek Art.* John Fothergill, trans. Duckworth and Co., London.

Lowie, Robert H.
 1954 *Indians of the Plains.* American Museum of Natural History/McGraw-Hill, New York.
Martin, John Rupert
 1977 *Baroque.* Harper and Row, New York.
McEvilley, Thomas
 1984 "Doctor, Lawyer, Indian Chief: 'Primitivism in 20th Century Art' at the Museum of Modern Art." *Artforum* 23(3):54–61.
 1985 "Letter on 'Doctor, Lawyer, Indian Chief,' Part II." *Artforum* 23(9):63–71.
Miller, Arthur Green
 1973 *The Mural Paintings of Teotihuacán.* Dumbarton Oaks, Washington, DC.
 1978 "A Brief Outline of the Artistic Evidence for Classical Period Cultural Contact between Maya Lowlands and Central Mexican Highlands," in *Middle Classic Mesoamerica: A.D. 400–700.* Esther Pasztory, ed. Columbia University Press, New York.
Millon, René
 1973 *The Teotihuacán Map.* Urbanization of Teotihuacán, Mexico, vol. 1. University of Texas Press, Austin.
Mukherjee, Bharati
 1988 "Immigrant Writing: Give us your Maximalists." *New York Times Book Review,* August 28, 1.
Nicholson, H. B., with Eloise Quiñones Keber
 1983 *Art of Aztec Mexico: Treasures of Tenochtitlan.* National Gallery of Art, Washington, DC.
Nowotny, Karl Anton
 1960 *Mexikanische Kostbarkeiten au Kunstkammern der Renaissance im Museum für Völkerkunde Wien und in der Nationalbibliothek Wien.* Museum für Völkerkunde, Vienna.
Panofsky, Erwin
 1955a *The Life and Art of Albrecht Dürer.* Princeton University Press, Princeton.
 1955b *Meaning in the Visual Arts.* Doubleday Anchor, Garden City, New York.
Pasztory, Esther
 1976 *The Murals of Tepantitla, Teotihuacan.* Garland Publishing, New York.
 1982 "Three Aztec Masks of the God Xipe," in *Falsifications and Misreconstructions of Pre-Columbian Art,* Elizabeth Boone, ed., 77–106. Dumbarton Oaks, Washington, DC.
 1983 *Aztec Art.* Harry N. Abrams, New York.
 1988a "A Reinterpretation of Teotihuacán and Its Mural Painting Tradition," in *Feathered Serpents and Flowering Trees: Reconstructing the Murals of*

Teotihuacán, Kathleen Berrin, ed., 45–77. Fine Arts Museum of San Francisco, San Francisco.

1988b "Catalogue of the Wagner Murals Collection," in *Feathered Serpents and Flowering Trees,* Kathleen Berrin, ed., 135–193. Fine Arts Museum of San Francisco, San Francisco.

Paz, Octavio
1972 *The Other Mexico: Critique of the Pyramid.* Lysander Kemp, trans. Grove Press, New York.

Reed, C. H.
1910 "Ancient Peruvian Pottery." *Burlington Magazine* 17(85):22–26.

Robertson, Donald
1959 *Mexican Manuscript Painting of the Early Colonial Period.* Yale University Press, New Haven.

Rubin, William
1984a "Modernist Primitivism: An Introduction," in *"Primitivism" in 20th Century Art,* William Rubin, ed., vol. 1, 1–84. Museum of Modern Art, New York.

1984b *"Primitivism" in 20th Century Art,* William Rubin, ed., vol. 2. Museum of Modern Art, New York.

Russell, John
1968 *Henry Moore.* Penguin Books, Harmondsworth, Middlesex, England.

Schapiro, Meyer
1969 "On Some Problems in the Semiotics of Visual Art: Field and Vehicle in Image-Signs." *Semiotica* I(3):487–502.

1977 "On the Aesthetic Attitude in Romanesque Art," in *Romanesque Art.* George Braziller, New York.

Schele, Linda, and Mary Miller
1986 *The Blood of Kings: Dynasty and Ritual in Maya Art.* Kimball Art Museum, Fort Worth, Texas.

Serra, Richard
1989 "'Tilted Arc' Destroyed." *Art in America* 77(5):34–47.

Stchoukine, Ivan
1959 *Les peintres des manuscrits Safavis de 1502 à 1587.* Paul Geuthner, Paris.

Storr, Robert
1985 "'Tilted Arc': Enemy of the People?" *Art in America* 73(9):90–97.

Summers, David
1982 "The 'Visual Arts' and the Problem of Art Historical Description." *Art Journal* 42(4):301–310.

Toscano, Salvador
1984 *Arte precolombino de México y de la América Central.* First edition, 1944. Universidad Nacional Autónoma de México, Mexico City.

Varnedoe, Kirk
1984 "Contemporary Exploration," in *"Primitivism" in 20th Century Art,* William Rubin, ed., vol. 2, 661–685. Museum of Modern Art, New York.

Von Hagen, Victor W.
The Desert Kingdoms of Peru. London: Weidenfeld and Nicolson, 1965.

This book first arose out of a passage in Borges, out of the laughter that shattered, as I read the passage, all the familiar landmarks of my thought—our thought, the thought that bears the stamp of our age and our geography—breaking up all the ordered surfaces and all the planes with which we are accustomed to tame the wild profusion of existing things, and continuing long afterwards to disturb and threaten with collapse our age-old distinction between the Same and the Other. This passage quotes a "certain Chinese encyclopaedia" in which it is written that "animals are divided into: (a) belonging to the Emperor, (b) embalmed, (c) tame, (d) sucking pigs, (e) sirens, (f) fabulous, (g) stray dogs, (h) included in the present classification, (i) frenzied, (j) innumerable, (k) drawn with a very fine camelhair brush, (l) et cetera, (m) having just broken the water pitcher, (n) that from a long way off look like flies." In the wonderment of this taxonomy, the thing we apprehend in one great leap, the thing that, by means of the fable is demonstrated as the exotic charm of another system of thought, is the limitation of our own, the stark impossibility of thinking that.

Michel Foucault, *The Order of Things*, 1970

When I entered graduate school at Columbia University in 1965, Douglas Fraser was away on sabbatical, and I spent my first year studying with Paul Wingert, just before his retirement. Wingert was among the first art historians to define "primitive art" as a field of academic study. His approach to primitive art was then called the "style-area" method. Works of art—for Wingert that meant primarily sculpture—were analyzed in language derived from the study of modern art. Wingert would discuss a figure in terms of shapes, surfaces, and transitional passages, articulating in words the nature of the artist's conventions. He defined style by the conventions of a few normative pieces in each tribe or tribal area.[1] In a very short time we learned the criteria of each style, the names of the ethnic groups, and their geographic locations on the map. In one academic year we could tell Bamana from Baule (Figs. 13.1, 13.2) and could identify the tribal styles of Africa, Oceania, and North America. Learning these tribal styles transformed primitive art into a finite group of coherent, familiar traditions. Wingert assured us that we now knew everything there was to know on the subject and cautioned us against reading a lot of newfangled books that merely confused the picture. Douglas Fraser returned the following year and assigned us all the books Wingert had warned against. I still think back with nostalgia to that brief period of intellectual certainty engendered in us by Wingert.

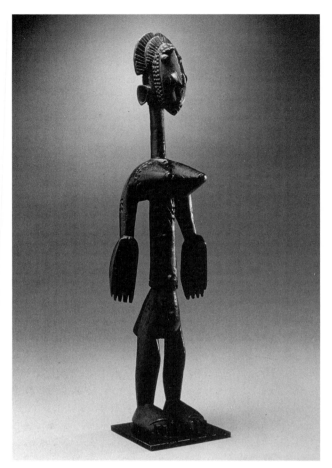

Figure 13.1 Sculpture of a woman, Bamana, Africa, wood, 46.3 cm. Courtesy The University of Iowa Museum of Art, Stanley Collection (1986.575).

Figure 13.2 Baule female figure, Ivory Coast, Africa, wood, 34.6 cm (13 5/8 in.). Photograph courtesy of Pace Primitive, NYC.

The recognition that each ethnic group had its own style was indeed momentous: it provided an easy way to distinguish between different peoples. More important, by having distinct styles, each of these peoples became comparable to a chronological period or to the work of an artist belonging to the canon of Western art. The style-area method was significant to the processes through which non-Western objects were validated as works of art and primitive peoples were reevaluated positively. The mere fact that these people had ethnic styles of such clarity indicated that they were creative animals like us and belonged to the family of humans.

The style-area method was first devised in museums as a classification scheme for sorting artifacts from around the world. For example, Olbrechts based his classic work of 1946, *Plastiek van Congo*, on the organization of materials deposited in the Belgian Musée Royale de l'Afrique Centrale, Tervuren.[2] Classification was also a useful way of organizing the material for art history classes. Intellectually, however, the concept was riddled with difficulties. For one thing the concept was entirely ahistorical, assuming that these styles had existed in these forms from time immemorial. This was due in part to the nature of the materials themselves—most of the arts were created in perishable media in tropical climates where wood decays normally in fifty to a hundred years. With a few exceptions, old works of art were not available for the creation of an art

history. This supported the prevailing opinion that these cultures were extremely traditional and the notion that, like living fossils, they had preserved the lifestyles of early and neolithic humans. In this context, discussion of the origin and development of styles was unlikely; the tribal styles were seen as a spontaneous and vague reflection of a given ethnic group's personality or "genius." The modern concept of Afro-American "soul" derives from this idea.

A second and I think even greater problem is that from the viewpoint of style area, the only cultures that existed on our mental map were those with distinctive art styles. In addition to the list we memorized in graduate school, there were groups whose style was neither consistent nor coherent from object to object, groups whose style seemed to be an uncomfortable blend of their neighbors' styles, and those whose artworks were so rudimentary that one could not speak of a "style" at all. There also seemed to be groups not particularly interested in the visual arts. We dealt with these groups either by ascribing to them the inferior status of "minor artists," on the model of Western art, or by simply disregarding them. While art style was used to validate the worth of some groups, its absence was used to banish others to a limbo of uncreativity, which meant nonexistence. "Oh yes, the Tiv, they don't *do* anything . . ."

The question not asked by Wingert and his generation was, why do some people develop distinctive styles at certain times and others do not? What circumstances favor the development of group styles? This question was never asked because it was assumed that ethnic styles emerged spontaneously. The very existence of ethnic style was taken as proof of its universal existence. Consider, for example, the Maya villages of Guatemala where the men and women of each village have their own style of weaving and embroidery, which distinguishes each village's, and each person's, ethnic identity (Figs. 13.3, 13.4).[3] Such distinguishing style could be perceived in folk villages anywhere around the world. Since it was assumed that if folk cultures do something it must be universal, the issue of ethnic style seemed to need little more explanation than a reference to the collective unconscious. This was not strange to us in the

Western tradition in which English, French, Italian, and German styles in art, music, and literature are clear and apparently self-evident. I will try to show that our very notion of group style emerges from, and is defined by, our Western experience of ethnicity and art, and that other, different concepts of style and ethnicity may exist but have not been examined. I will seek to show that just because the phenomenon of ethnic division through style is widespread, it is not necessarily a psychological or social universal. I shall try to determine what functions ethnic styles might fulfill in various societies on the basis of a few selected examples.

First, however, a note on the word "ethnic," which conveys several meanings. In a landmark study, *Ethnic Groups and Boundaries*, Fredrik Barth defined an ethnic group as having four central aspects: a self-perpetuating biology (sometimes racial), a shared basic culture, a shared system of communication (usually language), and a personally affirmed identity.[4] His study suggests that the concepts of ethnic groups, cultures, language groups, and societies are so interwoven that they are hard to unravel. Ethnographers are accustomed to talking about "tribal" groups, sociologists about "ethnic" groups, archaeologists about "cultures," and historians about "peoples and societies." I have chosen to use the term "ethnic" because it encompasses language, culture, and society. I shall use other terms as needed.

One aspect of the meaning of ethnic styles has already been discussed in terms of the style-area approach to the study of non-Western art; there is no question that the presence of ethnic styles enabled Western outsiders to more easily grasp different cultures, the necessary first step before we could evaluate such cultures positively or negatively.

The basic function of an ethnic style is to create a coherent visual form that functions as a badge of identity within the group; by projecting the image of a self, ethnic style immediately implies the existence of others who do not belong. Ethnic styles create identity and difference through the formal articulation of visual images, ranging from dress to architecture. Barth has noted that ethnic identity is

Figure 13.3 Modern men in native dress. Solala, Guatemala, 1977. Photograph by David Alan Harvey. Courtesy Magnum Photos.

Figure 13.4 Modern women in native dress. Chichicastenango, Guatemala, 1979. Photograph by Jerry Jacka. Courtesy Heard Museum, Phoenix, Arizona.

not created once and for all. The dynamics of ethnic identity require all individuals to make continuous affirmations of their sense of belonging and of their culture's acceptance. In this process, visual symbols in works of art are essential, they are continuously needed, and they are manufactured.

The meaning of styles as badges of identity has been wonderfully exploited in cartoons (Fig. 13.5). The young lady in the *Punch* cartoon rejects her suitor solely because he is drawn in pre-Columbian style. The point of the joke is that we grasp the difference between the styles and identify with the style of the girl and her mama. In identifying with them we also do not see their style as consisting of arbitrary signs but as the normal representation of forms and con-

cepts. Thus the essence of stylistic identification is to see our own style as natural and the style of the other as artificial and literally unnatural, or against nature.

My attention was first drawn to the uses and meanings of ethnic styles by a few highly unusual works of Mesoamerican art that juxtapose two different styles, as if in a European painting one figure were in the style of Rogier van der Weyden and the other in that of Piero della Francesca. On the Bazán Slab, found at Monte Albán in Oaxaca, two figures are incised in stone (Fig. 13.6). The figure in front is an anthropomorphic jaguar named 3 Turquoise. He is represented in flowing curvilinear lines. Behind him, 8 Turquoise is rendered in angular lines and shapes that approximate geometric forms such as

"Mama, I don't care how much gold he's got – I don't love him!"

Figure 13.5 Cartoon from *Punch* magazine, December 12, 1984. Courtesy Punch Limited.

squares, circles, triangles, and trapezoids. The figure of 8 Turquoise is represented in the style of Teotihuacán, a contemporary of Monte Albán, 350 kilometers from Oaxaca.[5] The Teotihuacán-style figure is very close to Teotihuacán priest figures found on mural paintings and pottery (Fig. 13.7). Its identity is further indicated by a tasseled headdress glyph that may be either a name or rank, found in the column of glyphs before the figure on the Bazán Slab.

Although I consider such style juxtapositions theoretically and culturally highly significant, I must emphasize that they are very rare in Mesoamerican art. Nevertheless, I consider them symptomatic and therefore far more important than their rarity might suggest. Significantly, most are found in the Classic period, a point to which I will return later.

A possible contemporary stela, dated AD 445, from the Maya city of Tikal, shows on its front the ruler Stormy Sky surrounded by curvilinear scrolls and masked personifications (Fig. 13.8).[6] The side figures are wearing Teotihuacán costumes: feathered headdresses and shell necklaces. A tasseled headdress similar to the Teotihuacán representations is shown on the head of the deity on the shield (Fig. 13.9). The central figure is clearly and entirely Maya in style. The side figures are composites: their linear

simplicity and angular composition are close to Teotihuacán style, while the proportions and naturalistic details are Maya. The identity of the side figure is not clear, and it is unclear as well whether the two views are of one figure or two figures. He is described in much of the popular scholarly literature as an "ambassador" from Teotihuacán but more recently has been identified as the father of Stormy Sky, who may have originated from a Teotihuacán dynasty. Teotihuacán is nearly a thousand kilometers from Tikal.

What is significant in both instances is that two individuals are represented in different styles on the same work in order to indicate the ethnic groups to which they belong. This is very unusual in the history of Western art, and I could not find parallel examples in other cultures of what I am calling style juxtaposition. (I do not, of course, claim to be familiar with all of world art, and I hope that scholars in other fields will add to and modify these statements.) A cursory glance at the art of many parts of the world suggests that in almost all situations of culture contact, some effort is made to blend styles and create visual harmony rather than to exaggerate differences.

When the artists of Darius designed the sculptures of Persepolis, the vastness of the Persian empire was

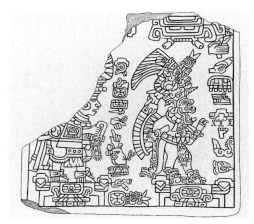

Figure 13.6 Bazán Slab, Classic period, stone relief, Monte Albán, Oaxaca, Mexico. From *Indian Art of Mexico and Central America,* by Miguel Covarrubias, copyright © 1957 by Alfred A. Knopf, a division of Random House, Inc. Used by permission of Alfred A. Knopf, a Division of Random House, Inc.

Figure 13.7 Heart sacrifice ritual procession, Classic period, Teotihuacán, Mexico. Courtesy Fine Arts Museums of San Francisco, Bequest of Harald J. Wagner, 1985.104.11.

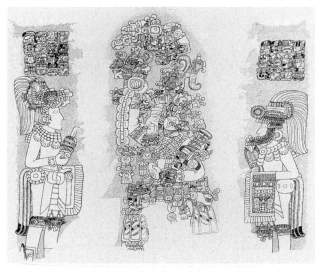

Figure 13.8 Stela 31, drawing of front and two sides, Classic period, stone relief, 230 cm. Tikal, Guatemala. Reproduced from William R. Coe, "Tikal: Ten Years of Study of a Mayan Ruin in the Lowlands of Guatemala." *Expedition* (1965) 8(1):33. Courtesy Tikal Project, University of Pennsylvania Museum.

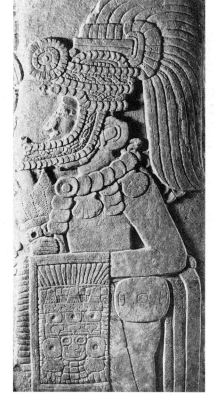

Figure 13.9 Stela 31, detail of figure in Teotihuacán costume, Classic period, stone relief, 230 cm. Tikal, Guatemala. Reproduced from William R. Coe, "Tikal: Ten Years of Study of a Mayan Ruin in the Lowlands of Guatemala." *Expedition* (1965) 8(1):33. Courtesy Tikal Project, University of Pennsylvania Museum.

represented by tribute bearers from all corners of the realm, whose ethnic features and distinctive dress were clearly delineated (Figs. 13.10, 13.11).[7] However, although the curly hair of the Armenians and the peaked cap of the Phrygians were faithfully represented, the figures were stylistically identical,

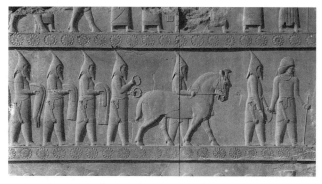

Figure 13.10 Scythian tribute bearers from eastern stairway, c. 500 BC, stone relief, Apadana, Persepolis, Iran. Courtesy of the Oriental Institute of the University of Chicago.

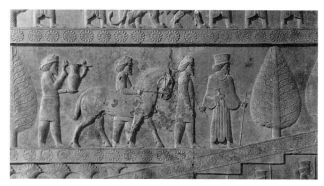

Figure 13.11 Armenian tribute bearers from eastern stairway, c. 500 BC, stone relief, Apadana, Persepolis, Iran. Courtesy of the Oriental Institute of the University of Chicago.

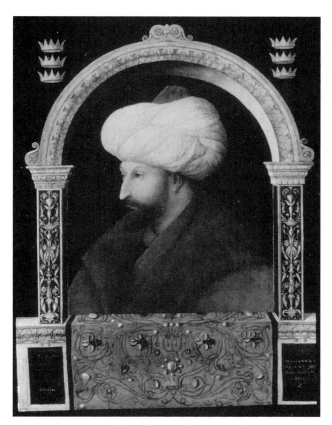

Figure 13.12 Gentile Bellini, *Mahomet II*, oil, 70 cm x 50 cm. Copyright National Gallery, London.

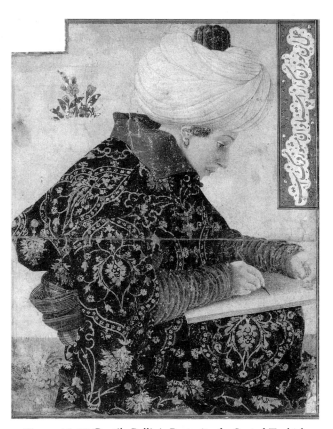

Figure 13.13 Gentile Bellini, *Portrait of a Seated Turkish Scribe or Artist*, pen and gouache on parchment, 18.4 cm x 14 cm. Courtesy Isabella Stewart Gardner Museum, Boston.

and that style is clearly what we call Achaemenid Persian. The empire is visually evoked by the homogeneity of the Achaemenid style, and the minor differences of its subject peoples are relegated to details. In the metaphor of language, we could say the Persepolis reliefs proclaim that all of Persia speaks the same language, although its dialects are different. By contrast, the Bazán Slab represents a situation in which two languages of equal stature confront one another.

So far my discussion has focused on patrons and social contexts rather than the artist. There are few examples of artists working in both their home style and the style of an alien group, although with recent studies the list is growing. An example familiar to me is Gentile Bellini's portrait of a Turkish artist in the style of a Turkish miniature in the Isabella Stewart Gardner Museum, Boston.

Gentile Bellini, a Venetian, spent several months between 1479 and 1480 at the court of Mohammed II in Istanbul.[8] The sultan had asked for a portrait painter because he was enamored of Venetian art, and this cultural mission took place after the signing of a peace treaty between Venice and the sultan. Among works Bellini painted in his home style for the sultan is a royal portrait in oil, now in London (Fig.

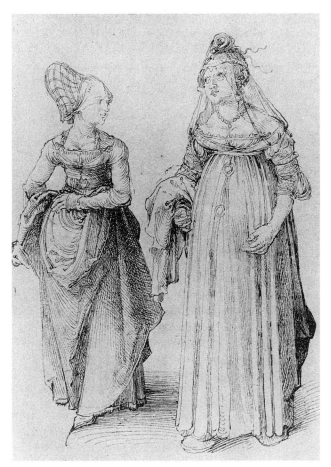

Figure 13.14 Albrecht Dürer, *Lady of Nürnberg and Lady of Venezia*, undated, pen and ink, 24.5 cm x 16 cm. Courtesy Städelsches Kunstinstitut Frankfurt.

13.12). More unusual, however, is the little miniature, painted on parchment with pen and gouache, that looks surprisingly like a work of Oriental art (Fig. 13.13). We do not know what this means, in the sense of the interaction between the two artists. Is it Gentile saying: "I can work just as well in your style!"? Is it Gentile's appreciation of Turkish art or of his friendship with this particular artist? The answers to these questions may lie either in the personal realm—the relationship between artists—or in the aesthetic realm—the play with different stylistic traditions for its own sake. Clearly the sultan did not commission Gentile Bellini to work in the Turkish style—the mere notion is absurd.

Another possible example of style juxtaposition in the work of a European artist is a drawing by Dürer in which a Venetian and Nuremberg costume are compared (Fig. 13.14).[9] Erwin Panofsky described this drawing in terms of the concept of style opposition that was then current in art historical thinking:

. . . in one truly remarkable drawing he illustrated the fundamental difference between the Southern and Northern fashion by representing a Venetian gentildonna side by side with a Nürnberg Hausfrau. Everything wide and loose in the Italian dress is narrow and tight in the German one, the bodice as well as the sleeves and the shoes. The Venetian skirt is cut on what may be called architectural lines; the figure seems to rise from a solid horizontal base, and the simple parallel folds give an effect not unlike that of a fluted column. The German skirt is arranged so as to taper from the waist downward. The Italian costume accentuates the horizontals (note the belt and the very form of the necklace), uncovers the shoulder joints and emphasizes the elbows by little puffs. The German costume does precisely the opposite. The very idea of this juxtaposition might have been suggested by Heinrich Wölfflin. Dürer contrasted the two figures as the modern art historian would contrast a Renaissance palazzo with a Late Gothic town house: there is in fact another Dürer sketch, probably made on the occasion of his second trip to Venice (1582), where an analogous

comparison is drawn between the ground plan of two central-plan buildings, one medieval and the other Leonardesque. In sum the costumes are interpreted not only as curiosities, but also as documents of style.[10]

Like the Gentile Bellini portrait of a Turkish artist, the Dürer drawing is a personal sketch and not a commission. It tells us a great deal about Dürer's psychology both as an artist and as an individual. Panofsky has shown that Dürer was the earliest German artist to take a trip to Italy and to try to bring Italian Renaissance styles and theories of art, which he saw as superior, to the north. His friends were aristocrats and intellectuals, and he became an artist in the southern tradition of humanists rather than in the northern tradition of craftsmen. The comparison in the drawing is therefore skewed; the Venetian *gentildonna* is meant to be superior and historically more modern than the Nuremberg *hausfrau*. Panofsky does not ask whether there is anything special in the political situation of Europe that results in such communications between artists and comparisons of styles. I find it striking that both Gentile Bellini and Albrecht Dürer are nearly contemporary, that Dürer stayed in Giovanni Bellini's house in Venice and copied paintings by Gentile Bellini, including one entitled *Turks*,[11] and that Venice had especially close connections with a non-European culture and had, too, a highly developed sense both of itself and of that Other. Neither does Panofsky ask why Dürer in particular should have been so interested in the issue of ethnic and cultural identity and comparison; he merely lets it go as a "curiosity."

What is unusual about the Mesoamerican works of art in which style juxtaposition is present is that they are public rather than private statements and represent politically sanctioned attitudes toward style. The significance of style juxtaposition for Mesoamerica and for the study of style will be clarified by a brief look at Mesoamerica. Since most of the history of Mesoamerica is archaeological, we are used to speaking of its various cultures, some of which have been given ethnic names, such as Maya or Aztec; but for many cultures, such as Teotihuacán, the ethnic identity is not known. In terms of political organization, most of the cultures in Mesoamerica were states, although we often have little detail about them. I shall use the term "polity" to refer to these states.

Mesoamerica is comparable to Europe in that it consisted of diverse ethnic groups speaking different languages and living in politically separate and independent states (Fig. 13.15). Even the largest empire we know, that of the Aztecs, never conquered and controlled more than two-thirds of Mesoamerica, and at no time was the whole area politically unified (Fig. 13.16). This is not unlike the situation in Europe, with Hitlers and Napoleons trying to unify it on occasion, but through most of its history the area has consisted of highly interactive but independent countries.

The Aztec state became a conquest empire and tried to control a large part of Mesoamerica. This empire, however, was not a territorial empire but what has been called a hegemonic empire.[12] Conquered territories outside the capital and heartland were allowed to retain their local rulers and customs, and in most cases Aztec colonists did not move in and settle among them. Conquered areas were expected to send tribute to their overlords, who depended on the raw materials, manufactured goods, or labor skills the areas possessed. Provinces frequently rebelled by not sending the agreed tribute, and the Aztec empire was constantly at war putting down rebellions. This is very different from the European concept of empire, in which territory is overtaken, colonies are settled, languages may be changed, and an attempt made by the conqueror to impose his art and culture on the conquered. In the extreme case of Hitler, the conqueror sought to control even biology.

Because the Aztec empire was conquered by the Spanish in 1521, only about 150 years after its inception, it is difficult to know whether a more integrated imperial structure might have developed in time. It has been suggested that an integrated state did not develop in Mesoamerica due to physical constraints, such as the lack of draft animals for transport, essential both for commerce and war. The formation of an integrated state was also hampered by the nature of the Mesoamerican

worldview, which saw the cosmos in a constant, ineluctable state of flux between creation and destruction. Whether the nature of Mesoamerican states and cultures was determined by material conditions or ideology is a complex question I shall not try to consider here. I am suggesting that the material and ideological contexts of Mesoamerica made unlikely the visualization of a stable, universal state.

The history of Mesoamerica is divided into three periods: the Preclassic period from 1500 BC to AD 300, the Classic period from AD 300 to 900, and the Postclassic period from 900 to the Spanish conquest in 1521. The empire of the Aztecs existed during the latter half of the Postclassic period.

In the Classic period, Mesoamerica did not have a single major empire like that of the Aztecs. The largest and most influential state was that of Teotihuacán in central Mexico, about 50 kilometers northeast of Mexico City. Other important states were Monte Albán in Oaxaca, El Tajín in Veracruz, and Kaminaljuyu in the Guatemala highlands. The Maya of Yucatán, Guatemala, and Honduras lived in city-states, the most important of which included Tikal, Palenque, Piedras Negras, Copán, Uxmal, Dzibilchaltún, and Chichén Itzá (Fig. 13.15).

Like Europe, Mesoamerica formed its own "known world" in Fernand Braudel's sense of the term, through shared customs and institutions. The states were associated with each other through long-distance trade in necessary items such as obsidian and grinding stones, as well as in luxury goods such as exotic feathers, shells, and greenstone. The elites of the different states frequently intermarried and were related by shifting alliances and wars. Although each

MIDDLE AMERICA

A *CENTRAL PLATEAU: the valleys of Mexico, Toluca, Morelos, Puebla, Tlaxcala, and Tula*
B *THE MIXTECA*
C *THE VALLEY OF OAXACA AND TEHUANTEPEC*
D *THE GULF COAST—HUAXTECA*
E *THE GULF COAST—VERACRUZ*
F *THE SOUTHERN MAYA AREA*
G *YUCATAN*
H *THE PACIFIC COAST: southern Chiapas, Guatemala, Honduras, El Salvador*
I *WESTERN MEXICO: Guerrero*
J *WESTERN MEXICO: Michoacán*
K *WESTERN MEXICO: Colima, Nayarit, Jalisco*

Figure 13.15 Map of Mesoamerica and its culture areas. From *Indian Art of Mexico and Central America* by Miguel Covarrubias, copyright © 1957 by Alfred A. Knopf, a division of Random House, Inc. Used by permission of Alfred A. Knopf, a Division of Random House, Inc.

state had its own customs, they all shared a similar calendar, religion, and worldview. This is comparable to Christianity in Europe, which was a unifying force despite the great differences between Catholics and Protestants. The Maya area might be comparable to Renaissance Italy in comprising an area in which a single language and culture were widely shared, although it was politically fragmented into separate city-states. Teotihuacán, Monte Albán, and El Tajín were larger polities comparable to the emerging nation-states in the Renaissance, such as England or France, in each of which there was a different spoken language and a different sense of ethnic identity.

George Kubler discussed the characteristic architectural profile associated with each of the major polities in classic Mesoamerica (Fig. 13.17).[13] He suggested that these were similar to the classical orders, and if we think of the orders as having different origins, rather than different symbolic functions, that is a good parallel. However, the architectural profiles in Mesoamerica never served different purposes at the same site, and they were more rigidly polity-related than the Greco-Roman orders. Until the Classic period, pyramid profiles consisted of simple vertical or sloping sides. In the Classic period each platform stage was articulated into two or more segments, consisting of vertical, horizontal, and diagonal sections. The tropical sun striking these forms directly from above creates high contrasts of light and dark, making them effective from a distance.

At Teotihuacán the pyramid stages were divided into a sloping *talud* and a rectangular panel with an inset called a *tablero*, creating a series of horizontal forms (Fig. 13.18). At Monte Albán the *tablero*

Figure 13.16 Map of Postclassic Mesoamerica and the Aztec empire. Reproduced from Muriel P. Weaver, *The Aztecs, Maya, and Their Predecessors*, New York: Academic Press, 1972. Courtesy Academic Press.

Figure 13.17 Comparison of Mesoamerican architectural profiles. Drawing: Janice Robertson.

consists of overhanging square panels, emphasized on the corners where they create definite ends, thus avoiding the monotony of the horizontal Teotihuacán forms (Fig. 13.19). In Veracruz at El Tajín, a flaring cornice, reversing the line of the *talud,* is added on the *tablero* (Fig. 13.20). Among the Maya there is variability from site to site, but in general a sloping *talud* usually has other sloping elements such as apron moldings on top of it, avoiding the more dramatic contrast of a *tablero* (Fig. 13.21). The presence of inset corners and continuous sloping lines emphasizes the vertical forms. The greatest contrast in style is between Teotihuacán and the Maya.

For hundreds of years these profiles were characteristic of important structures in these areas, and they appear to have been visual symbols of identity and belonging, like the dress of Guatemalan villagers today. So clear are these conventions that a building in an alien style at a given site is generally believed to represent a foreign conquest or an interaction of similar magnitude. An example is the small shrine with a characteristic Veracruz profile at the Maya site of Tikal, which stands out as highly unusual (Fig. 13.22).

Of particular interest is that such articulated profiles were unknown in the Preclassic period and were much less developed in the Postclassic era. Both in Preclassic and Postclassic periods platforms generally had simple sloping stages without elaborate articulation, although Aztec temples have a characteristic balustrade form. This suggests that in the Classic period, for some reason, ethnic and polity differences were so important that identifying symbolism evolved even in architecture. In other words,

Figure 13.18 Platform with *talud-tablero* profile, Classic period, stone. Teotihuacán, Mexico. Photograph: Esther Pasztory.

Figure 13.19 Temple model, Classic period. Monte Albán, Oaxaca, Mexico. Museo Nacional de Antropología, Mexico City. Reproduction authorized by the Instituto Nacional de Antropología e Historia. Photograph: Vincent Phillips.

Figure 13.20 Pyramid of the Niches, detail, Late Classic period. Tajín, Veracruz, Mexico. Photograph by Marvin Cohodas.

Figure 13.21 Temple II, detail showing inset corners and moldings, Classic period. Tikal, Guatemala. Photograph: Esther Pasztory.

Figure 13.22 Central acropolis, Structure 5D-43, Classic period. Tikal, Guatemala. Photograph: Fred Werner.

architectural profiles in Mesoamerica appear to have been symbolic of polity identity in some periods, but not all, suggesting that the visualization of group identity is not always equally important in societies and that its presence needs explanation.

It is notable that in Mesoamerica of the Classic period a large number of coexisting, separate, ethnic groups came into intensive and extensive contact with one another. Despite the intensive contact, the maintenance of cultural differences appears to have been a major concern. The Dürer drawing discussed earlier makes clear the different situation in Europe: Dürer casts the Venetian lady as superior to the Nuremberg one because of the superiority of Italian style. There is no suggestion that for Dürer art style is related to politics or religion, and that by espousing Italian style he is also espousing Italian politics or religion.

The Bazán Slab and Stela 31 from Tikal were made in a context of localism and cosmopolitanism where the differences between groups were seen as unbridgeable. The origin of a person is depicted not just in dress but in the style of the entire figure. On a structural level this implies that we cannot read a common denominator, such as "person" into the Bazán Slab. "Person" is inseparable from "Teotihuacán person" or "Monte Albán person." In Classic Mesoamerica there is an unusually strong sense of the difference between the self and the other, which is seen as being practically insurmountable. Like the maiden and the suitor in the cartoon, marriage is not possible because the figures inhabit different visual worlds. Mesoamerica in the Classic period therefore appears to have considered ethnic units as basic and immutable and to have created rigid barriers in order to maintain them. In this view, style was inseparable from society, politics, and probably even linguistic or biological roots.

Further proof of the association of style and ethnic identity in Mesoamerica are two conquest monuments in alien styles. The style of the Maya city-state of Tonina is characterized by an unusual emphasis on three-dimensional forms (Fig. 13.23). It was therefore surprising to find in the Tonina excavations a monument in the low-relief style of Palenque (Fig. 13.24).[14] Recent breakthroughs in the decipherment of Maya hieroglyphic writing have made it possible to identify these personages. The Palenque-style relief at Tonina represents the Palenque ruler Kan Xul, taken prisoner at Tonina and probably sacrificed there. Tonina commemorated the coup by a relief in which the Palenque ruler was represented in his home style. We do not know how this was done: a Tonina artist may have imitated Palenque style, or a Palenque artist may have been made to carve the relief as an added humiliation. I find the second possibility intriguing. Sixteenth-century sources tell us that when the Aztecs defeated a polity they often asked the conquered people to build roads and causeways or other projects as a form of tribute. Sometimes they did this if the polity was well known for its building crafts.[15]

Linda Schele and Mary Miller have suggested that Piedras Negras Stela 12 is very likely a monument carved by a Pomona artist to represent the Piedras

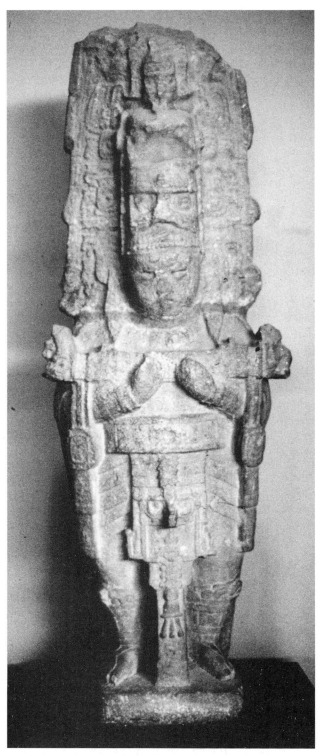

Figure 13.23 Stela, Classic period. Tonina, Chiapas, Mexico. Museo Nacional de Antropología, Mexico City. Reproduction authorized by the Instituto Nacional de Antropología e Historia. Photograph: Esther Pasztory.

Negras conquest of Pomona (Fig. 13.25).[16] They cite as evidence the unusually individualized and even sympathetic portrayal of the victims bound by ropes (Fig. 13.26). It would seem that in Mesoamerica it was possible to capture not only prisoners but also styles. Further, it would seem that at this time there was no concept of stylistic assimilation or of a melting pot, just as there was no concept of a territorial empire. Alien groups may have been conquered and made to send tribute, and their leaders may have been killed and sacrificed, but there was no attempt to destroy the land, culture, or style of the other either by incorporation or annihilation. Despite all the warfare and the sacrifice of individuals, the right of the other to exist as a group was continuously validated and maintained. We might even say that erecting a Palenque-style conquest monument at Tonina was a reaffirmation of the continued separate existence of Palenque. Palenque was not wiped out visually; it was humiliated but maintained with the understanding that at some future time it might be victorious over Tonina.

Until recently, the Palenque-style relief at Tonina would have been attributed to the "influence" of Palenque, based on a European-derived art history in which style had been seen as advancing aggressively on its own like a conquering army. Michael Baxandall has shown that this view reverses actual events, since the influenced party is in fact the active

Figure 13.24 Monument 22, drawing in Palenque style, Classic period. Tonina, Chiapas, Mexico. Drawing: Janice Robertson.

agent. He demonstrates the complexity and richness of this process by the words available to describe it: ". . . draw on, resort to, avail oneself of, appropriate from, have recourse to, adapt, misunderstand, refer to, pick up, take on, engage with, react to, quote, differentiate oneself from, assimilate oneself to, align oneself with, copy, address, paraphrase, absorb, make a variation on, revive, continue, remodel, ape, emulate, travesty, parody, extract from, distort, attend to, resist, simplify, reconstitute, elaborate on, develop, face up to, master, subvert, perpetuate, reduce, promote, respond to, transform, tackle."[17] I have quoted him in full because this wonderful list of words expresses primarily the various modifications that interactions are expected to induce, and allows little room for situations of juxtaposition in which the aim is not to modify but to maintain as is. Baxandall's language is incorporative in the tradition of European art history.

Art and theories of art are related to larger social and political contexts, and I would like to illustrate the Mesoamerican preoccupation with the maintenance of the other, as this is seen in art and style, with the example of an Aztec custom. The concept of the maintenance of the other goes to the extreme of preserving the enemy; it can be seen in one of the Aztec institutions most incomprehensible to the Western mind: "flowery war." According to sixteenth-century histories, this institution was begun under Motecuhzoma I when the Aztec empire was so large and consolidated that wars were fought far from home. Since one of the aims of war was to bring victims home for ritual sacrifice, the lack of warfare near home created a problem. This was solved by a mutual agreement with the polity of Tlaxcala, never conquered but close to the capital, to hold periodic ritual wars. Battles were declared at an appointed place so both sides could take prisoners. These wars were considered good training ground for soldiers, but clearly this aspect was secondary. Although the sixteenth-century texts suggest that the Aztecs invented the practice, this is historical fiction. There is evidence that the practice existed earlier among the Chalca, and it very likely existed in different forms at different times and places."[18] In the flowery war it was more important to capture victims to sacrifice

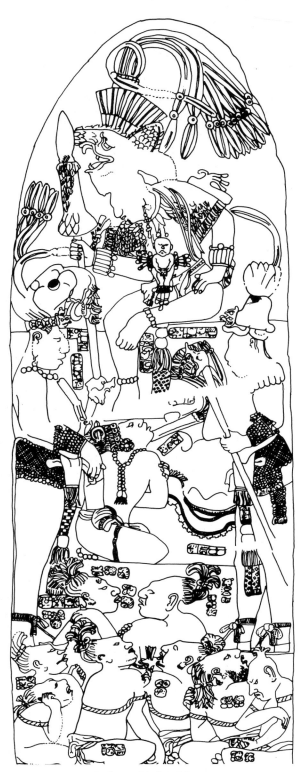

Figure 13.25 Stela 12, Piedras Negras, AD 795, Guatemala. Drawing: Janice Robertson.

than to conquer and control an alien group and territory. Indeed, there was a positive commitment to the preservation of different ethnic groups, since the victim needed to come from an alien group.

We still do not know what mechanisms and institutions in Classic Mesoamerica allowed for the reasonably stable period of six hundred years in which these highly individual and distinctive cultures flourished with a maximum of interaction without the breakdown of barriers. I would like to suggest that some of the interaction between groups may have been highly organized and perhaps ritualized. The extensiveness of the interaction was, in my view, a critical aspect of this period. The exchange of trade, ideas, and perhaps even personnel is evident everywhere and seems to account for the signs of wealth and florescence. This exchange did not occur without war, but it was limited and neither drastically changed the status quo nor altered the territorial situation.

I have long been intrigued by the Mesoamerican ball game, and wondered what political and economic circumstances fostered the development of this institution. Although this game was played throughout Mesoamerican history, from the point of view of related architecture and sculpture, it was most important in the Classic period.[19] At that time

Figure 13.26 Rubbing of prisoner figures, Stela 12, Piedras Negras, AD 795, Guatemala. Copyright Merle Greene Robertson, 1972.

most sites had at least one masonry ball court, and some had nine or more. Moreover, ball players were frequently represented on monumental sculpture as well as on pottery and figurines (Fig. 13.27). The characteristic thick padding they wear and their special playing postures make them easily recognizable. The game, a team sport, was played with a solid rubber ball hit by the hips, knees, or elbows. A number of reliefs indicate that the ball game was important ritually and carried a sacrificial aspect. Ball players are shown decapitated, sometimes with flowering vines emerging from their necks, as though some symbolism of cosmic regeneration were suggested by the game (Fig. 13.28). Frequently the two teams shown on the reliefs represent different ethnic types and costumes, although in this example they are not in different styles (Figs. 13.29, 13.30). On this Chichén Itzá relief, a team with mosaic collars faces a team with shell necklaces. The teams have sometimes been said to represent ethnic groups; historical events, such as a conflict between the Maya and the Toltec;[20] or ritual groups divided into teams representing the cosmic forces of light and dark.[21] I will not try to determine whether these players represent certain ethnic groups or ritual performers. But it is relevant that through ethnic dress the two teams are visualized as separate and distinct.

We know the ritual and mythic aspects of the ball game from the Popol Vuh, a Quiche Maya book from the colonial period.[22] The story of the ball game follows immediately the description of the creation of the world, and is therefore placed in a privileged context. Two brothers, the hero twins of the story, play ball on the surface of the earth, angering the lords of the underworld who envy their playing gear. The lords invite them to play ball in the underworld, planning to kill them. Before the ball game, the twins must stand various trials, each of which they lose, and after finally losing the game, they are decapitated. The head of one brother is placed on a calabash tree, and the tree miraculously bursts into fruit. A maiden of the underworld passes by and becomes pregnant from the spittle of the skull. When the lords of the underworld discover her pregnancy, they are extremely angry and banish her. She goes up to the world and resides with the old grandmother of the

Figure 13.27 Ball player figurines, Jaina style, Classic period, Mexico. Museo Nacional de Antropología, Mexico City. Reproduction authorized by the Instituto Nacional de Antropología e Historia.

original twins until she gives birth to a second set of twins, who are the heroes reborn in magic guise. They too play ball and are invited into the underworld by the lords of death, but this time they have various magic tricks and succeed at all the impossible trials. Finally, they show the lords of death that they are masters over life and death when one hero cuts up the other and brings him back to life. The lords of death ask that the same be done to them too, and of course the twins do not bring them back to life. The story ends with the hero twins ascending in the sky and becoming the sun and the moon.

It is accepted that this Maya version of the harrowing of hell is a cosmic parable with two parallel stories: the first ball game in which the lords of death are victorious and the second in which the lords of life—the sun and the moon—are victorious. In each, victory is at the expense of those comprising the other, who die. These zero-sum games are consistent with the widespread Mesoamerican belief that all cosmic forces are cyclical: the sun is defeated by the forces of darkness when it enters the earth at sunset in the west, and the forces of darkness are defeated by the sun reborn every morning in the east. Each alternation represents a birth and a death. Although the story has a happy ending, the implication of course is that this cycle never ends. A second aspect of the myth is the blooming of the tree in the underworld when the decapitated head is placed on it, expressing the necessity of the first deaths: the sacrificial death of the heroes brings forth the resurgence of nature and the rebirth of the forces of light.

Figure 13.28 Drawing, central section of great ball court relief. Chichén Itzá, Yucatán. Reproduced from Ignacio Marquina, *Arquitectura prehispánica*, Mexico City: Instituto Nacional de Antropología e Historia, 1964. Reproduction authorized by the Instituto Nacional de Antropología e Historia.

Figure 13.29 Drawing, detail of ball players of the team with mosaic necklaces. Chichén Itzá, Yucatán. Reproduced from Marquina, 1964. Reproduction authorized by the Instituto Nacional de Antropología e Historia.

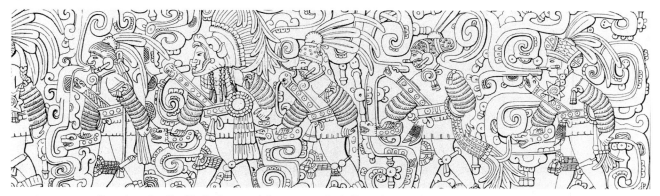

Figure 13.30 Drawing, detail of ball players of the team with shell pendant necklaces. Chichén Itzá, Yucatán. Reproduced from Marquina, 1964. Reproduction authorized by the Instituto Nacional de Antropología e Historia.

It is very likely that some ritual games ended with sacrificing a member of the losing team, and that the game was a reenactment of the myth, with the players representing the forces of light and darkness. The winners and losers were probably thought to have been selected by the gods and therefore preordained. The game could have been played by different teams in the home city, but I think it possible that in the Classic period games might have been played between ethnic groups as well. The representation of different ethnic associations on the reliefs suggests this much. Some sources in the

sixteenth century indicate that in certain situations, instead of fighting a war to determine who paid tribute to whom, a ball game was played. Rulers are shown confronting each other within a ball court in a scene in the Codex Nuttall.[23] I am suggesting that the ritual ball game served to channel hostile ethnic competitiveness, in order to obtain sacrificial victims from alien ethnic groups while at the same time fostering interaction, trade, and other activities concurrently with the games. The ball game may have been one of several ritualized mechanisms for interaction and exchange among ethnic groups in Mesoamerica that nonetheless maintained separation and even hostility.

Writing about the modern Maya villagers of Chiapas in Mexico, Henning Siverts stated that their cultural differences are "overcommunicated," a term that is apt for Classic Mesoamerica.[24] This is evident in the presence of clearly defined polity styles and architectural orders that are unique to certain groups. Unusual representations, such as style juxtapositions and the use of an alien style to represent conquered individuals, indicate that style is not considered a "manner" superimposed on things and traveling separately on its own, but part of the essential nature and reality of things.

Mesoamerican art is not simply different from Western European art, but it developed in the context of a different understanding of style. There is a possibility that the uses and meanings of style as a whole differ greatly between groups and at different times in the same group. Similarly, our own concepts of style as art historians and archaeologists are part of a specific European tradition of understanding the nature of style. The practice and theory of style therefore exist together and reinforce one another. When Paul Wingert taught African art from the perspective of style area in a way that was so handy for students, that concept was not intrinsic to the material, but was an artifact of European thought derived from the notion of folk and national styles characteristic of European culture. Future art historians interested in this subject may find significant differences between the theory and behavior of styles in various parts of the world. Such research might add new dimensions to art history as a discipline.

It is not my purpose here to describe our own concepts or style except by way of brief illustration. As Westerners, we tend to value highly distinct and formalized styles and to feel uncomfortable with indefinite ones. The styles of the non-Western world have been defined from this perspective as "tribal" and "cultural" styles. Rather than seeing these as normal to societies, such group styles need to be regarded as specific reactions to certain circumstances that have practical economic and political dimensions. "Tribes" and "chiefdoms" and the making of ethnic maps were largely the creation of colonialist administrators for the purposes of political and economic control. In effect, these colonial governments created clear boundaries whether they existed or not, thereby creating a situation in which some groups, previously not clearly defined, could, if they wished, nurture and emphasize their own tribal identity through art and ritual. Other tribes, upon being separated into different European colonies, and speaking different European languages, also began a process of cultural differentiation and separation. On the basis of the material remains discovered through archaeological excavation, Mesoamerica appears to have had a more rigidly defined sense of stylistic boundary than many other parts of the world, including Western Europe.

On the basis of this rather briefly sketched material, I would like to conclude with a few hypotheses:

Ethnic or polity styles emerge primarily as a way of dealing with others, and their main purpose is the creation of difference. The socio-political conditions essential for them is the close proximity of other independent groups with whom there is interaction that probably includes competition and hostility. This condition can exist on the tribal village level, as in many areas of Africa; on the peasant folk level, as in the Guatemala highlands; on the state level as in Mesoamerica; and on the level of the nation-state.

Such group styles are therefore not linked to any developmental stage of culture, such as folk or tribal cultures, but are linked to the patterns of interaction between centers among the cultures. For example, in Preclassic Mesoamerica, when states and chiefdoms were few and just emerging, polity styles were not highly developed. In fact, many of the high-status

items in different centers were similar, suggesting that the elite were sharing objects for ritual and prestige.[25] Group styles are clearer in the pottery and figurines on the village level, suggesting that interaction between villages was highly structured and defined. By AD 300, ethnic styles existed on the level of state polities.

Ethnicity has been of great intellectual interest in the last twenty years. In 1955 Nikolaus Pevsner still attributed the "Englishness of English art" to language and the misty weather, otherwise accepting the immutability of national style and character.[26] It has now become fashionable to talk about the invention of traditions everyone once felt were buried in antiquity. Hugh Trevor-Roper's analysis of the Scottish tartans widely believed to be clan symbols is a very fine example of such intellectual unmasking.[27] He has shown that the clan tartans were introduced by an English industrialist and were later elaborated into named designs by textile firms competing for business. The tartans were associated with spurious texts about the antiquity of the highland Scot tradition by various individuals. Some of these individuals always knew that the antiquity of the tartans was bogus, while others involved in the creation of the myth believed it themselves. What Hugh Trevor-Roper does not ask is why the clan tartans became so popular, since correct information was always available and many voices were raised against the collective tartan-"hallucination." Although Scotland is not my story here, it is evident that for various economic and political reasons Scotland needed an ideology and visual indicators of ethnic identity so much that even the spurious would do. Siverts has shown in the case of the Indians of Chiapas that the nature of ethnic symbols may change and may even incorporate alien elements. The Chamula use as Indian a costume derived from a French grenadier's uniform introduced under Maximilian in 1862.[28]

Some of the most perceptive work on ethnicity and society has been undertaken by anthropologists and sociologists. Fredrik Barth has shown that "ethnic distinctions do not depend on an absence of mobility, contact, and information," and he considers simplistic the view that geographical and social isolation have been critical in sustaining cultural diversity.

Instead, he suggests that ethnicity is intentionally created *despite* contact between groups. He recommends focusing on the boundaries that separate groups, through which a steady stream of contact is structured in such a way that the ethnic identity of both sides is preserved. Ethnicity for Barth means the maintenance of boundaries; and he suggests that the ethnic boundary defines a group rather than the cultural stuff it encloses.[29]

Abner Cohen has analyzed the ways in which Hausa traders in West African cities maintained their ethnicity.[30] In brief, his study suggests that the development of clear ethnic identity and culture was of great economic and practical value for the Hausa living within the ethnically very different Yoruba towns. In the creation of ethnicity he singles out the creation of distinctiveness through art and myth, a shared ideology, and patterns of communication, authority, and discipline. He supports Barth's view that ethnicity is not static once it is achieved but survives only if individuals are constantly making personal commitments to it throughout their lives.[31]

The following are my hypotheses about the nature of the relationship between art and ethnicity:

Cultural Dimensions of Ethnic Art Styles
All peoples and cultures do not automatically evolve ethnic styles. Such styles emerge only when external articulation of ethnic identity is necessary for a variety of political and economic reasons. Although information is often lacking or may not be recoverable, various lines of evidence have shown that ethnicity in art and ideology is tightly related to practical and material aspects of society, and is a strategy for survival.

Formal Aspects of Visual Identity; Articulation and Standardization; the Creation of a Brand Image
Visual forms are essential in the realization of ethnic identity both on political and personal levels. In the arts the forms may include anything from architecture to dress. Characteristically, visual distinctions are made through articulation—the manipulation of forms so they result in distinct, clear units, easily remembered, recognized, and repeated—and through their repetition, once the forms have become standardized.

They may be the result of increasing complexity, or of the simplification, of forms. Good examples are the pyramid profiles in Mesoamerica or the various Guatemalan weaving patterns.

The Overt Meaning Given to New Forms—
a Mythical Historic Identity

As has been mentioned briefly, the actual forms used to create ethnic identity may be borrowed or historically bogus, as in the case of the Scottish tartans, which in no way lessens their effectiveness. Such forms, whether architectural orders or patterns, are associated with a mythology of meanings. The foremost of these meanings concerns antiquity. The forms used are said to be ancient, ancestral, and proper, and are meant to embody the identity of the group from time immemorial. This is a form of validation through history.

The Covert Meanings of Ethnic Styles—
Competition and Difference

While the articulated forms ostensibly are looking backward to an authentic past, covertly they are also looking to a present occupied by other ethnic groups or polities similarly creating images of themselves and trying to be distinct from their neighbors. These social relations are often competitive and hostile; and many ways of showing ethnic distinctness are oppositions: curves oppose straight lines, verticals oppose horizontals, life forms oppose geometrics, three-dimensionality opposes two-dimensionality. Such patterns of oppositions can be found on a variety of levels from the national to the individual, and are as true of the Bazán Slab as of the Dürer drawing.

Ethnic Art Styles Result from Interaction,
Not Isolation

Cultural and ethnic art styles as defined above are the physical representations of the complex boundary between a polity and its neighbors. The *talud-tablero* of Teotihuacán represents, not Teotihuacán, but Teotihuacán in relation to its past and its contemporary neighbors in Oaxaca, Veracruz, and Guatemala. Isolated peoples, whether New Guinea highlanders or Iowans, are not known for their highly developed ethnic styles.

Theoretical Concepts of Style

Although a few generalizations can be made about ethnic styles at present, the issue is complicated by the fact that different historical traditions have different understandings of style in general; styles, therefore, do not behave in the same way from culture to culture. Because of the high development of European art history, its theoretical models hold a privileged position and are generally believed to be universal. The European concept or style, including the concept of influence or borrowing and the gradual annihilation of old styles by newer styles, is an evolutionary paradigm that may be related to European patterns of politics and war and a theory of history. If there are any universal patterns and functions of stylistic behavior in art, these are yet to be discovered. A comparative analysis of the practice and theory of style in various other cultures might provide the factual information on which such a theory could be based. I hope that this study of ethnicity in Mesoamerican art is a step in that direction.

NOTES

1. Paul S. Wingert, *Primitive Art: Its Traditions and Styles* (New York, 1962).

2. Franz M. Olbrechts, *Plastiek van Congo* (Antwerp, 1946).

3. Mary G. Dieterich, Jon T. Erickson, and Erin Younger, *Guatemalan Costumes* [exh. cat., Heard Museum] (Phoenix, 1979). Anne P. Rowe, *A Century of Change in Guatemalan Textiles* [exh. cat., Center for Inter-American Relations] (New York, 1981).

4. Fredrik Barth, ed., *Ethnic Groups and Boundaries: The Social Organization of Culture Difference* (Boston, 1969), 9–38.

5. Kent V. Flannery and Joyce Marcus, *The Cloud People: Divergent Evolution of the Zapotec and Mixtec Civilizations* (New York, 1983), 179.

6. Christopher Jones and Linton Satterthwaite, *The Monuments and Inscriptions of Tikal: The Carved Monuments,* Tikal Reports no. 33 (Philadelphia, 1982), 64–74.

7. Michael Roaf, "The Subject Peoples on the Base of the Statue of Darius," in *Délégation Archéologique Française en Iran, Cahiers de la Délégation Archéologique Française en Iran* (Paris, 1974), 73–160. Erich F. Schmidt, *Persepolis* (Chicago, 1953).

8. Howard F. Collins, "Gentile Bellini: A Monograph and Catalogue of Works" (Ph.D. diss., University of Pittsburgh, 1970).

9. I would like to thank Professor Egon Verheyen of George Mason University for bringing this drawing to my attention.

10. Erwin Panofsky, *The Life and Art of Albrecht Dürer* (Princeton, 1943), 36.

11. Panofsky 1943, 36.

12. Ross Hassig, *Trade, Tribute, and Transportation* (Norman, 1985).

13. George Kubler, "Iconographic Aspects of Architectural Profiles at Teotihuacán and in Mesoamerica," in *The Iconography of Middle American Sculpture* (New York, 1973), 24–39.

14. Pierre Becquelin and Claude F. Baudez, *Tonina, Une Cité Maya du Chiapas, Mexico, Mission Archéololgique et Ethnographique Française au Mexique* (Mexico City, 1982).

15. Esther Pasztory, *Aztec Art* (New York, 1983), 52.

16. Linda Schele and Mary Miller, *The Blood of Kings: Dynasty and Ritual in Maya Art* [exh. cat., Kimbell Art Museum] (Fort Worth, 1986), 219.

17. Michael Baxandall, *Patterns of Intention* (New Haven, 1985), 59.

18. Nigel Davies, *The Aztecs* (London, 1973), 324.

19. Esther Pasztory, "The Historical and Religious Significance of the Middle Classic Ball Game," in *Religion in Mesoamerica, XII Mesa Redonda, Sociedad Mexicana de Antropología* (Mexico City, 1972), 441–455.

20. Alfred M. Tozzer, "Chichén Itzá and Its Cenote of Sacrifice: A Comparative Study of Contemporaneous Maya and Toltec," in *Peabody Museum Memoirs,* vols. 11, 12 (Cambridge, 1957).

21. Marvin Cohodas, "The Great Ball Court at Chichén Itzá, Yucatán, Mexico" (Ph.D. diss., Columbia University, 1978).

22. Dennis Tedlock, *Popol Vuh: The Definitive Edition* (New York, 1985).

23. Zelia Nuttall, ed., *Códice Nuttall* (Mexico City, 1974), 80.

24. Henning Siverts, "Ethnic Stability and Boundary Dynamics in Southern Mexico," in Barth 1969, 101–116.

25. David Grove, "The Olmec Horizon" (Paper presented at the Symposium on Pre-Columbian Horizon Styles, Dumbarton Oaks, Washington, DC, 1987).

26. Nikolaus Pevsner, *The Englishness of English Art* (New York, 1955).

27. Hugh Trevor-Roper, "The Invention of Tradition: The Highland Tradition of Scotland," in *The Invention of Tradition,* ed. Eric Hobsbawm and Terence Ranger (London, 1983), 15–42.

28. Siverts in Barth 1969, 111.

29. Barth 1969, 16.

30. Abner Cohen, *Custom and Politics in Urban Africa: A Study of Hausa Migrants in Yoruba Towns* (Berkeley, 1969).

31. Barth 1969, 73.

14

THE PORTRAIT AND THE MASK
Invention and Translation

How, then, should we interpret the great divide, which runs through the history of art and sets off the few islands of illusionist styles, of Greece, of China, and of the Renaissance, from the vast ocean of "conceptual" art?
—Ernst Gombrich 1963

The Olmec portrait heads astonish Westerners—who come upon them usually in a dimly lit museum hall—by their scale and realism. There are now seventeen heads found at three sites, the last as recently as 1994. These massive basalt heads were pecked and carved with simple flint and basalt hammerstones and required enormous effort to sculpt. San Lorenzo Monument 1, for example, is 2.75 meters high and weighs 16 tons (Fig. 14.1). Westerners used to colossal modern engineering and buildings respond positively to the size of the heads on this account alone. But the Westerner is also used to realism in art. According to the model developed by Johann Winckelmann (1968) in the eighteenth century, and still so presented in survey books, art began in rigid stylization as in Egypt and only in time became realistic in the hands of the Greeks.

Various types of realism have been the favorite styles of the West. Only two epochs, the Middle Ages and the twentieth century, have favored nonrealistic styles. Whether the modern viewer prefers realism or abstraction, Western thought has long associated realism with higher cultures. The Olmec heads are amazing, not only because they were transported over a long distance (70 kilometers from the quarry), but also because such realistic effects were created with crude stone tools at the very beginning of an artistic tradition (c. 1200–700 BC). The Westerner has seen many realistic images but is *still* impressed by the wrinkled brow, parted lips as if speaking, pupils in the eyes, and fleshy jowls of the Olmec colossal heads. These are the pre-Columbian waxworks of rulers long gone by. We do not know whether they were in fact rulers, but most informed opinion thinks so.

The pre-Columbian viewer probably saw the heads in bright sunshine or rain, set up in rows outdoors. As far as we can surmise, nothing in earlier art prepared him or her for the scale of the heads. Earlier and contemporary arts were in ceramic or wood and probably smaller in scale. Nothing prepared the viewer for that realistic gaze either. It was as if the rulers of the past had come back to life in a colossal, permanent stone form. They were so near and lifelike that they may have seemed real and so big as to be frightening. To the Olmec viewer, I imagine that the stone heads did not so much signify a high degree of cultural development as an enormous presence of power.

Figure 14.1 Olmec colossal head. Height 1.67 m, width
1.26 m. San Lorenzo Monument I, basalt. Xalapa
Museum, Veracruz. Reproduction authorized by the
Instituto Nacional de Antropología e Historia.

NATURALISM AND PORTRAITURE

In the Western paradigm of art history, the natural-
ism of Greek art is intimately related to democracy
and the concept of individual freedom. In contrast,
the stiff and rigid conventionalization of Egyptian
art, from which it supposedly derived, is related to
the absolute power of Pharaonic rule. Already in
Winckelmann's (1968) history it is clear that certain
forms of art were associated with certain forms of
political rule. In the works of many subsequent
art historians, including Ernst Gombrich (1960),
non-Western arts take the place of Egypt as the prim-
itive others against which to play the miracles of clas-
sical civilization. Egypt, with its animal-headed
deities and idol worship, is reminiscent of Hindu or
pre-Columbian civilizations. Had the Olmec heads

looked conventionalized like the ones from Easter
Island, they would have occasioned little surprise as
works of non-Western art. The colossal heads' evoca-
tive likenesses to real persons—even to a racial
type—have been a source of fascination. Although
earlier scholars supposed that the more naturalistic
heads were made last, and thus a conventionaliza-
tion-to-naturalism development could be suggested
for the heads themselves (see Graham 1989), the best
archaeological evidence suggests that the most realis-
tic ones are the earliest, and the development pro-
ceeds in the other direction (Milbrath 1979).

Olmec art is surprising not only due to the possi-
ble portraiture in the heads but also in the freedom of
design in the lifesize carvings of bodies. Although

Figure 14.2 Kneeling figure, c. 1200 BC. San Lorenzo
Monument 34, stone. Xalapa Museum, Veracruz.
Reproduction authorized by the Instituto
Nacional de Antropología e Historia.

hands and feet are often rudimentary, on several sculptures bodies are asymmetrical and twist about their axes in a manner that occurs in Greek art only relatively late. One sculpture had arms inset into sockets, presumably for an even greater illusion of movement (Fig. 14.2).

Because pre-Columbian art emerged outside the Old World, it is a testing ground for theories based on Old World art. Olmec art allows one to examine the issue of naturalism and the development of art in a comparative context. Does naturalism have to occur gradually, or can it develop suddenly? If it does not develop according to the Egyptian-to-Greek paradigm, how does one account for its appearance?

Not all Olmec art is equally naturalistic. Many other figures, particularly human were-jaguar combinations, are much more stylized (Fig. 14.3). Instead of the well-developed pectorals and calves, these figures have much more schematic bodies and grotesque heads with angular elements. Art history based on European models has sought to create lawlike patterns in the development of style that were based on the consistency of form. Pairings such as "classical" and "baroque" (Wölfflin 1922) created various classifications of line and form that were mutually exclusive. On this basis Gombrich (1960) divided art into the "perceptual" and the "conceptual." In the perceptual mode, the artist seeks to match the image to reality and to create the illusion that it is indeed real. It is a physical, psychological, and philosophical vision that Gombrich associated with relatively secular and "free" societies. In the conceptual mode, artists create what they already know or imagine in their mind without an outside referent. To Gombrich, this represented the epitome of a religious worldview and, developmentally speaking, was anterior to perceptual art. Realism was related to the humanism of the classical and Renaissance worlds.

In the case of the Olmecs, however, the perceptual and the conceptual coexisted. The "conceptual" San Lorenzo Monument 52 is coeval with the "perceptual" colossal heads and with Monument 34. We therefore have to look for an explanation that allows for the existence of naturalism in the beginning of a tradition, intermixed with conventionalization and outside of a classical context.

Figure 14.3 Were-jaguar canal stone, c. 1200 BC. San Lorenzo Monument 52. Reproduction authorized by the Instituto Nacional de Antropología e Historia.

The Olmec situation is rare in art but not unique. A similar phenomenon occurs in two other places in the world, at Ife/Benin in Africa and Moche in the Andes (Griffin 1976; Peterson 1981). It is the presence of naturalistic heads that has made both of these traditions favorites of Westerners with a classical viewpoint. The terracotta and brass heads of Ife (Fig. 14.4.) and the ceramic effigy vessels of the Moche (Fig. 14.5) are both believed to represent rulers in an idealized youthful-mature age. The heads are similar in the representation of racial types, idealized good looks, and some personal specificity (fat or thin faces,

an occasional smile). The period of realistic representation does not last a very long time in either area. Moreover, as in the case of the Olmecs, bodies and other figures are not necessarily treated equally realistically. Bodies may be proportionately short or schematized. In all three art styles, there is an easy continuum between the realistic and the conventionalized. And in all three some aspects of the figures are detailed and realistic, as in a close-up, while other aspects are simpler (for example, the ears of the colossal heads are quite stylized).

It is not certain that any of these remarkably idealistic heads are portraits. Nevertheless, scholars studying each art style have felt that the heads were meant to represent rulers, despite a wide variety of contexts. According to one theory, the Ife heads were dressed with the regalia of the *oni* (king) and presented as an effigy on a funerary occasion (Willett 1967). Or, possibly, they held crowns and regalia (Drewal 1989). The Moche vessels are found in burials, but in the burials of men other than the ruler himself, since they exist in moldmade multiples (Donnan 1976; Strong and Evans 1962). The Olmec heads were on permanent display (Ann Cyphers, personal communication, 1996).

One can try to find an answer to the question of the development of naturalism in the sociopolitical integration of these three cultures. It is my impression

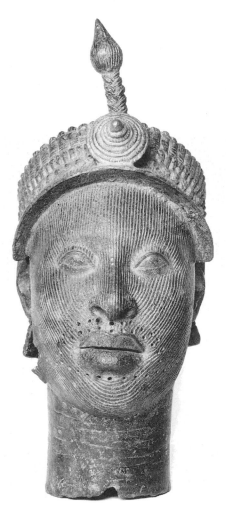

Figure 14.4 Brass head from Ife, c. 1200 AD. © Copyright The British Museum.

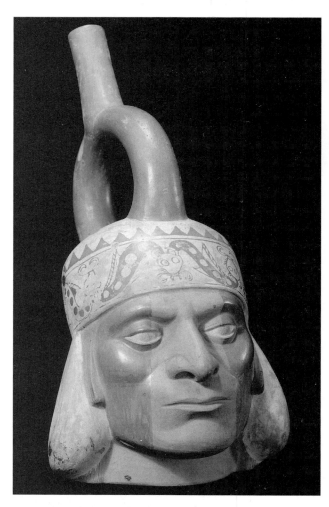

Figure 14.5 Peru, Moche culture, stirrup-spout head vessel from Peru, 100 BC–AD 500, 26 cm x 17.8 cm, Buckingham Fund, 1955.2341 © The Art Institute of Chicago.

that in all cases the societies were highly stratified and were either complex chiefdoms or states. Each area had an agricultural base and trade in exotic materials, such as fine stones or metals. In chiefdoms, as defined by Elman Service (1962, 1975), societies focus on chiefs and the hierarchies surrounding them, but rulers may rule by consensus only and not have absolute power. Such rulers often play important ceremonial roles. Large and complex chiefdoms have built some impressive architectural structures, such as the Polynesian *marae,* and have set up large monuments, such as the Easter Island heads.

States are generally defined as polities with greater executive power in the hands of the ruler and classlike divisions in the populations. Usually, states build impressive monuments, roads, and irrigation canals and engage in other engineering projects that require a large, well-organized labor force. The difference between the rulers and the ruled is much more sharply defined in states than in chiefdoms in which lineages may have titled members. Nevertheless, the difference between a powerful chiefdom and a small state may not be easy to see in the archaeological record. Olmec, Ife, and Moche fit into this borderland category of social integration types. It is striking that such portraiture and realism should be associated with this type of social integration in which a great deal of attention is lavished on powerful rulers. Evidently, realism may be a feature of the art of such societies, but it is by no means a standard or necessary feature. The Easter Island heads, erected in the context of a chiefdom, for example, are quite schematic. The notion of realistic portraiture, therefore, needs to have a more specific context beyond that of the chiefdom or state.

MASKS AND MASKING

While the West sees portraits and naturalism as unexpected wonders in other cultures, masks are seen as non-Western par excellence. The grotesque Olmec mask in the Dumbarton Oaks collection is a perfect embodiment of the "primitive" as seen in the West (Fig. 14.6). Indeed, masks are among the most important works of art in village societies. I see the relationship of art and society in the tribal contexts, as

defined by anthropologists, to be quite different from chiefdoms. Village societies are not usually stratified into ranks or by titles. Rather, authority is usually in the hands of elders and, more specifically, delegated to the spirit world. Ancestor cults are usually important, and ancestors and nature spirits often visit the village and oversee initiations and curing rituals and reinforce social norms. These spirits are usually impersonated by villagers wearing masks. While the portrait is presumably a likeness of the self devoid of cover, the mask is a constructed identity covering a real self. Such a central role for masquerades is usually found in societies with relatively egalitarian social structures, where humans may literally hide behind the spirits in enforcing social norms. No one person is meant to be important enough to be represented by portraiture. Ancestral images may be "portraits" in terms of scarification designs or by being named but not in terms of outward appearance. In this sense, the portrait with physiognomic likeness is the opposite of the mask.

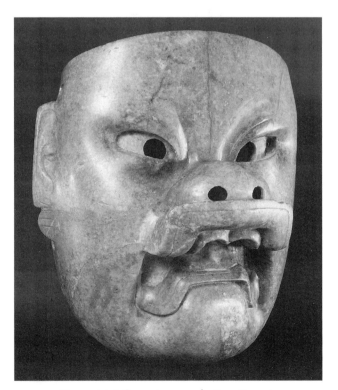

Figure 14.6 Greenstone mask, 800–600 BC. Courtesy Dumbarton Oaks, Pre-Columbian Collection, Washington, DC.

Enormous variety characterizes the masks of village societies, usually made of a perishable material such as wood. Many of the spirits are powerful and dangerous, and sharply conventionalized, dramatic, "cubistic" shapes are felt to be appropriate to them. Beautiful and serene faces also occur, but they too are often simplified into abstract forms rather than portraiture. Sometimes they are coupled, as in the "beauty and beast" masks of Nigeria. Village cultures, masking, and conventionalized art styles appear to go together.

In chiefdoms and states, masks do not have a central role for the obvious reason that authority is in the person and court of the ruler and not in a masking society of elders. Masking societies sometimes disappear once a village becomes a chiefdom, or often the society is attached to the court and becomes an arm of the ruling power. The form and meaning of the masks do not disappear entirely in states and chiefdoms. They are often turned into chiefly regalia: headdresses, pectorals, and loincloth adornments. The Benin Oba wore beautiful ivory mask pendants at his waist. Moreover, these mask images may be transferred from the perishable material of wood into rare and costly treasures such as ivory or greenstone. Much of the art of chiefdoms consists of the insignia of the ruler in costly and exotic materials. While the art of villages is dramatic but rough, the art of chiefdoms is lustrous and smooth.

It is only possible to sketch the artistic situation prior to Olmec times in the Basin of Mexico. Given the quantity of masks in later Mesoamerican art, and of the importance of masking in colonial and even in modern times, it seems reasonable to suppose that early Mesoamerica might have had strong traditions of masking. The existence of a single Olmec wooden mask (from Guerrero) in the American Museum of Natural History indicates that masking existed in Olmec times. There are finds of masks and masked figurines from sites such as Tlatilco in the Basin of Mexico that date around 900 BC (Coe 1965).

The evidence of representations also indicates that the Olmec rulers employed the usual strategies with masking: they appropriated it to the uses of power and prestige in the form of insignia, thereby indicating that access to the supernatural was not through independent societies but through the ruler and aristocracy. Many Olmec pectorals survive with masked faces of the jaguar-human supernatural with his cleft head and angular mouth. Some human figures with portraitlike faces wear stylized were-jaguar masks as headdresses (Fig. 14.7). The forms of these masks are dramatic and reminiscent of village art. Their very purpose, in my view, was to conserve continuity with a past and to present its long traditions in a new form. Indeed, if their meaning is traditional, and in order to maintain the traditional in meaning, their form would have had to have been kept as well.

It is no accident that the supernaturals in Olmec art all derive from or are related to these grotesque mask forms. Their bodies are not grotesque, although they are often child-size. The head, however, is a mask (Fig. 14.3). Even the confusing multiplicities of Olmec deities that have been so difficult to tease apart may go back to various masking personae. The mask form was such a powerful icon among the Olmecs that it was even used in symbolic designs

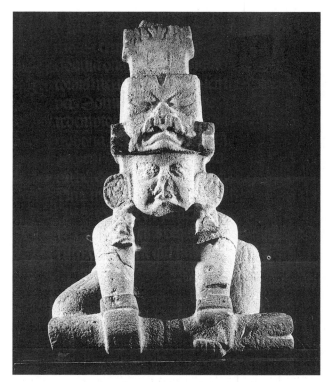

Figure 14.7 Kneeling figure with mask headdress, San Martín Pajapan, 1000–800 BC, stone. Reproduction authorized by the Instituto Nacional de Antropología e Historia.

incised on celts or on figures, such as the one from Las Limas. As such, it becomes a frame for a variety of facial features and markings that in their complexity resemble glyphs. While none of the Olmec designs are considered writing, they bear both a superficial and structural resemblance to Maya glyphs. Many Maya glyphs, especially such basic ones as the head variants of numbers, have masklike flames that function in a similar manner and may be descendants of Olmec mask designs.

The mask form in Mesoamerica underwent a complex series of translations, with each descendant possibly coexisting with the parent form: actual masks in wood, ritual masks in greenstone, ruler insignia, deity face, sign system, and glyph. One of the ways in which art forms develop is through the creative translation of one image into the other, from one medium to another, from three dimensions to low relief, and so on. I am calling these transformations "translations" to indicate both the continuity and the magnitude of the changes. The term "translation" puts the emphasis on the translators who were charged with finding idioms in the language of the current time and practices for the language of the past. Translation may try to minimize change, but change is unavoidable due to new circumstances. Translation is an outwardly conservative process that nevertheless results in creative change. The history of art is an endless series of translations.

WHY OLMEC NATURALISM?

Unlike the Olmec masks and supernaturals for which I have suggested earlier sources, the colossal heads and figures have no known prototypes. They appear in the archaeological record as sudden and surprising inventions. Ife and Moche portraiture are similarly sudden within their own contexts. Instead of long developmental periods, we have to assume that certain rulers/patrons and their artists conceived of such new ways of representation for their purposes. The power of a ruler to change the canons of art and begin something completely new and radical is illustrated by the historic account of Akhenaton, whose political and religious agenda included a veristic artistic one. It does not take more than one ruler of

vision to sponsor a new style. The invention happens once, as the subsequent rulers usually continue the new tradition or, as in Akhenaton's case, discontinue it. Thus all Olmec colossal heads, Ife bronzes, and Moche portrait vessels bear family likenesses as a result of continuity after initial invention (Fig. 14.8).

It is significant for the how-to aspect of these portraits that both Ife and Moche art is, or is based on, easily modeled clay forms and not carvings. Because of the rich evidence of clay modeling of various types of figures in the Olmec area, I am postulating that the Olmec made clay models of their sitters—or of that first sitter—and subsequently carved the stones from them.

Why the choice of naturalistic representation? Reception theory may suggest some answers. Conventionalized styles keep their viewers at an emotional distance. The Olmec jaguar supernaturals, for example, have a mystery about their non-natural

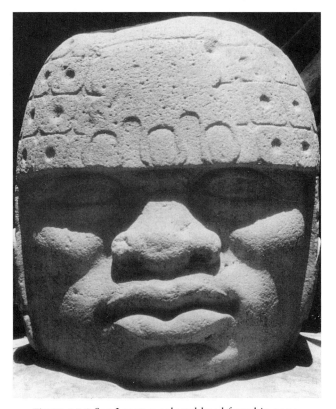

Figure 14.8 San Lorenzo colossal head found in 1994, c. 1200 BC, basalt. Reproduction authorized by the Instituto Nacional de Antropología e Historia. Photograph: Ann Cyphens.

forms that distances them from this world. Masks in general suggest that another reality lies underneath their rigid and nonmoving forms. Naturalistic art, by contrast, implies that one is not in the presence of an artifact but of the "real" and draws one in seductively. (This is not to say that a stylized work cannot be felt to have power within it, but that it is more through the mystery of the strange than through the insinuation of the familiar.) We respond to portraits as if they were real beings before we have decided that they are real or not real.

Many twentieth-century writers and artists dislike realism's power for attracting viewers and undermining their intellectual faculties. Jean Baudrillard (1987) has written extensively about the effect of modern realistic images in film and advertising that blur the borders between the real and the human-made in an instantaneous emotional reaction. According to him, naturalism encourages passive viewing and passivity in general (see, e.g., *The Evil Demon of Images*). Some hyperrealist modern artists have explored the various facets of this illusion of the real. All over the United States people bump into and have their picture taken with hyperrealistic modern bronze sculptures by J. Seward Johnson, set up outside shops and in parks. George Segal's white plaster figures are also in public places like bus stations, where they appear to be passengers (Hunter 1989). Most colorful of all are the works of Duane Hanson, whose ladies in curlers and museum guards are meant to fool the eye of the sophisticated museum goer in the museum itself (Bush 1976). The aim of such verism is to scramble the perceptions of the viewer. The impact of all of these figures has to do with the question of their reality. We are used to naturalistic images, and our artists have to develop many tour-de-force tricks to create this illusion of the real for us. The viewing audience of the Olmec colossal heads was probably less jaded by the effects of naturalism, and therefore the impact of the colossal stone heads must have been correspondingly greater.

The secret of naturalistic representation is not so much the acquisition of a particular "vision," as Gombrich (1960) thought, as the desire to create the illusion of the "real" for a particular purpose. The illusion is created by relatively well-known means. Conceptual art focuses on the denotative features of the face—the eyes, nose, and mouth—but however detailed they are, they remain abstract if the intervening areas are not developed. The illusion of reality is created by modulating and developing the "insignificant" intermediate areas of the cheeks and eye sockets and situating the features within them. In Norman Bryson's (1983) terms, such images are overarticulated and informationally expensive. Olmec artists also understood that strict symmetry and regularity read as pattern and not as "life." The eyes and lips of San Lorenzo Monument 1 (Fig. 14.1) are all slightly asymmetrical, the figure emerging from the niche on La Venta Monument 4 has asymmetrically arranged arms, and so on. The illusion of Olmec realism is but a bag of artistic tricks, and their purpose might have been to astonish and overwhelm. Naturalistic rendering, as such, is a form of mysterious and miraculous knowledge and therefore also a form of power. Such power belonged to the ruler and his circle and was not available to others.

PRESENTATION OF THE BODY

Besides the choice of naturalism, the Olmecs also chose to represent themselves and their power through the body (Fig. 14.9). There is little emphasis on costume or headdresses, and when they exist, they are secondary in importance to the body. This emphasis on the body coincides with the three-dimensionality that is the preferred form. The Olmec rulers claimed power in themselves as physical entities. They are shown as a physically powerful group with heavy muscles and heavy jowls. Their hands, often clenched, hold ropes or staffs. Their faces scowl and their gazes are fierce. By contrast, in the art of later Mesoamerica, most rulers claim legitimacy through costume and insignia that relate to their ancestors or to the spirit world, not through their bodies and faces (the Herrera stela dated AD 36 is an example). In later art, writing and glyphs bolster the claims of rulers. Information is given visually in a two-dimensional form, and the physical presence of the figure is lost in the process.

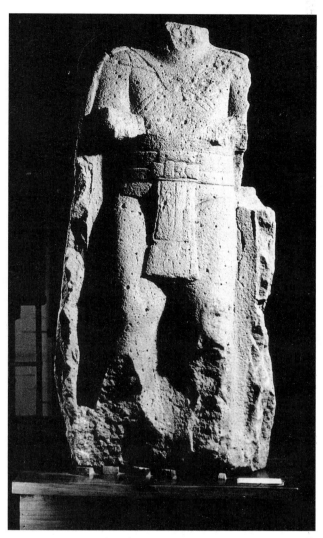

Figure 14.9 Standing figure in cape, Laguna de los Cerros Monument 19, c. 1000 BC, stone. Reproduction authorized by the Instituto Nacional de Antropología e Historia.

Naturalism is most impressive and awesome when the subject is the human face and body. The choice of portraiture in the experimentation with naturalism is not accidental. My argument is that naturalism is always potentially available for the artist—that is, it does not take generations to master it—but only at certain times has it been chosen as a preferred visual language. Art develops through two major processes: translation and invention. Realism is often an invention in the midst of conventionalized styles. Why then is it as rare as Gombrich has pointed out?

CONCLUSION

Not all cultures share the joy of realism. Robert Thompson (1971, 376–377) describes the Yoruba whose aesthetic ideal is "'mimesis at midpoint'—i.e., the siting of art at a point somewhere between absolute abstraction and absolute likeness . . . Portraiture in the Western manner is considered virtually sinister by traditional Yoruba. It is interesting that Hans Himmelheber was told by a Guro artist on the Ivory Coast: 'I am afraid to carve the face of a particular man or girl, for if that person should die soon after, people might attribute death to this portrait.'"

Reading such ethnographic detail makes it seem that "primitives" are frightened of realism, while the more "civilized" are not. David Freedberg's (1989) *Power of Images* tries to undo these tropes by arguing that even the most "civilized" person has a response to images that operates before aesthetic appreciation or any other kind of analysis takes place, and that this response could be innate. It is normal and common to confuse the image with what it is supposed to be. Although he suggests that we have a response to all images, hyperrealistic ones evoke a particularly strong reaction. He analyzes the extremely lifelike European wax images, emphasizing the fear they cause in the viewer: "We are arrested by these images at least partly out of fear that they might just come alive, just open their mouths, just begin to move. We fear the lifelike because the dead substance of which the object is made may yet come alive" (Freedberg 1989, 231). "Of course we marvel at the skill of the maker, at mechanical contrivance, and the artistry that makes objects seem real: but at the same time, fear of the lifelike haunts the warring perceptions of the image as reflection and the image as reality" (Freedberg 1989, 221). For Freedberg, the waxwork figures are merely the end points in verisimilitude, but objects all along the continuum of abstraction to naturalism have some uncanny power to move the beholder.

The choice of realistic human representation and portraiture is an investment in a new kind of power and emotional manipulation of the viewer. The rarity

of such representation indicates avoidance. Its presence suggests the purposeful transgression of something of a representational taboo. Rather than being the benign signs of cultures at a "higher level of civilization," they suggest profoundly complex deployments of power.

The aim of all realistic art, whether it is the nineteenth-century novel, the twentieth-century film, or Olmec portraits, is the eradication of distance between the viewer and the object viewed. A realistic image suggests that we are in the actual presence of the person depicted, despite the fact that we know that it is only celluloid, paint, or stone. Realistic depiction works on the emotional level to create intimacy. The more realistic Olmec heads, for instance, are experienced as "closer" and friendlier than the stylized ones. The Western preference for realistic styles has suppressed their uncanny features except in extreme examples.

The rarity of naturalistic arts elsewhere indicates that naturalism signifies not only intimacy but a certain kind of undesirable power. I see the creation of Olmec portrait heads as a strategy invented by the rulers of creating images of immediacy and thus making their rule appear accessible, personal, and perhaps inescapable. At the same time, the portrait heads represent the power of the ruler which can come to life at any time in a colossal incarnation. Friendly as they appear to us, in their own time they must have been more awesome and frightening than the jaguar-human supernaturals.

BIBLIOGRAPHY

Baudrillard, Jean
 1987 *The Evil Demon of Images*. Sydney, Australia.
Bryson, Norman
 1983 *Vision and Painting*. New Haven, Conn.
Bush, Martin H.
 1976 *Duane Hanson*. Wichita, Kans.
Coe, Michael D.
 1965 *The Jaguar's Children*. New York.
Donnan, Christopher
 1976 *Moche Art and Iconography*. Los Angeles.
Drewal, Henry John
 1989 Ife: Origins of Art and Civilization. In *Yoruba: Nine Centuries of African Art and Thought*, ed. Alan Wardwell, 45–76. New York.
Freedberg, David
 1989 *The Power of Images*. Chicago.
Gombrich, Ernst
 1960 *Art and Illusion*. Princeton.
 1963 *Meditations on a Hobby Horse*. Chicago.
Graham, John
 1989 Olmec Diffusion: A Sculptural View from Pacific Guatemala. In *Regional Perspectives on the Olmec*, ed. Robert Sharer and David Grove, 227–246. Cambridge.
Griffin, Gillett
 1976 Portraiture in Palenque. In *The Art, Iconography, and Dynastic History of Palenque, Part III*, ed. Merle Greene Robertson, 137–147. Pebble Beach, Calif.

Hunter, Sam
 1989 *George Segal*. New York.
Milbrath, Susan
 1979 *A Study of Olmec Sculptural Chronology*. Washington, DC.
Peterson, Jeanette
 1981 On Portraiture: African and Precolumbian. Paper presented at the annual meeting of the College Art Association, San Francisco.
Service, Elman
 1962 *Primitive Social Organization*. New York.
 1975 *Origins of the State and Civilization*. New York.
Strong, William D., and Clifford Evans
 1962 *Cultural Stratigraphy in the Viru Valley in Northern Peru*. New York.
Thompson, Robert D.
 1971 Aesthetics in Traditional Africa. In *Art and Aesthetics in Primitive Societies*, ed. Carol Jopling, 374–381. New York.
Willet, Frank
 1967 *Ife in the History of West African Sculpture*. New York.
Winckelmann, Johann J.
 1968 *History of Ancient Art*. New York.
Wölfflin, Heinrich
 1922 *Principles of Art History*. New York.

AESTHETICS AND PRE-COLUMBIAN ART

. . . art is and remains for us, on the side of its
highest vocation, something past.
—Hegel, *Philosophies of Art and Beauty*

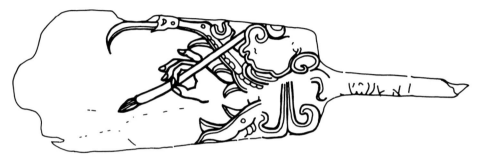

Figure 15.1 Artist's hand emerging from a monster maw. Incised bone.
Tikal temple 1. Drawing: Janice Robertson.

It has often been said that in archaic societies, art is the handmaiden of religion. Concomitant with that is the fact that in such societies there is no word for "art." Yet these societies have a remarkable number of formally sophisticated objects that appear to fit the concept of art held by those societies that have it. Moreover, despite the apparent emphasis on religion, some of the most sacred objects in archaic societies are not formally exquisite works of art but simple, rough-hewn or even found objects, like pebbles and feathers in bundles or rock outcrops, indicating that the relationship of art and sacredness is not a simple matter. Artistry is clearly lavished on the dresses, badges, crests, palaces, temples, and images of the social and political world. Thus, although its subjects are often religious, art is, more correctly, the handmaiden of society.[1]

Aesthetics emerged as a separate field of study in eighteenth-century European philosophy when the notion of the Godhead as an organizing principle in the world was on the wane and while the scientific outlook became ever more pervasive and dominant. In the perspective of aesthetics, art acquires some of the transcendental qualities traditionally associated with religion. "Art," which used to be thought of largely as craft, becomes the work of genius, to be placed on a pedestal as embodying "divine values." In the sixteenth century, clerics debated the question of whether the Indians discovered in the New World were truly human and endowed with immortal souls worth saving, or whether they were more like animals whose labor could be thoroughly exploited. In the twentieth century, little is left of the transcendent except for the concepts of "genius" and

"creativity," which are almost seen as supernatural. We cling desperately to the notion of the "divinity" of the creativity that resides in humans. The questions now about the Indians are: Did they have art? and How good was it? Heidegger agreed with Hegel that the concept of art always refers to the past and is therefore always a hindsight.[2] Much as clerics once decided who had souls, we now decide who had art and was therefore fully human. And Heidegger's past for us is also represented by contemporary "stone age" or tribal societies.

Pre-Columbian aesthetics can be reconstructed either by pretending that we are on the inside of the culture or through various Western views of it from the outside. Despite the traditional anthropological attitude that assumed that an inside view was possible, such a reconstruction is still an artifact of Western thought. Much of twentieth-century reconstruction of exotic life is tinged with romantic primitivism that sees it more as the "opposite" of what is imagined to be Western than what it "really" is. For example, although traditional cultures value complex craft techniques as power and control over nature by humans and an indication of the superiority of human intellect, these cultures are always seen by Westerners as more in tune with nature than we are. We seek them out precisely to prove how little in tune we are with nature and to express our nostalgia for an imagined Eden of harmony between humans and nature.

Pre-Columbian concepts of art are coded into the works of art themselves and hence implicit. We, the collectors, curators, scholars, and tourists, tease an aesthetic philosophy out of the works, the texts, and other data. It is our creation. The aesthetic does not reside in the object nor in the mind of the viewer but is a complex relation of the two. Reconstructing the mind of the pre-Columbian viewer in the absence of texts and informants is nearly impossible. Nevertheless, pre-Columbian cultures are particularly instructive for the Western intellectual quest to understand the nature of art. In at least one pre-Columbian society, the Classic Maya, art appears to have been a somewhat self-conscious enterprise with a glorification of the artist that is closer to the concept of art and artist in the West. Having emerged outside of the Old World traditions, the cultures of ancient America are a fruitful testing ground for theories derived from the development of Western art.

Before attempting a reconstruction of the pre-Columbian concept of art, it is useful to note how the West had come to see it as "art" and how it has been fitted into Western schemas of aesthetics. In the sixteenth century when the Americas were conquered, the only arts admired were those of architecture and engineering. The bridges, causeways, and temples of the Aztec and the Inca aroused the admiration of Europeans used to living with monumental architecture. It was a sign of high civilization. The other arts were seen as either heathen images and works of the devil which had to be destroyed or merely as quaint curiosities. There is a famous passage in Dürer's notebooks in which he merely admired the Mexican objects taken to the court of Charles V in Brussels for their ingenuity and strangeness, in the same way as he was fascinated by all other oddities he came across on his trip.[3] His language in describing them is not the one he uses for Western art. No one in the sixteenth century admired the "art" of the goldwork enough not to melt it down for the value of the metal. It can be said quite categorically that in Renaissance times, pre-Columbian things were wonderful curiosities but not "art." Moreover, despite the interest in local European styles—northern and southern, Florentine and Venetian—there is much less a sense that for them exotic objects had a "style" of their own other than a generic strangeness, crudeness, or grotesqueness. (The one foreign artistic tradition the West saw and understood to some extent was that of the Islamic Arab countries, because of their closeness and long intertwined history with the West.) So it is not surprising that in the many books on the Americas engraved by Theodor de Bry there is often no precise knowledge of, or apparent desire for, accurate stylistic depiction.[4] Roman arches form the buildings and European pitchers and trays are put in the hands of the Inca. Naked Caribbean Indians greet Columbus with similar Renaissance gold vessels in one de Bry engraving. Such stylistic vagueness is generally true of early illustrated books, such as the Nurenberg

Chronicle (1493), in which all dress and constructions of various places and epochs are seen as if they were contemporary or purely imaginary.

Recognizably exotic styles emerged in the illustrations of the middle of the seventeenth century as, for example, in the monumental treatise on Egypt written by Athanasius Kircher.[5] Egypt plays the role of the exotic ancient other to classical European civilization. Kircher compares Egyptian to all exotic world art known to him, including Chinese, Hindu, and pre-Columbian, and the illustrations indicate a sense of the style of each of these. Their spirit, however, is scientific rather than artistic or aesthetic. To Kircher's mind, all these styles were similar to one another and to the Egyptian and different from that of the West. This attitude in various guises has remained in force until the first half of the twentieth century.

The late eighteenth/early nineteenth century was the great sorting ground of the arts and civilizations in Western thought. While on the one hand this is the era of Lord Elgin and the museum enshrinement of the marbles of the Parthenon, of Winckelmann's glorification of Greek art as the supreme creation of the West, it is also the time of the creation of the exotic, the non-Western, the archaic, and the primitive. The fascination with Greece coincides in time with Napoleon's colossal scientific project regarding the antiquities of Egypt, visits to the ruins of the ancient Near East, and the beginning of the exploration and recording of Maya ruins. The apotheosis of the classical and the delectation of the exotic go hand in hand, and, in fact, define each other. John Lloyd Stephens and Frederick Catherwood both traveled in Greece, Egypt, and the Near East looking at ruins before joining forces and setting out in search of the Maya. Their attitude was thoroughly comparative.

None of this could have been possible without a philosophical concept of aesthetics. It is precisely the separation of the aesthetic aspect of works of art from their functional, social, and religious aspects that made it possible to see alien arts as nonthreatening and nonheretical. While the sixteenth century saw the art of the Americas in religious terms, the eighteenth century could see it in two new ways:

scientific and aesthetic. These indicate a major change in attitude to which the Kantian concepts of disinterest, detachment, and universal judgment of taste are crucial. While the scientific attitude is detachment for the sake of knowledge, the aesthetic attitude is detachment for the sake of appreciation. The foreign can now be understood and enjoyed without having to be the same as one's own. There is no heresy involved. The eighteenth-century concept of the sublime also allowed for exotic beauty and grandeur that was not within the canons of Western art but could include that which was strange, violent, disturbing, or perhaps even ugly.[6] The only element alien to the aesthetic, for Kant, was the disgusting.

The Western measure of exotic art was, and to a large extent still remains, classical art, and especially the art of the Greeks, which still in the mid-twentieth century Gombrich considered unique and a "miracle" ("The Miracle of the Greeks").[7] Idealistic naturalism, characteristic of Greek art, is still therefore the favorite style of the West. Maya sculptures, first brought to Western attention in the late eighteenth century, were immediately fascinating precisely because such "idealistic naturalism" is their hallmark. (Eventually the Maya would be considered the "Greeks of the New World.") When Frederick de Waldeck, the self-proclaimed pupil of the neoclassic painters David, Vien, and Prudhon, depicted the images of Palenque with some enthusiastic inaccuracy, he saw them as approximating neoclassic forms.[8] Actually, Waldeck's original drawings were in the "scientific tradition," much like his sketches of fish and flowers and quite exact in that sense. As he elaborated them into paintings, however, the Maya forms began to look more and more Western and classical, in order to become "beautiful," while their grotesque features were also exaggerated in order to become "sublime." In his finished paintings, he enlarged them next to small human figures, in order to increase the sense of their awesomeness. (Piranesi had already used such changes in scale to make his views of Roman ruins more exotic.) Many modern collectors still appreciate Maya art the way Waldeck did because its ideals of beauty are close to that of the

classical while it has the added excitement of the exotic features, mysterious hieroglyphics, and barbaric (that is, violent or sexual) elements that to the West signify the other. At the end of the twentieth century, the most accessible and favorite pre-Columbian style remains that of the Maya.

Most other pre-Columbian styles had to wait for the twentieth-century language of modernism and the appreciation of abstraction and conventionalization to be seen as works of art. While the art of the Maya is lauded for its elegance and naturalism, the arts of Mezcala, Teotihuacán, or Tiahuanaco are appreciated for their abstraction and compared to Brancusi, Braque, or Picasso. Modernism set itself up in opposition to classical values of representation and has sought as authorities and precursors various primitive, archaic, and medieval styles.[9] There is no question, however, that Western modes of art wag the tail of pre-Columbian appreciation. Minimalist earth art of the 1960s, for example, has kindled interest in the famous lines in the desert of the Nazca plateau in Peru. The very language of the appreciation of these pre-Columbian arts is borrowed directly from the formal analysis of modern art, with its preoccupation with lines and shapes and the invention of ingenious abstractions. While modern art in the West has a sizable following, it is still an acquired taste for most people, whose preference is for classical forms. There is thus a clear ranking of pre-Columbian arts in the minds of both scholars and the public. These tastes determine the valuation, language, and even prices paid for pre-Columbian arts. The rise of any new Western artistic movement may potentially rescue some thus far obscure pre-Columbian artistic tradition.

Because of the preference for classical art, since the nineteenth century evolutionist theories have generally imagined art to have a stylistic progression from abstraction, which seemed to be "crude and easy," to naturalism, which was seen as "sophisticated and difficult." These concepts derive from a parallel of art and technology, the acquisition of naturalism being compared to the slow accumulation of technical and scientific knowledge. In most of his work Gombrich is still a proponent of this idea, on the basis of the type of "vision" required for naturalism, which in his view is a detached, scientific vision in which an attempt is made to match images to the real world rather than to create, through abstractions, alternative worlds.[10] Abstraction is thus associated with "magical" as opposed to "scientific" thinking. His terms for these visions are the "conceptual" and the "perceptual." According to the prevalent nineteenth-century art historical paradigm, the Greeks created a "perceptual" art out of the rigid "conceptual" canons of Egyptian art by gradually "matching" the image to reality. Nineteenth-century anthropologists studying ornament debated endlessly whether designs began in naturalistic forms and became more abstract as time went on or the opposite.[11] Such evolutionist theories presupposed gradual, incremental evolution in a single direction (even though neither medieval nor modern art fit into that schema particularly well). Non-Western arts were condemned often for not fitting into linear evolutionary sequences and thus lacking proper "development" and in any case remaining at a primitive, non-naturalistic level.

Pre-Columbian art history, as we know it so far through archaeology, does not support the Western evolutionary paradigm of naturalism rising out of abstraction. The earliest art in Mesoamerica, that of the Olmecs, is one of the most naturalistic, three-dimensional and free in movement (1300–900 BC). Thereafter the arts are, in many ways, more constricted in form. Olmec art does not appear to have emerged out of an older more "abstract" tradition, but appears to have been invented fully in that form. Some centuries later, Classic Maya art undergoes a 700-year-long history in which for about 150 years there is remarkable naturalism in style (AD 650–800). Andean art has its idealized/naturalistic cameo appearance in the Moche style (200 BC–AD 600) but then becomes progressively more abstract and minimal. Idealized naturalism occurs at various points in pre-Columbian history, but it is more episodic than developmentally determined.

Because the arts of pre-Columbian America emerged entirely separately from the arts of the Old World, they are crucial to the understanding of the evolution of art and the roles of naturalism and abstraction. It is clear that naturalism and abstraction are cultural choices and potentially always

possible, not steps on a ladder or end points on a scale. Naturalism is neither a specific vision nor a technological skill belonging to a particular stage of culture. It has most to do with the social and political requirements of a given context. Moreover, it is also clear that there is not necessarily a grand overall development in the arts of an area.

Development is restricted largely to the art of individual cultures, such as Olmec, Moche, or Maya. Within individual cultures there are developments that can be described as formative, classical, or baroque and tendencies either toward or away from naturalism. But, the disjunctions *between* cultures are great enough to redirect art into any new directions, depending on the given social conditions. The developments of Western art seemed so compelling to art historians such as Wölfflin precisely because they were a part of a single cultural tradition.

In order to reconstruct pre-Columbian aesthetics, one is forced to deal with the context as defined anthropologically. The most immediate issue is the function of art, which is said to be "utilitarian" in traditional societies and "free" in the modern West. While we can say that as an embodiment of value, status, taste, and intellect, art of all periods has a similar function, there is indeed a difference between implicit and explicit concepts of aesthetics. Pre-Columbian cultures whose arts survived in permanent media were complex hierarchical societies defined as chiefdoms and states. Having limited systems of writing, artworks were the most important communicating media.[12] While their means were aesthetic, these were as implicit as the good design of cars or rockets is implicit—indeed not their primary function. (We usually do not ask who designed the lines of a space shuttle.) Any perusal of the few texts available on the arts or artists of the Aztec, Inca, and Maya indicates a high regard for skill, the ability to understand a commission in terms of the genre required, and the imagination to invent something new and different.[13] Curiously, traditional non-Western arts are considered not just conservative and unchanging (the Egyptian example is usually quoted) but also extremely varied and ingenious (the vast variety of non-Western styles). The variety of styles existing worldwide and archaeologically makes sense

only if the notion of sticking to tradition was very loosely understood in most of these cultures.

Every culture has its concept of the beautiful. Very frequently this is evident in an idealized or stylized human figure or face or in elaborate ornament. Both from contexts and from texts we know that the beautiful, the good, and the powerful were often equated with one another. Characteristic of preindustrial arts of states is a high valuation of technical skill, virtuosity of craftsmanship, and labor and time intensiveness—the use of stone tools to carve jade and basalt in Mexico, the painstaking textile techniques of the Andes. There is also evidence that the artist is seen to have a mysterious creative power akin to the supernatural and that some of that power also resides in the work created by him.

What most pre-Columbian art does not share with Western art since the Renaissance is a background that includes a "cult of the aesthetic" and a "cult of the artist." Artists did not sign their works or make images of themselves. The aesthetic features of their works may have been discussed as better or worse than others, but there was no philosophy of art. This did not make such art anonymous, since these artists were most likely known in their day. But the lack of the glorification of the artist affects the nature of the art created. It gives it a straightforward, self-assured, and un-self-conscious quality sometimes much admired by aesthetically self-conscious cultures such as ours. Mannerist strivings for effect—or a kind of visual signature—are usually lacking.

A partial exception to this in the Americas is the Maya, who appear to have had a cult of the aesthetic. The evidence that the Maya focused specifically on the aesthetic as a facet of experience comes from the nature of their art and the inscriptions. Aestheticism among the Maya is generally an aspect of the emphasis on individual rulers and aristocrats. The glorification of individual achievement characterizes much of Maya art, which is concerned with dynastic matters such as accessions and conquest. Rulers are sometimes individualized by portraiture and by inscriptions giving their names, proofs of legitimacy, and exploits.[14] It is this climate of the celebration of individual achievement that appears to be behind the development of individual polity styles

in art. Within the short span of Classic Maya art (AD 250–900) there is a wide variety of regional styles, as each Maya city, like the cities of Renaissance Italy, has its own genres and forms.

Proskouriakoff has shown that temporal changes in style affect the art of all the Maya cities, indicating high levels of interaction. As she conceptualizes them, these phases are comparable to the European developmental notions of the formative, classic, and baroque.[15] It is relatively easy within a given site, like Yaxchilan, to select out the work of an individual carver on the basis of style.[16] Advances in hieroglyphic inscriptions have made it possible to see the styles favored and patronized by individual rulers.

Aesthetic preoccupation is also evident in the design of individual monuments, in which the elegance of forms and exquisiteness of detail suggest patrons interested in aesthetic matters and especially clever refinements. All these elements can be read out of the works of art with just a cross-cultural knowledge of art. Recent excavations and finds have brought to light more specific proofs of this aesthetic interest in the form of a sculpture from Copán of a deity represented as an artist with a brush in his hands,[17] as well as names on pottery that are interpreted by some as the names of the artists who painted them.[18] Most dramatic of all is a carved bone from Tikal which represents the hand of an artist with a brush emerging from the maw of a supernatural creature in the same way that deities are often shown emerging from supernatural maws.[19] It does not take much imagination to interpret the hand and brush as representing the divine aspect of artistic creation. Various pre-Columbian sources indicate that younger sons of aristocratic families were involved in different sorts of artistic activity and that artistic activity was an integral part of court life, especially among the Maya.

Besides idealistic naturalism, self-conscious aestheticism brings the Maya close to the Western classical ideal of high art. The really interesting question is why explicit aestheticism developed among the Maya only for that relatively brief period of time. One possible answer is that, like the Balinese or Louis XIV, the Maya lords ruled through a form of theatricality, of which aesthetics was a very significant and distinct component.[20] Aesthetics was separated out because it was in some ways socially useful. As Geertz noted about Bali, theatrical aesthetic activity may be one way for a state to pretend to have, and thus acquire, power it is not able to amass in more practical ways. Another possible answer is that with the high development of hieroglyphic writing, images were freed from the necessity of conveying certain sorts of information and were available to communicate ideas about art itself. However, this does not answer the question of why writing was so much more elaborate among the Maya than their neighbors. Writing seems to have been invested with an artistic interest similar to that of calligraphy in Asia. Regardless of cause and effect, the Maya were clearly separating image and text, and it is partly from that separation that explicit aestheticism emerged.

The aesthetic attitude assumes that the raison d'être of art objects is to be visual. That is, they can be examined, decoded, enjoyed, perhaps even feared or hated, but the sensory experience of vision and the intentionality of some visual effect are presumed to be primary. This is indeed the case in Western art since the Renaissance; an invisible work of art is meaningless. (Market value and aesthetic delight assumes a human audience. Twentieth-century art has tried to invert this value by creating nonvisual or noncollectible arts.) Archaic societies are neither visual nor antivisual in this sense. The Aztecs carved the bottom of colossal sculptures with intricate images of the earth, presumably for the visual appreciation of a supernatural audience with human tastes. Many Maya reliefs, such as lintels, were originally embedded in badly lit and difficult-to-see architectural contexts accessible only to the elite. The designs of the Nazca lines are mainly visible from the air or partially from a nearby hill but were invisible to their makers and users the way we see them now. Aestheticism assumes display—in a church, museum, palace, home—in which a work can be present as background ornament or as the focus of attention.

Aestheticism emerges in a continuum and not as an absolute stage. It is, however, always involved

with display and thus with secular, political power or the pomp and circumstance aspect of religious power. The most sacred objects of many cultures are either natural objects not fashioned by humans, such as the rocks of Mecca and Jerusalem, or crude and overtly nonaesthetic objects, such as the *boli* (wood/mud/blood/cloth image) of the Bamana. In many cultures artworks are destroyed in the process of their use. The "oracle" in the Andean temple of Chavín de Huántar was a crudely carved natural stone, much less finished and "beautiful" than the carvings in the anteroom courtyards.[21] The Aztec patron god Huitzilopochtli had no images and was perhaps a collection of powerful charms in a bundle or a dough image.[22] The really sacred statue of Athena on the Acropolis was an old wooden one and not the colossal ivory and gold masterpiece of Phidias in the Parthenon. In many cultures, natural, crude, or old objects are venerated more as *sacra* than elaborately made new ones.

Magnificent objects buried with the dead in many past cultures also illustrate the point that availability for use and visibility to the living were not always the basis of an object's function in the past. The beautiful and elaborate, when it is meant to be visual, is intended to communicate with a human audience in some social context. In a spectacular funeral there is at least one final, grand display. Subsequently, the objects communicated functionally and aesthetically with the dead and the gods. Aesthetics in this sense is an immanent rather than transcendent social value. The ultimate powers of the unseen are often felt to be inexpressible, invisible, and unrealizable beyond the province of the visual arts.

The transcendent aspects of aesthetics, art turned into the expression of the divine in humans, emerges fully in eighteenth-century European thought associated with the decline of religious faith. Since the eighteenth century, aesthetics has become a sort of religion, a substitute for the forms of worship of the past with the museum as its temple.[23] This is not, however, a sudden and total change, nor is it restricted to the West. Various forms of aestheticism existed in Asia and Africa as well as in pre-Columbian America. Paradoxically, though the aesthetic has always been

felt to have something supernatural about it, it is mostly secular and worldly in its manifestations; this too it has in common with aspects of religion.

One of the most striking aspects of archaic and exotic arts is the ease with which we recognize them as "arts" and the extent to which we can understand their formal "message," even if their precise cultural meanings are unknown. One of Kant's most important observations about aesthetic judgment is that it is universal—even if we don't agree, the mere fact that we can quarrel over taste means that we have grounds in common. We need not have the same opinions, but we have a similar ability to form judgments. Kant's own taste seems to have run to classical allegories and English gardens, but Maori tattoos, Sumatran pepper gardens, mathematics, and tulips are among the broad range of global things that informed his thinking.[24] This eighteenth-century concept of a shared, universal ability to make aesthetic judgments is related to the new ability to see and valorize exotic arts as desirable and pleasurable. Many eighteenth-century scholars and travelers routinely compared the arts of all of these peoples in charts.[25] The aim of these comparisons was to show the similarities, despite the apparent differences, between Egyptian, Hindu, Maya, and other styles. While this attempt seems naive to us, attuned to the study of difference, it underlines the universalizing tendency of the previous century and the process by which the foreign was made available as art in Western terms. In the sixteenth century, the Aztec god Huitzilopochtli was represented in European prints as a devil with hoofs. To the eighteenth century, pre-Columbian art looks more like Greek art. For the twentieth century, pre-Columbian art outdoes cubism in abstraction and complexity.

Nevertheless, while pre-Columbian art reveals a great richness and variety of traditions and implicit aesthetics, and while it has been and will be used to justify and authorize Western experiments in art, as Henry Moore once used it, it is a passive body of material on which aesthetic theory can play its games and test its various ideas.[26] While these aesthetic games have been suspect in the eyes of anthropologically oriented scholars in the business of serious

cultural reconstruction, would we expend the energy on excavation and analysis of the Maya if it were not for the great body of extant Maya art and what it means to us? While we claim that reason, science, and technology are more central to our culture than art, we define the peoples and cultures of the past through their art. It matters a great deal who has art and what kind of art it is.

NOTES

1. Esther Pasztory, "Shamanism and North American Indian Art," in *Native North American Art History: Selected Readings,* ed. Aldona Jonaitis and Zena P. Mathews (Palo Alto, California: Peek Publications, 1982), 7–30.

2. Martin Heidegger, "The Origin of a Work of Art," in *Philosophies of Art and Beauty: Selected Readings in Aesthetics from Plato to Heidegger,* ed. Albert Hofstader and Richard Kuhns (Chicago: University of Chicago Press, 1964), 650–730; reference to Hegel, 702.

3. Esther Pasztory, "Still Invisible: The Problem of the Aesthetics of Abstraction in Pre-Columbian Art and Its Implications for Other Traditions." *Res* 19/20(1990–1991):105–136.

4. The de Bry family published thirteen illustrated books collectively entitled *The Great Voyages* between 1590 and 1634 in Strasbourg and Frankfurt.

5. Athanasius Kircher, *Oedipus Aegyptiacus,* 4 vols. (Rome: Vitalis Mascardi, 1652–1654).

6. Edmund Burke, *A Philosophical Enquiry into the Origin of Our Ideas of the Sublime and Beautiful* (1757; reprint, University of Notre Dame Press, 1968).

7. Ernst H. Gombrich, *The Story of Art* (London, 1950).

8. Claude-François Baudez, *Jean-Frederick Waldeck, Peintre, Le premier explorateur des ruines mayas* (Paris: Hazan, 1993).

9. Barbara Braun, *Pre-Columbian Art and the Post-Columbian World* (New York: H. N. Abrams, 1993). See especially the chapter on Henry Moore.

10. Ernst H. Gombrich, *Art and Illusion* (Princeton: Princeton University Press, 1960).

11. For W. H. Holmes, see D. Meltzer and R. C. Dunnell (eds.), *The Archaeology of William Henry Holmes* (Washington, DC: Smithsonian Institution Press, 1992), and for Hjalmar Stolpe, see Henry Balfour (ed.), *Collected Essays in Ornamental Art* (Stockholm: Aftonbladets tryckeri, 1927).

12. Esther Pasztory, "The Function of Art in Mesoamerica," *Archaeology* 37, no. 1 (1984): 18–25.

13. On the Aztec artist and concepts of art, see Miguel León-Portilla, *Aztec Thought and Culture* (Norman: University of Oklahoma Press, 1963), and Esther Pasztory, *Aztec Art* (New York: H. N. Abrams, 1983).

14. Portraiture among the Maya was first discussed extensively by George Kubler in *Studies in Classic Maya Iconography,* Memoirs of the Connecticut Academy of Sciences, vol. 18 (New Haven, 1969).

15. Tatiana Proskouriakoff defined Maya styles in terms of developmental trends. *The Study of Classic Maya Sculpture,* Carnegie Institution of Washington, Pub. 593 (Washington, DC, 1950).

16. Marvin Cohodas, "The Identification of Workshops, Schools and Hands at Yaxchilan, a Classic Maya Site in Mexico." *Proceedings of the 42nd International Congress of Americanists* 7 (1976): 301–313; Carolyn Tate, *Yaxchilan: The Design of a Maya Ceremonial City* (Austin: University of Texas Press, 1992), 29–49.

17. William L. Fash, *Scribes, Warriors and Kings: The City of Copan and the Ancient Maya* (New York: Thames and Hudson, 1991), fig. 76.

18. Dorie Reents-Budet, *Painting the Maya Universe: Royal Ceramics of the Classic Period* (Duke University Press, 1994).

19. Michael D. Coe, *The Maya* (New York: Thames and Hudson, 1966), fig. 66.

20. Arthur A. Demarest, "Ideology in Ancient Maya Cultural Evolution: The Dynamics of Galactic Polities," in *Ideology and Pre-Columbian Civilizations,* ed. Arthur A. Demarest and Geoffrey W. Conrad (Santa Fe, New Mexico, 1992), 135–158. The concept of the "theatre state" is based on Clifford Geertz, *Negara: The Theatre State in Nineteenth Century Bali* (Princeton: Princeton University Press, 1980).

21. Richard L. Burger, *Chavin and the Origins of Andean Civilization* (New York: Thames and Hudson, 1992), fig. 126.

22. Elizabeth H. Boone, "Incarnations of the Aztec Supernatural: The Image of Huitzilopochtli in Mexico and Europe." *Transactions of the American Philosophical Society* 79 (1989).

23. Tony Bennett, *The Birth of the Museum* (London: Routledge, 1995).

24. Immanuel Kant, *Critique of Judgment,* (1790; reprint, Indianapolis: Hackett, 1987).

25. Baudez (see note 8), fig. 25.

26. Barbara Braun, "Henri Moore and Pre-Columbian Art." *Res: Anthropology and Aesthetics* 17/18 (1989):158–197.

ANDEAN AESTHETICS

The ancient Peruvians erected no Parthenons or Colosseums, they carved no Venus di Milo, they painted no masterpiece. Their architecture was characterized by massiveness rather than by beauty, remarkable for its stupendous masonry rather than for its art. Stone sculptures are rare on the coast, ponderous and severe in the highlands. It was on the smaller objects, the pottery vessels, the textiles and the metal-work, that the Peruvian artist lavished his skill and his creative art. Art was a constant element of his daily life, not an interest apart from it. However, it was as a craftsman—or craftswoman—rather than as an artist, that the Peruvian was pre-eminent. As weavers, potters, and goldsmiths they could hold their heads proudly among their peers anywhere in the world. And in the textile industry the Peruvian woman is considered by many technical experts to have been the foremost weaver of all time.
J. Alden Mason, *The Ancient Civilizations of Peru*

It has taken a long time for Andean objects to be admired as works of art by Westerners.[1] As late as 1957, the distinguished historian J. Alden Mason felt the need to apologize for the lack of monumental sculpture and architecture and praised mainly the crafts and techniques in the smaller media. Peru did not have ruins like Palenque in Mexico to draw the nineteenth-century explorer and artist. No early drawings or photographs made the area famous. There were no writing systems to decipher, as in Mexico and Egypt. At best, turn-of-the-century books on ornament—which was considered by many at the time to be secondary to real art—included bits of Andean textile designs as examples of primitive designs.[2]

Then two discoveries in the early twentieth century altered Peru's status in the world of art and antiquities. In 1911 Hiram Bingham found the ruins of Machu Picchu and Peru was added to the map of great ancient cultures for tourist pilgrimage. The other major discovery was the find, in a Copenhagen library in 1908, of Guaman Poma de Ayala's lengthy illustrated letter to the king of Spain. Unpublished until 1936, the letter, in which the author complained that the Spanish governed Peru worse than the Inca, had been written in the seventeenth century but never reached the king.[3] Its four hundred illustrations are unique in the colonial texts of the Andes. No pictorial codices like those in Mexico exist and the Spanish made no illustrated texts either. Without the drawings of Guaman Poma—who was probably taught to write and draw in a Christian school—reconstructing Andean life would be impossible. His authentic depictions of life in the Inca empire provide images to go along with sixteenth-century chronicles and documents.

Only at the beginning of the twentieth century, then, did the art of the Andes begin to emerge from obscurity, and Mason's assessment indicates the generally apologetic attitude typical still at midcentury. Although the Museum of Modern Art put Peruvian objects on display in 1954, asserting thereby that they were "art," the text of the catalog was strictly anthropological and not aesthetic. Based on the choice of objects, the general theme was evidently abstraction. In his introduction René d'Harnoncourt wrote that he found Peruvian art puzzling and lacking in spontaneity.[4] It was not surprising to him that modern artists were not as influenced by Andean art as they were by African.

Andean artistic traditions also suffered from a lack of definition: what exactly was the nature of Andean art and what was its relationship to the Andean worldview? Was there an Andean worldview? In the second half of the twentieth century, Andean art and culture have been extensively studied and certain specific Andean characteristics in aesthetics, culture, and thought patterns have been identified.

Andean concepts of art were clearly very different from those of Mesoamerica and of Europe and the United States, and it is precisely because of this difference that recognition came so slowly. So well preserved that one could put thatched roofs back on and move in, Machu Picchu has a surprising lack of the figurative arts. With not one image anywhere, it is all stone masonry, rock, and scenic views. Instead of elaborately carved stone monuments such as the Aztec Coatlicue or the Calendar Stone, the Inca set up or modified natural stones with abstract carvings.[5] These stones range from the partly modified to the entirely natural (Fig. 16.1). Beautiful, precisely fitted masonry encircles them or provides a platform. Springs, caves, geological faults, ice-age striations are incorporated into shrines. The idea that nature is alive and all aspects of it are interconnected is expressed purely abstractly, rather than through the animal/human/plant combinations of earlier Andean cultures. The various gradations between the human and the natural suggest that the Inca saw a continuum between those two realms.

Reminiscent in their aesthetic of Japanese rock gardens and of the earth art created in the United States by such artists as Robert Smithson and Michael Heizer in the 1970s, the Inca shrines are now much appreciated in the West.[6] Often we value the art of another time insofar as it relates to our own aesthetic ideas. Many of us now find meanings in those aspects of Andean art that were perhaps difficult to understand by some in the early part of the century.

Figure 16.1 Natural rock shrine, Machu Picchu. Photograph: Esther Pasztory.

In their book *The Code of the Quipu,* Marcia and Robert Ascher outline an ideology that helps give a context for the famed Inca stones. Inca thought, they suggested, is exemplified by the sophisticated yet abstract *quipu,* a knotted-string recording device (Berrin 1997, cat. no. 136). Made of yarn, the primary symbolic material in the Andes, information is encoded not in pictures, glyphs, or narratives—as in the codices of Mesoamerica—but in the decimal placement of knots on various colored strings.[7] The spatial placement of elements was emphasized in this highly cerebral system. Tom Zuidema has studied the stones in the Cuzco area and how they fit into the social and religious system known as *ceque,* which was well described in the sixteenth century.[8] All shrines in the Cuzco area were conceptually aligned on forty-one imaginary lines radiating from the Coricancha, or Sun Temple of Cuzco (Fig. 16.2). The

shrines numbered close to 365 and were cared for in daily rotation by various families. Like an imaginary *quipu* spread out over the land, the *ceque* system linked together the calendar, the social system, and the shrines. Shrines could be temples, springs, rocks, or even views. The last view of Cuzco from a given spot was often a shrine in itself. The idea that a view could be a shrine indicates the extent to which mental concepts were as important as material things to Andeans.

The preoccupation with spatial relations, mental patterns, and the lack of interest in visibility place the famous Nasca geoglyphs (Fig. 16.3) squarely into this Andean system. An entire plateau, barren except for lines and figures created by the placement of surface rocks into paths, was a huge sacred area.[9] Visible only from a nearby hill or from the air, the lines were probably laid out with ropes and may be ceremonial

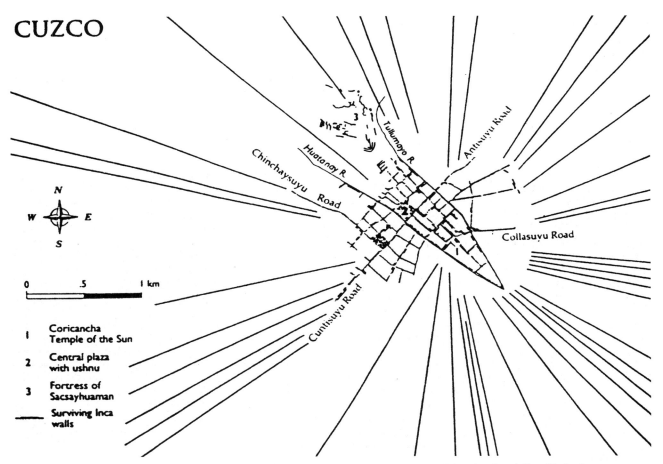

CUZCO

N
W ⊕ **E**
S

0 .5 1 km

1 Coricancha
 Temple of the Sun

2 Central plaza
 with ushnu

3 Fortress of
 Sacsayhuaman

—— Surviving Inca
 walls

Chinchaysuyu Road
Huatanay R.
Tullumayo R.
Antisuyu Road
Collasuyu Road
Cuntisuyu Road

Figure 16.2 Cuzco and the *ceque* (sight-line) system. Peru, Inca. Drawing: Mapping Specialists Limited.

paths. Because it could not be seen, the shape needed to be imagined and experienced. The same can be said of the Inca road system, which has been considered as much an imperial symbol and ceremonial construction as a practical road.[10] No one person was likely to traverse the entire 4,800-kilometer length of it—it existed as a spatial concept as much as it did as a reality.

The habit of thinking in networks and invisible lines might derive, according to many Andeanists, from the textile arts, because designs on textiles must be planned before the weaver begins to move the yarns. Among the most ancient of Andean art forms, textiles are found in preceramic contexts, as early as the third millennium BC. All known techniques in the preindustrial world—plus a few incredibly cumbersome types unique to the Andes—have been identified among the Andean repertoire.

One of these unique types is the discontinuous warp technique. In most textiles a set of warp threads is held in place and various colored weft threads are passed over and under the warp threads. The warp gives shape and tension to the textile in the process of being woven. In the weaving of a discontinuous warp textile, there is no set of warp threads. Instead, a set of temporary yarns is put in place

(known as scaffolding) because neither the warp nor the weft threads go all the way through the textile. When the piece is finished, the scaffolding threads are removed. Although the actual reason for using such a complex technique is unknown, Elena Phipps has theorized that the goal may have been to have the same color in both weft and warp for each color area, resulting in rich color and light weight—because the weft threads need not cover the warp as densely as in the more usual type of weaving.[11] Some of the most amazing textiles in Peru represent complex figures woven in such discontinuous sections. The special qualities of these textiles are not necessarily apparent—some technical knowledge is required for their appreciation. These textiles reveal other aesthetic values that are not readily apparent to the eye. Weight and texture, for example, are as important in fabrics as appearance. Because they are usually seen behind museum glass, one rarely discerns the delicacy and lightness of Andean textiles.

As indicated by the saturated color areas found in the discontinuous warp textiles, Andeans may have also had a belief in the importance of essences. Heather Lechtman has argued for the concept of essences in the use of alloys and depletion gilding in Andean metalwork.[12] In depletion gilding the surface

Figure 16.3 Nasca geoglyphs. Drawing: Janice Robertson.

of a copper and gold alloy object is made to look all gold by the removal of the copper by an acid. If saving the metal had been the primary interest, Lechtman argues, a copper object could have been given a gold-foil cover. The gold inside the alloy is therefore seen as superfluous technically but necessary ideologically for the object to have significance. Techniques in weaving and metalwork are interesting because they provide insights unavailable from other sources. The concept of essences would seem to indicate that to Andeans materials were more aesthetically and religiously powerful if they were somehow pure and solid throughout. They were as interested, it would seem, in the material itself—like stone—as in the processes that transformed it. In architecture this notion is evident in their use of colored stones and in their practice of not covering walls in plaster and paint.

Visibility is one of the major issues in Andean art, not just in what cannot be seen from the ground but in the importance of the burial cults and objects made for burial. Huge amounts of textiles, gold, and pottery were buried with the dead and thereby removed from view. These burial cults may have been facilitated by the desert sands of Peru and the remarkable preservation of bodies as well as things. While these cults removed things from currency, they also preserved them. New graves often cut into old ones and resulted in the discovery of older styles, which were often copied. We are quite familiar with the Moche copies of Chavín-style vessels, as well as with the Chimú copying and revival of Moche vessels.[13] Archaism is deeply embedded in the Andean tradition. Besides the imitation of forms or subjects, techniques were also revived. Even after the introduction of redware pottery, the earlier blackware continued. This archaism was such that some designs could be perfectly at home in later periods. For example, the preceramic textile designs of Huaca Prieta (a site on the North Coast c. 2500 BC) were not inappropriate among the Chimú more than three thousand years later.

The idea we now have of Andean art is of a tradition that was not, for the most part, based on picturing or reproducing the world, but on constructing mental diagrams of it. In this system the actual objects or places are nodes within larger networks. It is no accident that we have come to understand this aspect of Andean art in the last twenty years when our own art has become minimal, conceptual, and philosophical. Mel Bochner, Sol LeWitt, and Barry Le Va all created conceptual systems rather than works of art in a mimetic sense. Sol LeWitt's work was praised by one author because of its systemic quality: "[T]here is always a system, thus rather stressing the mental process than the finished product."[14]

Try as we might to get at the Andean view of things, we keep discovering that we can see best those aspects of the Andes that relate to our own views. This does not mean that our understanding of the conceptual aspect of Andean art is incorrect, merely that currently we have a tendency to focus on these aspects. In fact, much of Andean art fits well into this schema, and I would argue that only through it have we been able to see some of the unique aspects of this art that had not been discerned before.

The aesthetic we currently see as Andean was not the one Larco Hoyle is likely to have imagined, given that he was more interested in anthropological questions—chronology, for example, and the meaning of the various designs. Nevertheless, he had an aesthetic view based on the arts of his time. Writing from the 1930s to 1960s, he is likely to have seen Andean art through a classical and modernist lens.

Connoisseurs in Larco Hoyle's time were interested in objects that could fit more readily into existing traditions of European art. This meant modeled and painted objects, which in Peru are usually in the form of ceramic vessels. While some of these—such as the Moche portrait heads—are remarkable for their naturalism, most, when compared to European art, are schematic and conventionalized. Images of animals, plants, humans, and scenes in their liveliness and simplicity are, however, very similar to sculptural styles then popular in Europe or seen in the works of Chaim Gross (Fig. 16.4) in the United States.[15] At the time, these styles were seen as radical departures from European tradition in their avoidance of realistic form. Moreover, the more abstract styles had been inspired by so-called primitive art. Still maintaining the traditional types and subjects of European art—sculptures of figures, nudes, mothers and children—

Figure 16.4 Chaim Gross, *Adolescent*. Courtesy Philadelphia Museum of Art, gift of David A. Teichman.

modernism's combination of a clear subject with the stylization of form gives it much in common with Moche and other art of the North Coast of Peru. The abbreviation of the seated man (Berrin 1997, cat. no. 71) or the exquisite lines of the simplification of the cormorant (Berrin 1997, cat. no. 49) are the sort of things that appealed to writers and collectors in midcentury.

Some Andean objects—such as the Huari figures (Berrin 1997, cat. nos. 118, 119, 122)—are so geometric and abstract that they bring cubism or the works of Mondrian to mind. Nor should the Chimú wooden figures (Berrin 1997, cat. nos. 128, 129) be left out of such a catalog of images appreciated through the lens of modernism. Their Brancusi-like geometric perfection found an audience in its time. All these types of objects were brought together in the Museum of Modern Art exhibition of 1954.

In the late 1950s the Peruvian tradition of modeled figures was compared to the ceramics of western Mexico, which were also extremely popular. Miguel Covarrubias, as an artist as well as collector, expressed most vividly what was appreciated about them.[16] Because modernists also disliked the complex art of organized religions with its elaborate iconography to be decoded, the art of Moche and western Mexico were popular partly because they appeared not to have a complex iconographic system but to be representations of things of daily life. Potatoes, gourds, fish, frogs, and birds were immediately recognizable. Until the work of Benson and Donnan, Moche iconography was given a simple interpretation. Art lovers like d'Harnoncourt could imagine that the objects could be experienced unmediated. At their best, their appeal lay in their presumed directness and spontaneity.

What was most evident to the modernist collector was the aesthetic choices the artists made in order to stylize and yet to add vivid lifelike detail to forms. The pleasure of the viewer was translated into the pleasure of the artist. Writers imagined that the artists responsible for these modeled and painted traditions were free from the usual artistic constraints and could experiment with forms and explore the wide world of abstraction. Clearly, the model here in

this joy of formal exploration was the postcubist Western artist liberated from the classical tradition. Despite the many elaborate iconographic studies undertaken since, aesthetically it is almost impossible to see these modeled arts outside of the conceptual visual categories of modernism.

An exception to this is the famous Moche portrait heads (Berrin 1997, cat. nos. 64–67), which were appreciated for their realism as early as the turn of the century and which fit easily within the European classical aesthetic. Larco Hoyle liked them the best. The first European writer on art to mention them was H. Reed, who in 1911 considered all the rest of Moche and Peruvian art "rude" but found the portrait heads fine and in particular similar to a representation of Jean, Duc de Berry, on his tomb at Bruges, as drawn by Holbein![17] The West is so wedded to the classical heritage in art that wherever Westerners see something similar—as in the art of the Maya of Mesoamerica or the Ife in Africa—they are amazed, impressed, and appreciative.

Curiously, however, these European aesthetic visions are mutually exclusive: the modernists developed in opposition to the classical. Moreover, they are assumed to be consistent but contradictory ways of seeing the world that therefore cannot coexist at one time or one place (except for Picasso, who bridged the times and places in his own life).[18] In the case of the Moche, realistic and conventionalized forms coexist in a way that makes little sense to the European view of art. Some images—the heads and a few figures or the details of a figure—are seen as if in a close-up realistically, while the rest is schematized. We may see Moche art through various lenses derived from European tradition, but we may find the Moche view in the various aspects that appear most contradictory to us.

The same can be said of the painting style—in some pieces it is reminiscent of the classical Greek style of vase painting in its elegance and purity of line, while in others it is reminiscent of cartoonlike styles like those of artist George Grosz (Fig. 16.5). This is particularly true of scenes with surrealistic elements such as those of the women with skull heads.[19] It is Western art of this sort that makes us appreciate

the simplicity, the stylization, and the preoccupation with detail that characterizes the Moche. Perhaps Moche art throws a new light on Grosz as well.

Moche studies have been so involved with issues of chronology and thematic interpretation that the formal aspect of the objects has been left unexamined. We must ask not only, What do these objects tell us about the Moche? but, What do they tell us about the processes of art that might add to art theory? First of all, they tell us that the notion of the integrity of a style based on a particular type of vision is a European construct, valid only in its own context and useful only for discussion. If anything, the Moche example shows that naturalism can develop in almost any context and does not require anything more specific than the desire to achieve verisimilitude. It need not take centuries to develop, and it need not affect all of the arts or all of a figure.

Figure 16.5 Drawing by George Grosz from *The Berlin Years* showing military figures in front and skull-faced women in the rear. © Estate of George Grosz / Licensed by VAGA, New York, NY.

Evidently able to create realistic images, artists often do not. So the really interesting question is, Why do they select the styles, or combination of styles, that they do? Would the Moche have selected the same pieces that the museum has for this exhibition?

The answers emerge in the examination of the objects. The paintings, for example, are more involved in conveying scenes with many levels of meaning—formal invention, iconographic complexity, or humor—rather than just the re-creation of appearances. In fact, this combination is very similar to the combination of elements in a Grosz drawing. A good line in the drawing of arms and legs is necessary but is not the primary emphasis of the artist. Abstraction and conventionalization is always a better matrix for a multiplicity of contradictory tasks than realism, which is in some ways an artistic straitjacket.[20]

It is impossible to talk about Moche art without talking about its humor. Much of the humor is sexual humor, which always cuts deep into the psyche, religion, and social behavior. Without written texts, it frequently is difficult to see humor in another culture, according to Bergh.[21] Sexual humor, in its most basic forms, certainly has evocations that defy barriers of time and place. Whatever specific meanings the vessel of a woman lying on her back with a stirrup emerging from her vagina (Fig. 16.6) may have meant to a Moche, it is amusing as a Bergsonian unexpected juxtaposition. One can also see it as frightening, however, as if she were pinned by the stirrup.

One doesn't know where humor starts and where it ends. A great deal of what the Moche do with beans—bean warriors, beans turning into warriors—is humorous on a level to which a child can relate. The famous mural from the Pyramid of the Moon of the battle gear rising up and fighting humans (Fig. 16.7) is amusing even if the makers believed that these armaments had souls of their own and were beings in their own right. Little feet indicate the aliveness of inanimate things such as bowls (Fig. 16.8), who manage to walk on their own—a little like the Paul Klee painting called *Mask of Fear* (Fig. 16.9) that walks on four little legs.[22] Details less obvious than these in the rendering of plants and dogs and the details of bodily parts bring forth our delight

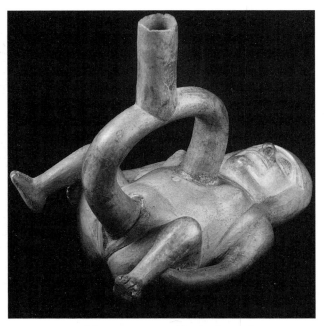

Figure 16.6 Stirrup-spout vessel in the form of a woman lying on her back. Courtesy Museo Larco, Lima, Peru. Photograph: Juan Pablo Murrugarra.

and amusement. It is hard to imagine that they left the Moche cold. Although it is not possible to be certain in the matter of humor, its very possibility is significant. The issue does not come up with the reliefs of Chavín de Huántar or Chan Chan, for example. Moche humor may be close to that of Bosch or Brueghel in spirit and could have been based on proverbs and well-known elements. It could have been collectively understood yet personal, ribald or naive, positive or full of darker meanings.

With its exuberant subject matter and naturalism, Moche art is something of an anomaly in the art of Peru. Most Andean art is conventionalized and abstract in form, and there is little narrative or figural interaction. Although the art of the North Coast was always more human and lively, Moche art is still a surprise. Ascher and Ascher have used the term "insistence" to describe the predominant style of a culture. Every culture has its own style, and it affects everything from its concept of time to its art objects. The Andean insistence appears to have been a focus on conceptual networks, which include kinship ties, the procurement of goods from different ecological zones, the *quipu* record-keeping device, and the

Figure 16.7 Drawing of beans and bean warriors from a Moche vessel. Drawing: Janice Robertson.

Figure 16.8 Drawing of vessels with feet from a Moche vessel
(after Larco 1939 Tomo II, Lamina XXXI). Drawing: Janice Robertson.

various arts, especially textiles. Such a conceptual tradition dominated Peru from Huaca Prieta in preceramic times to Inca Cuzco (AD 1450–1550). Whether its causes are environmental or social and political is very difficult to determine. It may be based on early initial choices that were felt to be viable in later times and became a "tradition." This insistence remained the Andean lens as late as the seventeenth century when Guaman Poma made his illustrations.[23] As Rolena Adorno has shown, the structure of Guaman Poma's Europeanized drawings continues to be based on the Andean system.

Moche art indicates that it is possible for a culture to go against the prevailing traditions of its time and place and develop in another direction. Taking the existing tradition of modeling and human subject matter, the Moche explored naturalism and narrative in addition to conventionalization and the conceptual. Curiously, in the art of Mesoamerica, which is predominantly based on the human figure, glyphs, and narratives, one culture, that of Teotihuacán, goes against the grain in the direction of abstraction and the systemic.[24] These two examples, Teotihuacán and Moche, indicate that an "insistence" within a tradition is not an absolute necessity but primarily a tendency that subsequent cultures reaffirm or not. They indicate not necessarily the freedom of the artist to escape convention but the freedom of the culture to select its own emphases over time. Evidently, however, this does not happen often. In the case of

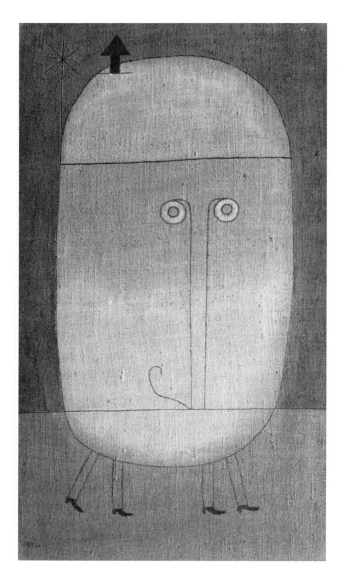

Teotihuacán, I have shown that the reason for its style may have been the collective nature of Teotihuacán culture, quite unlike that of its Mesoamerican neighbors. In the case of the Moche, I would suggest that the opposite might have been the case. The individualized heads, the individualized exploits of humans and gods, the glorification of conflict in war and in mythology in Moche art suggest a culture in which these values were preferred over those of harmony, order, and the collective.

Moche art could fit comfortably in Mesoamerica, while Teotihuacán art could fit in the Andes. What's fascinating about them is that they are where they are. It's their opposition to the prevailing traditions that makes one ask why they should have developed in such different directions. The answers to this lie in history that may be hard to recover archaeologically. Anomalies in their own traditions, they are proof of the vitality of cultures and their artistic experiments. As exciting as the Moche experiments in art were, in our eyes, they were not imitated by other Andean cultures. Despite their admiration and copying of things Moche, the Chimú never imitated the most radical innovations of the Moche: the portrait heads and the fineline drawing scenes. These belonged to a social context that existed only for a short time on the North Coast of Peru.

Figure 16.9 Paul Klee, *Mask of Fear*, 1932, oil on burlap, 39.5 x 22.5 in. Nelson A. Rockefeller fund (854.78). Museum of Modern Art, New York. Digital Image © The Museum of Modern Art / Licensed by Scala / Art Resource, NY.

NOTES

1. This paper was written for the exhibition catalog *The Spirit of Ancient Peru: Treasures from the Museo Arqueológico Rafael Larco Herrera,* edited by Kathleen Berrin (New York: Thames and Hudson, 1997).

2. Alexander Speltz, *The History of Ornament* [Leipzig, 1915] (New York: Portland House, 1989), pls. 1–2.

3. John V. Murra y Rolena Adorno, *"El primer nueva crónica y buen gobierno" por Felipe Guaman Poma de Ayala,* 3 vols. (Mexico City: Siglo Veintiuno, 1980).

4. "While it would be difficult to find anywhere in the world standards of technical excellence to match those of Peruvian ceramics and textiles, in certain types of work such as the quantity production of elaborately decorated ceramics typical of the later phases of Peruvian art standardization of skill seems to have produced a conflict between quality of execution and quality of design. Looking at a large number of such vessels one is often struck by their monotony in spite of the great variety of subject matter in their decoration. The designs seem to have been put together according to established formulas rather than by spontaneous reaction to an artistic problem." René d'Harnoncourt, introduction to *Ancient Arts of the Andes,* by Wendell C. Bennett (New York: Museum of Modern Art, 1954), 12.

5. Esther Pasztory, "Presences and Absences in Inca Stonework," paper presented at the Douglas Fraser Memorial Symposium on Primitive and Pre-Columbian Art, Columbia University, April 15, 1983. César Paternosto, *Piedra abstracta, la escultura Inca: una visión contemporánea* (Mexico City: Fondo de Cultura Económica, 1989).

6. For a discussion of earth art in comparison to the art of the Andes, see Lucy Lippard, *Overlay: Contemporary Art and the Art of Prehistory* (New York: Pantheon Books, 1983), 135–141. For earth art, see also Julia Brown, *Michael Heizer: Sculpture in Reverse* (Los Angeles: Museum of Contemporary Art, 1984), and Robert Hobbs, *Robert Smithson: Sculpture* (Ithaca: Cornell University Press, 1981).

7. Marcia and Robert Ascher, *The Code of the Quipu* (Ann Arbor: University of Michigan Press, 1981).

8. R. Tom Zuidema, *The Ceque System of Cuzco* (Leyden: E. J. Brill, 1964) and *Inca Civilization in Cuzco* (Austin: University of Texas Press, 1990).

9. Marilyn Bridges, *Planet Peru: An Aerial Journey through a Timeless Land* (New York: Photography Division of Eastman Kodak, 1991); Tony Morrison, *Pathways to the Gods: The Mystery of the Andes Lines* (New York: Harper and Row, 1978).

10. John Hyslop, *The Inka Road System* (New York: Academic Press, 1984).

11. Elena Phipps, "Discontinuous Warp Textiles in Pre-Columbian Weaving Tradition," (master's thesis, Columbia University, 1982); Rebecca Stone-Miller, *To Weave for the Sun: Andean Textiles in the Museum of Fine Arts, Boston* (Boston: Museum of Fine Arts, 1992).

12. Heather Lechtman, "Issues in Andean Metallurgy," in *Pre-Columbian Metallurgy of South America,* edited by E. P. Benson (Washington, DC: Dumbarton Oaks, 1979), 1–41.

13. John H. Rowe, "The Influence of Chavín Art on Later Styles," in *Dumbarton Oaks Conference on Chavín, 1968,* edited by E. P. Benson (Washington, DC: Dumbarton Oaks, 1971), 101–123.

14. Enno Develing, quoted in *Sol LeWitt* (The Hague: Haags Gemeentmuseum, 1969), 21. For conceptual artists, see also Richard S. Field, ed., *Mel Bochner: Thought Made Visible, 1966–1973* (Yale University Gallery, 1973), and Barry Le Va, *Barry Le Va, 1966–1988* (Pittsburgh: Carnegie Mellon University Press, 1988). See also Ann Goldstein, *Reconsidering the Object of Art: 1955–1975* (Los Angeles: Museum of Contemporary Art and MIT Press, 1995).

15. Fran Getlein, *Chaim Gross* (New York: Harry N. Abrams, 1974).

16. Miguel Covarrubias, *Indian Art of Mexico and Central America* (New York: A. Knopf, 1966).

17. Esther Pasztory, "Still Invisible: The Problem of the Aesthetics of Abstraction in Pre-Columbian Art and Its Implications for Other Traditions," *Res* (1990–1991): 110.

18. Ernst Gombrich, *Art and Illusion* (Princeton University Press, 1960).

19. *George Grosz: obra gráfica, los años de Berlín: IVAM Centre Julio González, 13 mayo–28 junio, 1992* (Valencia, Spain: Institut Valencia d'Arte Moderna, 1992), pl. 127.

20. Esther Pasztory, "Still Invisible."

21. Susan E. Bergh, "Death and Renewal in Moche Phallic-Spouted Vessels," *Res* (1993): 78–94.

22. Enric Jardi, *Paul Klee* (New York: Rizzoli, 1991), pl. 75.

23. Rolena Adorno, *Writing and Resistance in Colonial Peru* (Austin: University of Texas Press, 1986), 80–114.

24. Esther Pasztory, *Teotihuacán, An Experiment in Living* (Norman: University of Oklahoma Press, 1997).

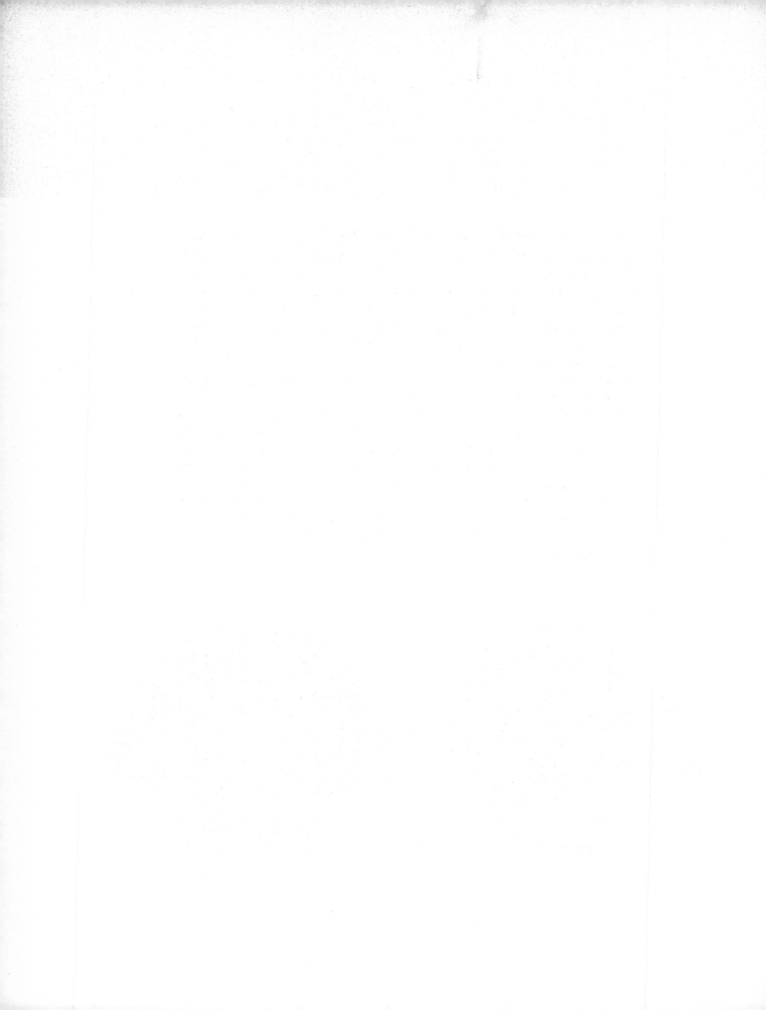

THREE AZTEC MASKS OF THE GOD XIPE

Until the end of the nineteenth century, the pre-Columbian art of Mexico was thought to be synonymous with Aztec art. Since then, archaeological excavations have revealed the marvels and mysteries of the Olmec, Maya, and Teotihuacán cultures which flourished many centuries before the Aztecs. These earlier wonders have come to overshadow those of the Aztecs, who are now seen as barbarian and eclectic latecomers, capable of a single burst of creativity just before they were felled by the Spanish. While excavations continually bring to light artworks requiring analysis and interpretation, everything seems to have been said about Aztec art by the great turn-of-the-century scholars such as Eduard Seler and Hermann Beyer.[1] Major Aztec artworks in museums, acquired many years ago, have the unquestioned patina of age and familiarity. Three famous masks, two in the British Museum and one in the Musée de l'Homme, have been reproduced and exhibited so often that they have come to represent for us the very essence of Aztec craft and sensibility (Figs. 17.1–17.3). For Henry Moore, the British Museum masks were quintessentially Aztec and he reinterpreted them in his own sculpture. He saw in them "stoniness," "power without loss of sensitiveness," "full three-dimensional conception," and "truth to material" (James 1966, 159) (Fig. 17.4). When examined more closely, these Xipe masks raise a number of disquieting questions.

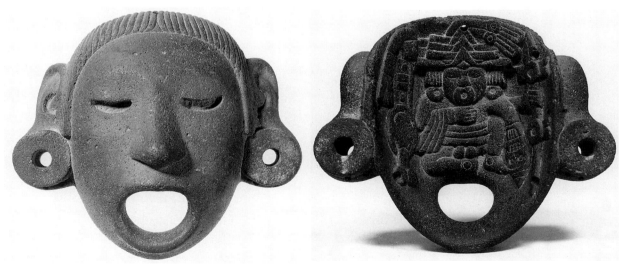

Figure 17.1 Xipe mask, front and back. Height 23 cm, width 26 cm. Henry Christy Collection. © Copyright The British Museum.

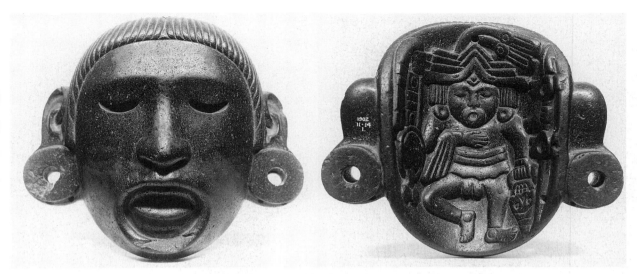

Figure 17.2 Xipe mask, front and back. Height 21 cm, width 216.5 cm.
purchased from A. P. Maudslay. © Copyright The British Museum.

All three masks are generally believed to represent the deity Xipe Totec, in whose honor the Aztecs performed one of their most grisly sacrifices, the flaying of the skin of a human victim. The flaying ritual took place during the month Tlacaxipehualiztli, which was either the first or second month of the year. The ritual had both fertility and military aspects (Broda de Casas 1970). Those warriors who had captured victims for the festival were honored by gifts and watched a gladiatorial sacrifice in which a victim armed with a club and feathers fought Eagle and Jaguar knights holding obisidian-bladed weapons. The sacrifice was attended by the ruler and by guests invited from neighboring cities. Afterward, poor men dressed in the skins and went begging from house to house for twenty days, bringing fertility and good luck to those who gave them special foodstuffs. Finally the skins were buried in the temple with first fruit offerings. Though many scholars have tried to interpret the meaning of the flaying sacrifice, its precise symbolism is not recorded in any source.

A number of Aztec sculptures represent Xipe Totec as a human wearing a flayed skin. The powerful effect of these sculptures lies in contrast—the sense of a living, breathing body pulsating under dead and flaccid skin. This is epitomized in the dark cavity of the eyeholes, stretched to a mongoloid slant, that suggest living eyes within; in the open mouth, visible through the circle of the dead lips; and in the dead hands, hanging limp next to the living hands, curled to grasp a now missing object.

The British Museum masks represent the head of Xipe in the front and a relief of the full figure in the back (Figs. 17.1, 17.2).[2] They are very close in size and design, but one is pierced through the mouth, while the other is not. Both masks are effigies and probably not meant to have been worn. A number of perforations on both masks indicate that they might have been attached to something. The mask without the opening through the lips is 8 3/8 inches tall, of dark acid lava stone (Fig. 17.2). The smooth planes of the face are beautifully modeled to reveal a sense of flesh under a taut layer of skin. The face is framed by realistically detailed ears, distended to hold large cylindrical earplugs, and by hair, carefully ordered into striations and subtly parted in the middle. The crescent eye cavities appear to look down and to focus inward. The figure on the back is shown frontally, in low relief, with one leg raised in a dancing position; the arms hold a rattle staff, a shield and spear, and a trophy head or incense bag. He wears a folded triangular hat with two plumes.

The mask with the open mouth is nearly identical in size, 9 inches, but carved from a coarser, reddish

Figure 17.3 Xipe Totec mask from Teotitlan del Camino, Oaxaca. Height 10.9 cm. Courtesy Musée de l'Homme, Paris.

Figure 17.4 Henry Moore, *Mask*, 1929. Courtesy Henry Moore Foundation.

stone (Fig. 17.1). The figure in relief is exactly the same as the other, except that the legs are raised asymmetrically so as to leave room for the mouth opening. Because of the massive quality of the stone, the contrast of the perforation of the open mouth adds a sense of life to this mask that is missing in the other.

The mask in the Musée de l'Homme is carved out of green rhyolite and is only 4 1/4 inches high (Fig. 17.3). This highly polished greenstone mask is not carved on the back but is related to the British Museum masks, especially in the design of the mouth, framed by the skin, and the parted and striated hair.

Because of the complexity of design, craftsmanship, and high polish, these sculptures relate to the fine sculptures made for the major temples of the Aztecs, rather than to the more crudely finished sculptures which were made in large quantities. One of the features that distinguishes the works of the elite from the rest of Aztec art is the unique conception of each figure, in which iconography is reinterpreted in dramatic new ways (Pasztory 1980). The anomalies to be observed in these masks may indicate that they belong to that group of ideosyncratic sculptures.

The curious detail that first drew my attention to these works is the presence of four arms on the relief figures carved on the back of the British Museum masks. Three of the arms hold objects, while the fourth is placed across the chest with what looks like drapery hanging over it. This appears to be a misunderstanding of the four hands of Xipe sculptures, of which two are alive and two are dead. There is no tradition of multiple-limbed figures in pre-Columbian art and religion. So far I know of only one example, and that is on an Aztec skeletal figure carved on the side of a death deity. The figure was found in 1901 in the Escallerillas Street excavations in Mexico (Fig. 17.5). This is a frontally seated figure with a profile head (Seler 1960–1961, 2, fig. 34). An explanation of the four arms may lie in the three-dimensional figure which may be based on a Janus image of two figures, including two sets of arms, placed back to back. An attempt may have been made to show in relief such a Janus figure, thus accounting for the four arms (Umberger n.d.). Whatever this four-armed skeleton may signify, it does not explain the Xipe figure, in which the contrast should be based on alive and active versus dead

and passive hands; in no circumstances should the dead hands be active. The contrast is illustrated by the painting of Xipe in the Codex Borbonicus, where the living hands, painted red, hold a staff and shield, while the yellow dead hands merely hang down.

Four-armed deities are unlikely to be found in Aztec art because of the prevailing concepts of the human body and of divine energy. In the Aztec view, the concept of bodily perfection did not allow for multiple limbs, which would have been seen as monstrous. Sahagún's description of the youth who was selected to represent Tezcatlipoca for a year and who was sacrificed at the end of that time indicates the Aztec idea of human beauty. The chosen man had to be without blemishes, because the outer body was believed to reflect the inner state of the soul:

> For he who was chosen was of fair countenance, of good understanding and quick, of clean body—slender like a reed; long and thin like a stout cane; well-built; not of overfed body, nor corpulent, and neither very small nor exceedingly tall.

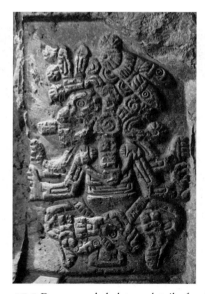

Figure 17.5 Four-armed skeleton, detail of a death deity carved in greenstone. 76 cm. Museo Nacional de Antropología, Mexico. Reproduction authorized by the Instituto Nacional de Antropología e Historia. Photograph: Emily Umberger.

For anyone who was formed [thus] defective, who was too tall, to him the women said: "Tall one; headnodder; handful of stars!" He who was chosen impersonator was without defects.

[He was] like something smoothed, like a tomato, or like a pebble, as if hewn of wood. [He did] not [have] curly hair, [but] straight, long hair; [he had] no scabs, pustules, or boils on the forehead, nor skin growths on the forehead, nor [was he] large-headed, nor with the back of the head prominent; nor of a head shaped like a carrying-net, nor with the sutures of the crow yet soft; not broad-headed, nor with a square head . . . Not with protruding or long ears, nor with torpid neck, nor hunch-backed, nor stiff-necked, nor with neck elongated, much elongated, nor twisted, nor kinked; neither with unduly long hands, nor lacking one hand, nor wanting both hands, nor fat-fingered . . . (Sahagún 1950–1971, bk. 2:64–65).

There are some figures in Aztec mythology who are deformed, such as Xolotl and Nanahuatzin, but they too are represented with the usual number of limbs. Xipe Totec was both an agricultural and military deity, venerated especially by warriors and even by the Aztec ruler. There is no reason why he should have been given what the Aztecs would have considered a monstrous form.

Even more compelling than their view of physical perfection was the Aztec idea of divine power. Unlike the Hindu perception of gods, who were conceived as physically powerful and whose dynamism was represented visually by the tension of dancing bodies and multiple heads or arms, divinity according to the Aztecs resided not in the body but in costume and insignia. The body was merely the support for those objects in which the power was actually thought to reside. If the body had any special power, in the Aztec view, that resided in the blood offered in sacrifice and self-mortification. Thus in the codex illustrations of the gods, the bodies are virtually identical and personality is distinguished through dress. There was therefore no ideology that a four-armed figure could represent visually in Aztec religion.

Once the problem presented by the four arms is raised, other features of the relief figure can also be seen as problematic. Frontal figures in relief are, with the exception of earth monsters and a few other reliefs, rare in Aztec sculpture (Klein 1976). The dancing pose, with one leg raised to the knee, is also highly unusual. The triangular headdress is unique, and what looks like folded drapery over the arm is meaningless. And finally, while relief carvings on the backs and bottoms of Aztec sculptures are frequent, these rarely represent the same personage who is shown on the front or top. (The Museum of the American Indian Xipe has the date 2 Reed carved on the back, and the Hamburg Museum Xipe head has a Smoking Mirror emblem.)

The closest parallel to the British Museum masks is a mask in the Museum für Völkerkunde in Berlin (Seler 1960–1961, 2:953–958) (Fig. 17.6). The front of the mask represents an unidentified male, while the back shows Ehecatl, the wind god, seated cross-legged but with the head in profile, as is traditional. The front of the Berlin mask is also significant in this comparison. The face is well modeled and characteristically Aztec, as its similarity to many masks and faces of figures indicates. It is close in outline and

features to a mask in the American Museum of Natural History (Ekholm 1970, 61) and to a mask in Dumbarton Oaks (Dumbarton Oaks 1963, pl. 108). None of these masks have built-in earplugs, though most have holes for the insertion of ornaments. With the exception of the Berlin mask, none have striated hair. The striated hair of the Berlin mask consists of parallel lines without a part suggested in the center. This is in keeping with the simple and straightforward representation of ornamental details in Aztec sculpture.

If we disregard for a moment the three masks under discussion and the Berlin mask, striated hair that is unadorned by a headdress is quite rare in Aztec sculpture. To my knowledge, only the greenstone birth-giving goddess at Dumbarton Oaks (Fig. 17.7) and the wood figure of a male in the Leff Collection (Easby 1966, 40–41; Nicholson and Berger 1968, fig. 13) have striated hair without a headdress, and it is possible—although not certain—that both figures were once adorned with a removable headdress (see Nicholson 1971, 127).

The hair of the London and Paris masks is also unusual because of the part in the center, a detail of refinement that adds much subtlety to the carvings.

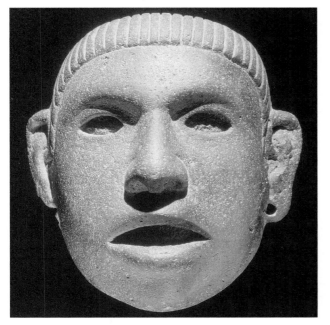
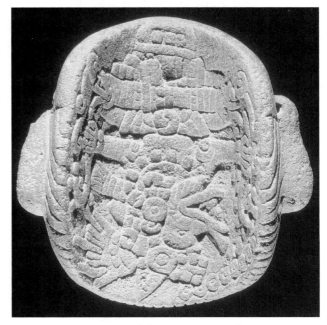

Figure 17.6 Mask, front and back. Height 12 cm, width 11 cm. Courtesy Staatliche Museen zu Berlin, Preußischer Kulturbesitz, Ethnologisches Museum. Photographs: Martin Franken, 2002.

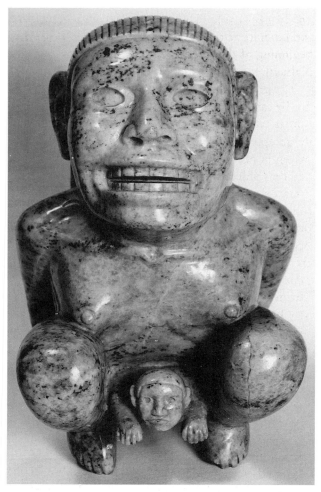

Figure 17.7 Birth-giving goddess. Height 20.2 cm, width 12 cm. Courtesy Dumbarton Oaks, Pre-Columbian Collection, Washington, DC.

There is no parallel to this detail on any other Aztec sculpture known to me so far, and in the whole of Aztec art only the Tlazolteotl pictured in the Codex Borbonicus (trecena 13) has hair parted in the center. Instead, the part in the hair on the three masks under discussion is reminiscent of the elegant hairline of figures in Indian and Oriental art rather than that of Aztec sculpture.

In order to understand the three Xipe masks, one must try to reconstruct the time of their appearance in the nineteenth century. It is surprising to discover how few artworks were available until the middle of the century and how little was known about them. At the time of the conquest, Aztec artistic remains

were considered heathen idols, to be broken up and buried. Since they appeared primitive by classical standards, they were not saved on aesthetic grounds. Durán wrote in his *Historia* that a monument, which he believed was commissioned by Motecuhzoma I, came to light during the building of the cathedral. However significant he might have thought that monument as an historical document, the idea of conserving or studying it seems not to have occurred to him. He actually thought that it should have been converted into a baptismal font: "It [is] good that this stone be used in the service of our God, so that that which was a container for human blood, sacrificed to the devil, may now be the container of the Holy Spirit" (Durán 1964, 119).

In the eighteenth century, educated opinion held that the pre-Columbian cultures were inferior. So few ancient monuments were visible that writers could claim the ancient Mexican civilization was backward because of the lack of ruins (Keen 1971, 261–309). The discovery of Palenque (around 1750), Xochicalco (1784), and the Calendar Stone, Coatlicue, and Stone of Tizoc (1790) changed that situation, although the Stone of Tizoc was almost cut up for paving stones and the Coatlicue was reburied for fear of stimulating a nativistic revival.

During the first half of the nineteenth century, there was a new interest in the Aztec past. In Mexico the revival of interest in the indigenous past was associated with the War of Independence from Spain, which began in 1810 (Keen 1971). The Mexican leaders saw themselves as restorers of the Aztec empire which had been interrupted by the Spanish conquest. The Museum of Antiquities was founded in 1822 and the first nationalistic law to prohibit the removal of antiquities was adopted in 1829. European interest in pre-Hispanic antiquities was a result of recent archaeological discoveries in Europe, such as Pompeii in 1748. Charles III, who founded the Museum for Antiquities in Naples, also ordered the exploration of Palenque. Charles IV sent Dupaix on three trips to Mexico between 1805 and 1808, but the War of Independence interrupted the publication of his book.

The publication of several important works on Mexican antiquities spurred great interest in America

and Europe and acquainted a wider public with new exotica. Humboldt published his *Vues des cordillères et monuments* in 1810. The Mexican museum's first publication was a set of lithographs by Waldeck in 1827 (Mexico 1827). Dupaix's volume with Castañeda's illustrations and Nebel's book on travel and archaeology were finally published in 1834 and 1836 in Paris. Kingsborough's nine-volume encyclopedia came out between 1831 and 1848, and Prescott's influential *Conquest of Mexico* in 1844. Stephens' and Catherwood's *Incidents of Travel in Yucatan* appeared in 1834. In 1823 William Bullock traveled in Mexico and took plaster casts of famous monuments, such as the Calendar Stone and Coatlicue (dug up for the occasion but reburied), to his Piccadilly exhibition in 1824.

The dissemination of information about Mexican antiquities spurred the collection of artifacts. Bullock and Dupaix collected numerous objects, as did a steady stream of travelers. The Englishman Henry Christy, traveling in Mexico in 1856–1857 had perhaps one of the finest collections. In the 1860s Napoleon III sent a scientific commission, led by Eugène Boban, to collect works of art, which were exhibited in 1867 at the Trocadero Museum (Eudel 1909, 31). Napoleon III's interest in Mexico may have been an attempt to emulate Napoleon I's explorations in Egypt. The ill-fated Maximilian was also interested in the past and had the Mexican museum moved to a new location (Sánchez 1877, 2), which it occupied until 1964. Although most Westerners still considered Aztec art to be ugly, as curiosities the objects were sought after by rulers as well as by a few private collectors.

During the first half of the nineteenth century, interest in the Aztecs was romantic and sentimental. While the Aztecs were described as gruesome and bloodthirsty, they were often preferred to the Spanish, and their very barbarism was a source of exotic fascination. Many poems, novels, plays, and operas evoked the refinements of the noble savages (Keen 1971). In the absence of enough genuine available sources, fabrication flourished. Pseudo-Aztec poems were written by Pesado and Villalon in the 1850s, some attributed to Nezahualcoyotl but bearing little resemblance to Nahuatl poetry (Martínez 1972, 145–150). (This faking actually began with Ixtlilxochitl at the end of the sixteenth century and beginning of the seventeenth, but he at least imitated Nahuatl conventions.)

The growing interest in Mexican antiquities could not be satisfied by accidental finds, but since the customers were not very discriminating, fakes were easily accepted. It is generally assumed at present that faking in pre-Columbian art is a recent phenomenon and that objects that have been in collections for fifty years or more are genuine. Ekholm (1964) suggests that this is incorrect and that many old "masterpieces" may have to be reevaluated. According to Batres (1909), the manufacture of fakes goes back to the sixteenth century, when a Tlatelolco barrio was famous for souvenirs made for the conquerors. Throughout the nineteenth century, Tlatelolco and San Juan Teotihuacán were manufacturing antiquities, especially in clay. Tylor (1861, 101, 229) described obsidian knives and clay vessels that were made in great quantities in the 1850s. The Mexican museum actually had an entire room full of ceramic fakes. Tylor assumed that most fakes were ceramics because jade and obsidian objects were "cheaper to find than to make" (1861, 229). This assertion seems hard to believe, considering that in the absence of archaeological information the natives could hardly have been assured of finding first-quality artifacts on demand.

The falsifications that were eventually recognized as such in the nineteenth century were mainly ceramics. Clay figurines made from preconquest molds were added to newly made pottery vessels with feet and lids, resulting in compositions of baroque complexity (Figs. 17.8, 17.9). Except for the figurines, which were from genuine molds, the constructions as a whole had no precedent in pre-Columbian art. Like the Aztec poems, they were invented out of thin air. Most remarkable is the figure "Dying Aztec" (Fig. 17.11). A famous vessel representing the entire Mexican pantheon, supposedly found in Texcoco, fell apart while it was exhibited at the Trocadero Museum. It had been collected by Napoleon III's commission (Eudel 1909, 31–32). On his first trip to Mexico in 1878, Désiré Charnay had copies made of many vessels in the Mexican museum before he

realized that all the ones he had copied were fakes (1885, 37–38). By 1889 the corpus of Tlatelolco fake ceramics was recognized, and Holmes dealt it the final blow in publication. He estimated that three-fourths of the objects in collections were fakes, including works in wood, gold, bronze, and quartz. In his 1909 book on fakes, Batres included works in clay, gold, silver, obsidian, and marble. In addition, between 1830 and 1866 alabaster vases were imported from Italy and carved with pseudo-Mexican scenes and glyphs. Batres said that artisans specialized in different media, and he published the photographs of several artists in their workshops, adding the intriguing information that most forgers were alcoholics.

In reconstructing the artistic climate of the nineteenth century, it is important to recognize how long the most absurd fakes could fool even the specialists. In part, this was the result of not having enough authentic objects available for analysis. But this is not the entire explanation. Until the second half of the century, Westerners could not *see* the stylistic

qualities of Mexican art, as indicated by the drawings published in the books of Dupaix, Waldeck, and Gondra.[3] The dramatic conventionalization so characteristic of pre-Columbian art was for them invisible. The drawings indicate the artists' desire to grasp an alien style through some details, but they then filled in the rest with hesitant outlines, smooth surfaces, or European conventions. On many plates it is

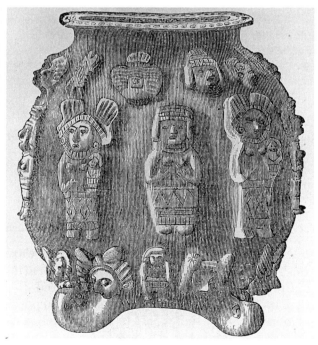

Figure 17.8 Drawing of a fake vessel. Reproduced from William Henry Holmes, "On Some Spurious Mexican Antiquities and Their Relation to Ancient Art," *Smithsonian Institution Annual Report, 1886.* Washington, DC, 1889.

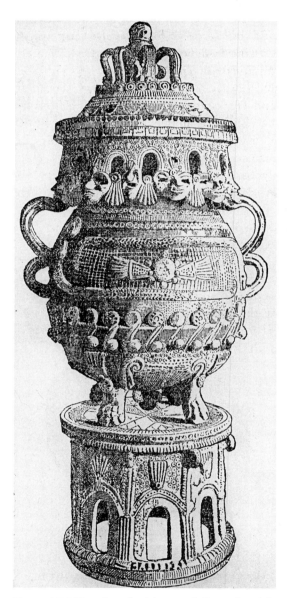

Figure 17.9 Drawing of a fake vessel. Reproduced from William Henry Holmes, "On Some Spurious Mexican Antiquities and Their Relation to Ancient Art" *Smithsonian Institution Annual Report, 1886.* Washington, DC, 1889.

impossible to tell the would-be cultural affiliations of the monuments (Fig. 17.11). Given the general inability to comprehend the pre-Columbian style, it is not surprising that objects that did not even look pre-Columbian could pass as genuine.

As there were two major groups of collectors— ordinary travelers looking for inexpensive souvenirs and well-to-do collectors willing to pay high prices for unusual antiquities—there were two kinds of falsifications. The cheap clay forgeries were eventually recognized, but some of the fine ones may still be around. That they did exist is indicated by the case of the gold statuette of Tizoc. This piece was published by Saville (1929, frontispiece) but was proven by Easby and Dockstader (1964) to be a fake on the basis of style and technique. The maker of the piece was far from naive. He was familiar with pre-Columbian art, including the day signs and the ruler's name glyphs, since both appear on the figure. The famous rock crystal skulls in the Musée de l'Homme (acquired by Boban) and in the British Museum (purchased from Tiffany in 1898) present a similar problem of well-made objects in precious media of problematic authenticity. Ekholm (1964, 25–26) considers all large objects of obsidian, especially masks, to be of questionable authenticity. He points out that masks were, and still are, one of the most popular types of faked sculptures.

We do not have a complete history of the Xipe masks. The British Museum mask with the open mouth was in the Christy collection by 1861 and was illustrated by Tylor in his book (1861, facing p. 226) (Fig. 17.1). The other mask (Fig. 17.2) in the British Museum was bought from Alfred Maudslay in 1902. According to the catalog notes of the British Museum, it came from Texcoco. This may not be significant. In the nineteenth century Texcoco was believed to have been the artistic capital of the Aztec empire, and many objects were attributed to that city. The mask in the Musée de l'Homme was said to have come from Teotitlan del Camino in Oaxaca (Musée de l'Homme catalog notes). It was collected by Boban for Napoleon III in the 1860s, as was the famous Quetzalcoatl and the infamous Texcoco vase. A fourth Xipe mask of greenstone, without hair designs, was in the estate of the emperor Maximilian in 1868 and was acquired by the Vienna Museum für Völkerkunde in 1881 (Museum für Völkerkunde catalog notes). The Berlin mask was given to the museum by Seler in 1905, but he said that it had been in a Mexican collection for at least fifty years

Figure 17.10 Drawing of a fake clay figure. Reproduced from William Henry Holmes, "On Some Spurious Mexican Antiquities and Their Relation to Ancient Art" *Smithsonian Institution Annual Report, 1886*. Washington, DC, 1889.

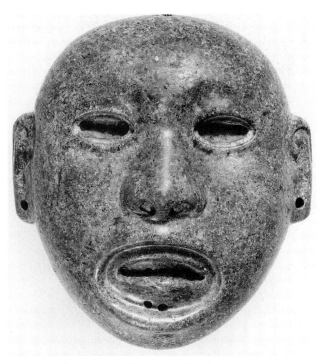

Figure 17.11 Xipe mask. Height 21.5 cm. Courtesy Kunsthistorisches Museum, Wien.

(1960–1961, 2:953). Except for the Maudslay mask —which must have been made by the same artist who carved the Christy mask—all these Xipe masks and the Berlin mask came to light between 1850 and 1870, the time when Aztec scholarship was still very limited and fakes were not easily recognized.

It is significant to note that these masks were not identified as the god Xipe at the time they were found, because Xipe, as a type of sculpture, does not appear to have been defined prior to 1901 (Seler 1960–1961, 2:910–912). The catalog of the Christy collection published in 1862 did not identify the deity represented by the mask (British Museum 1862, 32).[4] The relief was described as the figure of a god or priest. The large earplugs were compared to Malay and Brazilian Indian earplugs. As far as the mask's function was concerned, the explanation given was that "old manuscripts tell us that it was customary to mask the idols when the king fell sick, or in the case of other public calamities." In 1897 Hamy (p. 22) accepted Rosny's (1875) identification of the Paris greenstone mask as the Mexica priest wearing the skin of the Culhuacan princess who was flayed in an episode of the early Aztec migration history. Moreover, the large diorite head we are accustomed

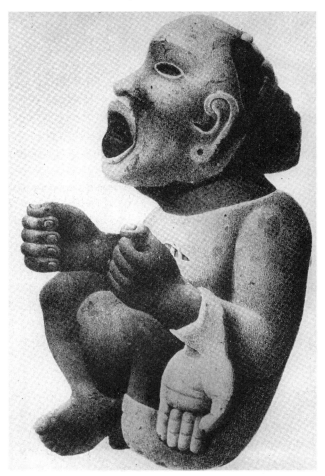

Figure 17.12 Drawing of a Xipe figure. Reproduced from Carl Nebel, *Voyage pittoresque et archaeologique dans la partie la plus intéressante du Mexique.* Paris: M. Moench, 1836.

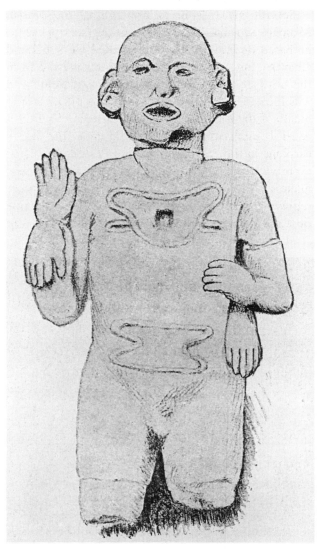

Figure 17.13 Drawing of a Xipe figure. Reproduced from Alfredo Chavero, "Historia antigua y de la conquista." In Vicente Riva Palacio, *México a través de los siglos.* Barcelona: Espasa, 1887.

to call Coyolxauhqui (Fig. 17.14) was identified as Xipe by Chavero in 1887 (p. 317).

Xipe sculptures were very rarely represented among the nineteenth-century illustrations of Aztec art and were not called Xipe. Nebel (1836) illustrated a seated Xipe figure (Fig. 17.12) but did not identify it as such. Chavero (1887, 317) illustrated a large (over a meter high) ceramic Xipe figure but identified it on the basis of a pectoral as a "Xiuhtletl," or fire god (Fig. 17.13). He interpreted the extra hands as living and said that the multiplicity of arms signifies expressively that this is a creator god.[5]

Several visual sources are behind the British Museum Xipe masks. The front of the face appears to be based on Xipe faces, as illustrated by Nebel and Chavero, but with a number of aspects derived from the head of Coyolxauhqui (Fig. 17.14). That head was found in 1829 and was one of the major monuments of the Mexican National Museum. There is a general similarity in the striated hair, the heavy earplugs in the ears, and especially the shape of the eyebrows and eyelids. However, while the earplugs make sense on Coyolxauhqui, because the sculpture represents a decapitated head, they are questionable on a mask. Another possible prototype for the front

of the British Museum masks is a clay panel of a mask with dead eyes, open mouth, and large earplugs in the Mexican National Museum. This plaque was established by Gondra in 1844–1846 in a monograph on the holdings of the museum. The book was the third-volume appendix to Prescott's *Conquest of Mexico*. Gondra described the figure as Quetzalcoatl (Fig. 17.15).

The concept of a relief on the back of the masks probably also originated from reliefs seen on the backs and undersides of sculpture such as the Coyolxauhqui or the Berlin mask. The four-armed dancing figure carved in relief appears to combine the four "arms" of the freestanding sculptures of Xipe with specific details taken from relief panels of frontal figures holding insignia (Fig. 17.16). Following the clay plaque in his book, Gondra (1844–1846) illustrated this relief of a maize goddess holding a maize plant and a rattle staff. He identified the figure as Huitzilopochtli, the Aztec war and patron deity. This relief was one of the most frequently illustrated Aztec sculptures in the nineteenth century (Siegel 1953).[6] The headdress of the British Museum figure appears to be a free adaptation of the maize goddess, with the two corncobs transformed into plumes, and a spear

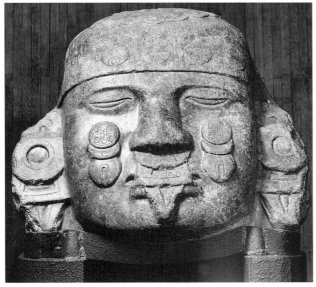

Figure 17.14 Coyolxauhqui head. Height 36 in., width 42 in., diameter 30 in. Museo Nacional de Antropología, Mexico. Reproduction authorized by the Instituto Nacional de Antropología e Historia.

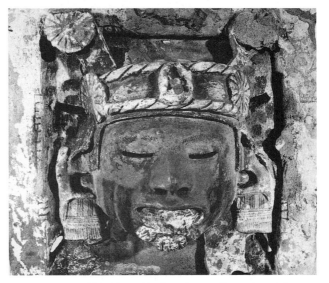

Figure 17.15 Drawing of a clay plaque. Reproduced from William H. Prescott, *Historia de la conquista de México*. Mexico, 1844–1846. Courtesy General Research Division, The New York Public Library, Astor, Lenox and Tilden Foundations.

and shield added to the rattle staff. In his text, Gondra associated sacrifice by flaying with the cult of Huitzilopochtli.

There are two possible conclusions. The Xipe masks may be genuine, idiosyncratic works. Such sculptures did exist, as the dancing monkey figure, excavated during the construction of the Metro, demonstrates (Gussinyer 1970). The fluid moving pose of that sculpture is quite different from the rigid and static canons we accept as characteristically Aztec. If that piece had not been excavated but found in a collection, it might have been difficult to accept as genuine.

The second possibility is that the masks were made in the middle of the nineteenth century by a carver who was familiar with Aztec art in the Mexican museum but who did not fully understand Aztec iconography, which is not surprising, because at that time few people did. It is unlikely that the carver of the masks intended to represent the god Xipe, as we know it today. That identification was not conclusively related to these figures until 1901 by Seler.

Although the carver must have been familiar with a number of Aztec artworks, his major source appears to have been Gondra's book, in which he used two adjacent pictures for inspiration for the front and back of his mask. If he read the text at all, he would have found ample justification for Indian details. Gondra interpreted Aztec art by references to all other ancient cultures known to him—Egyptian, Hebrew, Indian, and Greek. He called Tezcatlipoca the "Brahma" of the Aztecs. The commentary, for the relief he calls Huitzilopochtli, consists of an essay on the similarities between Aztec, Egyptian, and Indian religions. He derives the Nahuatl word for temple, *teocalli*, from Kali—the terrible Indian goddess who wears a skull necklace—and from *theos*, the Greek word for god (Gondra 1844–1846, 68, 70–71, 77). Considering the skill devoted to the making of the masks and prototypes used as models, nothing less than the most important Aztec god must have been intended—Huitzilopochtli, god of the sun, of war, and patron of the Aztec ruling class: a pre-Columbian equivalent of Siva, the destroyer. The interpretations of Gondra's book soon became outdated, but the masks have not been questioned until now. The combination of a gruesome subject, such as sacrifice

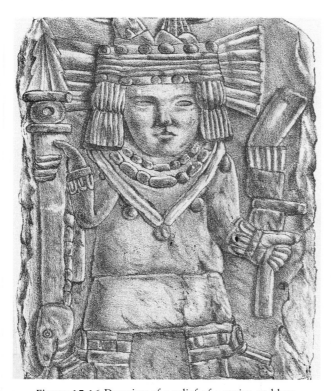

Figure 17.16 Drawing of a relief of a maize goddess. Reproduced from William H. Prescott, *Historia de la conquista de México*. Mexico, 1844–1846. Courtesy General Research Division, The New York Public Library, Astor, Lenox and Tilden Foundations.

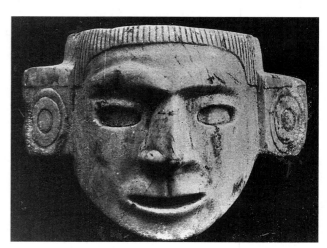

Figure 17.17 Mask in marble. Reproduced from Leopoldo Batres, *Antigüedades mejicanas falsificadas*, 1909, Mexico: Soria.

by flaying, treated with exquisite refinement and elegance, added to the exoticism of a four-armed dancing figure, is the perfect embodiment of what the mid-nineteenth century thought of as the savage yet noble art of the Aztecs.

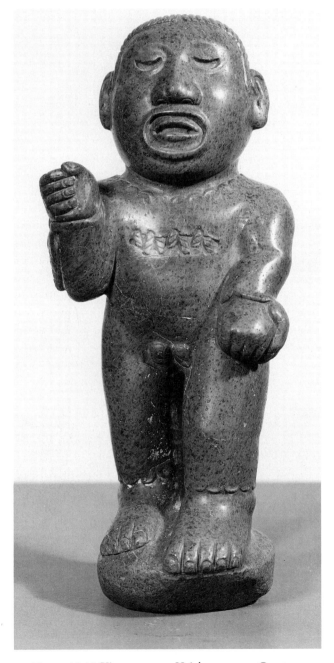

Figure 17.18 Xipe statuette. Height 23.5 cm. Courtesy Dumbarton Oaks, Pre-Columbian Division, Washington, DC.

Figure 17.19 Stone relief, front and back. Photograph: H. B. Nicholson.

POSTSCRIPT. These Xipe masks have come to exemplify Aztec art to such an extent that they have been the inspiration for several obvious later forgeries. In his book on fakes, Batres (1909) published a crude marble mask of a face with striated hair and earplugs that was clearly modeled on the British Museum Xipe masks (Fig. 17.17). In the Dumbarton Oaks collection, a small, greenstone Xipe statuette (the authenticity of which has been questioned) has parted, striated hair and facial features that are possibly in imitation of the mask in the Musée de l'Homme (Fig. 17.18). If it is false, it may have been carved during the first half of the twentieth century when these masks were already identified as Xipe figures.

In addition, H. B. Nicholson has kindly brought to my attention photographs of a relief in the Echániz collection that show a monument similar to the relief on the back of the British Museum masks (Fig. 17.19). The Echániz sculpture is a rectangular block with relief on all sides. The correspondence of details is striking: the face and headdress are nearly identical, one arm is across the chest, and the other arms hold rattle staffs carved on the back. In fact, there are no elements in the relief that do not have a parallel in the British Museum masks.

There are several elements in the Echániz relief that do not fit within Aztec conventions: arms are wrapped around the front, side, and back in a diagonal; the arm across the chest is oddly misshapen; and the rattle staffs on the back, especially the two placed one on top of the other, do not make any iconographic sense. It is my opinion that the relief was carved after an illustration of the British Museum mask, which was published as early as 1861.

NOTES

1. Since 1978, when this paper was originally written, Aztec studies have undergone a renaissance due in large part to the spectacular find of the Coyolxauhqui relief and the subsequent excavation of the Templo Mayor by Eduardo Matos Moctezuma.

2. I would like to thank Emily Umberger for examining for me the masks in the British Museum and the Musée de l'Homme.

3. This does not mean that all illustrations were badly drawn, but that correctness was the exception rather than the rule. Catherwood's drawings for Stephens' volume are particularly remarkable for their high quality of verisimilitude at a time when that was highly unusual.

4. I would like to thank Elizabeth Carmichael, the curator of the British Museum, for sending me a copy of the Christy collection catalogs.

5. In 1897 Saville identified a terracotta Xipe figure as a warrior wearing a quilted armor (Beyer 1965, 343).

6. The relief was acquired by the Brooklyn Museum in 1951.

BIBLIOGRAPHY

Batres, Leopoldo
 1909 *Antigüedades mejicanas falsificadas.* Soria, Mexico.
Beyer, Hermann
 1965 ¿Guerrero o Dios? *El México Antiguo* 10:343–352.
British Museum
 1862 *Catalogue of a Collection of Ancient and Modern Stone Implements, and of Other Weapons, Tools, and Utensils of the Aborigines of Various Countries, in the Possession of Henry Christy, F.G.S., F.L.S., & c.* Catalogued by M. Steinhauer. Printed privately, London.

Broda de Casas, Johanna
 1970 Tlacaxipehualiztli: A Reconstruction of an Aztec Calendar Festival from 16th Century Sources. *Revista Española de Antropología Americana* 5:197–224.
Bullock, William
 1824a *Six Months' Residence and Travels in Mexico.* John Murray, London.
 1824b *A Description of the Unique Exhibition Called Ancient Mexico.* J. Bullock, London.
Burland, C. A.
 1973 *Montezuma Lord of the Aztecs.* G. P. Putnam's Sons, New York.

Charnay, Désiré
1885 *Les anciennes villes du Nouveau Monde.*
Hachette et Cie., Paris.
Chavero, Alfredo
1887 *Historia antigua y de la conquista.* México á
través de los siglos (Vicente Riva Palacio, ed.), vol.
1. Espasa, Barcelona.
Dumbarton Oaks
1963 *Handbook of the Robert Woods Bliss Collection
of Pre-Columbian Art.* Dumbarton Oaks,
Washington, DC.
Dupaix, Guillermo
1834 *Antiquités mexicaines.* 2 vols. Bureau des
antiquités mexicaines, Paris.
Durán, Diego
1964 *The Aztecs: The History of the Indies of New
Spain* (D. Heyden and F. Horcasitas, trans.).
Orion Press, New York.
Easby, Dudley T., Jr., and Frederick J. Dockstader
1964 Requiem for Tizoc. *Archaeology* 17:85–90.
Easby, Elizabeth K.
1966 *Ancient Art of Latin America from the Collection
of Jay C. Leff.* Brooklyn Museum, New York.
Ekholm, Gordon F.
1964 The Problem of Fakes in Pre-Columbian Art.
Curator 7:19–32.
1970 *Ancient Mexico and Central America.* American
Museum of Natural History, New York.
Eudel, Paul
1909 *Falscher Künste.* Grunow, Leipzig.
Gondra, Isidro
1844–1846 Explicación de las láminas pertenecientes a la
historia antigua de México y a la de su conquista. In
William Hickling Prescott, *Historia de la conquista
de México,* vol. 3. Ignacio Cumplido, Mexico.
Gussinyer, Jordi
1970 Deidad descubierta en el Metro. *Boletín del
Instituto Nacional de Antropología e Historia*
40:41–42. Mexico.
Hamy, Jules Théodore Ernest
1897 *Galerie americaine du Musée d'ethnographie du
Trocadero.* E. Leroux, Paris.
Holmes, William Henry
1889 On Some Spurious Mexican Antiquities and Their
Relation to Ancient Art. *Smithsonian Institution
Annual Report, 1886,* 319–334. Washington, DC.
Humboldt, Alexander von
1810 *Vue des cordillères et monuments des peuples
indigènes de l'Amérique.* F. Schoell, Paris.
James, Phillip Brutton
1966 *Henry Moore on Sculpture.* Macdonald, London.

Keen, Benjamin
1971 *The Aztec Image in Western Thought.* Rutgers
University Press, New Brunswick, New Jersey.
Kingsborough, Viscount (Edward King)
1831–1848 *Antiquities of Mexico, Comprising
Facsimiles of Ancient Mexican Paintings and
Hieroglyphics.* 9 vol. A. Aglio, London.
Klein, Cecelia
1976 *The Face of the Earth.* Garland Publishing,
New York.
Martínez, José Luis
1972 *Nezahualcóyotl: vida y obra.* Fondo de Cultura
Económica, Mexico.
México, Museo Nacional
1827 *Colección de las antigüedades mexicanas que
existían en el Museo Nacional* (Engravings by
Federico Waldeck). Mexico. (Reprint: 1927).
Nebel, Carl
1836 *Voyage pittoresque et archaeologique dans la
partie la plus intéressante du Mexique.* M.
Moench, Paris.
Nicholson, H. B.
1971 Major Sculpture in Pre-Hispanic Central
Mexico. In *Handbook of Middle American
Indians* (Robert Wauchope, Gordon F. Ekholm,
and Ignacio Bernal, eds.) 10:92–134. University
of Texas Press, Austin.
Nicholson, H. B., and Rainer Berger
1968 *Two Aztec Wood Idols: Iconographic and
Chronologic Analysis.* Studies in Pre-Columbian
Art and Archaeology 5. Dumbarton Oaks,
Washington, DC.
Pasztory, Esther
1980 Masterpieces in Aztec Art. *XLII International
Congress of Americanists,* 1976 12:377–390.
Paris.
Prescott, William Hickling
1844 *History of the Conquest of Mexico.* 3 vols. R.
Bentley, London.
Rosny, Lucien de
1875 Recherches sur les masques, le jade et l'industrie
lapidaire chez les indigènes de l'Amérique antique.
Archives de la Société Américanistes de France
(n.s.) 1:308. Paris.
Sahagún, Bernardino de
1950–1971 *The Florentine Codex* (Arthur J. O.
Anderson and Charles E. Dibble, trans.).
School of American Research, Santa Fe.
Sánchez, Jesús
1877 Reseña histórica del Museo Nacional de México.
Anales del Museo Nacional 1:1–2. Mexico.

Saville, Marshall H.
1929 *Tizoc: Great Lord of the Aztecs*. Contributions from the Museum of the American Indian, Heye Foundation, vol. 7, no. 4. New York.

Seler, Eduard
1960–1961 *Gesammelte Abhandlungen zur Amerikanischen Sprach-und Alterthumskunde* 5 vols. Akademische Druck- und Verlagsanstalt, Graz.

Siegel, Flora
1953 An Aztec Relief in the Brooklyn Museum. *Brooklyn Museum Bulletin* 4(4):8–14.

Stephens, John Lloyd
1843 *Incidents of Travel in Yucatan*. Harper and Brothers, New York.

Tylor, Sir Edward Burnett
1861 *Anahuac; or, Mexico and the Mexicans*. Longman, Green, Longman and Roberts, London.

Umberger, Emily
1981 Aztec Sculptures, Hieroglyphs and History. PhD diss., Columbia University, Department of Art History and Archaeology, New York.

Westheim, Paul, Alberto Ruz, Pedro Armillas, Ricardo de Robina, and Alfonso Caso
1972 *Prehispanic Mexican Art* (Lancelot C. Sheppard, trans.). G. P. Putnam's Sons, New York.

18 SHAMANISM AND NORTH AMERICAN INDIAN ART

Every so often a specific word or concept, known only to a handful of specialists, emerges from relative obscurity and is applied to an increasingly broad range of phenomena.[1] It becomes a magic word that transforms many a lackluster subject into one that glows with meaning. One of these words is "shamanism." Shamanism once referred to a specific religious system in northern Siberia in which the religious specialist, called a shaman, mediated between humans and the supernatural by going into a trance. During this trance he could take the form of an animal helping-spirit and journey to the upper world or the lower world in order to cure sickness by recapturing lost souls, to conduct the dead to their final resting place, or to communicate with the supernaturals who control nature. The use of the word "shaman" was eventually extended to include religious specialists in societies elsewhere in the world if those individuals entered ecstatic trances similar to those of Siberian shamans. Many derogatory nineteenth-century names, such as "medicine man" and "witch doctor," have now been supplanted by the general term "shaman," which fortunately has no negative connotations. The use of a single word to describe a wide variety of religious specialists in different societies is useful in that attention is focused on the basic similarities between them.

Similarities have also been noted not just in the nature and activities of individual shamans but also in the myths and cosmological beliefs of their societies. One of the great mythmakers of our own time, Mircea Eliade (1964), created a consistent cosmology out of these varied traditions, which he called shamanism. Shamanism has now come to mean the entire belief system of societies that have shamans, including a large proportion of primitive cultures around the world.

Shamanism, in this sense, has a broad distribution not only in space but also in time. The religious system of our paleolithic ancestors is supposed to have been shamanism, elements of which are supposed to have survived to the present time in almost all cultures, including our own. Shamanism has become the most ancient, most widespread, and most persistent religious system known to humanity. To call something shamanistic now is to endow it with the magic of several thousand years of antiquity. In this age of rapid change, it is perhaps reassuring to think that some of our traditions and behavior are so securely rooted and have managed to survive unchanged through all that time.

The word "shamanism," in referring to so much, is in danger of losing its meaning altogether. What Eliade considers to be shamanism seems suspiciously similar to what he elsewhere describes as the basic nature of all religious experience (1961). The word "shamanism" is now nearly synonymous with the concept of a magic worldview and inspirational religious experience. One may well ask why we should quibble over the meaning of words and what is wrong with

the broad use of the word "shamanism." The word, as now used, is often misleading because it refers both to very specific and very general characteristics, resulting in considerable confusion.

Terms that acquire sudden popularity are not easily put back in their place. The wide meanings associated with the word "shamanism" are probably here to stay. What we can do, however, is to try to add a qualifier to indicate in what sense, the general or specific, we are going to use it. Shamanism should be defined as a religious system which centers around an individual religious specialist who communicates with the supernatural through a trance state. The religion of a society should be called shamanistic only if the shaman plays a central role in it. If the shaman is secondary in importance to other types of religious specialists, the society is not, strictly speaking, shamanistic but has some shamanistic traits. That is, the word "shamanism," denoting a system, should be limited to areas where the shaman is of the first importance, but shamanistic elements or traits could be recognized in many other types of religious systems.

It is also worth continuing a distinction sometimes made among societies that are shamanistic: the distinction between Siberian and general shamanism (Eliade 1964; Hultkrantz 1967). Siberian and some types of North American shamanism share a number of very specific characteristics which do not exist elsewhere in the world. Siberian shamanism is probably a late development in the history of shamanism and its distribution is relatively limited. It is sometimes called "classic" shamanism, but the word "classic" has too many connotations of superiority to be acceptable. Shamanism in other areas of the world is sometimes called "simple" shamanism in contrast to the Siberian "classic" variety. Instead of "simple," however, it would be preferable to use the word "general" shamanism. General shamanism would refer to societies whose religion is primarily shamanic but not especially related to Siberian shamanism.

Discussions of shamanistic art are equally fraught with problems. Artworks are often used to illustrate shamanistic beliefs, whether they occur in truly shamanistic contexts or not. Moreover, certain motifs associated with shamanism in some areas are called shamanistic wherever they occur, even if their context has nothing to do with shamanism. Examples of such motifs are animals and humans shown with their bones or interior organs (Lommel 1967) and the cosmic tree (Vastokas 1974). Both images occur in important shamanistic contexts but in others as well. In shamanistic art, the representation of skeletons and organs may represent the transformation of the shaman's body during his initiation into one that has magic power. In other arts, skeletal figures may represent ancestors, shown as the dead, or the gods and demons of death. Similarly, the cosmic tree, the vertical axis that connects the upper and lower worlds, climbed by the shaman in his ecstatic journeys, is an important image rather infrequently represented in shamanistic art. Cosmic tree images are more frequent in non-shamanistic contexts. They exist in the art of agricultural societies as images of natural fertility and abundance. One may argue that ultimately all skeletal figures and cosmic tree representations derive from shamanistic imagery, but that means reducing the interpretation to too general a level. It is a little like saying that the similarities between the different races of humanity all derive from their origin in the ape, a statement that may not be true but, even if it were, would not be very satisfying.

One of the reasons that non-shamanistic arts are often used to illustrate the concepts of shamanism is that shamanism is not everywhere associated with art. Although the shaman may on occasion be the only or the most important creative artist in a society, and many scholars suggest that the shaman was the first artist (Lommel 1967; Chatwin 1970), visual art is not essential to shamanism. Books on shamanistic art naturally emphasize those groups in which the shaman is surrounded by elaborate art objects. Some shamanistic trances are mixed-media dramatic events. The shaman may be dressed in a complex costume, which represents his spirit helpers and the structure of the cosmos, and his performance may take place in a building that is a microcosm of the universe. His performance may be a mixture of song, drama, and dance. There are many shamans, however, who have no, or very little, ornamental paraphernalia and who do not perform in a specific or separate structure. While there may be a shamanistic performance

without the visual arts, it cannot take place without music, song, and drama. Shamanism is primarily linked with aural traditions and only secondarily with the visual.

The visual arts are associated with concepts of permanence and display, neither of which is essential to or necessarily aligned with the values of shamanism. The aural arts have two basic characteristics: one is that they take place in time and their essence is the process; the other is that once they are concluded nothing tangible remains. By contrast, in the visual arts the process of making the objects is generally less important than the display of the finished objects having a degree of permanence. The aural arts enact concepts in a dynamic form, while the visual arts are the embodiment of concepts in static form.

The essence of shamanism is its variability and dynamism. What distinguishes the shaman from the priest is the active role he plays. The priest may be defined as a religious specialist who deals with the supernatural indirectly by performing precise rituals or repeating standard formulas in prayers (Hultkrantz 1963). He may be, on occasion, possessed by the supernatural spirit, but in that case the active spirit enters the passive priest. The priest does not enter a trance or travel to various parts of the supernatural universe to converse, wrestle, or mate with the spirits. The shaman, by contrast, is a dynamic agent who moves among the supernaturals as though he were one of them. No two encounters with the spirits or journeys are ever exactly alike: the emphasis in shamanism is on the uniqueness and individuality of each seance. By contrast, the emphasis in priestly ritual is on the undeviating repetition of ritual words and acts.

The static characteristics of the visual arts are, therefore, in conflict with the dynamic values of shamanism, and it is unlikely that the institution of shamanism alone can account for the original development of the visual arts. When art objects are used by shamans, they acquire characteristics that fit in with shamanic values. Some of these characteristics include an emphasis on process rather than display and on perishability rather than permanence.[2]

Objects used by shamans are often crude and unfinished in appearance. There is little apparent interest in skill, beauty of form, or decorative elaboration. For example, among the Salish groups of the Northwest Coast of America, the shaman takes a trip to the underworld to retrieve the soul stolen from a sick person (Waterman 1930). The dramatic journey and the capture of the soul is enacted in a house, which is symbolically transformed into a canoe and peopled with the shaman's helping spirits (Fig. 18.1). Painted planks are set up around the room and represent the canoe as well as the spirit helpers. The planks have generalized outlines that suggest, but do not depict, an animal. Without verbal identification, one cannot tell a whale from a salmon. Certain traits are indicated by sloppily applied paint. Post figures, equally simply and schematically rendered, represent the passengers (Fig. 18.2). The shaman uses staffs to represent paddles, spears, poles, or bows as they are called for in the drama. The performance may be compared to a modern play in which the setting is abstract and general, and where the same prop can be used for a variety of purposes. In both instances, the visual appearance of the objects is not very important, because the words used provide them with meaning. Many shamanic art objects are made for a single ritual and destroyed, abandoned, or otherwise disposed of afterward. Among the Salish, the boards are used for only one ceremony and have to be remade every time. Objects may be destroyed because

Figure 18.1 Snoqualmie ceremony. Reproduced from R. M. Underhill, *Red Man's Religion* (University of Chicago Press, 1965). Copyright 1982 Peek Publications.

the sick or evil spirits are captured in them, or simply because no two journeys and spirit gatherings are entirely identical.

How unimportant the finished artwork is in shamanistic ideology is evident in rock art. Some petroglyphs and rock paintings in North America are clearly associated with shamanistic ritual. For example, the paintings of Panther Cave near the Pecos River in Texas (Fig. 18.3) represent frontal figures in animal disguise carrying bags, which probably contained mescal beans (Kirkland and Newcomb 1967). Mescal beans were used by shamans in the southern United States to induce hallucinatory visions. Such beans, dating back to the archaic period, have been found preserved in the cave. The point I want to stress is that several images are painted one on top of the other in Panther Cave, with no apparent regard for the finished piece. The act of painting appears to be more significant than the result.

The many exquisitely carved Northwest Coast artworks associated with shamanism are not beautiful because visual beauty is necessary to the shamanistic performance, but because in Northwest Coast society the quantity and quality of artworks are used to validate social status. The shamanistic objects, such as masks and soul catchers, are as finely finished and detailed as is the rest of Northwest Coast art. Some Northwest Coast artworks that represent shamans are more grotesque and distorted than other figures (Fig. 18.4). In these instances, distortion of form may

Figure 18.2 Snoqualmie spirit canoe figure. Reproduced from P. S. Wingert, *American Indian Sculpture*, 1940. Courtesy J. J. Augustin, New York.

Figure 18.3 Panther cave painting, Pecos River, Texas. Copied July 10, 1937, by Forrest Kirkland. Courtesy Texas Memorial Museum, The University of Texas at Austin.

serve to express the emotional content of the trance state, and may differentiate these from more socially motivated Northwest Coast art objects.

Since art objects in shamanism are made to help communicate certain ideas, more emphasis is placed on the subjects they represent than on their formal appearance. Shamanistic themes divide into four major categories: human figures, animals, animal-human contact, and cosmic charts. Anthropomorphic figures may represent the image of the shaman, or a mythical first shaman, as a human individual with magic powers (Fig. 18.5). Magic powers may be suggested by the representation of a heart or skeleton, animal horns, or masks. The power and control of some shaman figures is further suggested by their frontal poses and orant gestures. Anthropomorphic figures may also be used to represent some of the helping spirits of shamans as well as deities who control nature and who have to be propitiated by humans (Fig. 18.6). Without ethnographic information, it is often impossible to tell shamans, spirits, and deities apart; all partake of similar power attributes and have interchangeable iconographic traits.

The ubiquity of animal images in shamanistic art is to be expected in view of the fact that so many shamanistic societies subsist on hunting. The animals represented include the hunted animals, such as the deer, mountain goat, or fish, as well as power animals. The power animals may be animal versions of

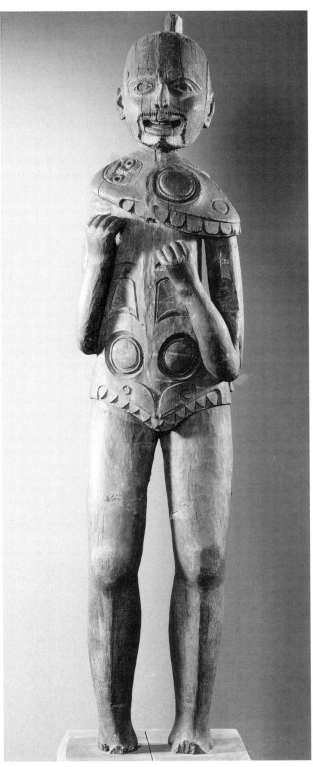

Figure 18.4 Tlingit guardian figure for a shaman's grave house. Neg. no. 326304, courtesy the Library, American Museum of Natural History.

Figure 18.5 Apache medicine man's shirt. Drawing by Salvador Rosillo.

the supernatural deity who controls the animals, the helping spirit of the shaman, or the shaman in animal disguise. Power animals are usually carnivorous and hunt like humans but have certain abilities that humans do not possess, such as great physical strength, swiftness, or flight. Power animals include the bear (Fig. 18.7), especially in circumpolar regions, the feline in tropical areas, and raptorial birds, such as the eagle. These animals are often represented as fabulous composite beasts, which further indicates their magic powers.

Shamanistic art is rarely narrative or concerned with illustration. The supernatural encounters of shamans are rarely represented in art. Occasionally, humans and animals, or two different animals, may be shown in physical struggle, which may represent a variety of shamanistic experiences, such as the initiation of the shaman by being killed and brought back to life by a helping spirit, an encounter with an evil spirit, or even a fight in spirit form with another shaman.[3] Physical contact between figures may represent protection or threat, but because the threatening powers are frequently transformed into agents of protection, it is unclear in the representations which is intended. Representations of figures locked in a struggle convey the ambivalent quality of spiritual power which can be both creative and destructive.

Since the shaman journeys through different parts of the supernatural world, the structure of the cosmos is sometimes the subject of visual representation.

Figure 18.6 Eskimo ivory doll from Bering Straits. Courtesy National Museum of the American Indian, Smithsonian Institution (03/9249). Photograph by Carmelo Guadagno.

Figure 18.7 Medicine Rapids, Saskatchewan, rock painting. Reproduced from Campbell Grant, *Rock Art of the American Indians* (New York, 1967). Courtesy Clara Louise Grant.

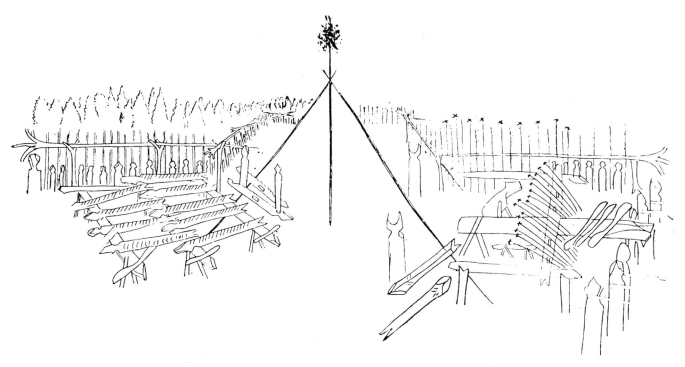

Figure 18.8 Evenk shaman's tent. Reproduced from A. I. Anisimov, "The Shaman's Tent of the Evenks and the Origin of the Shamanistic Rite," *Studies in Siberian Shamanism*, ed. H. N. Michael, 1963. Courtesy University of Toronto Press.

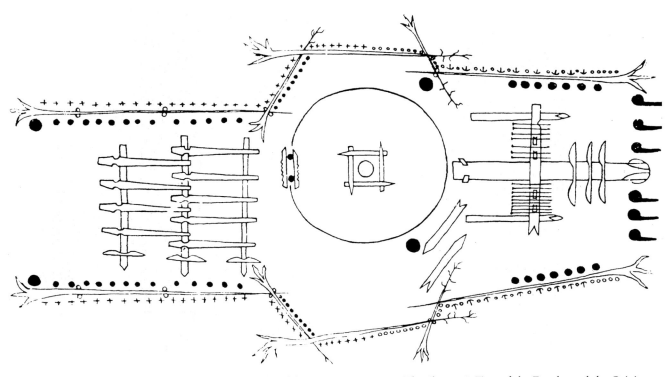

Figure 18.9 Evenk shaman's tent, plan. Reproduced from A. I. Anisimov, "The Shaman's Tent of the Evenks and the Origin of the Shamanistic Rite," *Studies in Siberian Shamanism*, ed. H. N. Michael, 1963. Courtesy University of Toronto Press.

Generally, the cosmos is represented in microcosm in three-dimensional form. The Salish spirit canoe, described above, is such an example. Among the Evenk of Siberia, a special tent is set up for a curing ritual (Anisimov 1963). The central post represents the cosmic tree that connects the upper and lower worlds (Figs. 18.8, 18.9). On the outside, post figures of fish and humans are set up to represent the upstream and downstream segments of the river of life, which is conceptually related to the upper world of the sky and the lower world of the interior of the earth. The tent, placed in the middle, represents the middle world of the surface of the earth. The Evenk tent is very elaborate; in other shamanistic groups the mise-en-scène may be much simpler and may consist of only a central pole that represents the world axis.

A three-dimensional representation of the cosmos is often an integral part of the shamanistic performance. By contrast, two-dimensional representations of the cosmos, which can rarely be used in a seance and are significant especially as visual images, are much less frequent. A shaman may need props and objects, but he has less use for pictures and diagrams. The famous painted Goldi costume (Figs. 18.10, 18.11) is a unique and atypical example of a two-dimensional cosmic chart from Siberia. On most Siberian shamans' costumes birds or animals are represented and objects that symbolize the powers of the shaman, such as chains, masks, dolls, and pendants, are attached (Fig. 18.12). On the Goldi costume, the painted design represents the structure of the universe: the cosmic trees of the central axes, the power animals, such as bears and felines, and the circle, possibly the opening into the sky (Vastokas 1974). These representations are not simply embodiments of concepts but explanations of complex interrelationships. They are close to the picture a modern ethnographer might draw on the basis of

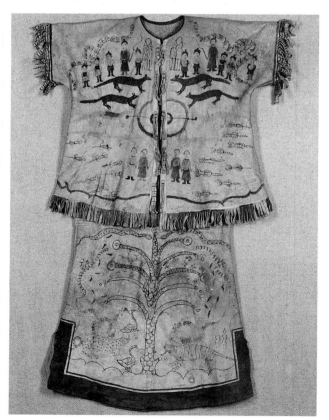

Figure 18.10 Shaman's coat, Goldi tribe, front view. Neg. no. 315731 (photograph by Charles H. Coles), courtesy the Library, American Museum of Natural History.

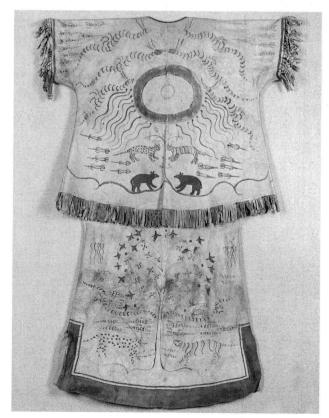

Figure 18.11 Goldi shaman's coat, back view. Neg. no. 315732 (photograph by C. H. Coles), courtesy the Library, American Museum of Natural History.

verbal accounts. The Goldi live in southwestern Siberia and are strongly influenced by Manchurian and Chinese culture. Two-dimensional depictions of the cosmos in shamanistic contexts are found elsewhere in areas influenced by other, especially agricultural, societies and civilizations.[4]

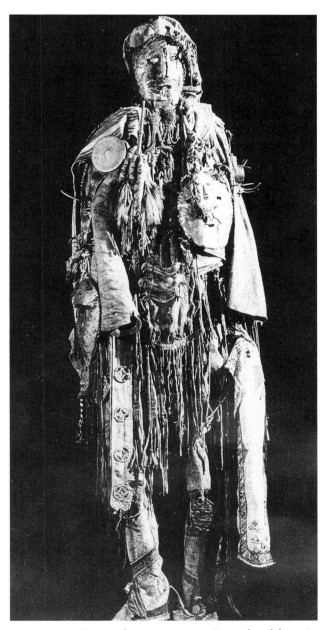

Figure 18.12 Tungus shaman's costume. Reproduced from A. Lommel, *Shamanism: The Beginnings of Art* (New York: McGraw-Hill, 1967) with permission of The McGraw-Hill Companies.

In general, the subjects of shamanistic art are relatively limited. They are simple in form and lack detail, often needing verbal description in order to acquire meaning. An elaborate tradition of shamanistic art is the result of either the influence of non-shamanistic arts or an overall cultural preoccupation with high-quality material objects.

Many recent studies have shown that the significance of a variety of images in different societies is shamanistic, and in so doing have reduced the meaning of those images to the same general level. This is especially true of North American Indian art, in which shamanistic themes admittedly do predominate. In North America, there are many different types of institutions which have shamanistic traits within different social, cultural, and artistic contexts. A similar variety of shamanistic practices is evident in eastern Asia and Indonesia, although no attempt will be made here to relate them to the North American traditions. Some of the North American types of shamanism will be analyzed to arrive at certain general patterns.

It is likely that the earliest Asian migrants who settled the Americas during the last ice age were hunters and gatherers with a religion that was probably shamanistic (La Barre 1972). The shamanism brought by these early settlers was probably a form of general shamanism, and this survives in different societies of the Americas from the Arctic to the Tierra del Fuego. Individual shamanism is particularly characteristic of hunting-and-collecting bands and tribes. General shamanism is usually found in societies with little material culture and therefore few shamanistic art objects. In these societies, although an entire complex of shamanistic mythology and ideology may be present, it is expressed verbally rather than visually. The objects most necessary are musical instruments, such as drums and rattles, which help put the shaman into a trance, but they need not be ornamented. The shaman may wear no distinctive clothing, or may be painted and decorated with feathers, or he may wear the skin of an animal. Other objects owned by the shaman may include charm stones and sucking tubes. The Paiute of the Great Basin (Park 1938), the Chumash (Fig. 18.13) (Grant 1965), and Luiseño (Fig. 18.14) (DuBois 1908) of California are examples

of small societies in which shamans perform with a minimum of material accessories. In both areas there are petroglyphs and rock paintings which may have been made by shamans (Heizer and Baumhoff 1962). These petroglyphs are the only works that have a formal and aesthetic content.

Individual shamanism, closely related to Siberian shamanism, is found in northern America and is probably the result of many centuries of contact among circumpolar populations. The costume and paraphernalia of the Tlingit and Tsimshian shaman have many parallels with the elaborate costume of the Siberian shaman (Drucker 1955:159–160). In the Northwest Coast the rattle and the drum are essential and they are often ornamented with supernatural images. The costume may consist of a painted skirt with a border of charms and noise-makers, a crown, representing bear claws (Fig. 18.15), and a mask. Masks are not as a rule associated with shamanism either in Siberia or in societies that have a form of general shamanism. Masks were adopted for the use of individual Northwest Coast shamans in imitation of the local initiation societies using masks. Among the Eskimo, wooden masks are used by shamans only in southern Alaska, where contact with the Northwest Coast was considerable (Ray 1967:72–83).

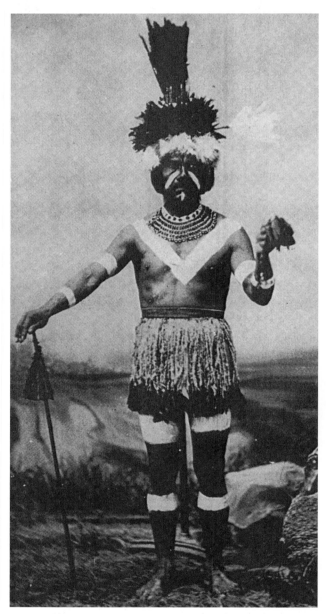

Figure 18.13 Chumash shaman. Reproduced from Campbell Grant, *The Rock Paintings of the Chumash* (Berkeley: University of California Press, 1965). Courtesy Clara Louise Grant.

Figure 18.14 Luiseño shaman swallowing sword. Reproduced from C. D. Dubois, "The Religion of the Luiseño Indians," *University of California Papers in American Archaeology and Ethnology*, vol. 8, no. 3, 1909.

The Northwest Coast shaman performs curing rituals, ensures plenty of fish and game, and may make war magic. Individual shamanism, however, is not the only or the most important religious institution in the area. Shamanistic ideas are used and transformed by dancing societies and hereditary clans. For example, the shamanistic scenario of ritual death and rebirth and the acquisition of a supernatural patron are the basis of the initiation of new members into various Northwest Coast dancing societies. The purpose of these societies is as much to confer social and economic status as it is to acquire spiritual powers. While some initiates may undergo an intense spiritual experience comparable to that of a true shaman, others have to be satisfied with the less intense enactment of the experience. As the focus shifts from the true trance of the individual shaman to the enactment of the trance by the initiate, the surroundings and the paraphernalia become visually more expressive. A variety of masks and art objects are used by the initiates in the masking societies that are unnecessary for the individual shaman. In their cannibal and grizzly bear society initiations, the Kwakiutl use props, lights, trapdoors, and other scenic effects for dramatic realization (Drucker 1955:163).

The social and economic function of shamanistic societies in North America is especially evident among the Ojibwa of the Great Lakes area. Individual Ojibwa shamans use simple material objects which may include drums, rattles, and sucking tubes, as well as wooden figurines (Hoffman 1885). However, the most elaborate expression of shamanistic ideology is to be found in the Midewiwin society. The Mide society initiates have to pay to enter the society and each time they advance to one of the four grades. They learn songs and traditions and undergo an initiation ritual of mock shooting, death, and rebirth, but only a few among those who reach the fourth grade ever acquire spiritual powers comparable to that of the individual shaman. In such a society, the acquisition of some spiritual power is a form of social rank.

Art objects used by the Mide society are more elaborate and explicit in meaning than the objects used by the shamans, which is in keeping with the theatrical nature of Mide rituals. The Mide lodge

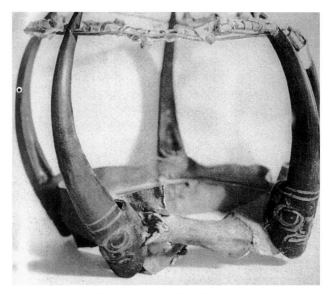

Figure 18.15 Tlingit shaman's headdress. Courtesy of the Southwest Museum, Los Angeles. Photo # 981.G.16.

represents the cosmos, with posts topped by birds that represent the cosmic tree erected in the center. Members of the society own ornamented animal skin bundles containing various charms as well as wooden boards or bark scrolls on which the songs taught during initiation are represented by symbols. The society also owns birch bark scrolls on which the origins of the society are depicted. One of these scrolls represents the Mide lodges of the four grades as replicas of the original Mide lodge in the sky (Fig. 18.16). The society was given to the Ojibwa by a deity, who is represented on the scroll as an individual shaman with power rays surrounding his head and a drum in his hands. Shamanistic societies make a watered-down version of the shamanistic experience available to a large group of people, but the initiates get more social prestige than actual psychic power out of it. The shamanistic scenario is used to dramatize the initiation, and, insofar as the experience is less internalized, more emphasis is placed on its external articulation and representation in art objects.

One form of the democratization of shamanism is the institution of shamanistic societies in which members have to pay for initiation. Another form of the broader distribution of shamanic powers is to be found in the vision quest of the Plains Indians. In Plains culture there are individual shamans as well as

shamanistic initiation societies (Lowie 1954). However, in Plains society, all persons desire to acquire at least a modicum of spiritual power through the vision experience. The structure of the Plains vision is comparable to the initial encounter of the shaman, except that the vision is not accidental but induced by fasting, exposure to cold, and even bodily mutilation (Benedict 1923). The individual, if successful, encounters a supernatural who becomes his patron and gives him a song, a design, and a special power for curing or in warfare. The vision experienced by the Plains Indian does not necessarily turn him into a shaman. It is another avenue of social and military advancement, parallel to membership in various societies. The only difference is that in the Plains area greater emphasis is placed on the authenticity of the visionary experience.

Many types of decorative and expressive artworks are made for individual and initiation society use in the Plains area. The artworks associated with the individual vision quest often have shamanistic designs, such as skeletal figures, bears, or thunderbirds. These designs, given by the initiating spirits, are usually painted on shields (Fig. 18.17) and teepee covers. They are necessary as a form of visual validation of the spiritual encounter which took place in

isolation and cannot be repeated in public. (The initial spiritual experience of the shaman may be in isolation too, but subsequently he goes into a trance state in public rituals.)

The controversial question of hallucinatory drug use in relation to shamanism makes sense when individual shamanism is distinguished from shamanistic societies.[5] The individual shaman may or may not use drugs, depending on the availability and traditional local practice. A shaman, by definition, is able to enter trance states frequently without the use of drugs, and when he uses drugs he has greater control over them and over the supernatural powers to which the drugs provide access. However, many persons who seek to acquire spiritual power, such as the ones who enter the various shamanistic societies, may lack the natural abilities of the shaman. As we have seen, shamanistic societies may dispense with the necessity of a true vision and simply mimic one, or individuals may mortify the flesh to try to induce one. The availability of substances that, when eaten, snuffed, smoked, or chewed, elicit hallucinatory states may provide the needed vision for these individuals. Drugs are very frequently used in North and South America by people in groups (Harner 1973:6). Initiates using hallucinogenics expect a shamanistic encounter with

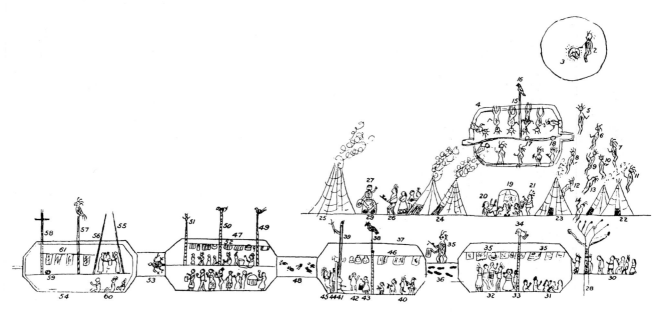

Figure 18.16 Ojibwa Mide society scroll. Reproduced from W. J. Hoffman, "The Midewiwin or 'Grand Medicine Society' of the Ojibwa," *7th Report of the Bureau of American Ethnology,* 1885–1886.

a transforming supernatural spirit. The northern Mexico Huichol peyote hunt is a ritualized group vision-quest led by an individual whose powers are comparable to those of a true shaman (Furst 1974).

Individual shamanism is especially characteristic of small hunting and gathering societies organized in bands. In the larger tribal societies of North America, individual shamanism is not the only or the most important focus of religious activity. Instead, much emphasis is placed on societies that serve to integrate a larger and more heterogeneous population. Certain shamanistic concepts may predominate in these societies in the scenario of initiation and in the motifs used to ornament the necessary ritual paraphernalia. However, supernatural power is sought not only for its own sake but as a major avenue of social advancement and prestige. Where prestige and social status are as important as spiritual values, works of art tend to be more numerous and more artfully made.

Both the band and tribal societies of North America discussed previously are either hunters and gatherers or part-time agriculturalists. The fully sedentary and agricultural way of life, restricted in North America to the Southwest and Southeast, is not generally associated with shamans or shamanism.

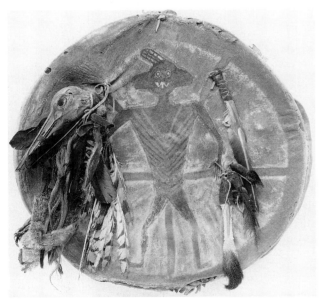

Figure 18.17 Crow buffalo shield, Chief Arapoosh, 1800–1834. Courtesy National Museum of the American Indian, Smithsonian Institution (11/7680). Photograph by Carmelo Guadagno.

Tribal societies that subsist almost entirely on grain agriculture are usually more rigidly organized than the ones in which hunting is more significant. Agriculture requires considerable cooperation and some specific calendric knowledge. In agricultural societies, individual interests are generally subordinated to those of the community, and individual undertakings such as the vision quest of the Plains tribes are not acceptable (Underhill 1948). Religious specialists can be defined as priests rather than shamans. One of their functions is the regulation of the agricultural year in accordance with calendric computations, which is a matter of restricted knowledge rather than inspiration. Among the Pueblo groups of the American Southwest, for example, disease is believed to be caused by a breach of taboo as well as by the loss of a soul or the intrusion of a foreign object as in shamanistic societies (Underhill 1948:35–40). Disequilibrium in society is caused by the intervention of spiritual agents and also by the infraction of rules by humans, which brings down the wrath of supernaturals. Equilibrium is restored, not by a shaman who personally battles the spirits, but by a priest who performs ritual actions including prayers, sacrifices, and offerings which the gods accept. The primary Pueblo cults, such as the Kachina cult, venerate ancestors and nature spirits by the performance of a complex yearly cycle of festivals and ceremonies. Shamanistic traits survive only in a very limited form in the initiation rites of the curing societies, in which fasting and a dramatization of ritual death and rebirth occur but without any of the participants actually going into a trance.

A unique blending of agricultural and hunting ideology has taken place in Navajo culture. The Navajo are an Athabascan-speaking group whose nearest relatives still live in Canada and Alaska in small hunting and gathering groups. The Navajo came to the Southwest around the twelfth or thirteenth century (Spencer and Jennings 1965:322). They were strongly influenced by their Pueblo neighbors and after European contact stopped being hunters and became specialized sheep herders. The most important feature of Navajo religion is the sand-painting ritual, which is performed for general tribal welfare, for curing, for the exorcism of sorcery, for warfare, and

for hunting (Reichard 1950). The Navajo religious specialist is a curious mixture of shaman and priest. Like a shaman, he goes into a trance to divine the cause of illnesses. However, the cure of illness is not another trance in which he takes a trip in the realm of the supernatural but the performance of the sand-painting ritual and chant. The Navajo chanter has memorized several hundred paintings and the chants associated with them, some of which are selected for a specific cure. Both the paintings and the chants have to be repeated exactly. The knowledge of the chanter is as important as his ability to communicate with the supernatural. The sick person is seated in the center of the painting while the chant is sung over him. When the ritual is concluded, the sand is carefully collected and ritually disposed of.

The chants sung by the Navajo healer recount the experiences of mythical heroes. The stories are comparable to shamanistic encounters. The mythical hero is usually a human who takes a journey into the realm of the supernatural and meets with various good and evil spirits, who in the end confer upon him supernatural powers and teach him the sand-painting rituals. The heroes return to earth and teach people what they have learned, then depart for good. The making of a sand painting is the reenactment of the myth in which the hero originally acquires power over the supernatural through the acquisition of ritual. The stories of the hero's adventures are very similar to the trips of the shaman, but the Navajo chanter himself does not go on a trip; he merely recounts the myth. The person of the chanter is, therefore, less important than that of the supernatural heroes. The power resides in the proper performance of the ritual and not in the spirit of the individual chanter.

Like the chants, the sand paintings have power only if they are exact copies of the original sand paintings given by the heroes. Each painting represents an event in the myth. The events are not represented naturalistically, in scenes of action, but emblematically. In one Bead Chant painting, for example, the hero, Scavenger, is shown in a scene in an eagle's nest (Fig. 18.18). The nest is located in the sky, and the white shells on the hero's body represent the powers given to him by the eagles. The human figure with supernatural powers imagery and the presence of the eagles as transforming agents are derived from shamanistic imagery. In its emphasis on the precision of line and design, the nature of the painting is quite different from truly shamanistic arts, in which the quality of design is not significant. The precision of pattern in sand painting is difficult to achieve by spreading sand with the hands and requires great manual skill and control on the part of the artist. Absolute perfection of design is necessary for its efficacy.

Most Navajo sand paintings do not represent a single figure but several repeating figures within a cosmic chart (Fig. 18.19). The cosmos is represented by a square or a circle that represents the four cardinal directions and the center. The various spirits are placed in fours or in multiples of fours in each quadrant. Associated colors indicate the directions. Color symbolism and the importance of the four directions are derived from Pueblo agricultural ritualism. Cosmic charts are also used in shamanistic contexts, but they differ in a fundamental respect from Navajo representations. Shamanistic ideology emphasizes a vertical division of the cosmos, the upper, middle, and lower worlds, and places the emphasis on the axes that connect them (Fig. 18.20). In actual representations, this view may be shown as a vertical or horizontal line along which movement occurs. The Evenk tent and figures, arranged in relation to upstream and downstream, represent a horizontal version of this linear shamanic conception.

The Navajo and Pueblo also believe in a three-tiered universe, with upper, middle, and lower worlds connected by an axis, but they emphasize not the vertical but the horizontal extension. The Navajo cosmos, as represented in the sand paintings, is planar in extension and radial in organization. The focus in a radial design is on the center and on the lines that move out from the center. In contrast to a line, a plane is a static form. The Navajo cosmic chart is, therefore, more static than the cosmic charts of shamanistic societies.

In Navajo and Pueblo cosmology, humans are believed to be relatively stationary while the spirits move around them. The supernatural is controlled by artifacts, such as ritual objects and ceremonies. Even the temporal arts, such as music, song, and dance, are made static by precise memorization and repetition.

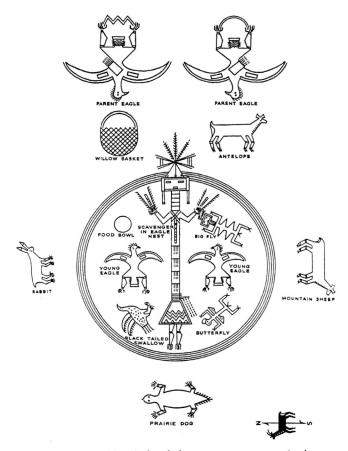

Figure 18.18 Navajo bead chant scene: scavenger in the eagle's nest. Reproduced from G. A. Reichard, *Navaho Medicine Man: Sandpaintings and Legends of Miguelito*, 1939. Courtesy J. J. Augustin Publishers.

Figure 18.19 Navajo shooting chant scene: four thunderers. Reproduced from F. J. Newcomb and G. A. Reichard, *Sandpaintings of the Navajo Shooting Chant*, 1937. Courtesy J. J. Augustin Publishers.

The Navajo sand painting is meant to be perishable and is destroyed after the ritual, but its temporariness is negated by the fact that the design and the chant are memorized and may be re-created in the same forms at any time. If shamanistic ritual is comparable to improvisational theater within simple and potentially all-purpose settings, then the rituals of agricultural societies are comparable to the performances of nineteenth-century operas in prescribed period costumes and settings. In improvisational theater, all depends on the quality of the actors; in opera, magnificent settings may make up for less inspired singing and acting.

Shamanism should be defined as a specific form of religious institution in which an individual shaman mediates between humans and the supernatural by entering a mystic trance. Shamanism is especially

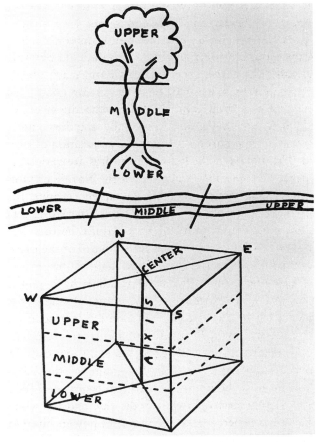

Figure 18.20 Comparison of Evenk and Navajo concepts of the cosmos. Drawing by Esther Pasztory.

characteristic of small hunting and gathering societies, and its origins may go back to the Paleolithic period and to the culture of early humans. As such, shamanism could be the most basic and ancient form of religious experience. The mystic trance is a peculiarly human ability that individuals may have at any time and place, but it is institutionalized in widely different forms. In the twentieth century, for example, we have faith healing and psychiatry (Lévi-Strauss 1963).

Despite the presence of shamanistic traits in many cultures, individual shamanism is the dominant religious institution of only a few relatively small and simple societies. The concepts of shamanism may be incorporated in a multitude of religious institutions, such as the shamanistic initiation societies and the individual vision-quest in North American Indian culture. However, both shamanistic societies and the vision quest are to a considerable extent socially and economically motivated and are not purely spiritual institutions. Shamanistic concepts are used as a metaphor rather than a spiritual reality.

Shamanism is not characteristic of specialized agricultural populations, but shamanistic concepts may survive in them. They survive particularly in myths and legends in which the mystic power of the shaman is no longer recognized among mortals, even religious specialists, but is attributed to supernatural heroes. In shamanistic religion, humans and supernaturals share the same types of spiritual power. In priestly religion, a greater gap divides the spirits from the humans, and mystic power may be the exclusive attribute of the spirits.

The dominant values of shamanism are individualism, variation, and movement. The arts most basic to shamanism are the ones in harmony with these values: the temporal arts of music, song, and dance. The visual arts are secondary, and in many instances shamanism exists without them. Since the concern of shamanism is with states of transition, with becoming rather than being, the forms of ritual objects are rarely important in themselves and little effort is expended to make them aesthetically pleasing or precise in meaning. Aesthetic values are more closely associated with the importance of social and economic status. When shamanistic imagery is used as a metaphor to mark the transition from one social or economic level to another, the artworks are usually more elaborate in form, more precise in meaning, and more skillfully made. Art objects are also essential in agricultural and priestly religions, because in these cultures supernatural power is often believed to reside in objects rather than in persons. The greatest skills in formal and iconographic invention are therefore employed to give the invisible spirits the most expressive form and to make visual distinctions between them.

NOTES

1. This paper was presented at Skidmore College, January 18, 1975, at a symposium entitled "Shamanism and the Arts of Asia and the Americas."

2. Shamanism is not the only institution that encourages the destruction or abandonment of artworks after a ritual. Many societies around the world have collective festivals at the end of which the artworks are abandoned for a variety of reasons.

3. Physical struggle is frequent in Northwest Coast American Indian and in Siberian "animal style" art.

4. Two-dimensional representations of the cosmos are frequent in Indonesian art. The Ngadju shamans used a painting with the ship of the dead with a cosmic tree in its center (Scharer 1963).

5. Eliade (1964) believed that the original ancient shamans did not use drugs, and that the use of drugs by some shamans is a cheap substitute for a genuine mystic experience. By contrast, Wasson (1968) and La Barre (1972) have sought the origin of shamanistic ideology in hallucinatory drug use. Both positions are probably overstatements and reflect our own feelings about drug use. Eliade, writing in the 1950s, disapproved of drugs. In the wake of the drug-using counterculture of the 1960s, La Barre and Wasson overemphasize the significance of hallucinogens. Drugs may be useful to shamans and institutionalized in use, but there is plenty of evidence that humans have the ability to experience visions without them. Shamanism need not originate necessarily from drug use.

BIBLIOGRAPHY

Anisimov, A. I.
1963 "The Shaman's Tent of the Evenks and the Origin of the Shamanistic Rite," *Studies in Siberian Shamanism*, edited by H. N. Michael, 84–123. Arctic Institute of North America, Toronto.

Barbeau, M.
1958 "Medicine Men of the North Pacific Coast," *National Museum of Canada Bulletin*, No. 152, Ottawa.

Benedict, R. F.
1923 *The Concept of the Guardian Spirit in North America*, American Anthropological Association Memoir 29.

Chatwin, B.
1970 "The Nomadic Alternative," in *Animal Style Art from East to West*, 176–183. Asia Society, New York.

Drucker, P.
1955 *Indians of the Northwest Coast*, Natural History Press, New York.

DuBois, C. D.
1908 *The Religion of the Luiseño Indians*, University of California Papers in American Archaeology and Ethnology, vol. 8, no. 3.

Edsman, C. M.
1967 *Studies in Shamanism*, Stockholm.

Eliade, M.
1961 *The Sacred and Profane: The Nature of Religion*, New York.
1964 *Shamanism: Archaic Techniques of Ecstasy*, New York.

Furst, P.
1974 "The Roots and Continuities of Shamanism," *Arts Canada*, nos. 184–187:33–60.

Grant, C.
1965 *The Rock Paintings of the Chumash*, University of California Press, Berkeley and Los Angeles.
1967 *Rock Art of the American Indians*, New York.

Harner, M. J., ed.
1973 *Hallucinogens and Shamanism*, Oxford University Press, New York.

Heizer, R. F., and M. A. Baumhoff
1962 *Prehistoric Rock Art of Nevada and Eastern California*, University of California Press, Berkeley.

Hoffman, W. J.
1885 *The Midewiwin or 'Grand Medicine Society' of the Ojibwa*, Annual Report of the Bureau of American Ethnology, vol. 7, pt. 2.

Hultkrantz, A.
1963 *Les Religions des Indiens primitifs de l'Amérique*, Stockholm Studies in Comparative Religion 4.
1967 "Spirit Lodge, a North American Shamanistic Seance," *Studies in Shamanism*, edited by C. M. Edsman, 32–68.

Inverarity, R. B.
1950 *Art of the Northwest Coast Indians*, University of California Press, Berkeley and Los Angeles.

Kirkland, F., and W. W. Newcomb
1967 *The Rock Art of the Texas Indians*, University of Texas Press, London and Austin.

La Barre, W.
1972 "Hallucinogens and the Shamanic Origins of Religion," *Flesh of the Gods: the Ritual Use of Hallucinogens*, edited by P. T. Furst, Praeger, New York.

Lévi-Strauss, C.
1963 "The Sorcerer and his Magic," *Structural Anthropology*, 161–180, Doubleday, New York.

Lommel, A.
1967 *Shamanism: The Beginnings of Art*, McGraw-Hill, New York.

Lowie, R. H.
1954 *Indians of the Plains*, Natural History Press, Garden City, New Jersey.

Newcomb, F. J., and G. A. Reichard
1937 *Sandpaintings of the Navajo Shooting Chant*, J. J. Augustin, New York.

Park, W. Z.
1938 *Shamanism in Western North America: A Study in Cultural Relationships*, Northwestern University Studies in the Social Sciences 2, Evanston.

Ray, D. J.
1967 *Eskimo Masks: Art and Ceremony*, University of Washington Press. Seattle.

Reichard, G. A.
1939 *Navaho Medicine Man: Sandpaintings and Legends of Miguelito*, J. J. Augustin, New York.
1950 *Navaho Indian Religion: A Study of Symbolism*, Pantheon Books, New York.

Scharer, H.
1963 *Ngaju Religion: The Conception of God among a South Borneo People*, M. Nijhoff, The Hague.

Spencer, R. F., J. D. Jennings, et al.
1965 *The Native Americans*, Harper and Row, New York.

Underhill, R. M.
 1948 *Ceremonial Patterns in the Greater Southwest,*
 Monographs of the American Ethnological Society
 13, New York.
 1965 *Red Man's Religion,* University of Chicago Press.
Vastokas, J. M.
 1974 "The Shamanic Tree of Life," *Arts Canada,* nos.
 184–187:125–149.
Wardwell, A.
 1964 *Yakutat South: Indian Art of the Northwest
 Coast,* catalog, Art Institute of Chicago.

Wasson, R. G.
 1968 *Soma: Divine Mushroom of Immortality,*
 Harcourt Brace Jovanovich, New York.
Waterman, T. T.
 1930 *The Paraphernalia of the Duwamish 'Spirit-
 Canoe' Ceremony,* Indian Notes and Monographs,
 vol. 7, no. 2–4, Museum of the American Indian,
 New York.
Wingert, P. S.
 1940 *American Indian Sculpture,* J. J. Augustin. New
 York.

INDEX

Page numbers in italics refer to illustrations.

A

Aboriginal art. *See* Australian Aborigines

Abstract expressionism, 89, 118

Abstraction: aesthetic of, 91; definition of, 151n.8; in development of art, 29, 48–49, 50–51n.10; as global style, 94, 96; and minimalism, 152n.14; and modernism, 29, 89, 90, 94, 125, 126, 131, 179; naturalism versus, 29, 48–49, 118, 125, 126, 139, 192–193; as political gesture, 91; and pre-Columbian art, 118, 119–153; purpose of, 118; Teotihuacán aesthetic of, 128–146, 205–206

Achaemenid Persian style, 161–163, *163*

Adolescent (Gross), *202*

Adorno, Rolena, 205

Aestheticism: and beauty, 82–83, 84n.22, 97; and craft virtuosity, 62; definition of, 79, 84n.22; and display, 194–195; and historic religions, 75–76; and idolatry, 76–77, 79–81; and immateriality, 77–78; and interconnected Old World, 75; and Maya, 118, 193–194; and media, 91; and modernist art, 91; and painting, 81–82; in technological era, 36; and text/image, 78–79; and textural era, 75–83; and three-dimensionality in village style, 53

Aesthetics: of abstraction, 91; and African art, 85n.35; Andean, 197–206; beginning of, as separate field of study, 189; coining of term, 26n.35; and comparative artistic ranking, 127–128; Kant on, 99n.22, 191, 195; and naturalism and beauty, 71; and pre-Columbian art, 119–153, 189–196; and technological era, 88; and technologies, 11; Teotihuacán aesthetic of abstraction, 128–146; Western view of, 190–192, 194, 195, 203

Affine perspective, 81, 137, *137*

Africa: Africans' response to Picasso, 126–127; Africans' response to portraiture, 187; art of, 3, 4, 8, 9, 14n.17, *56*, 58n.2, 58n.12, 58n.15, 85n.35, 91, 92, 95, 117, 118, 157, *158*, 187; chiefdoms and kingdoms in, 34, *60*, 63; ethnic styles of, 157, *158*, 175; Ife heads, 63, *63*, 69, 181–182, *182*, 185; masks from, 41, *56*, 126, *126*, 184; San (Bushmen) of South Africa, 45, 48, 138; states in, 34, 39n.42; sub-Saharan cultures in, 39n.42; and trade, 176; villages in, 53; women on motorbike, *28*. *See also specific countries and tribes*

Akan (Fante), *60*, 62, 63, 85n.35

Akhenaten, 69, 104, 185

Alberti, Leon Battista, 26n.34, 85n.32

American Museum of Natural History, 8, 184

Americas. *See* Mesoamerica; North American Indians; Pre-Columbian art

Andes: and aesthetics, 197–206; and archaeology, 67; art of, 41, 69, 192, 195, 198–202; burial in, 201; and *ceque* system, 199, *199*; insistence and tradition in, 42, 43n.4, 204–205; metalwork of, 200–201; Moche portrait vessels in, 65n.9, 125, *125*, 181, 182, *182*, 185, 201, 203, 206; Nasca ground lines in, 46, 192, 194, 199–200, *200*; settled life in, 45; states and chiefdoms in, 33, 34–35; textiles of, 14n.15, 62, 193, 200. *See also* Inca

Angkor, 34

Animals and shamanism, 229–230, *230*, 236, 237

Anthropology, 13, 14n.22, 29, 30, 32, 34–35, 48, 63, 84n.25, 127, 176, 190, 192, 201

Anthropomorphic presence, 42, 68–69, 229

Apache, 229

Apollo Belvedere, 40

Apotheosis, 72

Appadurai, Arjun, 14n.22

Archaeology, 11–13, 30, 37nn.10-11, 46, 51n.10, 63, 84n.25, 127, 146–151, 159

Archaic societies, 32–34, 48, 67–72, 81, 189, 194

Architecture, 45, 67–68, 72n.8, 167–170, *168*, *169*, 177. *See also* Pyramids

Art: and artist tradition, 90, 97, 99n.21, 193; and beauty, 71, 82–83, 84n.22, 85n.35, 93–94, 97, 193, 195; concept of, 7–9, 13; content definition of, 8; designation definition of, 8–9; development of, 29, 48–49, 50–51n.10; eighteenth-century concept of, 90; ethnic styles of, 157–177; formal definition of, 8; Hegel and Heidegger on, 190; honorific definition of, 9; Kant on, 25n.29; and pleasure, 22–23, 83, 85n.35; purpose and function of, 4, 193; and technologies of communication, 11–12, 15n.26, 104, 105; terms for, 12–13; and things, 10–11, 13, 14–15n.22; versus not art, 9–10, 90; Western view of, 190–192. *See also* Aesthetics

"L'art brut," 84n.23

"Art for art's sake," 10–11, 15n.25

Art history, 23, 26n.35, 29, 32, 48, 89–90, 103, 134, 143, 179, 180

The Artist's Studio (Bazille), *ii*

Artist tradition, 90, 97, 99n.21, 193

Ascher, Marcia and Robert, 41, 199, 204

Ashton, Dare, 151n.5

Asia, 42, 87, 195. *See also specific countries*

Assurbanipal, 70

Assyrians, 72n.5, 80, 84n.13, 135

Australian Aborigines, 9, 10, 30, 46, 47, 49–50, 96, 97,
 100n.48
Automobiles, 19, 61, 85n.31
Autumn Rhythm (Pollock), *86*
Avant garde, 90, 99n.21, 99n.27, 151
Axial Age, 35, 39n.50, 76, 83n.6
Aztecs: art of, 7–8, 20, 68, 69, 80, 129, 133, 146, 151n.2,
 193, 194, 209–222, 214; building project of, 67; empire
 of, 165, *167*; and flowery war, 171–172; gods and
 goddesses of, 195, 212, 213, *214*, 219–220, *219*, *220*;
 human sacrifice by, 70, 210, 212, 220–221; and idea of
 human beauty, 212; masks of god Xipe, 118, 209–222,
 209–211, *217*; nineteenth-century interest in, 214–217;
 religion of, 70, 75–76; skeletal figure, 211–212, *212*;
 state of, 34, 41; and Teotihuacán, 128

Baining, 53
Balfour, H., 51n.10
Bali, 194
Ball game, 172–175, *173*, *174*
Bamana, 55, 157, *158*, 195
Bands. *See* Hunter-gatherers (bands)
Barber, Bernard, 87
Bardon, Geoffrey, 100n.48
Barth, Fredrik, 159–160, 176
Barthes, Roland, 10, 18, 19–20, 21, 24, 32, 61, 84n.25,
 85n.31
Bataille, Georges, 49, 50, 67, 95, 100n.37
Batres, Leopoldo, 215, 216, 222
Baudrillard, Jean, 11, 36, 39n.46, 42, 88, 186
Baule, 157, *158*
Baumgarten, Alexander, 26n.35
Baxandall, Michael, 48, 171
Bazán Slab, 160–161, *162*, *163*, 170
Bazille, Frédéric, *ii*
Beauty, 71, 82–83, 84n.22, 85n.35, 93–94, 97, 193, 195, 212
Bellini, Gentile, *163*, *164*, 165
Bellini, Giovanni, 165
Belting, Hans, 15n.29
Bem, Sacha, 25n.18
Bena Luluwa, 9
Benin, 34, 63, 184
Benjamin, Walter, 88
Bergh, Susan E., 204
Bergson, Henri, 17, 204
Bernini, Gian, 131
Beuys, Joseph, 93, 100n.39
Beyer, Hermann, 209
Binford, Lewis, 9, 10, 54
Bingham, Hiram, 197
Bird's eye perspective, 81, 137

Birkerts, Sven, 11
The Blood of Kings (Schele and Miller), 127
Boas, Franz, 18, 51n.10, 101n.55
Boban, Eugène, 215
Bochner, Mel, 201
Body, presentation of, 180–181, *180*, 186, *187*
Bois, Yve-Alain, 151n.5
Bonampak murals, 84n.27
Borgatti, Jean, 65n.7
Bouguereau, William, 10, 99n.17
Braque, Georges, 131
Braudel, Fernand, 166
Brazil, 88
Brett-Smith, Sarah, 58n.7
Brilliant, Richard, 65n.6
British Museum, 125, 209, 210, 217, 219, 222
Bryson, Norman, 125, 186
Bucher, Bernadette, 120–121
Buddhism, 75, 76, 78, 79, 84n.24
Bullock, William, 215
Burials, 70, 146, 195, 201
Bushmen, 45, 48, 138

Carneiro, Robert, 31, 34, 35, 37n.7, 38n.23, 39n.39, 87
Catherwood, Frederick, 191, 215, 222n.3
Cave of Lascaux, 46, 48–50, *49*, 50n.4
Cave paintings, 45, 48, *49*, 228, *228*
Ceque system, 199, *199*
Cézanne, Paul, 131
Chalca, 171
Chalcatzingo, 131
Chambi, Martín, 96
Chamula, 176
Charnay, Désiré, 215–216
Chavero, Alfredo, 219
Ch'en Shun, 74
Chiapas, Mexico, 175, 176
Chichén Itzá, 123, *123*, *173*, *174*
Chiefdoms, 30, 31, 33, 34, 38n.23, 48, 60, 61–64, 103, 175,
 183, 184, 193
Childe, V. Gordon, 29, 30
Chimú figures, 80, 201, 206
China, 30, 33, 35, 42, 48, 67, 69, 70, 75, 77, 80, 81, 85n.34,
 87, 137
Choiseul, theory of color of, 93
Christianity, 72, 75, 76, 77, 78, 79, 84n.24, 91
Christy, Henry, 215
Chumash, 233–234, *234*
Citroen, 19, 61, 85n.31
Clarity, 139
Clifford, James, 101n.55, 151n.5

Codex Borbonicus, 212, 214
Codex Borgia, 121
Codex Nuttall, 175
Cognitive dissonance, 21, 25n.18
Cohen, Abner, 176
Cole, Herbert, 54–55
Colors, 23, 25n.30, 93
Communication technologies, 11–12, 15n.26, 15n.29, 36, 96–97, 104, 105
Communism, 34
Computer games, 99n.15
Comte, Auguste, 24n.4
Conceptualism, 118
Conceptual/perceptual dichotomy, 48, 125, 130–131, 134–136, 139–140, 143, 146, 150, 152n.16, 181, 186, 192, 201
Conflict theory, 34
Confucius, 78, 80
Congo, Democratic Republic of, 9, 56
Connah, Graham, 39n.42
Consciousness, 21–22
Content definition of art, 8
Contrapposto, 80–81
Cook, Captain, 8
Copán, 194
Covarrubias, Miguel, 124, 202
Cowgill, George, 31
Coyolxauhqui head, 219, 219
Crary, Jonathan, 88, 98n.10
Critchfield, Richard, 38n.33
Csikszentmihalyi, Mihaly, 14–15n.22, 25n.17
Cubism, 104
Culin, Stewart, 78
Cultures, evolution of, 29–36
cummings, e. e., 141
Cuzco, 199, 199, 205

Damisch, Hubert, 85n.32
Dan people, 153n.21
Danto, Arthur C., 77, 84n.13, 89, 90, 151n.5
Davis, Whitney, 46, 50, 50n.4, 69
De Bry, Theodor, 121, 190
De Bry family, 120–121
Decorative design. See Ornament and decorative design
De Jong, Huib Leoren, 25n.18
De Kooning, Willem, 12
Deleuze, Gilles, 30, 38n.31
Dennett, Daniel, 22, 25n.23
Denton, Robert, 30, 31
Derrida, Jacques, 18, 72n.9
De Saussure, Ferdinand, 18
Designation definition of art, 8–9

D'Harnoncourt, René, 198, 202, 206n.4
Diker, Val and Chuck, 100n.42
Disney, Walt, 99n.17
Disneyland, 36, 42, 88
Dockstader, Frederick J., 217
Duchamp, Marcel, 9, 10, 90, 91, 102, 104
Dunn, Dorothy, 100n.48
Dupaix, Guillermo, 214, 215, 216
Durán, Diego, 214
Dürer, Albrecht, 7–8, 119–120, 122–123, 150, 151nn.1-2, 164–165, 164, 169, 190
Durham, Jimmy, 88, 89
Durkheim, Emile, 17
Duvignaud, Jean, 29, 37n.6

Earle, Timothy, 37n.10, 62
Earth art, 90, 92, 99n.35, 192, 198
Easby, Dudley T., Jr., 217
Easter Islands heads, 62, 64, 183
Echániz relief, 221, 222
Egypt: and archaeology, 67; art of, 29, 43n.4, 48, 69, 80, 81, 118, 136, 147, 179, 180, 192; burial in, 70; and exchange of ideas and inventions, 35; in Hollywood film, 67; Kircher's treatise on, 191; Napoleon's scientific project on, 191, 215; origination of Bible and classical texts in, 36n.2; pyramids in, 42, 128; state of, 33
Eisenstadt, Shmuel, 83n.6
Ekholm, Gordon F., 215, 217
Elgin, Lord, 191
Eliade, Mircea, 18, 24n.8, 100n.37, 225, 240n.5
Elkana, Y., 84n.20
El Tajín, 166, 167, 168, 169
Emmons, George, 8
Engels, Friedrich, 37n.7
Enhancement, 61–64
Eskimo. See Inuit (Eskimo)
Ethnic styles: architectural profiles of Mesoamerica, 167–170, 168, 169, 177; and ball game in Mesoamerica, 172–175, 173, 174; and ethnic boundary, 176, 177; function of, 159–160; hypotheses on, 175–177; and maintenance of the other in Mesoamerican art, 171–172; meanings of ethnic, 159; of Mesoamerican art, 160–161, 162, 165–175; of Persia, 161–163, 163; style-area method for, 157–159, 175; and style juxtaposition, 160–165, 175; uses and meanings of, 157–177; Western versus non-Western world, 175
Ethnography, 11, 12, 95, 128, 159
Evolution: of art, 29, 48–49, 50–51n.10, 192; biological, 31, 37n.11; neoevolutionism, 29–32, 62; of societies and cultures, 29–36, 37n.10
Experience, 20–21

f

Fakes, 118, 215–217, 216, 217, 220–222
Fante. *See* Akan (Fante)
Fenollosa, Ernest F., 85n.34
Films, 67, 69, 88, 89, 93, 186
Flat field, 134–136
Folk art, 89, 99n.17
Formal analysis, 19, 23–24, 124
Formal definition of art, 8
Formalism, 117, 118
Foster, Hal, 58n.14
Foucault, Michel, 18–19, 157
Fountain (Duchamp), 10, 91, 102, 104
Fragonard Room, Frick Collection, 16
Frank, Andre Gunder, 87
Fraser, Douglas, 58n.1, 157
Fraser, Sir James, 17
Freedberg, David, 64, 77, 78, 104, 187
Freud, Sigmund, 17, 22
Frick Collection, Fragonard Room, 16
Fried, Michael, 9
Fried, Morton, 31
Fry, Roger, 24n.6, 51n.11
Fukuyama, Francis, 87

g

Gauguin, Paul, 92
Geertz, Clifford, 194
Genius, 90, 97, 99n.22, 159, 189–190
Geoglyphs (ground lines), 40, 46, 194, 199–200, 200
Ghana, 60, 62
Giddens, Anthony, 35–36, 39n.53
Gigantism, 67–68, 104
Glitter, 64–65
Glucksberg, Sam, 84n.15
Goethe, Johann Wolfgang von, 82
Goldi, 232–233, 232
Golding, William, 31–32
Gombrich, Ernst H., 36n.1, 48, 49, 125, 126, 130, 134, 142, 150, 152n.16, 179, 180, 181, 186, 187, 191, 192
Gondra, Isidro, 216, 219–220
Goody, Jack, 77, 84n.16
Gould, Stephen Jay, 37n.11
Greek art, 29, 36n.1, 48, 80–81, 84n.20, 90, 92, 118, 123, 134, 179, 191, 192, 195
Greenberg, Clement, 99n.27
Gross, Chaim, 201, 202
Grosz, George, 203, 203, 204
Ground lines (geoglyphs), 40, 46, 194, 199–200, 200
Guaman Poma de Ayala, Felipe, 197, 205
Guatemala, 159, 160, 166, 167, 168, 169, 172, 175, 177
Guattari, Felix, 30, 38n.31
Guilbaut, Serge, 91, 99n.28

h

Habermas, Jurgen, 31, 32, 35, 38n.29, 39n.52
Haddon, Alfred C., 50–51n.9
Hagen, Margaret A., 81, 136–138, 137, 139
Hallucinatory drugs, 236–237, 240n.5
Hammurabi Law Code Stela, 68, 69
Hamy, Jules Théodore Ernest, 218
Hanson, Duane, 152n.14, 186
Harappan cities, 69
Harley, G. W., 33, 38n.35
Hausa traders, 176
Hauser, Arnold, 24n.6, 29, 37n.4
Hawaii, 62
Hegel, George, 8, 12, 29, 34, 190
Heidegger, Martin, 190
Heizer, Michael, 99n.35, 152n.18, 198
Helicopter, 6
Herodotus, 46, 75, 78
Himmelheber, Hans, 50n.7, 187
Hodder, Ian, 37n.11
Homer, 78
Honorific definition of art, 9
Hopi, 55
Hoyle, Larco, 201, 203
Huaca Prieta, 201, 205
Huari figures, 202
Human-made versus nature, 21
Human sacrifice, 70, 76, 95, 127, 170, 171, 174, 175, 210, 212, 220–221
Hummingbird geoglyph, 40
Humphrey, Nicholas, 22
Hungary, 3, 20–21, 39n.46
Hunt, George, 8, 101n.55
Hunter-gatherers (bands), 32, 38n.31, 45–50, 53, 54, 57, 82, 233, 237

i

Ibn Batutta, 75
Ibn Khaldun, 35, 46
Ibo, 55
Iconoclasm, 76–79, 97
Identity, 56–57, 87, 159–160
Idiotechnic function of things, 10–11
Idolatry, 7–81, 70, 72, 76–77
Ife heads, 63, 63, 69, 181–182, 182, 185
Image/text, 78–79
Immateriality, 77–78
Impersonation, 53–57. *See also* Masks
Impressionism, 71, 91, 93
Inca, 34, 41, 67, 69, 190, 193, 199, 199, 205
India, 33, 35, 67, 69, 75, 76, 80, 220
Indian in Paris (Scholder), 95–96, 95
Indians. *See* North American Indians

The Indians Bringing Gold Ransom to Free Atahualpa
(De Bry), *121*
Indonesia, 62, 63, 240n.4
Industrial Revolution, 35, 89, 90
Innovation, 103, 104
Insistence, 41–42, 43n.4, 204–205
Integration theory, 34
Intentionality, 151–152n.10
Inuit (Eskimo), 9–10, 46, 47, 100n.50, 125, 230
Inventiveness, 150–151
Iranian Mihrab, 74
Islam, 75, 76, 77, 79, 83n.9, 87, 153n.20, 190
Ivory Coast, 126, *126, 158,* 187
Izapan tradition, 131

Jansen, H. W., 11
Japan, 14n.15, 69, 75, 81, 85n.34, 87, 137, 198
Jaspers, Karl, 39n.50, 83n.6
Jencks, Charles, 151n.7
Jewsiewicki, Bogumil, 58n.12
Johnson, J. Seward, 186
Judaism, 71, 75, 77, 91

Kalf, Wilhelm, 82
Kan Xul, 170, *171*
Kant, Immanuel, 22, 23, 25n.29, 82, 99n.22, 191, 195
Keen, Benjamin, 151n.2
Keita, Seydou, *28,* 96
Kingery, W. David, 14–15n.22
Kingsborough, Viscount (Edward King), 215
Kircher, Athanasius, 191
Kitawa islanders, 58n.13
Klee, Paul, 79, 204, *206*
Klein, Cecelia, 32
Komar, Vitaly, 23
Komo mask, 55, 58n.7
Kosuth, Josef, 90, 99n.25
Kpomassie, Tete-Michel, 100n.50
Krauss, Rosalind, 99n.24, 151n.10
Kristeller, Paul Oskar, 7, 13
Kuba, 63
Kubler, George, 14n.22, 15n.31, 38n.27, 81, 84n.25, 103, 105, 105n.4, 167
Kwakiutl, 9, 10, 235

La Barre, W., 240n.5
Lacan, Jacques, 18, 24n.10
Lady of Nürnberg and Lady of Venezia (Dürer), 164–165, *164,* 169
LaGamma, Alisa, 58n.15

Langley, James C., 133–134
Language, 18–19, 24n.10, 84n.15, 85n.32
Lanning, Ed, 13
Lascaux Cave, 46, 48–50, *49,* 50n.4
Leo, bishop of Neapolis, 78
León-Portilla, Miguel, 83n.5
Leroi-Gourhan, André, 49
Le Va, Barry, 201
Lévi-Strauss, Claude, 5, 17, 18, 21, 32, 36–37n.3, 104
Lévy-Bruhl, Lucien, 17, 24n.4
LeWitt, Sol, 201
Libet, Benjamin, 22
Lipman, Jean, 99n.17
Lippard, Lucy, 96, 99n.35
Literature, 12, 13
Localization, 96
Loewy, Emanuel, 134
Loos, Adolf, 143
Lowie, Robert H., 152n.15
Lubar, Steven, 14–15n.22
Luiseño, 233–234, *234*

Machu Picchu, 197, 198, *198*
Madonna of the Finch (Raphael), 74
Mahomet II (Bellini), *163, 164*
Maine, Sir Henry, 37n.7
Maine artists, 100n.45
Malraux, André, 94–95, 98n.2, 100n.46
Manicheans, 75
Mann, Michael, 34
Mannerism, 79
Maori tattooing, 22
Marsh, H. Colley, 51n.10
Marx, Karl, 37n.7, 37n.10, 38n.29
Mask (Moore), *211*
Mask of Fear (Klee), 204, *206*
Masks: African, 41, *56, 126, 126,* 184; Aztec, in Berlin museum, *213, 213,* 217–218; Aztec, of god Xipe, 118, 209–222, *209–211, 217;* and change through translation, 103–104, 185; compared with portrait, 63; Hopi, 55; and masquerade, 56, 57, 61, 76; New Ireland, 52, 96; Northwest Coast, 8, 56, 234; Olmec, 183, *183,* 184–185, *184;* power of, 11, 55–56, 57; and shamanism, 234; and social control, 33, 38n.35; and spirits and ancestors, 54–55, 183–184; stone, from Teotihuacán, 103, 133, 147, *147;* and tribal villages, 54–56, 183–184; two-dimensional, 54, 58n.1; types of, 55
Mason, J. Alden, 197, 198
Masquerade, 56, 57, 61, 76
Mass media. *See* Films; Media; Television
Materiality, 70
Maudslay, Alfred, 217, 218

Mauss, Marcel, 100n.37
Maya: and aestheticism, 118, 193–194; architecture of, 168, *169*; art of, 84n.27, 122, *122*, 124, *124*, 125, 127, 131, *132*, 146, 161, *162*, 170, *170*, 190–194; conflict between Toltec and, 173; exploration of ruins of, 191; hieroglyphs of, 77, 103, 131, 170, 185, 192, 194; and human sacrifice, 127, 170; as kingdom or state, 34; and Piedras Negras stele, 127; and Popol Vuh, 84n.21, 173; reconstruction of Maya ritual from art of, 127; and Teotihuacán, 131, 161, *162*; and Tikal Stela 31, 131, *132*, 161, *162*; weaving by, 159, *160*
McCarthy, Thomas, 31
McEvilley, Thomas, 8–9, 10, 151n.5
McLuhan, Marshall, 4, 11, 82, 85n.31
Mead, Margaret, 38n.34
Media, 11–12, 36, 87–98, 152n.14, 186. *See also* Films
Medieval art, 134, 136, 149, 152n.13, 152–153nn.19-20, 179
Melamid, Aleksandr, 23
Melanesia, 58n.1, 58n.13, 92, 95
Mendelssohn, Kurt, 67, 72n.2
Mesoamerica: and archaeology, 67; architectural profiles of, 167–170, *168*, *169*, 177; art of, 41, 69, 81, 147, 160–161, *162*, 165–176; ball game in, 172–175, *173*, *174*; Classic period of, 166–175; ethnic groups in, 165–166, *166*, *167*, 169; ethnic styles, 160–161, *162*, 165–176, *168–174*; insistence and tradition in, 42, 43n.4; maps of, *166*, *167*; Postclassic period of, 166, 168; Preclassic period of, 166, 168, 175–176; pyramids in, 42; states of, 33, 34–35, 41, 165–166, 175. *See also* Aztecs; Inca; Maya; Olmecs; Pre-Columbian art; Teotihuacán
Mesopotamia, 33, 35, 43n.4, 67, 147
Metalwork, 62, 200–201
Metric perspective, 81, 136, *137*, *138*, *139*, 152n.13
Metropolitan Museum of Art, 8, 58n.15, 100n.42
Mexico, 7–8, 14n.17, 63, 92, 175, 202, 214–215. *See also* Aztecs; Pre-Columbian art; Teotihuacán
Middle Ages. *See* Medieval art
Midpoint mimesis, 53, 58n.2, 104, 187
Miller, Arthur Green, 136
Miller, Daniel, 14n.22
Miller, Mary, 127, 170–171
Millon, René, 146
Mimesis at midpoint, 53, 58n.2, 104, 187
Minimalism, 152n.14, 192
Mitchell, W. J. T., 88
Mixtec art and manuscripts, 134, 152nn.11-12
Moche, 42, 127, 202, 203–206, *204*, *205*
Moche portrait vessels, 65n.9, 125, *125*, 181, 182, *182*, 185, 201, *203*, 206
Modern art: and abstraction, 94, 126, 131, 179; and aestheticism, 91; Africans' views of, 126–127; characteristics of, 134; hyperrealistic art, 186; and medieval art, 152–153n.19; and Native Americans, 95–96; nonvisual or noncollectible arts, 194; political aspects of, 99n.28; and primitive art, 93, 118, 126, 134, 146, 192; Rubin on, 150. *See also specific artists*
Modernism, 29, 95, 122–123, 151, 192
Modernity, 36, 39n.53
Mohenjo Daro culture, 69
MoMA. *See* Museum of Modern Art
Mona Lisa, 105
Mongols, 75
Monte Albán, 160–161, *162*, 166, 167–168, *168*
Moore, Henry, 92, 122–123, *123*, 124, 150, 151n.4, 195, 209, 211
Morgan, Louis Henry, 37n.7
Morris, William, 143
Motecuhzoma I, 171, 214
Motorcycles, 28, 104
Moundbuilders, 63
Mountains in Clouds (Ch'en Shun), 74
Mudimbe, V. Y., 58n.12
Mukherjee, Bharati, 152n.14
Mumford, Lewis, 98n.7
Murdock, G. P., 37n.7
Museum of Modern Art, 9, 12, 58n.14, 126, 146, 151n.5, 198
Music, 12, 13

Napoleon, 191
Napoleon III, 215, 217
Nasca ground lines, 46, 192, 194, 199–200, *200*
Native Americans. *See* North American Indians
Naturalism: abstraction versus, 29, 48–49, 118, 125, 126, 139, 192–193; and art as imitation of nature, 71; and European insistence, 42; Gombrich on vision required for, 192; and masks, 55–56; of Maya art, 124–125, 127, 131, 191–192; Olmec, 104, 130–131, *131*, 180–181, 185–188, 192; and ornament, 143; and portraiture, 180–183, 185–188; and power, 71; and states, 69
Nature versus human-made, 21
Navajo Indians, 237–239, *239*
Nazism, 34
Nebel, Carl, 215, 219
Neoclassicism, 90, 91
Neoevolutionism, 29–32, 62
Neolithic period, 32–35, 41, 54
New Age beliefs, 93
New Guinea, 33, 53, 57, 76
New Ireland masked men, *52*, 96
Nicholson, H. B., 222
Nietzsche, Friedrich, 99n.22
Nigeria, 8, 14n.17, 55, 63, 184

N

Nomads, 38n.31, 75
Non-art, 9–10, 90
Nonconscious, 22
Norretranders, Tor, 22, 25n.30
North American Indians: and agriculture, 237; art by, 94, 100n.42, 100n.48; Crow buffalo shield, 237; and decorative art, 152n.15; Dürer's drawing of, 120; Europeans' concept of, 120–122, 120–122, 190, 190–191; and hallucinatory drugs, 236–237; in Hollywood films, 93; masks of, 8, 55, 56, 234; Navajo, 237–239, 239; of Northwest Coast, 8, 9, 10, 46, 56, 63, 101n.55, 227–229, 227–229, 234–235, 235, 240n.3; Ojibwa Mide society, 235, 236; and Panther Cave painting, 228, 228; photography of, 101n.55; Plains, 152n.15, 235–236, 237; Pueblo, 237, 238–239, 239; Scholder's lithograph of, 95–96, 95; and shamanism, 225–240; Southwest and Southeast tribes, 78, 237
Nurenberg Chronicle, 190–191

Oaxaca, 160–161, 162, 166, 167–168, 168, 177
Ojibwa, 235, 236
Olbrechts, Franz M., 158
Olmecs: art of generally, 146; body in sculptures by, 180–181, 180, 186, 187; heads, 48, 63–64, 63, 65n.9, 69, 104, 130–131, 131, 179–182, 180, 185, 185, 186, 188; jaguar images in art of, 181, 181, 185–186; masks of, 183, 183, 184–185, 184; naturalism in art of, 104, 130–131, 131, 180–181, 185–188, 192
Ornament and decorative design, 142–145, 152n.15, 153n.20, 192
Orozco, Jimmy, 88

Pacal, 70, 124
Painting: frames, 13, 15n.32; landscape, 81; perspective in, 81–82, 85n.32, 136–138, 137. See also specific artists
Paiute, 233–234
Palenque, 122, 122, 124, 170–171, 171, 191, 197, 214
Paleolithic period, 45–50, 54, 64, 138, 225, 240
Panofsky, Erwin, 82, 85n.32, 143, 164–165
Panther Cave painting, 228, 228
Paul, St., 79
Paz, Octavio, 152n.18
Peirce, Charles, 18
Perceptual/conceptual dichotomy, 48, 125, 130–131, 134–136, 139–140, 143, 146, 150, 152n.16, 181, 186, 192, 201
Persepolis sculptures, 161–163, 163
Persia, 75, 161–163, 163
Perspective, 81–82, 85n.32, 136–138, 137
Peru, 70, 125, 147, 192, 197–206. See also Andes; Inca

Pevsner, Nikolaus, 176
Phipps, Elena, 200
Photography, 88–89, 96, 98–99n.14, 101n.55
Piaget, Jean, 50n.5
Picasso, Pablo, 12, 125, 126–127, 131, 203
Piedras Negras Stela 12, 170–171, 172
Pinker, Steven, 22
Piranesi, Giambattista, 191
Pirsig, Robert M., 25n.26
Pitt-Rivers, 50–51n.10
Plains Indians, 152n.15, 235–236, 237
Plato, 77, 80, 84n.13, 85n.32
Pleasure, 22–23, 25n.29, 83, 85n.35
Pollock, Jackson, 12, 86
Polo, Marco, 35, 75
Polynesia, 37n.10, 38n.36, 51n.10, 62, 183
Pop art, 89
Portrait of a Seated Turkish Scribe or Artist (Bellini), 163, 164
Portraiture: Africans' view of, 187; by Bellini, 163, 164; by Bernini, 131; and chiefdoms, 63–64; Ife heads, 63, 63, 69, 181–182, 182, 185; masks compared with, 63; Moche portrait vessels, 65n.9, 125, 125, 181, 182, 182, 185, 201, 203, 206; and naturalism, 180–183, 185–188; Olmec heads, 48, 63–64, 63, 65n.9, 69, 104, 130–131, 131, 179–182, 180, 185, 185, 186, 188; of Pacal, 124
Positions of things, 96–98
Poststructuralism, 29, 30, 39n.47
Pound, Ezra, 104
Power, 55–56, 57, 71–72, 72n.10, 82–83
Pre-Columbian art: and abstraction, 118, 119–153; and aesthetics, 189–196; and Andes aesthetics, 197–206; Aztec masks of God Xipe, 118, 209–222, 209–211, 217; and context of Western styles, 8, 118; Dürer on, 7–8, 119–120, 122–123, 150, 151n.2, 190; European drawings of, 121–122, 122; examples of, 123–124; and fakes, 118, 215–217, 216, 217, 220–222; invisibility of, 121–122; Moore on, 122–123, 124, 150; television image of, 99–100n.36; twentieth-century views of, 122–128. See also Aztecs; Inca; Maya; Teotihuacán
Prescott, William Hickling, 215, 219
Preston, George, 82, 85n.35
Price, Barbara, 30, 37n.10
Primitivism and the primitive: and abstraction, 29, 48–49, 50–51n.10, 57; and anthropology, 29; and art history, 89; definition and description of, 4, 91–93; individual artists' production of primitive art, 58n.15; Museum of Modern Art show (1984) of, 58n.14, 126, 146, 151n.5; and neoevolutionism, 32; and nonverbal cognition, 20; positive reevaluation of, in twentieth century, 30, 57, 58n.14, 92–93, 125; and rationality/irrationality, 17–18,

24n.6, 94–95; and shamanism, 17–18, 93, 100n.37, 100n.41, 225–240; and subliminal, 22; and totemism, 17. *See also* Africa; Aztecs; Ethnic styles; Inca; Maya; Pre-Columbian art

The Prince of Egypt, 67

Projective projection, 137–138, *137,* 152n.13

Projective systems, 136–138, *137*

Proskouriakoff, Tatiana, 194

Psychoanalysis, 100n.40

Pueblo Indians, 237, 238–239, *239*

Pygmies, 46

Pyramids, 35, 42, 66, 67, 72n.2, 128, 146, 167, *169*

Quipu, 199, 204

Raiders of the Lost Ark, 69

Raphael, 74

Rationality, 17–19, 48

Reading, 77–78. *See also* Writing

Realism, 64, 87, 98–99nn.14-15, 104, 118, 151n.9, 179, 181–183, 186–188, 203

Reclining Nude (Moore), *123*

Reed, C. H., 125, 127

Reed, H., 203

Regional art, 94, 100n.45

Religions, 75–76, 90, 189

Rembrandt, 104

Renaissance, 82, 90, 92, 93, 99n.20, 134, 137, 142, 167, 194

Replication and mass media, 11–12, 36

Robertson, Donald, 134, 152nn.11-12

Rochberg-Halton, Eugene, 14–15n.22, 25n.17

Rock markings, 46–50, *230,* 234

Rockwell, Norman, 99n.17

Rorty, Richard, 25n.23, 88

Rosny, Lucien de, 218

Rowland, Benjamin, 84n.26

Rubin, Arnold, 11

Rubin, William, 58n.14, 127, 150, 151n.5, 152n.18

Sacrifice. *See* Human sacrifice

Sagan, Carl, 98n.1

Sahagún, Bernardino de, 212

Sahlins, Marshall, 30, 37n.10, 58n.10

San (Bushmen), 45, 48, 138

Sanctuary of Les Trois Frères, 44

Sanders, William, 32, 37n.10

Sand painting, 237–238, *239*

Santa Fe School of Indian Art, 94

Saville, Marshall H., 217, 222n.5

Schapiro, Meyer, 46, 134–135, 150, 152–153n.19

Schele, Linda, 127, 170–171

Scholder, Fritz, 95–96, *95*

Schopenhauer, Arthur, 99n.22

Scoditti, Giancarlo, 58n.13

Scotland, 176

Sculpture, 41, 69, 81, 122–123. *See also* Greek art; Pre-Columbian art

Segal, George, 186

Seler, Eduard, 209, 217–218, 220

Semiotic analysis, 134–135

Semper, Gottfried, 51n.10

Senufo mask, 126, *126*

Serra, Richard, 153n.22

Service, Elman, 30, 32, 37n.10, 183

Sexual humor, 204

Shamanism, 17–18, 93, 100n.37, 100n.41, 225–240, 240n.5

Shang Ti, 70

Siberia, 226, 231, 232–233, *232,* 240n.3

Sieber, Roy, 38n.35

Signs, 135, 140–141, *141,* 152n.12

Similarity perspective, 81, 82, 85n.32, 137, *137,* 138

Simulacra, 36, 88–89

Siverts, Henning, 175

Smithson, Robert, 152n.18, 198

Snoqualmie, 227, 228

Social history, 29

Societies, evolution of, 29–36

Sociology, 35

Sociotechnic function of things, 10–11

Solomon, Deborah, 99n.17

South Africa, 45, 48

South America, 58n.1, 69. *See also specific countries*

Spencer, Charles, 31

Spencer, Henry, 37n.7

Spencer, Herbert, 37n.7

Spielberg, Steven, 67

Standardization of art, 147–148

States, 31, 33–34, 39n.42, 67–72, 81, 183, 184, 193

Status, 61

Stein, Gertrude, 41

Steinberg, Saul, 144–145, *144,* 152n.17

Stephens, John Lloyd, 191, 215, 222n.3

Steward, Julian, 30

Stolpe, Hjalmar, 51n.10

Storytelling, 46

Strother, Z. S., 54

Style, 10, 15n.23

Style-area method, 157–159, 175

Subliminal, 22

Sulka, 53

Summers, David, 135, 150
Superposition, 47–48, 50n.9

Tablero, 167–168, *168*, 177
Talud, 167–168, *168*, 177
Tanizaki, Jun'ichiro, 42
Technological era, 4, 32, 35–36, 42, 87–98
Technologies of communication, 11–12, 15n.26, 15n.29, 36, 96–97, 104, 105. *See also* Writing
Television, 99–100n.36
Teotihuacán: and aesthetic of abstraction, 128–146, 205–206; apartment compounds in, 148–149, *148*; art of, 124, *124*, 128–146, 192; border of mural paintings in, 149–150, *150*; collective ideology and the individual in, 146–151; composite incense burner in, 149; corporate ideology of, 117–118; coyote murals in, 136, *137*, 138, 150, *150*; dates of, 128; fishermen mural in, *142*; goddess and god images from, 132–133, *133*, 135, *135*, 140, *140*, 146, *147*; insistence and tradition in, 42; mapping and city plan of, 146; and Maya, 131, 161, *162*; meaning of name, 128; mural paintings of, 128–129, 132–136, *133*, *135–143*, 138–141, 145, *145*, 146, *147*, 148, 149–150, *150*, 161; net jaguar murals in, 138–139, *138–140*, 150, *150*; photograph of, *129*; plants in art of, 140–141, *141*, *143*; as polity, 166, 167; population of, 128, 146; priest figures in art of, 161, *162*; pyramids of, *66*, 128, 146, 167, *168*, 177; signs in art of, 135, 140–141, *141*; stone masks from, 103, 133, *147*, *147*; stone relief fragment from, 129–130, *130*, 132–133; Temple of Agriculture mural in, 146, *147*; Thin Orange ceramic in, 71, 146; writing system in, 133–134
Textiles, 41, 62, 64n.1, 121, 159, *160*, 193, 200
Text/image, 78–79
Textual era, 4, 32, 35, 70, 72, 75–83
Things: and anthropology, 14n.22; and art, 10–11, 13, 14–15n.22; idiotechnic function of, 10–11; nature versus human-made, 21; positions of, 96–98; sociotechnic function of, 10–11; style of, 10, 15n.23; as term, 13, 14–15n.22; thinking with, 17–24; in villages, 57
Thompson, Robert Farris, 53, 58n.2, 104, 126, 187
Three-dimensionality, 53–54, 81, 103, 122, 134, *137*
Tikal, 168, *169*, 189, 194
Tikal Stela 31, 131, *132*, 161, *162*, 170
Tilted Arc (Serra), 153n.22
Tjangala, Uta Uta, 96, 97
Tlingit, 234, 235
Toltec, 173
Tongue, Helen, 51n.11
Tonina, 170–171, *170*, *171*

Toscano, Salvador, 124
Totemism, 17–18, 21
Trade, 35, 75
Tradition, 41–42
Translation, 103–104, 185
Trevor-Roper, Hugh, 176
Tribalism, 31
Tribes (villages), 31, 32–33, 38n.33, 48, 53–57, 58n.10, 61, 70, 175
Les Trois Frères Sanctuary, 44
Tupperware, 10, 14n.20
Tutankhamen, 70
Two-dimensionality, 53, 81, 82, 103, 134, 136–138, *137*, 240n.4
Tylor, Sir Edward Burnett, 37n.7, 215, 217

Unconscious, 22, 100n.40

Valladao, Alfredo, 87
Van Eyck, Jan, 135
Van Gogh, Vincent, 93
Varnedoe, Kirk, 151n.10, 152n.18
Vasari, Giorgio, 23
Veracruz, 166, 167, 168, *169*, 177
Vico, Giambattista, 29, 36n.2
Villages. *See* Tribes (villages)
Virtuosity, 62
Vitruvius, 122
Vogel, Susan, 82

Waldeck, Jean Frédéric Maximilien de, 122, *122*, 191, 215, 216
Warhol, Andy, 12
Wasson, R. G., 240n.5
Weaving. *See* Textiles
Weiss, Joseph, 22
West Africa, 176
White, Leslie, 37n.10
Winckelmann, Johann Joachim, 26n.35, 29, 48, 80, 90, 103, 118, 179, 180, 191
Wingert, Paul, 157, 159, 175
Winter, Irene, 72n.5, 72n.7
Wolf, Eric, 30, 36
Wolfe, Tom, 91, 95
Wölfflin, Heinrich, 26n.35, 89–90, 103, 128, 193
Wood carvings, 53–54
Wright, Frank Lloyd, 72n.8
Writing: Derrida on, 72n.9; and dualism between rational and emotional, 97; Goody on elements

of, 84n.16; Mayan hieroglyphs, 77, 103, 131, 170, 185, 192, 194; and states, 68–69, 70; as technology of communication, 11, 36; in Teotihuacán, 133–134; and textual era, 35, 77–78; word versus, 15n.29
Wyeth, Andrew, 99n.17

X

Xipe figures, 218–219, *218, 220, 221, 222,* 222n.5
Xipe masks, 118, 209–222, *209–211, 217*

Y

Yoffee, Norman, 30, 31, 42
Yoruba, 8, 14n.17, 58n.2, 63, 176, 187
Young, Arthur, 6

Zeidler, James, 30
Zen and the Art of Motorcycle Maintenance (Pirsig), 22, 25n.26
Zuidema, Tom, 199

Z